CONTEMPORARY ART AND ARTISTS

CONTEMPORARY ART AND ARTISTS

AN INDEX TO REPRODUCTIONS

Compiled by Pamela Jeffcott Parry

GREENWOOD PRESS
WESTPORT, CONNECTICUT • LONDON, ENGLAND

Library of Congress Cataloging in Publication Data

Parry, Pamela Jeffcott.
 Contemporary art and artists.

 "List of books indexed" p:
 1. Art, Modern—20th century—Indexes. 2. Artists—
Indexes. I. Title.
N6490.P3234 709'.04 78-57763
ISBN 0-313-20544-2

Library of Congress Catalog Card Number: 78-57763
ISBN 0-313-20544-2

First published in 1978

Greenwood Press, Inc.
51 Riverside Avenue, Westport, Connecticut 06880

Printed in the United States of America

10 9 8 7 6 5 4 3 2 1

For LEE

Contents

Preface

Contemporary Art and Artists: An Index to Reproductions is a reference tool intended to guide the user in locating illustrations of works of art, dating from approximately 1940 to the present and covering all media except architecture. Based on more than sixty major books and exhibition catalogs, this index is truly international in scope. Part I, the Artist Index, gives the artist's name, as well as nationality and dates in most instances, plus a full entry for each work listed; while Part II, the Subject and Title Index, refers users back to the main listings in Part I.

TYPES OF WORKS LISTED

Reproductions of art works in all media save for architecture and, with some exceptions, crafts and decorative arts are included. Paintings, sculpture, drawings, prints, happenings, actions, environments, assemblages, conceptual pieces, earthworks, and video art are the primary basis for this index, although works in photography, film, and the crafts are listed if their makers are active in other media.

The time span for works covered by this index is generally from 1940 to the mid-1970s. Artists who died before 1950 are excluded, with the exception of those who were important to the development of later movements, such as Arshile Gorky. Only later works are listed for artists who have long and productive pre-1940 careers, such as Picasso or Matisse; while some pre-1940 works are included for younger or less well-known figures.

INFORMATION GIVEN IN THE INDEX

Works are listed under artist and selectively under title or subject. The Artist Index is the main section, with entries including the following information:

1. Artist—Name, alternative names, plus nationality and dates in

 most cases. Alternative names are cross-referenced.

2. Title of Work—Alternative or explanatory titles are given in paren-
 theses following the first title. Works with the same title or those
 labeled "Untitled" are listed by date or by number if they are part of
 a numbered series.

3. Date of Work—Discrepancies between the dates given in different
 reproduction sources are noted.

4. Material or Type of Work.

5. Location of Work—The institution, collection, or city in which a
 work is located is indicated by a geographical symbol as explained
 in the Key to Symbols for Locations of Works of Art. As examples,
 ELT refers to "England, London, Tate Gallery"; UNNMM refers to
 "United States, New York State, New York City, Metropolitan
 Museum of Art"; and -Fr refers to the "Collection of Dr. and Mrs.
 Oakley Frost" for which no city or country is known. The locations
 listed are those given in the publications indexed and may not be
 current, especially in the case of works listed as "Coll. Artist" or
 those in the possession of commercial galleries. Discrepancies in
 location between publications are indicated.

6. Publications in Which an Illustration of the Work Appears—Books
 in which the work is pictured are indicated by a brief reference,
 usually the author's last name, which is amplified in the "List of
 Books Indexed." Also given are the page, plate, or figure number
 and whether the illustration is in color or black-and-white. Users
 are advised that abstract works of art are frequently reproduced
 backwards or upside down.

BOOKS INDEXED

The publications indexed were chosen to include up-to-date, well-
illustrated works in English that would be available in most museum, college,
or public libraries containing art book collections. Emphasis is on books
and exhibition catalogs that survey contemporary art in general or focus on
a particular medium, country, or style, and on catalogs of important collec-
tions of contemporary art. Monographs on individual artists are excluded.

SUBJECT AND TITLE INDEX

This section is meant to be an aid in locating works that depict a par-
ticular subject or theme. Since many of the works indexed are abstract or
otherwise without identifiable subjects, it was deemed that a blanket listing
by title would not be helpful and would perhaps be misleading for icono-
graphical purposes. The Subject and Title Index has therefore been limited

to those works that are representational or semiabstract in nature. They are listed under title if the title is expressive of the work's content or under one of over eighty subject headings, such as Automobiles, Biblical and Religious Themes, Flowers, Nudes, and Portraits.

ACKNOWLEDGMENTS

I wish to express special thanks to the staff of the University of Iowa Art Library and in particular to its librarian, Harlan Sifford, for the generous assistance offered.

<div align="right">PAMELA JEFFCOTT PARRY</div>

List of Books Indexed

A-K Contemporary Art, 1942-1972; Collection of the Albright-Knox Art Gallery. New York, Praeger, 1972

Abstract Art Since Mid-Century; The New Internationalism. v.1--Abstract Art Since 1945. Greenwich, Conn., New York Graphic Society, 1971

Alloway Alloway, Lawrence. American Pop Art. New York, Collier, 1974

Amaya Amaya, Mario. Pop Art...And After. New York, Viking, 1966

Andersen Andersen, Wayne. American Sculpture in Process: 1930-1970. Boston, New York Graphic Society, 1975

Arnason Arnason, H. H. History of Modern Art; Painting, Sculpture, Architecture. New York, Abrams, 1968

Arnason 2 Arnason, H. H. History of Modern Art; Painting, Sculpture, Architecture. 2d ed. Englewood Cliffs, N. J., Prentice-Hall and New York, Abrams, 1977

Ashton Ashton, Dore. Modern American Sculpture. New York, Abrams, 1968

Barrett Barrett, Cyril. An Introduction to Optical Art. London, Studio Vista, 1971

Battcock Battcock, Gregory, ed. Super Realism: A Critical Anthology. New York, Dutton, 1975

Brett Brett, Guy. Kinetic Art. London, Studio Vista and New York, Reinhold, 1968

Busch Busch, Julia M. A Decade of Sculpture: The 1960s. Philadelphia, Art Alliance Press, 1974

Calas Calas, Nicolas and Elena. Icons and Images of the Sixties. New York, Dutton, 1971

Carmean The Great Decade of American Abstraction: Modernist Art 1960-1970. Houston, Museum of Fine Arts, 1974

Castleman Castleman, Riva. Contemporary Prints. New York, Viking, 1973

Celant Celant, Germano. Art Povera. New York, Praeger, 1969

Compton Compton, Michael. Optical and Kinetic Art. London, Tate Gallery, 1967

Popper Popper, Frank. Art: Action and Participation.
 New York, New York University Press, 1975

Popper 2 Popper, Frank. Origins and Development of Kinetic
 Art. Greenwich, Conn., New York Graphic Society,
 1968

Rose Rose, Barbara. American Art Since 1900. Rev. &
 exp.ed. New York, Praeger, 1975

Russell Russell, John, comp. Pop Art Redefined. New York,
 Praeger, 1969

Sandler Sandler, Irving. The Triumph of American Painting;
 A History of Abstract Expressionism. New York,
 Praeger, 1970

Seitz Seitz, William Chapin. The Art of Assemblage.
 New York, Museum of Modern Art; distrib. by
 Doubleday, Garden City, N. Y., 1961

Selz Selz, Peter. New Images of Man. New York, Museum
 of Modern Art; distrib. by Doubleday, Garden
 City, N. Y., 1959

Seuphor Seuphor, Michel. Abstract Painting; Fifty Years
 of Accomplishment from Kandinsky to the Present.
 New York, Abrams, 1961(?)

6 Yrs Lippard, Lucy R. Six Years: The Dematerialization
 of the Art Object From 1966 to 1972. New York,
 Praeger, 1973

Stuyvesant Contemporary British Painting. New York, Praeger,
 1968

Trier Trier, Eduard. Form and Space: Sculpture of the
 Twentieth Century. New York, Praeger, 1968

Tuchman Tuchman, Maurice. New York School, The First
 Generation, Paintings of the 1940s and 1950s.
 Los Angeles, Los Angeles County Museum of Art,
 1965

UK1 Kultermann, Udo. The New Sculpture; Environments
 and Assemblages. New York, Praeger, 1968

UK2 Kultermann, Udo. The New Painting. New York,
 Praeger, 1969

UK3 Kultermann, Udo. New Realism. Greenwich, Conn.,
 New York Graphic Society, 1972

UK4 Kultermann, Udo. Art and Life. New York, Praeger,
 1971

Walker Walker, John A. Art Since Pop. London, Thames &
 Hudson, 1975

Whitney Whitney Museum of American Art. Catalog of the
 Collection. New York, 1975

Wilson Wilson, Simon. Pop. London, Thames & Hudson,
 1974

Wolfram Wolfram, Eddie. History of Collage: An Anthology
 of Collage, Assemblage and Event Structures.
 New York, Macmillan, 1975

Key to Symbols for
Locations of Works of Art

(Locations given are from publications indexed and
may not be current)

Collections Not Identified by
Geographic Location

-A	Coll. Mr. and Mrs. Harry W. Anderson
-Ak	Coll. Zinta and Joseph James Akston
-Al	Coll. Tapiaza Aliata
-Ar	Arco d'Alibert Gallery
-Arc	Galleria Arco
-Art	Art Institute of Light
-Au	Coll. R. A. Augustinici (FPAu)
-Bar	Coll. Walter Bareiss
-Bau	Coll. Mme. M. Baumeister (GStB)
-Baz	Coll. Jean Bazaine
-Be	Coll. Warren and Bonnie Benedek
-Bl	Coll. Peter Blake
-Bla	Coll. Dr. H. Blake
-Blak	Coll. Mr. and Mrs. Thomas W. Blake
-Bo	Coll. David Bourden
-Bod	Bodley Gallery
-Bon	Coll. Alfred Bonino
-Br	Bradley Family Foundation
-Bu	Coll. William Burden
-By	Coll. Jeff Byers
-Cab	Coll. Reggie Cabral
-Car	Coll. Mr. and Mrs. Gilbert F. Carpenter
-Caro	Coll. S. M. Caro
-Cau	Coll. Ed Cauduro
-Cha	Coll. Mrs. Thomas B. Chambers
-Co	Coll. O. Le Corneur
-Cow	Coll. Charles Cowles
-Cu	Coll. Haigh Cundy
-Cul	Michael Cullen Gallery
-D	Coll. Mr. and Mrs. Barrie Damson
-Duf	Coll. Lord Dufferin
-Duh	Coll. Marcel Duhamel
-Dur	Coll. Philippe Durand-Ruel
-E	Coll. Dr. and Mrs. Andre Esselier
-Es	Coll. Lord Esher
-F	Coll. Susan Forrestal
-Fo	Coll. Mr. and Mrs. Thomas Folds
-Fr	Coll. Dr. and Mrs. Oakley Frost
-Fre	Coll. Betty Freeman

-G	Coll. Dr. and Mrs. Gerald Gurman
-Gab	Coll. Miriam Gabo
-Gan	Coll. Mr. and Mrs. Victor W. Ganz (UNNGan)
-Gar	Coll. Wreatham Gathright
-Gi	Coll. G. Gilles
-Gib	Coll. John Gibbon
-Gl	Coll. Mary Glazebrook
-Go	Coll. Wally Goodman and Stanley Picher
-Gor	Coll. Maro and Natasha Gorky
-Gos	Coll. Mrs. Edith Gossage
-Gr	Coll. Mrs. Helen Grigg
-Gra	Coll. Martha Graham
-Gu	Coll. Dr. Gerald Gurman
-H	Coll. A. Haigh
-Hal	Coll. Mr. and Mrs. David Halle
-Har	Coll. Mrs. Mortimer B. Harris
-He	Coll. Sonia Henje and Niels Onstadt (UCLHe)
-Hen	Coll. Alexandre Henisz
-Her	Coll. Dr. Jorst Herbig
-Hi	Hillman Periodicals, Inc.
-Hof	Coll. Paul and Camille Hoffmann
-Hoff	Coll. Nancy Hoffman
-Hofm	Estate of Hans Hofmann
-In	International Art Foundation
-Io	Coll. Alexandre Iolas
-J	Coll. William Jaeger
-Ja	Coll. Mr. and Mrs. Brooks Jackson
-K	Coll. Melvin Kaufmann
-Ke	Coll. Robert Kelly
-Kei	Coll. Mrs. Alex Keiller
-Ko	Coll. Dr. and Mrs. L. V. Kornblee
-Kr	Coll. Kronhausen
-Kra	Coll. Howard Kraushaar
-Krau	Kraushaar Family
-Ku	Coll. Katharine Kuh
-Lan	Coll. Mr. J. Patrick Lannan (UFPL)
-Lang	Coll. Victor Langen
-Lann	Lannan Foundation (UFPL)
-Le	Coll. Josias Leao
-Lef	Coll. Mr. and Mrs. Aphul Lefton
-Lew	Coll. Sydney and Frances Lewis
-Lie	Coll. Sandford Lieberson
-Lil	Coll. Mrs. Philip Lilienthal
-Lin	Coll. Mrs. Denver Lindley
-Ma	Coll. Saidie A. May
-Man	Coll. Manes
-Mand	Coll. Dr. and Mrs. Robert Mandelbaum
-Mar	Coll. Georges Marci
-Marl	Marlborough Gallery
-Marlb	Coll. Marlborough
-Marm	Coll. Dr. and Mrs. Judd Marmour
-May	Coll. Mrs. Robert Mayer
-Mayer	Coll. Robert Mayer (UICMay, UIWMa)
-Me	Coll. Mr. and Mrs. Robert E. Meyerhoff
-Mi	James A. Michener Foundation
-Mil	Coll. E. Millington-Drake

—Mila	Coll. Piero Milani
—Mo	Coll. W. Moos
—Moo	Coll. Miss Mary Moore
—Mor	Coll. Remo Morone
—My	Coll. Mr. and Mrs. Monroe Myerson
—Neu	Coll. Mr. and Mrs. Morton Neumann (UICNeu)
—No	Coll. Mr. and Mrs. S. B. Noble
—Nu	Nuova Tendenza
—P	Coll. Count Panza (IMPan)
—Pe	Coll. Dr. H. Peeters (BBrP)
—Ph	Coll. Jesse Phillips
—Pi	Coll. Edward Pillsbury
—Po	Coll. Lewis Pollack
—Por	Coll. Frank Porter
—Ran	Coll. Mrs. Paul Scott Rankine
—Re	Coll. Anita Reiner
—Rea	Coll. Reader's Digest
—Rei	Coll. Mrs. Ad Reinhardt
—Ren	Denise Rene Gallery
—Ric	Coll. Lewis Richman
—Rip	Coll. Dwight Ripley
—Ro	Coll. Neil Rosenstein
—Roe	Coll. Mrs. James Roemer
—Ros	Coll. Florence S. Roszak
—Rot	Coll. Samuel and Ethel Roth
—Roth	Coll. Philippe de Rothschild
—Row	Coll. Mr. and Mrs. Robert Rowan (UCPaR)
—Rub	Coll. Larry Rubin
—Run	Coll. Rundquist
—Saa	Coll. Charles and Doris Saatchi
—Saal	Coll. Mr. and Mrs. Albrecht Saalfield
—Sam	Coll. Hon. Anthony Samuel
—Schu	Coll. Mrs. Margarete Schultz
—Scu	Coll. Jonathan D. Scull
—Se	Coll. Stanley Seeger
—So	Coll. Toni and Martin Sosnoff
—Sp	Coll. Stephen Spender
—Spe	Coll. Stuart M. Spenser
—St	Coll. Saul Steinberg (UNNStei)
—Ste	Coll. M. J. Stewart
—Step	Coll. Dr. Ruth Stephan
—Str	Coll. Jon Nicholas Streep
—Sun	Sunderland Art Gallery
—Sut	Coll. Mrs. Graham Sutherland
—T	Coll. Mrs. Christophe Thurman
—Ta	Coll. Kay Sage Tanguy
—Tap	Coll. Tapie
—Te	Coll. David Teigen
—U	United Jewish Appeal
—Ul	Coll. Alberto Ulrich (IMU)
—Val	Coll. Mrs. W. R. Valentiner
—Vi	Coll. M. Visser
—Vog	Coll. Dr. Felicitas Vogel
—Wei	Coll. Dr. and Mrs. Jacob Weinstein
—Wes	Coll. Mr. and Mrs. Tom Wesselman
—Will	Coll. F. E. Williams

```
-Wins         Coll. Lydia and Harry Lewis Winston
-Wo           Coll. Renee and Jan Wojers
-Woo          Woodward Foundation
-Wr           Coll. C. B. Wright
-Ya           Coll. Hanford Yang
-Z            Coll. Mr. and Mrs. M. Zurier
-Za           Coll. Zalstem Zalewsky

                         Austria
AS            Salzburg
AVK           Vienna.  Coll. Kunstler
AVMH          -----  Municipal Hall
AVMu          -----  Museum der Stadt Wien
AVV           -----  Coll. City of Vienna
AVVe          -----  Coll. Willy Verkauf

                         Argentina
ArBB          Buenos Aires.  Galeria Bonino
ArBNB         -----  Museo Nacional de Bellas Artes
ArBT          -----  Museo Instituto Torcuata di Tella Jujuy

                         Australia
AuANG         Adelaide.  National Gallery of South Australia
AuCA          Canberra.  Australian National Gallery
AuMGV         Melbourne.  National Gallery of Victoria

                         Belgium
-BB           Belgian State Colls.
-BM           Maison des sourds-muets
BAAd          Antwerp.  Galerie Ad Libitum
BAKO          -----  Openluchtmuseum voor Beeldhouwkunst
              Middelheim
BAM           -----  Museum
BAMa          -----Coll. M. Machiels
BAW           -----Wide White Space Gallery
BBBi          Brussels.  Coll. M. Blicke
BBBr          -----  Coll. Isy Brachot
BBC           -----  Ministry of Culture
BBCa          -----  Galerie Carrefour
BBCl          -----  Coll. H. M. Claesens
BBCo          -----  Galerie Cogeime
BBCoq         -----  Coll. Jean Coquelet
BBD           -----  Coll. Christian Dotremont
BBDa          -----  Coll. Herman J. Daled
BBDo          -----  Coll. Philippe Dotremont
BBDot         -----  Coll. Dotremont
BBE           -----  Coll. G. Everaert
BBEv          -----  Coll. Mme. Everaert
BBG           -----  Coll. B. Goldschmidt
BBGi          -----  Coll. Mme. Robert Giron
BBH           -----  Coll. J. Huysman
BBHe          -----  Coll. Mar Hendrickx
BBI           -----  Galerie Internationale d'Art Contemporain
BBJ           -----  Coll. J. Janssen
BBL           -----  Coll. Baroness Lambert
BBLa          -----  Coll. Emile Langui
```

```
BBLac          Brussels.  Coll. Lachowsky
BBM            -----  Galerie Francoise Mayer
BBMag          -----  Coll. Georgette Magritte
BBN            -----  New Smith Gallery
BBNa           -----  Coll. Naessens
BBR            -----  Musees Royaux des Beaux-Arts de Belgique
BBRAM          -----  Musee Royal d'Art Moderne
BBSta          -----  Coll. Marcel Stal
BBSto          -----  Coll. Stoclet
BBV            -----  Coll. Van Parys
BBVe           -----  Coll. Vernanneman
BBW            -----  Coll. Withofs
BBrP           Bruges.  Coll. Dr. Hubert Peeters
BGG            Ghent.  Coll. K. J. Geirlandt
BGMS           -----  Museum voor Schone Kunsten
BL             Liege
BLB            -----  La Boverie Park
BLG            -----  Coll. Fernand C. Graindorge
BLMB           -----  Musee des Beaux-Arts
BLiJ           Lierre.  Coll. J. Janssen
BOsF           Ostende.  Fine Art Museum
BRU            Rhode St. Genese.  Coll. Urvater
BVeM           Veviers.  Musees Communaux

                        Brazil
BrBP           Brasilia.  President's Palace
BrREd          Rio de Janeiro.  Ministry of Education Building
BrRMo          -----  Museu do Arte Moderno do Rio de Janeiro

                        Canada
-CD            Department of External Affairs of Canada
CHaE           Hamilton.  Coll. Dr. and Mrs. N. B. Epstein
CMCa           Montreal.  Coll. Mr. and Mrs. Robert L. Cardoza
CME            -----  Expo 67
CMFA           -----  Museum of Fine Arts
CMG            -----  Coll. Mira Godard
CML            -----  Coll. Dr. Lariviere
CON            Ottawa.  National Gallery of Canada
CSU            Saskatoon.  University of Saskatchawan.
                 Norman Mackenzie Art Gallery
CTA            Toronto.  Art Gallery of Toronto
CTD            -----  Coll. Mrs. Harry Davidson
CTDa           -----  Coll. Mr. and Mrs. Roger Davidson
CTI            -----  Isaacs Gallery
CTM            -----  David Mirvish Gallery
CTMi           -----  Coll. Mr. and Mrs. David Mirvish
CTO            -----  Art Gallery of Ontario
CTR            -----  Roberts Gallery
CTS            -----  Sable-Castelli Gallery
CThW           Thornhill.  Coll. Dr. and Mrs. Sidney L. Wax
CVaA           Vancouver.  Vancouver Art Gallery

                        Denmark
-DA            Coll. of the State
DCG            Copenhagen.  Gladsaxe Commune
DCN            -----  Ny-Carlsberg Glyptotek
```

DCSt	Copenhagen. Statens Museum for Kunst (Musee Royal des Beaux-Arts)
DCT	----- Coll. Karl Thyrre
DHuL	Humleback. Louisiana Museum

England

-EG	Coll. Margaret Gardner
-EH	Coll. Ashley Havinden
-EHep	Estate of Barbara Hepworth
-EM	Coll. Mrs. Henry Moore
EBatB	Batley. Bagshaw Art Gallery
EBramM	Bramley. Coll. F. L. S. Murray
ECamE	Cambridge. Department of Engineering
EGlS	Gloucestershire. Coll. Richard Smith
ELA	London. Coll. Peter Adam
ELAle	----- Editions Alecto
ELAr	----- Arts Council of Great Britain
ELAx	----- Axiom Gallery
ELBat	----- Battersea Park
ELBea	----- Beaux-Arts Gallery
ELBo	----- Coll. Dennis Bowen
ELBr	----- British Petroleum Co. Ltd.
ELBrC	----- British Council
ELBra	----- Coll. Erica Brausen
ELCar	----- Coll. Timothy and Paul Caro
ELChet	----- Coll. Tom Chetwynd
ELCoc	----- Coll. Peter Cochrane
ELCont	----- Contemporary Art Society
ELDa	----- Coll. Dr. and Mrs. Charles Damiano
ELDe	----- Coll. Anthony Denney
ELDo	----- Coll. Mio Downyck
ELDu	----- Coll. Marquess of Dufferin and Ada
ELF	----- Coll. Dudley Fishburn
ELFr	----- Robert Fraser Gallery; Coll. Robert Fraser
ELFu	----- Coll. Mrs. I. Fullard
ELG	----- Gimpel Fils; Coll. Peter Gimpel
ELGal	----- Gallery House
ELGi	----- Gimpel and Hanover Gallery
ELGib	----- Coll. Christopher Gibbs
ELGl	----- Coll. Mark Glazebrook
ELGo	----- Coll. Lady D'Avigdor Goldsmid
ELGom	----- Coll. Donald Gomme
ELGor	----- Coll. Charles Gordon
ELGr	----- Nigel Greenwood, Ltd.
ELGra	----- Grabowski Gallery
ELGren	----- Coll. Phillip Grenville
ELGul	----- Calouste Gulbenkian Foundation
ELGuy	----- Guy's Hospital
ELH	----- Hanover Gallery
ELHa	----- Coll. Dominy Hamilton
ELHam	----- Hamilton Gallery
ELHay	----- Hayward Gallery
ELIC	----- Institute of Contemporary Arts
ELIn	----- Indica Gallery
ELJ	----- Annely Juda Fine Art
ELJa	----- Bernard Jacobson Ltd.

ELK	London. Kasmin Gallery
ELKee	----- Coll. Paul Keeler
ELKi	----- Coll. J. Kirkman
ELL	----- Lord's Gallery
ELLef	----- Lefevre Gallery
ELLen	----- Coll. John Lennon
ELLi	----- Lisson Gallery
ELLu	----- Coll. Edward Lucie-Smith
ELM	----- Lucy Milton Gallery
ELMa	----- Marlborough Gallery
ELMar	----- Coll. John Martin
ELMc	----- Coll. McRoberts
ELMcA	----- Coll. R. Alistair McAlpine
ELMcE	----- Coll. Rory McEwen
ELMcR	----- McRoberts & Tunnard, Inc.
ELNL	----- New London-Marlborough Gallery
ELP	----- Coll. Jill Phillips
ELPen	----- Coll. Roland Penrose
ELPet	----- Petersburg Press
ELPo	----- Coll. E. J. Power
ELPow	----- Coll. Alan Power
ELR	----- Redfern Gallery
ELRi	----- Coll. Miss S. Riley
ELRo	----- Rowan Gallery
ELS	----- Coll. Robert J. Saintsbury
ELSa	----- Felicity Samuel Gallery
ELSaa	----- Coll. Mr. and Mrs. Charles Saatchi
ELSh	----- Coll. Mrs. B. Shenkman
ELSi	----- Situation Gallery
ELSm	----- Coll. Harry Smith
ELSo	----- Soho Gallery
ELSon	----- Coll. Mr. C. Sonnabend
ELStH	----- State House
ELStr	----- Coll. Michel Strauss
ELStu	----- Peter Stuyvesant Foundation
ELT	----- Tate Gallery
ELTL	----- Time-Life Building
ELTa	----- Coll. Christopher Taylor
ELTho	----- J. Walter Thompson Co.
ELTo	----- Arthur Tooth & Sons
ELV	----- Victoria and Albert Museum
ELW	----- Waddington Galleries
ELWh	----- Coll. Michael White
ELWi	----- Coll. Percy Williams
ELivM	Liverpool. Coll. John Moores
ELivMo	----- Coll. Peter Moores
ELivW	----- Walker Art Gallery
ELouC	Loughborough. Loughborough College
ELyR	Lympstone. Coll. Royal Marines
EMaA	Manchester. City of Manchester Art Gallery
EMaG	----- Granada Television
ENP	Newbury. Coll. Alan Power
ENorM	Northamptonshire. St. Matthew Church
EOBa	Oxford. Bailliol College
EOxL	Oxfordshire. Coll. Hon. Mrs. Miriam Lane
ERicP	Richmond. Coll. Alan Power

ESoutS	Southampton. Southampton Art Gallery
EYoD	Yorkshire. Coll. Hon. James Dugdale

France

-FC	Coll. Dr. Jean Causse
FAntG	Antibes. Musee Grimaldi
FAntP	----- Musee Picasso
FBagN	Bagnolet. Quartier de la Noue
FBeL	Beauvoir. Coll. Philippe Leclerc
FBioL	Biot. Musee Fernand Leger
FGreM	Grenoble. Musee de Peinture et de Sculpture
FHL	Hem (Nord). Coll. Philippe Leclercq
FLeHM	Le Havre. Museum of Le Havre
FMaC	Marseilles. Musee Cantini
FMaF	----- Faculty of Medicine
FMoS	Montval. Galerie Soixante
FNW	Noisy-le-Roi. Coll. Mme. Grety Wols
FPA	Paris. Coll. Mme. Atlan
FPAM	----- Musee National d'Art Moderne
FPAr	----- Coll. Jean Arp
FPAri	----- Galerie Ariel
FPArn	----- Galerie Arnaud; Coll. Arnaud
FPAu	----- Coll. R. A. Augustinci
FPB	----- Galerie Claude Bernard
FPBea	----- Plateau Beaubourg
FPBel	----- Galerie Pierre Belfond
FPBer	----- Galerie Berggruen
FPBerg	----- Coll. Mme. Anna Eva Bergman
FPBet	----- Coll. Mme. Niomar M. S. Bettencourt
FPBl	----- Blumenthal Gallery
FPBo	----- Coll. M. and Mme. M. Boulois
FPBou	----- Coll. Alain Bourbonnais
FPBre	----- Coll. Andre Breton
FPBu	----- Galerie Jean Bucher
FPC	----- Centre National d'Art Contemporain
FPCa	----- Galerie Louis Carre
FPCah	----- Galerie Cahiers d'Art
FPCap	----- Coll. Gildo Caputo
FPCaz	----- Galerie Raymonde Cazenave; Coll. Raymonde Cazenave
FPChar	----- Galerie Charpentier
FPCl	----- Coll. L. G. Clayeau
FPCla	----- Coll. Max Clarac-Seron
FPCle	----- Galerie Iris Clert
FPCo	----- Galerie Daniel Cordier
FPCon	----- Galerie Suzanne de Coninck
FPCor	----- Coll. Daniel Cordier
FPCou	----- Coll. Michel Couturier
FPCout	----- Coll. Mme. Monique Couturier
FPCr	----- Galerie Creuzevault
FPCra	----- Coll. John Craven
FPD	----- Coll. Lucien Durand
FPDBC	----- Coll. D. B. C.
FPDe	----- Coll. Sonia Delaunay
FPDel	----- Coll. Delerve
FPDelo	----- Coll. Mme. Deloffre

```
FPDi        Paris.  Coll. Frederic Dittis
FPDr        -----  Galerie du Dragon
FPDu        -----  Galerie Dubourg
FPDub       -----  Coll. Jacques Dubourg
FPDup       -----  Coll. G. Dupin
FPDur       -----  Coll. Durand-Ruel
FPE         -----  Elysee Palace
FPEu        -----  Galerie Europe
FPF         -----  Coll. Mme. Simone Frigerio
FPFa        -----  Galerie Paul Facchetti; Coll. Paul
                   Facchetti
FPFel       -----  Galerie Mathias Fels
FPFen       -----  Coll. Felix Feneon
FPFl        -----  Galerie Karl Flinker
FPFo        -----  Galerie Jean Fournie & Co.
FPFr        -----  Galerie de France
FPFra       -----  Coll. Martine Franck
FPFran      -----  Coll. Sam Francis
FPFu        -----  Coll. Funck-Brentano
FPFue       -----  Coll. J. G. Fuentes
FPG         -----  Coll. Glaesser
FPGM        -----  Galerie Mai
FPGa        -----  Coll. Maurice Garnier
FPGe        -----  Galerie Daniel Gervis
FPGiv       -----  Galerie Claude Givaudan; Editions
                   Claude Givaudan
FPGo        -----  Coll. Mme. Roberta Gonzalez-Hartung
FPGom       -----  Coll. Henriette Gomes
FPH         -----  Coll. R. Haas
FPHai       -----  Coll. Claude Bernard Haim
FPHau       -----  Galerie Hautefeuille
FPHu        -----  Galerie La Hune; Editions La Hune
FPInt       -----  Galerie Internationale d'Art Contemporain
FPIo        -----  Galerie Alexandre Iolas; Coll. Alexandre
                   Iolas
FPJ         -----  Galerie J
FPJe        -----  Jeu de Paume
FPK         -----  Coll. Mme. Yves Klein
FPKe        -----  Coll. Mme. Madeleine Kemeny
FPKl        -----  Galerie Kleber
FPKn        -----  Galerie Knoedler
FPL         -----  Galerie Lacloche
FPLa        -----  Coll. Helie Lassaigne
FPLam       -----  Galerie Yvon Lambert
FPLan       -----  Galerie Landau
FPLar       -----  Galerie Jean Larcade
FPLe        -----  Galerie Louis Leiris
FPLei       -----  Galerie Louise Leiris
FPLev       -----  Coll. Raoul Levy
FPMP        -----  Musee d'Art Moderne de la Ville de Paris
FPMS        -----  Coll. M. S.
FPMa        -----  Galerie Maeght; Coll. Aime Maeght
FPMai       -----  Coll. Maillard
FPMas       -----  Galerie Jacques Massol
FPMo        -----  Coll. de Montaigu
FPMou       -----  Coll. Andre de Mourgues
```

FPNou	Paris.	Coll. M. and Mme. J. Y. Noury
FPOe	-----	Galerie d'Oeil
FPP	-----	Galerie Pierre
FPPet	-----	Galerie Petit
FPPeti	-----	Coll. A. Petit
FPPh	-----	Galerie Philadelphie
FPPoi	-----	Galerie Point Cardinal
FPPol	-----	Coll. Alexis Poliakoff
FPPr	-----	Coll. Miriam Prevot
FPPu	-----	Coll. Jacques Putnam
FPQ	-----	Galerie des 4 Mouvements
FPR	-----	Galerie Philippe Reichenbach
FPRa	-----	Coll. Michel Ragan
FPRan	-----	Galerie Jacqueline Ranson
FPRe	-----	Galerie Denise Rene
FPRes	-----	Coll. Pierre Restany
FPRi	-----	Galerie Rive Droite
FPRic	-----	Coll. M. and Mme. Richet
FPRiv	-----	Galerie Rive Gauche
FPRo	-----	Rothschild Pilot Bank
FPRoq	-----	Galerie Roque
FPRot	-----	Coll. Cecile de Rothschild
FPRoth	-----	Coll. Baroness Alice de Rothschild
FPRoths	-----	Coll. Elie de Rothschild
FPRothsc	-----	Coll. Baroness Edmond de Rothschild
FPS	-----	Coll. Michel Seuphor
FPSa	-----	Coll. Sauvage
FPSal	-----	Coll. Mme. Salomon
FPSam	-----	Coll. Henri Samuel
FPSch	-----	Galerie Andre Schoeller
FPSe	-----	Coll. Delphine Seyrig
FPSil	-----	Coll. Mme. Y. Silvers
FPSo	-----	Coll. M. and Mme. Sonnabend
FPSon	-----	Galerie Ileana Sonnabend; Coll. Mrs. Ileana Sonnabend
FPSp	-----	Coll. Darthea Speyer
FPSt	-----	Galerie Stadler; Coll. Stadler
FPT	-----	3 + 2 Gallery
FPTap	-----	Coll. Michel Tapie
FPU	-----	Coll. J. Ullmann
FPUn	-----	Unesco Conference Building
FPV	-----	Galerie XXe Siecle
FPVG	-----	Galerie Villand et Galanis
FPVis	-----	Visart and Cie.
FPW	-----	Coll. Mme. Grety Wols
FPWe	-----	Galerie Lucien Weil
FPY	-----	Galerie "Y"
FPZ	-----	Coll. Christian Zervos
FReF	Rennes.	Faculte de Medicine et de Pharmacie
FReuR	Reux.	Coll. Baroness Alix de Rothschild
FStA	St. Avold	
FStPM	St. Paul.	Fondation Maeght

Finland

FiHA	Helsinki.	Atheneum Art Museum (Ateneumin Taidemuseo)

```
FIOP              Orivesi.  Parish Church

                          Germany
-GB               Coll. Herr Bonig
-GV               Coll. C. Van Des Bosch
GAaL              Aachen.  Coll. Peter Ludwig
GAaN              -----  Neue Galerie
GBBe              Berlin.  Coll. City of Berlin
GBBl              -----  Galerie Block
GBG               -----  Coll. Prof. Gonda
GBH               -----  Coll. Ilse Hartung
GBHa              -----  Coll. Doris Hahn
GBHan             -----  Hansa Platz
GBM               -----  Modern Art Gallery
GBO               -----  Coll. Reinhard Onnasch
GBOp              -----  Opera House
GBSch             -----  Galerie Schuler
GBSp              -----  Galerie Springer
GBWer             -----  Galerie Michael Werner
GBadL             Bad Salzuflen.  LVA Clinic
GBaden            Badenberg
GBoE              Bonn.  Coll. Ludwig Erhart
GBocK             Bochum.  Coll. Klinker
GBocM             -----  Bochum Municipal Museum
GBodM             Bodensee.  Coll. Miller
GBrSM             Braunschweig.  Stadtisches Museum
GBremH            Bremen.  Coll. Michael Hertz
GBremK            -----  Kunstmuseum
GBremKH           -----  Kunsthalle
CCD               Cassel.  Documenta
GCo               Cologne
GCoAA             -----  Galerie Aenne Abels
GCoB              -----  Galerie Borgmann
GCoBa             -----  Baukunst
GCoF              -----  Coll. Heiner Friedrich
GCoGm             -----  Galerie Gmurzynska
GCoH              -----  Coll. Wilhelm Hack
GCoHah            -----  Coll. Wolfgang Hahn
GCoK              -----  Kolnisches Stadtsmuseum
GCoKl             -----  Galerie Klang
GCoL              -----  Coll. Ludwig
GCoM              -----  Coll. Paul Maentz
GCoMe             -----  Coll. Georg Meistermann
GCoMu             -----  Coll. A. O. Muller
GCoOp             -----  Coll. Baroness Oppenheim
GCoRi             -----  Galerie Ricke
GCoSc             -----  Coll. C. Scheibler
GCoSp             -----  Galerie Der Spiegel
GCoSt             -----  Coll. Stein
GCoT              -----  Galerie M. E. Thelen
GCoW              -----  Wallraf-Richartz Museum
GCoWi             -----  Galerie Winterberger
GCoZ              -----  Galerie Zwirner; Coll. Zwirner
GDaH              Darmstadt.  Hessisches Landesmuseum Darmstadt
GDaI              -----  Coll. Dr. H. J. Imela
GDaS              -----  Coll. K. Stroher
```

```
GDaSt          Darmstadt.  Coll. Karl Straker
GDorV          Dortmund.  Coll. Albert Schulze Vellinghausen
GDu            Duisberg
GDuK           ----- Wilhelm-Lehmbruck Museum der Stadt Duisberg
GDus           Dusseldorf
GDusB          ----- Coll. Heinz Beck
GDusG          ----- Coll. Graubner
GDusKN         ----- Kunstsammlung Nordrhein Westfalen
GDusKl         ----- Coll. Lilo and Konrad Klapheck
GDusSc         ----- Galerie Schmela
GDusW          ----- Coll. Dr. Weinsziehr
GDusWi         ----- Coll. Wilp
GDusZ          ----- Galerie 22
GEB            Essen.  Coll. Berthold Beitz
GEBo           ----- Coll. Berthold von Bohlenund Halbach
GEF            ----- Museum Folkwang
GEK            ----- Coll. Eberhard Kemper
GER            ----- Coll. Dr. H.-W. Rudhart
GET            ----- M. E. Thelen Gallery
GFM            Frankfurt.  Galerie Meyer-Ellinger
GFS            ----- Stadtlische Galerie
GFSt           ----- Stadelsches Kunstinstitut
GFW            ----- Coll. Wenninger
GFreiR         Freiburg im Breisgau.  Regierungsprasidium
                 Sudbaden
GFreiS         ----- Coll. Dr. Elfriede Schulze-Battmann
GFreiUL        ----- University Library
GGelH          Gelsenkirchen.  Haus Tollmann
GGelO          ----- Opera
GGelS          ----- Schalker Gymnasium
GGelSt         ----- Studiotheater
GGelT          ----- Stadttheater
GGlM           Gladbach.  Stadtisches Museum
GGmH           Gmund.  Coll. Werner Haftmann
GHBr           Hamburg.  Galerie Brockstedt
GHG            ----- Galerie de Gestlo
GHI            ----- International Garden Architecture Exposition
GHK            ----- Kunsthalle
GHL            ----- Lurup Estate
GHN            ----- Galerie Neuendorf
GHP            ----- Primary School Hamburg-Niendorf
GHPo           ----- Coll. S. and G. Poppe
GHaB           Hannover.  Galerie Dieter Brusberg; Coll. Heidi
                 and Dieter Brusberg
GHaL           ----- Niedersachsische Landesgalerie
GHaS           ----- Coll. Dr. Bernhard Sprengel
GHaU           ----- Union Boden
GIN            Ingolstadt.  Neue Galerie
GKarBu         Karlsruhe.  Bundesgartenschau
GKrefL         Krefeld.  Hans Lange Museum
GKrefW         ----- Kaiser Wilhelm Museum
GLeK           Leverkusen.  Coll. Udo Kultermann
GLeM           ----- Stadtisches Museum Leverkusen; Schloss
                 Morsbroich
GMB            Munich.  Staatsgemaldesammlungen
GMBa           ----- Coll. Walter Bareiss
```

GMF	Munich. Coll. Gunther Franke
GMFr	----- Galerie Heiner Friedrich
GMGe	----- Coll. Klaus Gebhard
GMKe	----- Galerie Ketterer
GML	----- Galerie van de Loo
GMLe	----- Galerie Leonhart
GMRu	----- Coll. Prof. Sep Ruf
GMS	----- Coll. Karl Strohrer
GMSta	----- Galerie Stangl
GMT	----- Galerie Thomas
GMaM	Mannheim. Kunsthalle
GMaiB	Mainz. Coll. H. Baier
GMulH	Mulheim/Ruhr. Coll. Dr. Hans Hohkramer
GMulK	----- Coll. Ursula Kuppers
GNK	Nuremberg. Kunsthalle
GNevS	Neviges. Coll. Willy Schniewind
GObG	Oberhausen. Gutteoffnungshutte
GRavC	Ravensberg. Church
GSaaS	Saarbrucken. Saarlandmuseum
GSaaU	----- Universitat
GScL	Schleswig. Landesmuseum
GStB	Stuttgart. Coll. Frau Margaret Baumeister
GStBa	----- Coll. Felicitas Karg-Baumeister
GStD	----- Coll. Dr. O. Domnick
GStG	----- Galerie der Stadt
GStI	----- Coll. Anneliese Itten
GStMu	----- Galerie Muller
GStP	----- Coll. K. G. Pfahler
GStR	----- Raichberg-Mittelschule
GStSt	----- Staatsgalerie
GUU	Ulm. Ulmer Museum
GViF	Villengen. Finunzamt (Revenue Office)
GWei	Weimar
GWieH	Wiesbaden. Coll. Otto Henkell
GWup	Wuppertal
GWupF	----- Coll. Frowein
GWupG	----- Coll. Klaus Gebhard
GWupJ	----- Coll. R. Jahrling
GWupM	----- Von der Heydt-Museum der Stadt Wuppertal
GWupZ	----- Coll. Dr. Ferdinand Ziersch
GWurS	Wurzburg. Coll. Heinz Simon

Ghana

GhA	Accra

Italy

-IM	Coll. Marchetti
IBaB	Bari. Coll. Angelo Baldessarre
IBoT	Bologna. Coll. Tavoni
IBrC	Breschia. Coll. Achille Cavellini
IBrD	----- Coll. Mario Dora
ICP	Castellanza. Coll. Luciano Pomini
IGenD	Genoa. Galleria del Deposito
IGenR	----- Coll. A. Della Ragione
ILegC	Legnano. Coll. Ernesto Crespi
ILegP	----- Coll. Franco Pensotti

IMA	Milan.	Coll. Angeli Frua
IMAM	-----	Civica Galleria d'Arte Moderna
IMAp	-----	Galleria Apollinaire
IMAr	-----	Galleria dell'Ariete
IMArr	-----	Coll. Arroyo
IMBa	-----	Coll. Mme. Baccia
IMBaj	-----	Coll. Enrico Baj
IMBes	-----	Coll. E. Bestagni
IMBl	-----	Galleria Blu
IMC	-----	Coll. Carrieri
IMCo	-----	Coll. Consolandi
IMD	-----	Coll. C. Donini
IMF	-----	Coll. Piero Fedeli
IMFo	-----	Coll. Teresita Fontana
IMGal	-----	Galleria Arte Borgogna
IMGr	-----	Galleria del Grattacielo
IMI	-----	Galerie Iolas
IMJe	-----	Coll. Emilio Jesi
IMJu	-----	Coll. Ricardo Jucker
IML	-----	Galleria Levi
IMLo	-----	Galleria Lorenzelli
IMLu	-----	Coll. Alberto Lucia
IMM	-----	Galleria Milano
IMMa	-----	Coll. Paolo Marinotti
IMMan	-----	Coll. Contessa Valeria Manzoni
IMMar	-----	Coll. Dr. Marzotta
IMMarc	-----	Coll. Giorgio Marconi
IMMi	-----	Galleria del Millione
IMMo	-----	Coll. Beatrice Monti da Rezzori
IMMon	-----	Mondadori Building
IMNav	-----	Galleria del Naviglio
IMP	-----	Coll. Palazzoli
IMPa	-----	Palazzo Reale
IMPan	-----	Coll. Conte Giuseppe Panza di Biumo
IMS	-----	Coll. Tristan Sauvage
IMSc	-----	Galleria Schwarz
IMSch	-----	Coll. A. Schwarz
IMSo	-----	Solaria Gallery
IMSp	-----	Coll. Gizn Enzo Sperone
IMTon	-----	Toninelli Arte Moderna
IMU	-----	Coll. Alberto Ulrich
IMV	-----	Coll. Valdameri
IParM	Parma.	Coll. L. Magnani
IR	Rome	
IRArt	-----	Galleria Nazionale d'Arte Moderna (IRN)
IRAt	-----	Galleria d'Arte l'Attico
IRB	-----	Coll. Pecci Blunt
IRBa	-----	Basaldella Estate
IRBie	-----	Coll. Baron Marschall von Bieberstein
IRBr	-----	Coll. Bracci
IRBu	-----	Galleria La Bussola
IRFra	-----	Coll. Franchetti
IRG	-----	Coll. M. Hugo Gouthier
IRLo	-----	Coll. Lockley-Shea
IRLu	-----	Coll. Luigi de Luca
IRMarl	-----	Marlborough Gallery

IRMas	Rome. Coll. Marcello Mastroiani
IRMe	----- Galleria La Medusa
IRN	----- Galleria Nazionale d'Arte Moderna (IRArt)
IRO	----- Galleria Odyssia
IRP	----- St. Peter's
IRPo	----- Galleria Pogliani
IRPog	----- Coll. Sergio Pogliani
IRSa	----- Coll. Dr. Ignio Sambucci
IRSal	----- Galleria La Salita
IRTar	----- Galleria La Tartaruga
ISpP	Spoleto. Piazza del Comune
ITL	Turin. Coll. Levi Leone
ITLe	----- Architetto Corrado Levi
ITMC	----- Museo Civico di Torino
ITMo	----- Galleria d'Arte Moderna
ITP	----- Coll. Luciano Pistoi
ITSp	----- Galleria Sperone
ITSt	----- Coll. Christian Stein
IVA	Venice. Galleria d'Arte Moderna
IVC	----- Galleria de Cavallino
IVCar	----- Coll. Cardazzo
IVG	----- Peggy Guggenheim Foundation
IVL	----- Galleria Il Leone
IVaM	Varese. Villa Mirabello
IVaP	----- Coll. Lucano Pomini, Castellanza
IVaPa	----- Coll. Count Panza di Biumo
IVaT	----- Coll. Vittorio Tavernari
IVeS	Verona. Studio la Citta
IVerF	Vercelli. Comm. Fila
IViL	Vicenza. Coll. Mrs. J. C. Lambert

Iceland

-IcR	Coll. Dieter Rot
IcRN	Rekjavik. National Gallery of Iceland

Ireland

IreBU	Belfast. Ulster Museum

Israel

-IsAp	Coll. Aplit
IsHM	Haifa. Museum of Modern Art
IsJI	Jerusalem. Israel National Museum
IsTK	Tel Aviv. Coll. Mr. and Mrs. Klier

Japan

JA	Ashiya City
JIcT	Ichinomiya. Coll. Tetsusaburo Tanaka
JKY	Kyoto. Yamada Art Gallery
JNagT	Nagoya. Coll. Tetsusaburo Tanaka
JNagaM	Nagaoka. Museum of Contemporary Art
JTA	Tokyo. Coll. Yasuhiko Aoyagi
JTId	----- Coll. Mr. and Mrs. Sazo Idemitsu
JTMi	----- Minami Gallery
JTO	----- Ohara Hall
JTT	----- Tokyo Gallery
JTY	----- Coll. Tokutaro Yamamura

Lebanon
LBS Beirut. Coll. Henri Seyrig

Mexico
-Me Mexico
MeGP Guadalajara. San Pedro Building
MeM Mexico City
MeME ----- Experimental Museum
MeMM ----- Coll. Tomas Marentes
MeMN ----- National Museum of Figurative Art
MeTaxU Taxco. Coll. Alberto Ulrich

Netherlands
NAS Amsterdam. Stedelijk Museum
NBaS Baarlo. Coll. Kasteel Scheres
NBerV Bergeyk. Coll. Mia and Martin Visser
NEA Eindhoven. Stedelijk van Abbe-Museum
NEm Emmen
NGM Groningen. Groninger Museum
NHB The Hague. Bouwegelust Settlement
NHG ----- Gemeentemuseum
NHO ----- Galerie Orez
NHiB Hilversum. Coll. Becht
NLoB Loenen a.d. Vecht. Coll. Frits A. Becht
NNM Noordwijk. Coll. A. M. Mees
NO Otterloo
NOG ----- Coll. C. M. J. de Groot
NOK ----- Rijksmuseum Kroller-Museum
NR Rotterdam
NRB ----- De Byenkorf Store
NRC ----- Rotterdam City
NRD ----- Galerie Delta
NRU ----- Unilever Building
NRiI Rijswijk. In de Bogaard Shopping Center
NSchS Schiedam. Coll. Dr. Pieter Sanders
NSchSt ----- Stedelijk Museum

Norway
NoOB Oslo. Oslo Byes Vel
NoOF ----- Coll. Richard Furnholmen, Jr.
NoOH ----- Coll. Sonia Henie and Niels Onstad
NoON ----- Norsk Hydro Administration Building

New Zealand
-NzA Arts Council of New Zealand

Poland
PLS Lodz. Museum Sztuki
PWB Warsaw. Coll. J. Brzozowski

Portugal
PoLG Lisbon. Fundacao Calouste Gulbenkian

Rumania
RTP Targu Jiu. Public Gardens

Scotland

-ScS	Stirling University
ScGG	Glasgow. Glasgow Art Gallery and Museum
ScGlK	Glenkiln. Coll. W. J. Keswick

Sweden

SnGV	Goteborg. Konstmuseet Vanner
SnMO	Malmo. Galleri Ostergren
SnSLar	Stockholm. Coll. Arne Larsson
SnSN	----- Nationalmuseum
SnSNM	----- Nationalmuseum Moderna Museet
SnSR	----- Coll. Oscar Reutersward

South Africa

-SoS	Coll. J. J. Sher
SoJH	Johannesburg. Coll. Mrs. Philip V. Harari

Spain

SpAlC	Alicante. Coll. Calpe
SpBaA	Barcelona. Coll. Aleu
SpBaCas	----- Casa Mila
SpBaGas	----- Galeria Gaspar
SpBaMe	----- Galeria Rene Metras; Coll. Rene Metras
SpBaV	----- Coll. Manuel Vinas
SpBilB	Bilbao. Coll. Fernando Barandiaran
SpCuM	Cuenca. Museum of Spanish Contemporary Art
SpCuZ	----- Coll. Fernando Zobel
SpIV	Ibiza. Coll. Carl Van der Voort
SpMaAm	Madrid. Coll. Jaime C. del Amo
SpMaM	----- Museo Nacional de Arte Moderno
SpMaMo	----- Galeria Juana Mordo
SpMaMu	----- Coll. Lucio Munoz
SpMaN	----- National Telephone Co.
SpMaR	----- Coll. Ruiz de la Prada
SpMaS	----- Coll. Antonio Santonja
SpMel	Mellila. Coll. of the City
SpSM	Seville. Coll. Vega McVeagh

Switzerland

-SwH	Coll. Dr. Paul Hanggi
-SwJ	Coll. Mme. Junod
SwBA	Basel. Allgemeine Gewerbeschule
SwBB	----- Coll. E. Beyeler
SwBBe	----- Galerie Beyeler
SwBFe	----- Galerie Feigel
SwBG	----- Coll. Karl Gerstner
SwBK	----- Offentliche Kunstsammlung
SwBKHa	----- Kunsthalle
SwBKM	----- Kunstmuseum
SwBe	Bern
SwBeF	----- Federal Government Coll.
SwBeKM	----- Kunstmuseum
SwBeKor	----- Kornfeld & Klipstein
SwBeMe	----- Coll. F. Meyer-Chagall
SwBi	Bienne
SwChaM	Chaux-de-Fonds. Musee des Beaux-Arts

SwChaMi	Chaux-de-Fonds. Galerie Mimosa
SwGA	Geneva. Musee d'Art et d'Histoire
SwGB	----- Galerie D. Benador
SwGC	----- Galerie Gerald Cramer
SwGE	----- Galerie Engelberts
SwGFC	----- Coll. F. C.
SwGK	----- Galerie Krugier
SwGrB	Grenchen. Galerie Brechbuhl
SwI	Interlaken
SwLaB	Lausanne. Galerie Bonnier
SwLaL	----- Landesausstellung
SwLaM	----- Coll. Eric Meyer
SwLaMe	----- Coll. H. L. Mermod
SwLaS	----- Swiss National Exhibition
SwLaSa	----- Galerie Gunther Sachs
SwLuA	Lugano. Art International
SwLutS	Lutry. Coll. Alberto Sartoris
SwSGC	St. Gallen. Galerie Gerald Cramer
SwSGH	----- Hochschule fur Wirtschafts und Sozialwissenschaften
SwThP	Thalwil. Coll. Dr. Pfluger
SwY	Yverdon
SwZB	Zurich. Coll. Dr. Walter Bechtler
SwZBe	----- Coll. Hans C. Bechtler
SwZBec	----- Coll. Walter Bechtler
SwZBi	----- Coll. Max Bill
SwZBis	----- Galerie Bischofberger
SwZBisc	----- Coll. Bruno Bischofberger
SwZCoh	----- Coll. V. N. Cohen
SwZE	----- Galerie Andre Emmerich
SwZGi	----- Coll. S. and C. Giedion-Welcker
SwZHu	----- Galerie Huber
SwZIL	----- Coll. I. L.
SwZK	----- Kunsthaus
SwZKo	----- Kornfeld & Klipstein
SwZL	----- Galerie Charles Leinhard; Coll. Charles Leinhard
SwZLo	----- Coll. W. Loeffler
SwZMe	----- Coll. Michel E. Meyer
SwZMey	----- Coll. Franz Meyer
SwZZu	----- City of Zurich
SwZZum	----- Coll. Gustav Zumsteg

United States

-UBl	Coll. Crawford Block
-UC	Container Corporation of America
-UCa	Coll. Carborundum Corporation of America
-UD	Coll. Burgoyne Diller
-UG	Coll. Ed Gregson
-UH	Coll. Mr. and Mrs. Sam Hunter
-ULau	Coll. Charles Laughton
-UM	Coll. Monroe Myerson
-UN	Coll. National Music Publishers' Association, Inc.
-UPo	Coll. John Powers
-URic	Coll. Hans Richter
-URu	Coll. Peter Rudel

-USimp	Coll. Max Simpson
-USm	Estate of David Smith
-UW	Coll. David Weill
-UWa	Coll. Max Wassermann
-UWei	Coll. Fred Weisman (UCBeW)

--Alabama

UA1BC	Birmingham. City Museum and Art Gallery

--Arizona

UAzPhA	Phoenix. Phoenix Art Museum
UAzSD	Scottsdale. Coll. Elise C. Dixon
UAzTUA	Tucson. University of Arizona. Art Gallery

--California

UCAtA	Atherton. Coll. Mr. and Mrs. Harry W. Anderson
UCBC	Berkeley. University of California. University Art Museum
UCBeB	Beverly Hills. Coll. Mr. and Mrs. David E. Bright
UCBeFa	----- Coll. Mr. and Mrs. Donald Factor
UCBeFo	----- Coll. Mr. and Mrs. Arthur Formichelli
UCBeG	----- Coll. Mr. and Mrs. Philip Gersh
UCBeH	----- Coll. Mr. and Mrs. Melvin Hirsh
UCBeK	----- Kleiner Foundation; Coll. Mr. and Mrs. Burt Kleiner
UCBeK1	----- Coll. Mr. and Mrs. Eugene V. Klein
UCBeP	----- Perls Gallery
UCBeS	----- Coll. Dr. and Mrs. Mac L. Sherwood
UCBeSc	----- Coll. Mr. and Mrs. Taft Schreiber
UCBeSh	----- Coll. Mr. and Mrs. Harry Sherwood
UCBeSi	----- Coll. Ben L. Silberstein
UCBeW	----- Coll. Mr. and Mrs. Frederick H. Weisman
UCCoG	Corona del Mar. Jack Glenn Gallery
UCDaH	Davis. Coll. Gerald Hoptner
UCF	Fresno
UCKH	Kentfield. Coll. Alfred Heller
UCLA	Los Angeles. Coll. Dr. and Mrs. Nathan Alpers
UCLB	----- Coll. Mr. and Mrs. Sidney F. Brody
UCLB1	----- Coll. Irving Blum
UCLBr	----- Coll. David E. Bright
UCLC	----- Coll. Bernard Cooper
UCLCM	----- Los Angeles County Museum of Art
UCLCo	----- Coll. Mr. and Mrs. Harry Cooper
UCLCr	----- Coll. Michael Crichton
UCLD	----- Dwan Gallery
UCLE	----- Everett Ellin Gallery
UCLE1	----- Coll. Jim Eller
UCLF	----- Ferus-Pace Gallery
UCLFa	----- Coll. Mr. and Mrs. Monte Factor
UCLG	----- Gemini G. E. L.
UCLG1	----- Coll. Mr. and Mrs. Merle S. Glick
UCLH	----- Coll. Dennis and Brooke Hopper
UCLHa	----- Coll. Robert H. Halff
UCLHe	----- Coll. Sonja Henie and Niels Onstad
UCLHo	----- Coll. Dennis Horlick
UCLHom	----- Home Savings and Loan Coll.

UCLJ	Los Angeles. Coll. Edwin Janss
UCLJe	----- Coll. Mr. and Mrs. Jester
UCLJo	----- Coll. Deane F. Johnson
UCLK	----- Coll. Edward Kienholz
UCLKi	----- Coll. Lyn Kienholz
UCLL	----- Felix Landau Gallery
UCLM	----- Coll. Mr. and Mrs. Paul Mills
UCLMcc	----- Coll. Mr. and Mrs. John McCracken
UCLN	----- Rolf Nelson Gallery
UCLO	----- Coll. Robert Ordover
UCLP	----- Coll. Max Palevsky
UCLPo	----- Coll. Barbara Reis Poe
UCLR	----- Esther Robles Gallery
UCLRu	----- Coll. Edward Ruscha
UCLS	----- Norton Simon Inc. Museum of Art; Coll. Mr. and Mrs. Norton Simon
UCLSp	----- Coll. Philip Spector
UCLSpe	----- Coll. Mrs. Vicci Sperry
UCLSt	----- Coll. Miss Laura Lee Sterns
UCLSte	----- Coll. Kate Steinitz
UCLStu	----- David Stuart Galleries
UCLUC	----- University of California at Los Angeles. Art Gallery
UCLUG	----- University of California at Los Angeles. Grunwald Graphic Arts Foundation
UCLW	----- Coll. Mr. and Mrs. Richard Weisman
UCLWi	----- Nicholas Wilder Gallery
UCLWil	----- Coll. Andy Williams
UCLonC	Long Beach. California State College
UCMM	Mill Valley. Coll. Mr. and Mrs. Wright Morris
UCMoG	Mountain View. Golden West Savings and Loan
UCNH	Newport Beach. Coll. Dr. and Mrs. Charles Hendrickson
UCOA	Oakland. Oakland Art Museum
UCOG	----- Golden West Towers
UCOJ	----- Coll. Howard E. Johnson
UCPaM	Pasadena. Pasadena Art Museum
UCPaR	----- Coll. Mr. and Mrs. Robert Rowan
UCPaT	----- Coll. Mr. and Mrs. Thomas Terbell
UCPacA	Pacific Palisades. Coll. Mr. and Mrs. Eddie Albert
UCPalmJ	Palm Desert. Coll. Mr. and Mrs. William C. Janss
UCPaloH	Palos Verdes. Coll. Hobson Harrell
UCPoW	Post Costa. Wonders of the World Museum
UCSBL	Santa Barbara. Coll. Wright Ludington
UCSBS	----- Coll. Mrs. Stanley Sheinbaum
UCSFDi	San Francisco. Dilexi Gallery
UCSFH	----- Coll. Mr. and Mrs. Gardiner Hempel
UCSFM	----- San Francisco Museum of Art
UCSFP	----- Gallery Reese Palley
UCSFR	----- Coll. Mrs. Madelein H. Russell
UCSFW	----- Coll. Mr. Walter Scott Woods, Jr.
UCSFWa	----- Michael Walls Gallery
UCSFWal	----- Coll. Brooks Walker
UCSaC	Sausalito. David Cole Gallery
UCSacD	Sacramento. Coll. Mr. and Mrs. Jean Davidson

UCSacS	Sacramento. Coll. Mr. and Mrs. Russ Soloman
UCSmoP	Santa Monica. Coll. Mr. and Mrs. Gifford Phillips
UCStbS	Santa Barbara. Coll. Mr. and Mrs. Stanley K. Sheinbaum
UCStbT	----- Coll. Mrs. Warren Tremaine
UCTC	Tustin. Coll. Mr. and Mrs. William Ching
UCThJ	Thermal. Coll. William Janza
UCThoJ	Thousand Oaks. Coll. Edwin Janss, Jr.
UCVA	Venice. Artist Studio
UCVC	----- Coll. Ron Cooper

--Colorado

UCoAP	Aspen. Coll. John G. Powers

--Connecticut

UCtBlC	Bloomfield. Connecticut General Life Insurance Company
UCtBrL	Bridgeport. Coll. Mr. and Mrs. Julian Levy
UCtCoR	Cos Cob. Coll. Peter Rubel
UCtFD	Fairfield. Coll. Dr. and Mrs. David Dworken
UCtGA	Greenwich. Coll. Mr. and Mrs. Nathan Allen
UCtGB	----- Coll. Mr. and Mrs. Charles B. Benenson
UCtGBa	----- Coll. Mr. and Mrs. Walter Bareiss
UCtGBr	----- Coll. Mr. and Mrs. Peter Brandt
UCtGD	----- Coll. Mr. and Mrs. Richard Deutsch
UCtGL	----- Coll. Mr. and Mrs. M. Lebworth
UCtGO	----- Coll. Frederic E. Ossorio
UCtGS	----- Coll. John Stephan
UCtGSt	----- Coll. Dr. Ruth Stephan
UCtHC	Hartford. Connecticut Bank and Trust Co.
UCtHM	----- Bruce McManus Memorial Plaza
UCtHW	----- Coll. Samuel J. Wagstaff, Jr.
UCtHWA	----- Wadsworth Atheneum
UCtMeT	Meriden. Coll. Mr. and Mrs. Burton Tremaine
UCtNcC	New Canaan. Coll. Charles Carpenter
UCtNcJ	----- Coll. Philip Johnson
UCtNcN	----- Coll. Mr. and Mrs. Eliot Noyes
UCtNcS	----- Coll. Mr. and Mrs. James Thrall Soby
UCtNhHi	New Haven. Coll. Mr. and Mrs. F. W. Hilles
UCtNhY	----- Yale University
UCtNhYA	----- Yale University. Art Gallery
UCtNoL	North Haven. Lippincott, Inc.
UCtRA	Ridgefield. Coll. Larry Aldrich
UCtRW	----- Coll. Mrs. Emily Walker
UCtSB	Stamford. Coll. Mr. and Mrs. Lionel Bauman
UCtWestS	Westbury. Schweber Electronics
UCtWoT	Woodbury. Coll. Mrs. Yves Tanguy
UCtWooI	Woodbridge. Coll. Mr. and Mrs. Norman Ives

--Washington, D. C.

UDCB	Coll. Abner Benner
UDCC	Corcoran Art Gallery
UDCE	Coll. Mr. and Mrs. Julian Eisenstein
UDCE1	Coll. Robert Elliott
UDCHi	Hirshhorn Museum and Sculpture Garden
UDCJ	Jefferson Place Gallery

UDCKr	Coll. Mr. and Mrs. David Lloyd Kreeger
UDCLl	Coll. Mrs. H. Gates Lloyd
UDCN	National Gallery of Art
UDCNMSC	National Collection of Fine Arts
UDCP	Phillips Collection
UDCPh	Coll. Mr. and Mrs. Gifford Phillips
UDCSa	Coll. Mr. and Mrs. Serge Sacknoff
UDCSwi	Coll. Mary Swift
UDCWo	Woodward Foundation

--Florida

UFKD	Kay Largo. Coll. Anasuya Devi
UFMA	Miami Beach. Arlin House
UFMC	----- City National Bank
UFMiA	Miami. Adlee Corporation
UFPL	Palm Beach. J. Patrick Lannan Foundation; Coll. J. Patrick Lannan
UFPS	----- Coll. Mary Sisler

--Georgia

UGAA	Atlanta. Atlanta Art Association
UGAH	----- High Museum
UGAU	----- Atlanta University
UGSW	Savannah. Coll. Albert F. Weis

--Hawaii

UHHA	Honolulu. Academy of Arts
UHHH	----- House of Representatives

--Illinois

-UIC	Coll. J. M. Comar
-UIW	Coll. Allen Weller, University of Illinois
UICA	Chicago. Art Institute
UICAC	----- Arts Club
UICAl	----- Coll. Mr. and Mrs. James M. Alter
UICB	----- Coll. Mr. and Mrs. Henry M. Bachbinder
UICBe	----- Coll. Mr. and Mrs. Edwin A. Bergman
UICBer	----- Coll. Mr. and Mrs. A. Bergman
UICC	----- Museum of Contemporary Art
UICCh	----- Chicago National Bank
UICD	----- Dell Gallery
UICF	----- Allan Frumkin Gallery
UICFe	----- Richard Feigen Gallery
UICFl	----- Coll. L. Florsheim
UICFr	----- Coll. Marshall Frankel
UICG	----- Coll. Mrs. Herbert S. Greenwald
UICGi	----- Lo Giudice Gallery
UICGid	----- Coll. Willard Gidwitz
UICH	----- Coll. Mr. and Mrs. Leonard Horwich
UICHar	----- Coll. William Harris
UICHarr	----- Coll. Eve Harrison
UICHok	----- Coll. Mr. and Mrs. Edwin E. Hokin
UICM	----- Coll. Mr. and Mrs. Arnold H. Maremont
UICMa	----- Coll. Mr. and Mrs. Lewis Manilow
UICMar	----- Coll. Mr. and Mrs. Henry A. Markus
UICMay	----- Coll. R. Mayer

UICN	Chicago. Coll. Arthur J. Neumann
UICNe	----- Coll. Mrs. Albert H. Newman
UICNet	----- Coll. Mr. and Mrs. Walter A. Netsch, Jr.
UICNeu	----- Coll. Mr. and Mrs. Morton G. Neumann
UICNew	----- Coll. Muriel Newman
UICP	----- Playboy Magazine
UICR	----- Coll. Mrs. Samuel G. Rautbord
UICRo	----- Coll. Mrs. Arthur G. Rosenberg
UICS	----- Coll. Jack Silverman
UICS1	----- Coll. Mr. and Mrs. John H. Slimack
UICSt	----- Coll. Mr. and Mrs. Joel Starrels
UICSte	----- Coll. J. Z. Steinberg
UICU	----- University of Chicago
UICW	----- Coll. Richard Well
UIChUK	Champaign. University of Illinois. Krannert Art Museum
UINE	Northfield. Coll. Mrs. Julius Epstein
UIOS	Oak Park. Coll. Mr. and Mrs. Joseph R. Shapiro
UIWM	Winnetka. Coll. Mr. and Mrs. Arnold H. Maremont
UIWMa	----- Coll. Mr. and Mrs. Robert B. Mayer

--Iowa

UIaDA	Des Moines. Des Moines Art Center
UIaDAm	----- American Republic Insurance Co.
UIaDP	----- Coll. Watson Powell
UIaIU	Iowa City. University of Iowa. Museum of Art

--Kansas

-UKM	Coll. Mr. and Mrs. Tom McGreery
UKLaG	Lawrence. Coll. Mr. and Mrs. Raymond Goetz
UKWA	Wichita. Wichita Art Museum
UKWaB	Walker. Coll. Mr. and Mrs. Charles F. Buck

--Louisiana

ULaNA	New Orleans. Isaac Delgado Museum of Art
ULaND	----- Coll. Mr. and Mrs. Walter Davis

--Massachusetts

UMAP	Andover. Phillips Academy. Addison Gallery of American Art
UMBA	Boston. Boston Museum of Fine Arts
UMBAt	----- Boston Atheneum
UMBI	----- Institute of Contemporary Art
UMBMi	----- Boris Mirski Gallery
UMBPa	----- Coll. Mr. and Mrs. Stephen D. Paine
UMBPo	----- Coll. Ted Poland
UMBRa	----- Coll. Natalie Rahv
UMBeL	Belmont. Coll. Mildred and Herbert Lee
UMBrZ	Brookline. Coll. Catherine Zimmerman
UMCB	Cambridge. Busch-Reisinger Museum
UMCF	----- Fogg Art Museum
UMCHG	----- Harvard University. Graduate Center
UMCM	----- Massachusetts Institute of Technology
UMCheW	Chestnut Hill. Coll. Wasserman Family
UMNSA	Northampton. Smith College. Museum of Art
UMNSH	----- Smith College. Coll. James Holderbaum

UMNeW	Newton. Coll. Mr. and Mrs. Wassermann
UMPeP	Petersham. Coll. Hall James Peterson
UMPiB	Pittsfield. Berkshire Museum
UMProC	Provincetown. Chrysler Art Museum
UMProK	----- Karlis Gallery
UMSpB	Springfield. Coll. Dr. and Mrs. Malcolm W. Bick
UMSpBr	----- Coll. Leonard M. Brown
UMWaB	Waltham. Brandeis University
UMWiB	Williamstown. Coll. Mr. and Mrs. Laurence Bloedel
UMWoP	Worthington. Coll. Arthur Waring Paddock

--Maryland

UMdBG	Baltimore. Goucher College
UMdBM	----- Baltimore Museum of Art
UMdBMe	----- Coll. Edgar Mermann
UMdBMey	----- Coll. Robert and Jane Meyerhoff
UMdBP	----- Coll. Winston H. Price
UMdBR	----- Coll. Dr. and Mrs. Israel Rosen
UMdCU	College Park. University of Maryland
UMdLL	Lutherville. Coll. Mr. and Mrs. Robert H. Levi

--Michigan

UMiBC	Bloomfield Hills. Cranbrook Academy Museum
UMiBiW	Birmingham. Coll. Mr. and Mrs. Harry Lewis Winston
UMiD	Detroit. Institute of Arts
UMiDB	----- Coll. Mr. and Mrs. S. Brooks Barron
UMiDF	----- Coll. Florist's Transworld Delivery Association
UMiDG	----- General Motors Company
UMiDL	----- Coll. Mrs. Hoke Levin
UMiDWa	----- Coll. Samuel Wagstaff, Jr.
UMiHK	Huntington Woods. Coll. Mr. and Mrs. Melvin Kolbert

--Minnesota

UMnMD	Minneapolis. Dayton's Gallery
UMnMF	----- Coll. Mr. and Mrs. Miles Q. Filterman
UMnMI	----- Minneapolis Institute of Arts
UMnML	----- Gordon Locksley Gallery
UMnMS	----- Shea Gallery
UMnMU	----- University of Minnesota
UMnMW	----- Walker Art Center
UMnMWa	----- Coll. R. Watkins

--Missouri

UMoKB	Kansas City. Coll. C. F. Buckwalter
UMoKG	----- Coll. Mr. and Mrs. Jack Glenn
UMoKM	----- Morgan Gallery
UMoKNG	----- William Rockhill Nelson Gallery. Atkins Museum
UMoSL	St. Louis. City Art Museum
UMoSLE	----- Coll. William Eisendrath
UMoSLH	----- Coll. Mr. and Mrs. Joseph Helman
UMoSLM	----- Coll. Dr. and Mrs. Edward Massie
UMoSLMa	----- Coll. Mr. and Mrs. Morton D. May

UMoSLO	St. Louis. Coll. Mr. and Mrs. Robert Orchard
UMoSLP	----- Coll. Joseph Pulitzer, Jr.
UMoSLWa	----- Washington University
UMoSLWe	----- Coll. Mr. and Mrs. Richard K. Weil

--New York

UNA1N	Albany. Coll. State of New York, South Mall
UNA1R	----- Coll. Nelson Rockefeller
UNBB	Brooklyn. Brooklyn Museum
UNBuA	Buffalo. Albright-Knox Art Gallery
UNEaD	East Hampton. Coll. Edward F. Dragon and Alfonso Ossorio
UNGA	Great Neck. Coll. Dr. Joseph Attie
UNGH	----- Coll. Mr. and Mrs. Paul Hirschland
UNGK	----- Coll. Mr. and Mrs. Harold Kaye
UNGS	----- Coll. Mr. and Mrs. Robert C. Scull
UNG1C	Glen Falls. Coll. D. Crockwell
UNHunG	Huntington. Coll. Lucie Glarner
UNIC	Ithaca. Cornell University
UNKinS	Kings Point. Coll. Mr. and Mrs. Rudolph B. Schulhof
UNLaK	Lawrence. Coll. Mrs. Ethel Kraushar
UNLarB	Larchmont. Coll. Mr. and Mrs. Jay R. Burns
UNLarC	----- Coll. Mr. and Mrs. Saul Z. Cohen
UNLarF	----- Coll. Mr. and Mrs. Henry Feiwell
UNMoS	Mountainville. Storm King Art Center
UNN	New York City
UNNA	----- Coll. J. Aberbach
UNNAb	----- Coll. Abrams Family
UNNAbr	----- Coll. Harry N. Abrams
UNNA1	----- Alan Gallery
UNNA1d	----- Coll. Larry Aldrich
UNNA11	----- Coll. Lawrence Alloway
UNNA1m	----- Almus Gallery
UNNAm	----- American Federation of Arts
UNNAme	----- Amel Gallery
UNNAn	----- David Anderson Gallery
UNNAu	----- Coll. Mr. and Mrs. Lee A. Ault
UNNB	----- Grace Borgenicht Gallery
UNNBake	----- Coll. Richard Brown Baker
UNNBaker	----- Coll. Oliver Baker
UNNBaro	----- Barone Gallery
UNNBau	----- Coll. Mr. and Mrs. Lionel R. Bauman
UNNBe	----- Coll. Charles Benenson
UNNBel	----- Coll. Richard Bellamy
UNNBen	----- Coll. Mr. and Mrs. Robert M. Benjamin
UNNBene	----- Coll. Warren Benedek
UNNBi	----- Coll. Mr. and Mrs. Edward Bianchi
UNNBia	----- Bianchi Gallery
UNNBiri	----- Coll. Ben Birillo
UNNB1i	----- Coll. Donald M. Blinker
UNNBo	----- Coll. Mr. and Mrs. Stephen Booke
UNNBol	----- Coll. Robert Bollt
UNNBoni	----- Galeria Bonino
UNNBor	----- Grace Borgenicht Gallery
UNNBr	----- Coll. Peter Brant

UNNBra		New York City. Coll. Mr. and Mrs. Warren Brandt
UNNBre	-----	Brewster Gallery
UNNBro	-----	Coll. Dr. and Mrs. Bernard Brodsky
UNNBun	-----	Coll. Mr. and Mrs. Gordon Bunshaft
UNNBur	-----	Coll. Mr. and Mrs. William A. M. Burden
UNNBurd	-----	Coll. Carter Burden
UNNByk	-----	Bykert Gallery
UNNC	-----	Leo Castelli Gallery; Coll. Mr. and
	Mrs.	Leo Castelli
UNNCa	-----	Carstairs Gallery
UNNCal	-----	Coll. Mrs. Mary Callery
UNNCare	-----	Coll. Edward Carey
UNNCas	-----	Castellane Gallery
UNNCat	-----	Catherine Street and the Bowery
UNNCh	-----	Galerie Chalette
UNNCha	-----	Coll. Mrs. Gilbert W. Chapman
UNNChas	-----	Chase Manhattan Bank
UNNCo	-----	Paula Cooper Gallery
UNNCoh	-----	Coll. Arthur Cohen
UNNColi	-----	Coll. Mr. and Mrs. Ralph F. Colin
UNNCop	-----	Coll. Mr. and Mrs. William Copley
UNNCor	-----	Cordier & Ekstrom
UNNCr	-----	Coll. Mr. and Mrs. Pierre de Croisset
UNNCri	-----	Andrew Crispo Gallery
UNND	-----	Downtown Gallery
UNNDa	-----	Coll. Mrs. Stuart Davis
UNNDan	-----	Bernard Danenberg Galleries
UNNDe	-----	Department of Parks
UNNDi	-----	Terry Dintenfass Gallery
UNNDik	-----	Coll. Mr. and Mrs. Charles M. Diker
UNNDin	-----	Coll. Nancy Dine
UNNDo	-----	Downtown Gallery
UNNDon	-----	Coll. Mr. and Mrs. Enrico Donati
UNNDu	-----	Coll. Mrs. Marcel Duchamp
UNNDw	-----	Dwan Gallery
UNNE	-----	Egan Gallery
UNNEa	-----	Museum of Early American Folk Arts
UNNEas	-----	Coll. Lee Eastman
UNNEd	-----	Coll. Dr. and Mrs. Theodore J. Edlich, Jr.
UNNEi	-----	Coll. Letty Lou Eisenhauer
UNNEl	-----	Robert Elkon Gallery; Coll. Robert Elkon
UNNEll	-----	Coll. Everett Ellin
UNNEm	-----	Andre Emmerich Gallery; Coll. Mr. and
	Mrs.	Andre Emmerich
UNNEp	-----	Coll. Mrs. Harry Epstein
UNNEq	-----	Equitable Life Assurance Co.
UNNFe	-----	Coll. Mrs. Julia Feininger
UNNFei	-----	Richard Feigen Gallery
UNNFeig	-----	Coll. Mr. and Mrs. Richard Feigen
UNNFerb	-----	Coll. Mr. and Mrs. Herbert Ferber
UNNFi	-----	Fine Arts Associates
UNNFis	-----	Fischbach Gallery
UNNFisc	-----	Coll. Marilyn Fischbach
UNNFish	-----	Coll. Mr. and Mrs. Carl Fisher
UNNFo	-----	Coll. Mr. and Mrs. Milton Fox
UNNFou	-----	Xavier Fourcade, Inc.

UNNFr	New York City. Coll. Helen Frankenthaler
UNNFram	----- Coll. Hollis Frampton
UNNFri	----- Rose Fried Gallery
UNNFrie	----- Coll. Mr. and Mrs. B. H. Friedman
UNNFru	----- Allan Frumkin Gallery
UNNFrum	----- Coll. Allan Frumkin
UNNG	----- Solomon R. Guggenheim Museum
UNNGan	----- Coll. Mr. and Mrs. Victor W. Ganz
UNNGel	----- Coll. Henry Geldzahler
UNNGell	----- Coll. Mr. and Mrs. Maurice Geller
UNNGi	----- Coll. John Gibson
UNNGl	----- Coll. Mr. and Mrs. Arnold B. Glimcher
UNNGo	----- Coll. Esther Gottlieb
UNNGol	----- Coll. Noah Goldowsky and Richard Bellamy
UNNGold	----- Coll. Mr. and Mrs. Arthur Goldberg
UNNGolu	----- Coll. Mr. and Mrs. Leon Golub
UNNGor	----- Coll. Mr. and Mrs. Milton Gordon
UNNGra	----- Coll. Robert Graham
UNNGrah	----- Graham Gallery
UNNGre	----- Coll. Mr. and Mrs. Clement Greenberg
UNNGro	----- Coll. Mr. and Mrs. Morris H. Grossman
UNNGroo	----- Coll. Lawrence Groo
UNNGros	----- Coll. Mr. and Mrs. I. Donald Grossman
UNNH	----- Coll. Joseph H. Hirshhorn; Joseph H. Hirshhorn Foundation
UNNHa	----- Coll. Joseph H. Hazen
UNNHah	----- Stephen Hahn Gallery; Coll. Mr. and Mrs. Stephen Hahn
UNNHarr	----- O. K. Harris Gallery
UNNHas	----- Coll. Haskell
UNNHau	----- Coll. Mr. and Mrs. Ira Haupt
UNNHay	----- Coll. David Hayes
UNNHe	----- Coll. Mr. and Mrs. Maxim L. Hermanos
UNNHel	----- Coll. Dr. and Mrs. Julius Held
UNNHell	----- Coll. Mr. and Mrs. Ben Heller
UNNHelle	----- William Heller, Inc.
UNNHelm	----- Coll. Joseph Helman
UNNHen	----- Henry Street Playhouse
UNNHeu	----- Coll. Heublein, Inc.
UNNHo	----- Coll. Mr. and Mrs. Richard Hokin
UNNHol	----- Coll. Holtzman
UNNHolt	----- Coll. Harry Holtzmann
UNNHor	----- Coll. Mr. and Mrs. Morton Hornick
UNNI	----- Alexander Iolas Gallery
UNNJ	----- Martha Jackson Gallery; Coll. Martha Jackson
UNNJa	----- Sidney Janis Gallery
UNNJac	----- Coll. Brooks Jackson
UNNJani	----- Coll. Conrad Janis
UNNJanis	----- Coll. Carroll Janis
UNNJe	----- Jewish Museum
UNNJoh	----- Coll. Philip C. Johnson
UNNJohn	----- Coll. Jasper Johns
UNNJohns	----- Coll. Marian Willard Johnson
UNNJu	----- Coll. Julie Judd
UNNK	----- M. Knoedler and Company

```
UNNKa          New York City.  Coll. Dr. and Mrs. Ernest Kafka
UNNKah         ----- Coll. Alexandre Kahan
UNNKahn        ----- Coll. S. Sidney Kahn
UNNKahnM       ----- Coll. Max Kahn
UNNKai         ----- Coll. U. K. Kiam
UNNKap         ----- Coll. Mr. and Mrs. Jacob Kaplan
UNNKar         ----- Coll. Mr. and Mrs. Ivan Karp
UNNKau         ----- Coll. Edgar Kaufmann
UNNKenn        ----- Kennedy Galleries
UNNKi          ----- Coll. Mrs. Frederick Kiesler
UNNKia         ----- Coll. Victor K. Kiam
UNNKn          ----- Knoedler Contemporary Art
UNNKo          ----- Samuel M. Kootz Gallery; Coll. Mr. and
                   Mrs. Samuel Kootz
UNNKor         ----- Kornblee Gallery
UNNKorn        ----- Coll. Dr. and Mrs. Leonard Kornblee
UNNKr          ----- Kraushaar Galleries; Coll. Leon Kraushaar
UNNKro         ----- Kronen Gallery
UNNL           ----- Coll. List Family
UNNLa          ----- Alan Landau Gallery
UNNLad         ----- Coll. Mr. and Mrs. Harold Ladas
UNNLas         ----- Coll. Mrs. Albert D. Lasker
UNNLau         ----- Coll. Mr. and Mrs. Lauder
UNNLaug        ----- Coll. Mr. and Mrs. Alexander M. Laughlin
UNNLav         ----- Coll. Mr. and Mrs. Frank A. Lavaty
UNNLe          ----- Coll. Mr. and Mrs. Victor M. Leventritt
UNNLef         ----- Lefebre Gallery
UNNLefe        ----- Coll. Mr. and Mrs. John Lefebre
UNNLei         ----- Coll. Jerry Leiber and Mike Stoller
UNNLej         ----- Coll. Dr. and Mrs. Arthur Lejwa
UNNLejw        ----- Coll. Miss Madeleine Lejwa
UNNLevy        ----- Julien Levy Gallery; Coll. Julien Levy
UNNLi          ----- Coll. Mr. and Mrs. Albert List
UNNLic         ----- Coll. Dorothy and Roy Lichtenstein
UNNLinc        ----- Lincoln Center
UNNLip         ----- Coll. Mr. and Mrs. Howard W. Lipman
UNNLis         ----- Coll. Albert A. List
UNNLo          ----- Longview Foundation
UNNLoe         ----- Albert Loeb Gallery; Coll. Albert Loeb
UNNLow         ----- Coll. Mr. and Mrs. Milton Lowenthal
UNNM           ----- McCrory Corporation
UNNMM          ----- Metropolitan Museum of Art
UNNMMA         ----- Museum of Modern Art
UNNMa          ----- Marlborough Gallery
UNNMac         ----- David McKee Gallery
UNNMack        ----- Coll. Harry and Linda Macklowe
UNNMan         ----- Manufacturers' Hanover Trust Company
UNNMat         ----- Pierre Matisse Gallery
UNNMatC        ----- Coll. Mr. and Mrs. Pierre Matisse
UNNMaz         ----- Coll. Stephen Mazon and Company
UNNMe          ----- Coll. Richard Meier
UNNMi          ----- Coll. Mr. and Mrs. Myron A. Minskoff
UNNMn          ---- Coll. Mrs. Harriet Mnuchin
UNNMnu         ----- Coll. Leon A. Mnuchin
UNNMo          ----- Coll. George Montgomery
UNNMull        ----- Coll. Mrs. Jan Muller
```

UNNN		New York City. New Gallery
UNNNYU	-----	New York University
UNNNag	-----	Tibor de Nagy Gallery
UNNNe	-----	Coll. Mr. and Mrs. Roy R. Neuberger
UNNNew	-----	Coll. Mrs. Barnett Newman
UNNNewh	-----	Coll. S. I. Newhouse, Jr.
UNNNewy	-----	New York Cultural Center
UNNNiv	-----	Coll. Mr. and Mrs. Constantino Nivola
UNNNol	-----	Coll. Mr. and Mrs. Kenneth Noland
UNNO	-----	Coll. David L. Orr
UNNOd	-----	Galleria Odyssia
UNNOl	-----	Coll. Mrs. Claes Oldenburg
UNNOld	-----	Coll. Pat Oldenburg
UNNOr	-----	Coll. Alfred Ordover
UNNOs	-----	Coll. Robert W. Ossorio
UNNP	-----	Coll. I. M. Pei
UNNPa	-----	Betty Parsons Gallery; Coll. Mrs. Betty Parsons
UNNPac	-----	Pace Gallery
UNNPan	-----	Pan-American Building
UNNPar	-----	Parma Gallery
UNNPara	-----	Parasol Press
UNNPark	-----	Coll. Mr. and Mrs. Bliss Parkinson
UNNParkp	-----	Park Place Gallery
UNNPat	-----	Coll. Dr. and Mrs. Russel H. Patterson, Jr.
UNNPau	-----	Coll. Mr. and Mrs. David Paul
UNNPer	-----	Perls Gallery
UNNPo	-----	Coll. Mrs. Barbara Reis Poe
UNNPoi	-----	Poindexter Gallery
UNNPoin	-----	Coll. George and Elinor Poindexter
UNNPol	-----	Coll. Mrs. Lee Krasner Pollock
UNNPow	-----	Coll. Kimiko and John G. Powers
UNNPr	-----	Coll. Mr. and Mrs. Charles Pratt
UNNPre	-----	Coll. Mr. and Mrs. Otto Preminger
UNNPu	-----	Coll. Dr. Frank Purnell
UNNRa	-----	Stephen Radich Gallery; Coll. Stephen Radich
UNNRap	-----	Coll. Mr. and Mrs. Seymour Rappaport
UNNRau	-----	Coll. Robert Rauschenberg
UNNRe	-----	Coll. Mr. and Mrs. Bernard J. Reis
UNNRee	-----	Coll. Miss Joan Reeves
UNNRei	-----	Coll. Anna Reinhardt
UNNRein	-----	Coll. Rita Reinhardt
UNNReina	-----	Coll. A. M. Reinach
UNNRen	-----	Denise Rene Gallery
UNNRey	-----	Coll. Jeanne Reynal
UNNRi	-----	Coll. Horace Richter
UNNRic	-----	Coll. Dustin Rice
UNNRiv	-----	Riverside Museum
UNNRo	-----	Coll. Nelson A. Rockefeller
UNNRoJ	-----	Coll. Mrs. John D. Rockefeller III
UNNRoa	-----	Coll. Mr. and Mrs. Richard Road
UNNRoc	-----	Rockefeller University
UNNRock	-----	Coll. Mrs. John D. Rockefeller
UNNRocke	-----	Coll. John D. Rockefeller III
UNNRos	-----	Coll. Robert Rosenblum

UNNRosen		New York City. Coll. Mr. and Mrs. Harold Rosenberg
UNNRosenb	-----	Paul Rosenberg and Company
UNNRoss	-----	Coll. Mr. and Mrs. Walter Ross
UNNRu	-----	Coll. Mickey Ruskin
UNNRub	-----	Coll. William Rubin
UNNRube	-----	Coll. Peter Rubel
UNNRubi	-----	Lawrence Rubin Gallery; Coll. Lawrence Rubin
UNNRubin	-----	Coll. Helena Rubinstein
UNNRubl	-----	Coll. Mr. and Mrs. John Rublowsky
UNNS	-----	Jacques Seligmann and Company
UNNSai	-----	Saidenberg Gallery; Coll. Mr. and Mrs. Daniel Saidenberg
UNNSal	-----	Coll. L. J. Salter
UNNSar	-----	Coll. Mr. and Mrs. Robert W. Sarnoff
UNNSc	-----	Coll. Arnold Scaasi
UNNScha	-----	Bertha Schaefer Gallery
UNNScho	-----	Schoelkopf Gallery
UNNSchw	-----	Coll. Mr. and Mrs. Seymour Schweber
UNNSchwa	-----	Coll. Mrs. Ethel K. Schwabacher
UNNSchwar	-----	Coll. Mr. and Mrs. Eugene M. Schwartz
UNNScu	-----	Coll. Mr. and Mrs. Robert C. Scull
UNNScul	-----	Sculpture Now, Inc.
UNNSea	-----	Seagram Building Plaza
UNNSef	-----	Coll. Mr. and Mrs. Michael Seff
UNNSei	-----	Seidenberg Gallery
UNNSh	-----	Coll. A. I. Sherr
UNNSha	-----	Coll. Willoughby Sharp
UNNSi	-----	Coll. Joan Simon
UNNSin	-----	Singer Company
UNNSli	-----	Coll. Mr. and Mrs. Joseph Slivka
UNNSm	-----	Smolin Gallery
UNNSmi	-----	Coll. Mrs. Bertram Smith
UNNSmit	-----	Al Smith Recreation Center
UNNSo	-----	Sonnabend Gallery
UNNSol	-----	Coll. Dr. A. Solomon
UNNSoli	-----	Coll. Mr. and Mrs. David M. Solinger
UNNSolo	-----	Coll. Mr. and Mrs. Horace Solomon
UNNSon	-----	Coll. Mr. and Mrs. Michael Sonnabend
UNNSp	-----	Coll. Mr. and Mrs. Robert Spitzer
UNNSpe	-----	Coll. Mrs. Vicci Sperry
UNNSt	-----	Staempfli Gallery; Coll. Emily B. Staempfli; Coll. Mr. and Mrs. George Staempfli
UNNSta	-----	Stable Gallery
UNNSte	-----	Coll. Mr. and Mrs. Robert A. M. Stern
UNNStei	-----	Coll. Saul Steinberg
UNNStein	-----	Gallery Gertrude Stein
UNNStel	-----	Coll. Frank Stella
UNNSto	-----	Allan Stone Gallery; Coll. Allan Stone
UNNStr	-----	Coll. Mr. and Mrs. Donald B. Straus
UNNStra	-----	Coll. Molly Straeter
UNNSw	-----	Coll. Mr. and Mrs. James Johnson Sweeney
UNNSwe	-----	Coll. Maurice Swergold
UNNT	-----	Coll. Mr. A. Alfred Taubman
UNNTh	-----	Coll. Marie Christophe Thurman

UNNTho	New York City. J. Walter Thompson Company
UNNTo	----- Coll. Harry Torczyner
UNNTr	----- Coll. Mr. and Mrs. Burton Tremaine
UNNTy	----- Coll. Miss Vivian Tyson
UNNV	----- Curt Valentin Gallery; Estate of Curt Valentin
UNNVa	----- Coll. Ondine Vaughn and Steve Schapiro
UNNVi	----- Catherine Viviano Gallery
UNNW	----- Whitney Museum of American Art
UNNWadd	----- Waddell Gallery
UNNWard	----- Coll. Mrs. Eleanor Ward
UNNWe	----- John Weber Gallery
UNNWeb	----- Coll. John L. Weber
UNNWei	----- Coll. Mr. and Mrs. Richard L. Weisman
UNNWein	----- Weintraub Gallery; Coll. William R. Weintraub
UNNWeins	----- Coll. Mr. and Mrs. Joseph Weinstein
UNNWeit	----- Coll. J. Daniel Weitzman
UNNWh	----- Coll. David Whitney
UNNWhi	----- Coll. William H. White, Jr.
UNNWhit	----- Coll. Mr. and Mrs. John Hay Whitney
UNNWhite	----- Coll. Mrs. Ruth White
UNNWi	----- Willard Gallery
UNNWil	----- Coll. William Wilson
UNNWin	----- Coll. Donald Windham
UNNWint	----- Coll. Mr. and Mrs. Lewis V. Winter
UNNWise	----- Howard Wise Gallery; Coll. Howard Wise
UNNWo	----- World House Galleries
UNNWor	----- World Trade Center
UNNY	----- Coll. Hanford Yang
UNNZ	----- Coll. Mr. and Mrs. Charles Zadok
UNNZe	----- Coll. Mr. and Mrs. William Zeckendorf, Jr.
UNNZei	----- Coll. Richard S. Zeisler
UNNZeis	----- Coll. Mrs. Claire Zeisler
UNNZi	----- William Zierler Gallery
UNNiC	Niagara Falls. Carborundum Company
UNOlP	Olcott. Coll. Charles R. Penney
UNPV	Poughkeepsie. Vassar College. Art Museum
UNPoK	Pound Ridge. Coll. Kannin
UNRyD	Rye. Coll. Mrs. Harry Doniger
UNRyF	----- Coll. Siv and David Fox
UNScB	Scarsdale. Coll. Mr. and Mrs. Herbert Beenhouwer
UNScE	----- Coll. Lee V. Eastman
UNSyE	Syracuse. Everson Museum of Art
UNUtM	Utica. Munson-Williams-Proctor Institute
UNWhO	White Plains. Coll. Myron Orlofsky
UNWoF	Woodstock. Coll. Mr. and Mrs. Henry Feiwel

--Nebraska

UNbLU	Lincoln. University of Nebraska. Art Gallery
UNbOJ	Omaha. Joslyn Art Museum

--North Carolina

UNcGC	Greensboro. Coll. Mrs. Gilbert Carpenter
UNcGU	----- University of North Carolina

 --New Jersey
-UNjP Coll. John G. Powers
UNjAD Atlantic Heights. Coll. Mrs. Burgoyne Diller
UNjMuB Murray Hill. Bell Telephone Laboratories
UNjNBR New Brunswick. Rutgers University
UNjNewM Newark. Newark Museum
UNjNewP ----- Prudential Life Insurance Company
UNjP Princeton. Princeton University
UNjPA ----- Princeton University Art Museum
UNjRW Rosemont. Coll. Mr. and Mrs. L. B. Westcott
UNjSS South Orange. Coll. Mr. and Mrs. Anthony Smith
UNjTrN Trenton. New Jersey State Museum

 --New Mexico
UNmClN Clovis. Coll. Vernon Nikkel

 --Ohio
-UOF Coll. Julius Fleischman
UOClA Cleveland. Cleveland Art Museum
UOClW ----- Coll. H. Wise
UODA Dayton. Art Institute
UOOC Oberlin. Oberlin College. Allen Memorial
 Art Museum
UOTA Toledo. Toledo Museum of Art

 --Oregon
UOrPC Portland. Coll. Ed Cauduro

 --Pennsylvania
UPAT Altoona. Coll. Mr. and Mrs. Frank M. Titelman
UPAlA Allentown. Allentown Art Museum
UPBK Bear Run. Coll. Edgar Kaufman
UPHaL Hanover. Coll. Boris and Sophie Leavitt
UPHavL Haverford. Coll. Mrs. H. Gates Lloyd
UPPCrt Philadelphia. Federal Courthouse
UPPF ----- Fairmont Park Association
UPPFed ----- Federal Reserve Bank
UPPFl ----- Sheldon S. Fleischer Art Memorial
UPPG ----- Coll. Mrs. Albert M. Greenfield, Sr.
UPPK ----- Coll. Mr. and Mrs. Robert Kardon
UPPPA ----- Pennsylvania Academy of Fine Arts
UPPPM ----- Philadelphia Museum of Art
UPPiC Pittsburgh. Carnegie Institute
UPPiH ----- Coll. Walter R. Hovey
UPPiM ----- Coll. Harry Miller
UPPiT ----- Coll. G. David Thompson
UPWP Wynnewood. Coll. David M. Pincus

 --Rhode Island
URPB Providence. Brown University
URPD ----- Rhode Island School of Design.
 Museum of Art
URPW ----- Coll. George Waterman

 --South Carolina
UScGrG Greenville. Greenville County Museum of Art

--Texas
```
-UTxW        Coll. Mr. and Mrs. Robert F. Windfohr
UTxAM        Austin.  University of Texas.  Michener Coll.
UTxDC        Dallas.  Coll. Mr. and Mrs. James H. Clark
UTxDG        ----- Coll. Mr. and Mrs. S. Allen Guiberson
UTxDM        ----- Dallas Museum of Fine Arts
UTxFA        Fort Worth.  Amon Carter Museum of Western Art
UTxFW        ----- Coll. Mrs. Robert Windfohr
UTxHA        Houston.  Museum of Fine Arts
UTxHF        ----- First National City Bank
UTxHL        ----- Coll. Mr. and Mrs. Theodore N. Law
UTxHLe       ----- Janie C. Lee Gallery
UTxHM        ----- Coll. de Menil
UTxHMe       ----- Coll. Francois de Menil
UTxHMen      ----- Coll. John de Menil
UTxHMeni     ----- Coll. Mr. and Mrs. Jean de Menil
UTxHMenil    ----- Coll. D. and J. de Menil
UTxHSp       ----- Coll. Joseph E. Spinden
UTxSAT       San Antonio.  Coll. R. L. B. Tobin
```

--Virginia
```
UVAM         Alexandria.  Coll. H. Marc Moyers
UVNC         Norfolk.  Chrysler Museum
UVRL         Richmond.  Coll. Mr. and Mrs. Sydney Lewis
UVRMu        ----- Virginia Museum of Fine Arts
```

--Vermont
```
UVtBF        Bennington.  Coll. Helen Webster Feeley
UVtWW        Windsor.  Coll. Nancy Nash Walker
```

--Washington
```
UWaBD        Bellevue.  Coll. Mr. and Mrs. John C. Denman
UWaSA        Seattle.  Seattle Art Museum
UWaSF        ----- First National Bank Coll.
UWaSWr       ----- Coll. Mr. and Mrs. Charles B. Wright
UWaSWri      ----- Coll. Mr. and Mrs. Bagley Wright
```

--Wisconsin
```
UWiMA        Milwaukee.  Milwaukee Art Institute;
             Milwaukee Art Center
UWiMP        ----- Performing Arts Center
UWiMY        ----- Coll. Richard Yoder
```

Venezuela
```
VC           Caracas
VCU          ----- Caracas University
VCV          ----- Coll. Carlos Raoul Villanueva
```

Yugoslavia
```
YLMa         Ljubljana.  Mala Galerija
YLMo         ----- Moderna Galerija
```

Abbreviations

a/c	acrylic on canvas
b/w	black-and-white
c.	circa
col.	color
Coll(s).	Collection(s)
cov.	cover
fig(s).	figure(s)
front.	frontispiece
Hon.	Honorable
n.d.	no date
no(s).	number(s)
o/c	oil on canvas
p.	page
pl(s).	plate(s)
pp.	pages
St.	Saint; Street

PART I
Artist Index

ABE, Nobuya (Japanese, 1913-)
 Gray Echo, 1964, encaustic and
 canvas on wood UNNRoJ
 Lieberman, p.41 (b/w)

ABERDAM, Alfred
 Composition
 Fig.Art, pl.22 (b/w)

ABRAHAMS, Ivor (British, 1935-)
 Arch I, 1971, lithograph ELJa
 Eng.Art, p.41 (b/w)
 Arch II, 1971, lithograph ELJa
 Eng.Art, p.41 (b/w)
 Arch III, 1971, lithograph ELJa
 Eng.Art, p.41 (b/w)
 Arch IV, 1971, lithograph ELJa
 Eng.Art, p.41 (b/w)
 Cut out Shrub with Steps, 1974-
 75, hard board, steel, decal,
 Coll.Artist
 Eng.Art, p.42 (b/w)
 The Huntress, 1963-66
 UK1, pl.19 (b/w)
 Red Riding Hood, 1963
 UK1, pl.14 (b/w)
 Shrubbery Group, 1975, glass
 fiber, resin, synthetic ena-
 mel, Coll.Artist
 Eng.Art, p.43 (b/w)
 Untitled, 1973-75, glass fiber,
 resin, etc., Coll.Artist
 Eng.Art, p.40 (b/w)

ABRAMS, Isaac (American, 1939-)
 Cosmic Orchid, 1967
 UK2, col.pl.XXXII
 Untitled, 1968
 UK2, pl.396 (b/w)

Untitled, 1968, o/c, Priv.Coll.,
 New York City
 Arnason, col.pl.261

ACCARDI, Carla (Italian, 1924-)
 A settori, 1962, tempera
 Metro, p.5 (col)
 Green Green, 1971, varnish on
 transparent plastic
 Liverpool, no.60 (b/w)
 Labyrinth N.19, 1957 FPSt
 Pelligrini, p.93 (b/w)
 Negative, 1956
 Seuphor, no.163 (b/w)
 Penetrazione, 1964, o/c
 New Art, pl.105 (b/w)
 Pittura, 1963
 UK2, col.pl.XVI
 Rosso verde scrittura, 1962,
 tempera
 Metro, p.4 (b/w)
 Three Tents, 1970, painted
 plastic
 Liverpool, no.59 (b/w)

ACCONCI, Vito (American, 1940-)
 Air-Time, Sonnabend Gallery,
 New York, 1973
 Popper, p.239 (b/w)
 Blindfolded Catching Piece,
 1970, film strip NSchS
 Hunter, pl.793 (b/w)
 Following Piece ("Street Works
 IV," Architectural League of
 New York), 1969, activity
 6 Yrs, p.117 (b/w)
 Hand in Mouth Piece, 1970, film
 Meyer, pp.4-5 (b/w)
 Learning Piece, 1970
 Meyer, p.7 (b/w)

Step Piece, 1970, performance
 Meyer, p.2 (b/w)
Zone, April 9, 1971, performance
 6 Yrs, p.232 (b/w)

ACKERMANN, Max (German, 1887-)
 Bejamar, 1957, o/c
 1945, pl.99a (b/w)

ACTON, Arlo (American, 1933-)
 Stash Box, 1965, mixed media,
 Coll.Artist
 Ashton, pl.LXXII (b/w)
 Tumblers Last Tumble, 1962,
 hardwoods UCBeFo
 Andersen, p.159 (b/w)

ADAM, Henri-Georges (French, 1904-
1967)
 The Couple, 1946, plaster for
 marble
 Trier, fig.2 (b/w)
 February 15, 1952, engraving
 Seuphor, no.250 (b/w)
 Flagstones, Sand, and Water,
 No.10, 1957, engraving FPHu
 Seuphor, no.249 (b/w)
 Graven Shadows, 1956, engraving
 Seuphor, no.248 (b/w)
 Sculpture, 1963, stone
 Metro, p.7 (b/w)
 Sleeping Woman, 1945, plaster,
 IVaM
 G-W, p.241 (b/w)
 Untitled, 1954-55 FLeHM
 G-W, p.241 (b/w)
 Trier, fig.207 (b/w)

ADAMI, Valerio (Italian, 1935-)
 Adulterio della moglie del nego-
 ziante, 1962 IMMarc
 Metro, p.9 (col)
 Crash, 1963, oil, Coll.Artist
 Haftmann, pl.1003 (b/w)
 Il Giardino del matrimonio,
 1963, o/c, Coll.Artist
 New Art, pl.129 (b/w)
 The Homosexuals, 1966, a/c,
 IMArr
 Kahmen, pl.321 (b/w)
 Look, 1968, acrylic emulsion and
 polymer on canvas, Priv.Coll.,
 Brussels
 Fig.Art, pl.316 (b/w)
 Pink Pornographic Tale (Racconto
 pornografico rosa), 1966, a/c
 Kahmen, pl.322 (b/w)

The Showcase, acrylic emulsion
 and polymer on canvas BBW
 Fig.Art, pl.284 (col)
 Wilson, pl.51 (col)
Le Stanze a cannocchiole, 1965,
 enameloid on canvas IMSc
 Lippard, pl.173 (b/w)
Trittico: per un Grand Hotel,
 1967
 UK2, pl.241 (b/w)
Western, 1962, o/c, Coll.Artist
 Metro, p.8 (b/w)

ADAMS, Pat (American, 1928-)
 Mortarless, 1965, a/c UDCHi
 Hh, pl.951 (b/w)

ADAMS, Robert (British, 1917-)
 Iron Sculpture, 1956 GWupJ
 Trier, fig.125 (b/w)
 Large Screen Form No.1, 1962,
 bronzed steel
 Metro, p.10 (b/w)
 Rising Movement No.2, 1962,
 bronzed steel
 Metro, p.11 (b/w)

ADER, Bas Jan
 I'm Too Sad to Tell You, 1970
 6 Yrs, p.134 (b/w)

ADERLECHT, Englebert van (Belgian,
1918-1961)
 La Nuit fait l'amour, 1959,
 o/c, Priv.Coll.
 New Art, col.pl.86

AEPPLI, Eva (Swiss, 1925-)
 Head, c.1965, fabric GDuSc
 Kahmen, pl.76 (b/w)

AESCHBACHER, Hans (Swiss, 1906-)
 Explorer I, 1964, Marmor Cris-
 tallina SwLaS(1964)
 New Art, pl.327 (b/w)
 Figur I, 1962
 Metro, p.12 (b/w)
 Figur IV, 1961 GBremK
 Metro, p.13 (b/w)
 Figure I, 1955, lava SwBi
 G-W, p.243 (b/w)
 Figure I, 1958, red stone SwZB
 Trier, fig.44 (b/w)

AFRO (Afro Basaldella) (Italian,
 1912-)
 Anniversary (Per una ricorren-
 za), 1955, oil
 Haftmann, pl.856 (b/w) UMoSLP
 Arnason, pl.976 (b/w) UNNG
 Big Grey, 1970, o/c, Coll.Artist
 Liverpool, no.9 (b/w)
 Burnt Shadow, 1956 UNNVi
 Abstract, pl.88 (b/w)
 Coat of Arms (Homage to Goffredo
 Petrassi), 1968, o/c, Coll.
 Artist
 Liverpool, no.6 (b/w)
 Composizione, 1962
 Metro, p.14 (b/w)
 Fear of the Night, 1952, o/c,
 UNBuA
 A-K, p.217 (b/w)
 Fondo degli Ulivi, 1958 IMJe
 Ponente, p.86 (col)
 Malabergo, 1962
 Pellegrini, p.91 (b/w)
 Ombra bruciata, 1956, o/c IRArt
 1945, pl.55 (b/w)
 Red Sky at Night...II, 1969, o/c
 Liverpool, no.7 (b/w)
 Silver Dollar Club, 1956, oil,
 IMJe
 Haftmann, pl.853 (b/w)
 Trofeo, 1961, oil UNNVi
 Metro, p.15 (col)
 Ultra-marine, 1969, o/c, Coll.
 Artist
 Liverpool, no.8 (b/w)
 Untitled, 1964, o/c
 New Art, col.pl.54
 Via delle Croce, 1959 UNNVi
 Ponente, p.89 (col)
 Viale delle Acacie, 1958, Coll.
 Artist
 Ponente, p.88 (col)
 Viale delle Acacie II, 1967, o/c,
 Coll.Artist
 Liverpool, no.5 (b/w)
 Villa Horizon, 1960, o/c FPFr
 Seuphor, no.339 (col)

AGAM, Yaacov (Israeli, 1928-)
 Appearance, 1965-66, oil on
 corrugated aluminum UNNMa
 L-S, pl.143 (b/w)
 Dans le temps et dans l'espace,
 1960 UNNKah
 Metro, p.17 (b/w)

Double metamorphose, 1964
 Popper 2, p.109 (b/w)
Double Metamorphosis II, 1964,
 oil on aluminum UNNMMA
 Arnason, fig.1102 (b/w)
Environment, Elysee Palace,
 Paris
 Popper, p.107 (col)
Free Standing, 1964, painted
 aluminum UNNMa
 New Art, pl.62 (b/w)
Free Standing Painting, 1971,
 painted aluminum, wood,
 stainless steel UNBuA
 A-K, p.335 (col)
Meta-Polyformic Painting, 1960-
 61 -Ren
 Pellegrini, p.167 (b/w)
Metamorphosis, 1957
 Popper, p.6 (b/w)
New Year, 1967, oil on aluminum,
 Priv.Coll.
 Abstract, pls.268-69 (col)
The Ninth Power, 1970-71, stain-
 less steel UNBuA
 A-K, p.336 (b/w)
Nouveau solfege, 1966
 Popper 2, p.229 (col)
Peinture polyphone-2 Themes-
 couleur contrepoint, 1955
 UK2, pl.351 (b/w)
Rhythmical Space: Let There Be
 Light, 1962, modulation of
 light by sound
 Abstract, pls.275-76 (b/w)
Sensibilite, 1961, elements on
 springs -URic
 Metro, p.16 (b/w)
Sounding Image II, 1964 UNNMa
 Brett, pp.84-85 (b/w)
Three Times Three Interplay,
 1970-71, stainless steel,
 UNNLinc
 Popper, p.77 (b/w)
Transparent Rhythms II, 1967-68,
 oil on aluminum relief UDCHi
 Hh, pl.955 (b/w)

AGOSTINI, Peter (American, 1913-)
 Cage II, 1967, plaster, wood,
 steel UNNRa
 Arnason, fig.1015 (b/w)
 Christmas Package, 1963,
 plaster UNNRa
 New Art, pl.41 (b/w)
 Rose, p.264 (b/w)

City Fragment, 1959-60, plaster
 Andersen, p.124 (b/w)
Egg Pile, 1964
 UK1, pl.104 (b/w)
Meat Rake, 1963-64, plaster and
 painted metal UNNRa
 Ashton, pl.XL (col)
Open Box, 1963, plaster UDCHi
 Hh, pl.883 (b/w)
Summer's End, 1964, plaster,
 Coll.Artist
 Hunter, pl.810 (b/w)
The Table, 1962, plaster
 Andersen, p.124 (b/w)

AKANA, Hiroshi (Japanese, 1922-)
Fighting Spirit, 1964, o/c,
 Coll.Artist
 Lieberman, p.54 (b/w)
Pair, 1963, o/c, Coll.Artist
 Lieberman, p.55 (b/w)

ALBERS, Joseph (German-American,
 1888-)
Ascension, from Graphic Tecton-
 ic, 1942, lithograph UNNMMA
 Castleman, p.147 (col)
Bent Black, 1940, oil on mason-
 ite UDCHi
 Hh, pl.477 (b/w)
Biconjugate Series: Chalk-Green
 Facade, 1960, oil on masonite,
 Coll.Artist
 Geldzahler, p.118 (b/w)
Biconjugate Series: Red Orange
 Wall, 1959, oil on masonite,
 Coll.Artist
 Geldzahler, p.117 (b/w)
Embossed Linear Construction,
 1969, engraving UCLG
 Castleman, p.149 (col)
Far Off, 1958, o/c UNGH
 New Art, pl.9 (b/w)
Graphic Tectonics
 Barrett, p.134 (b/w)
Growing, 1940, oil on masonite,
 UCSFM
 Geldzahler, p.113 (b/w)
Homage to the Square, 1963,
 o/c FPRe
 Abstract, pl.165 (col)
Homage to the Square, 1964
 UK2, pl.307 (b/w)
Homage to the Square (Plate
 VII), 1967, silkscreen SwBBe
 Castleman, p.151 (col)

Homage to the Square: Apodictic,
 1950-54, oil study, Priv.
 Coll., United States
 Haftmann, pl.344 (b/w)
Homage to the Square: Appari
 tion, 1959, oil on board,
 UNNG
 Metro, p.18 (b/w)
 Arnason, col.pl.137
 Hunter, pl.735 (col)
Homage to the Square: "Ascend-
 ing", 1953, oil on composi-
 tion board UNNW
 Whitney, p.60 (col)
Homage to the Square: Assertive,
 1958, o/c
 Seuphor, no.436 (col)
Homage to the Square: Broad
 Call, 1967, o/c UNNMMA
 Calas, p.188 (b/w)
Homage to the Square: Chosen,
 1966, oil on masonite UDCHi
 Hh, pl.985 (col)
Homage to the Square: "Curious,"
 1963, o/c ELMcA
 L-S, pl.70 (col)
Homage to the Square: Departing
 in Yellow, 1964, oil on
 hardboard ELT
 Barrett, p.135 (b/w)
 Compton, pl.2 (col)
Homage to the Square: Frislau,
 1955, oil on board UMBRa
 Rose, p.132 (col)
Homage to the Square: Glow,
 1966, oil on masonite UDCHi
 Hh, pl.866 (b/w)
Homage to the Square: In Wide
 Light, 1953, oil on mason-
 ite, Coll.Artist
 Geldzahler, p.117 (b/w)
Homage to the Square: New Gate,
 1951, oil on masonite, Coll.
 Artist
 Geldzahler, p.115 (b/w)
Homage to the Square: Ritardan-
 do, 1958 UNNJa
 Ponente, p.19 (col)
Homage to the Square: Terra
 Caliente, 1963, oil on mason-
 ite UNBuA
 A-K, p.310 (col)
Homage to the Square: With Rays,
 1959, oil on masonite UNNMM
 Hamilton, pl.366 (b/w)

Indicating Solids, 1949, oil on
masonite, Coll.Artist
Geldzahler, p.114 (b/w)
Intersecting Solids, 1949
Seuphor, no.438 (b/w)
Late Thought, 1964, oil on
board UDCWo
Geldzahler, p.65 (col)
Light Slate, 1961 UNNJa
Pellegrini, p.29 (b/w)
Partition Wall, 1950, brick,
UMCHG
Trier, fig.201 (b/w)
Prefatio, 1942, line engraving
Janis, p.313 (b/w)
Sanctuary, 1942 UNNJa
Seuphor, no.437 (b/w)
Single Answer, 1960, oil on
board CHaE
Hunter, pl.769 (b/w)
Structural Constellation (Struk-
turale Konstellation), 1953-
58, engraved in resopal (plas-
tic)
Kahmen, pl.301 (b/w)
Structural Constellation (Struk-
turale Konstellation), 1953-
58, engraved in resopal (plas-
tic)
Kahmen, pl.302 (b/w)
Structural Constellation, 1953-
58, Coll.Artist
Metro, p.19 (b/w)
Structural Constellation, En-
graving no.30, 1955 FPRe
Barrett, p.133 (b/w)
Structural Constellation JHC II,
1963, engraving on plastic,
UTxDC
Calas, p.170 (b/w)
Structural Constellation NHD,
1957, incised vinyl CMG
Hunter, pl.770 (b/w)
Transformations of a Scheme Ser-
ies: No.10, 1950, machine-
engraved in laminated formica,
Coll.Artist
Geldzahler, p.114 (b/w)
Transformations of a Scheme Ser-
ies: No.26, 1952, machine-
engraved in laminated formica,
Coll.Artist
Geldzahler, p.116 (b/w)
Untitled
Pellegrini, p.69 (col)

Vice Versa B, 1943, oil on ma-
sonite UDCHi
Hh, pl.475 (b/w)

ALBERT, Calvin (American, 1918-)
Moment of Precision, 1957, lead
alloy, stainless steel
Andersen, p.123 (b/w)

ALBRECHT, Joachim
Polar Route, 1967, metallized
paint on aluminum, Coll.
Artist
Abstract, pl.297 (b/w)

ALBRIGHT, Ivan Le Lorraine (Amer-
ican, 1897-)
Fleeting Time Thou Has Left Me
Old, 1946, lithograph
Hunter, pl.314 (b/w)
Poor Room-There is No time, No
end, No today, No yesterday,
No tomorrow, only the for-
ever and forever and forever
without end, begun 1941, o/c,
UICA
Arnason, fig.688 (b/w)
Show Case Doll, 1954, litho-
graph UNNW
Whitney, p.135 (b/w)
The Temptation of St. Anthony,
1947, o/c
Fig.Art, pl.135 (b/w)

ALCOPLEY (Alfred Lewin Copley)
(German-American, 1910-)
Painting, 1958-59, Coll.Artist
Seuphor, no.403 (col)
Peinture-Collage, 1954
Janis, p.156 (b/w)
Drawing, 1952
Seuphor, no.212 (b/w)

ALECHINSKY, Pierre (Belgian,
1927-)
Ant Hill, 1954, o/c UNNG
Arnason, fig.946 (b/w)
The Green Being Born, 1960, o/c,
BBRAM
L-S, pl.62 (b/w)
Greet the North, Greet the
South, 1962, o/c UNBuA
A-K, p.229 (col)
Imaginist Diary of 6-31 May
1968, pen and ink FPFr
Abstract, pl.129 (b/w)

Mr. Stanley, I Presume, 1960,
o/c FPCap
Seuphor, no.487 (col)
No Rattle (Sans Sonette), 1971,
aquatint and lithograph FPHu
On the other side of the prism
(De l'autre cote du prisme),
1964, oil UNNLef
Haftmann, pl.916 (b/w)
La Parole est aux enfants, 1962,
o/c NoOH
New Art, pl.186 (b/w)
Peinture, 1957, o/c
1945, pl.33 (b/w)
The Portugese Nun, 1951, Chinese
ink on paper, Coll.Artist
Fig.Art, pl.74 (b/w)
Quelque chose d'un monde, 1952-
53, etching and engraving,
UNNMMA
Castleman, p.77 (col)
Reponse Poussiereuse, 1961,
Priv.Coll.
Metro, p.20 (b/w)
Seize the Day, 1958, o/c UDCHi
Hh, pl.756 (col)

ALEXANDRIS, Sandro de
2 TS/P no.2, 1967
UK2, pl.341 (b/w)

ALFARO, Andreu (Spanish, 1929-)
Celui qui enferme un sourire,
celui qui emmure une voix,
1964, iron SpA1C
New Art, pl.142 (b/w)
Dawn, 1962, iron
Dyckes, p.83 (b/w)
If I Die, 1965, iron
Dyckes, p.83 (b/w)
My People and I, 1971, aluminum,
Coll.Artist
Dyckes, p.83 (b/w)

ALLEYN, Edmund (Canadian, 1931-)
The Big Sleep, 1968, assemblage,
FMoS
Fig.Art, pl.289 (b/w)

ALLING, Janet
Rubber Tree Plant 4, 1971, o/c
Battcock, p.239 (b/w)

ALTENBOURG, Gerhard (German,
1926-)
Boy at puberty (Knabe in Puber-
tat), 1949, chalk lithograph,
GHaB
Kahmen, pl.85 (b/w)
No man is born master of his
craft (Es ist kein Meister
von Himmel gefallen), 1949,
India ink GHaB
Kahmen, pl.83 (b/w)

ALTRI, Arnold d' (Italian, 1904-)
Genii, 1949, cement GLeM
Trier, fig.73 (b/w)

ALTRIPP, Alo (German, 1906-)
G41/57 II, 1957, charcoal
Seuphor, no.241 (b/w)
G121/58 XIII, 1958, charcoal,
Priv.Coll., United States
Seuphor, no.240 (b/w)

ALVAREZ, Domingo
Mirror Environment, New York,
1971-72
Popper, p.98 (b/w)

ALVERMANN, Hans Peter (German,
1931-)
Aphrodite 65, 1965
UK1, pl.20 (b/w)
Hommage a Dusseldorf, 1962,
mixed media GWupJ
New Art, pl.317 (b/w)
Hommage a Helena Rubenstein,
1964
UK1, pl.158 (b/w)
Portrait of an Electric Pater,
1963, object, Coll.Artist
Lippard, pl.162 (b/w)

ALVIANI, Getulio (Italian, 1939-)
Abito, 1963-64
UK2, pl.344 (b/w)
Abito, 1968
UK2, pl.299 (b/w)
Aluminum, 1961 -Nu
Pellegrini, p.187 (b/w)
Cubic Environment, 1964-69
Popper, p.103 (b/w)
Dress IGenD
Barrett, p.149 (b/w)
Linee luce, 1962
UK2, pl.305 (b/w)

Linee luce, 1962
 UK2, pl.348 (b/w)
Orecchino, 1967
 UK2, pl.301 (b/w)
Surface with Vibratile Texture,
 1962, aluminum, Coll.Artist
 Abstract, pl.264 (b/w)
Surface of Vibrant Texture,
 1963, aluminum FPRe
 Barrett, p.85 (b/w)
Superficie a testura vibratice
 assonometrica, 1966
 UK2, pl.346 (b/w)
Superficie a testura vibratice
 circolare, 1965
 UK2, pl.300 (b/w)
Superficie a testura vibratile,
 1964, aluminum
 New Art, pl.125 (b/w)

AMEN, Woody van (Dutch, 1936-)
 Checkpoint Charley, 1965, assem-
 blage NRC
 New Art, pl.154 (b/w)

ANDERSON, Jeremy (American, 1921-
)
 Early Morning Hours, 1966,
 enamelled wood
 Andersen, col.pl.3
 Shooting of Dan McGrew, 1962,
 wood, Priv.Coll.
 Andersen, p.152 (b/w)
 Toys of a Prince After G. de
 Chirico, 1965 (first version),
 mixed media UCSFDi
 Ashton, pl.LXIX (col)
 Untitled, 1957, redwood, Priv.
 Coll.
 Andersen, p.152 (b/w)

ANDERSON, John (American, 1928-)
 Solid Body, 1965, ash UNNSto
 Ashton, pl.LV (b/w)

ANDERSSON, Torsten (Swedish, 1926-
)
 Kallen II, 1962, o/c and wood,
 SnSNM
 New Art, col.pl.79

ANDRE, Carl (American, 1935-)
 Cedar Piece, 1964, cedar
 Andersen, p.215 (b/w) UNNFram
 Goossen, p.27 (b/w)
 Hunter, pl.847 (b/w) UNNWeb
 Cuts, 1967, concrete
 Celant, pp.208-09 (b/w)
 Calas, p.275 (b/w)
 Equivalents, 1966
 Eng.Art, p.317 (b/w)
 Event, Maeght Foundation, Saint-
 Paul-de-Vence, 1970
 Popper, p.238 (b/w)
 Joint, 1968, uncovered baled
 hay
 UK4, pl.149 (b/w)
 6 Yrs, p.46 (b/w)
 Lever, 1966, firebrick
 Andersen, p.216 (b/w)
 Log Piece, Aspen, Colo., summer
 1968
 Celant, p.207 (b/w)
 Hunter, pl.846 (b/w)
 144 Pieces of Aluminum, 1967,
 aluminum UNNDw
 L-S, pl.4 (b/w)
 144 Pieces of Lead, 1969, lead
 Andersen, p.217 (b/w)
 Reef, 1969-70 (original 1966),
 styrofoam GCoF
 Hunter, pl.848 (b/w)
 Rock Pile, summer 1968
 Celant, p.210 (b/w)
 Scatterpiece, 1967
 Walker, pl.26 (col)
 16 Pieces of Slate, 1967, slate
 Celant, p.205 (b/w)
 64 Pieces of Magnesium, 1969,
 magnesium UNNWe
 Hunter, pl.843 (b/w)
 Study for Fall, 1967, pen and
 ink on graph paper
 Goossen, p.46 (b/w)
 21 Pieces of Aluminum, 1967
 Celant, p.206 (b/w)
 Untitled, 1968, iron plates,
 GCoZ
 Kahmen, pl.308 (b/w)
 Untitled (Portrait of Richard
 Long), 1969, cut cable wires
 6 Yrs, p.100 (b/w)

ANGELI, Franco (Italian, 1935-)
 Frammento capitolino, 1964, o/c
 New Art, pl.130 (b/w)

ANNESLEY, David (British, 1936–
)
Orinoco, 1965, painted metal,
 ELT
 L-S, pl.204 (b/w)
Swing Low, 1964, painted steel
 Fig.Art, pl.161 (b/w) ELGul
 Eng.Art, p.276 (col) ELT
Untitled, 1965
 UK1, pl.205 (b/w)

ANSELMO, Giovanni (Italian, 1934–
)
Torsione, 1968, fustian and iron
 Celant, p.111 (b/w)
Torsione, 1968, cow hide, cement
 and wood
 Celant, p.113 (b/w)
Untitled, 1968, granite and
 flesh
 Celant, p.110 (b/w)
Untitled, 1968, brick, chalk,
 steel and water
 Celant, p.114 (b/w)
Untitled, 1968, cotton and water
 Celant, p.114 (b/w)
Untitled, 1969, cotton, water
 and plexiglass
 Celant, p.112 (b/w)

ANTES, Horst (German, 1936–)
Black-and-White Figure (Figur
 Schwarz-weiss), 1967, aquatint
 on canvas GDusKN
 Kahmen, pl.74 (b/w)
Figure with Black Cap, 1964,
 oil UNNLef
 Haftmann, pl.1002 (b/w)
Figure with White Boa and Head
 Turned, 1965–66, watercolor
 Fig.Art, pl.28 (col)
Figure with Ladder and Funnel
 (Figur mit Leiter und Rohr),
 1971, lithograph SwZKo
 Castleman, p.107 (col)
Gelbe Figur mit Vogel (Yellow
 Figure with Bird), 1964–65,
 o/c ELGi
 New Art, col.pl.128
 Arnason, fig.947 (b/w)
The Head (Die Lust an Adam),
 1967, painted sheet steel
 Trier, fig.221 (b/w)
Interior with Male Figure (Mann-
 liche Figur im Raum), 1964,
 etching and drypoint UNNMMA
 Castleman, p.105 (col)

Portrait Figure, 1960, o/c FPSp
 Seuphor, no.496 (col)

ANTHOONS, Willy (Belgian, 1911–)
Being, 1952–56, stone
 Trier, fig.126 (b/w)

ANTIN, Eleanor (American, 1935–)
Lighthouse Tenders (from Library
 Science), 1971
 6 Yrs, p.230 (b/w)
100 Boots on the Way to Church,
 Solana Beach, Calif., Feb.9,
 1971, 11:30 a.m., mailing
 date: April 5, 1971
 6 Yrs, p.223 (b/w)

ANTONAKOS, Stephen (American,
 1926–)
Hanging Neon, 1965
 Popper 2, p.198 (b/w)
Orange Vertical Floor Neon,
 1966, neon lights and metal,
 UNNFis
 Hunter, pl.921 (b/w)

ANUSKIEWICZ, Richard (American,
 1930–)
Complementary Fission, 1963,
 liquitex on wood UNNLis
 New Art, pl.26 (b/w)
Coruscate, 1965, liquitex,
 UNNLad
 Hunter, pl.713 (b/w) ·
Division of Intensity, 1964,
 liquitex on canvas UNNJ
 Barrett, p.138 (b/w)
 L-S, pl.142 (b/w)
 Pellegrini, p.152 (b/w)
Entrance to Green, 1970, a/c,
 UNNJa
 Hunter, pl.736 (col)
Hand Painted Pony Coat, 1965
 UK2, pl.345 (b/w)
Heat, 1968, a/c
 Abstract, pl.221 (b/w)
Inflexion, 1967, liquitex on
 canvas UNNJa
 Arnason, fig.1101 (b/w)
Iridescence, 1965, a/c UNBuA
 A-K, p.319 (col)
Knowledge and Disappearance,
 1961, o/c UNNBene
 Janis, p.311 (b/w)
Sol I, 1965, a/c UDCHi
 Hh, pl.986 (col)

12 Quadrate, 1968
 UK2, pl.306 (b/w)
Union of the Four, 1963 UCtNhH
 Barrett, p.137 (b/w)

ANZO (Jose Iranzo) (Spanish)
 Aislamiento-12, 1967
 UK2, pl.235 (b/w)
 Aislamiento-29, 1968
 UK2, pl.250 (b/w)
 Isolation, 1970, aluminum photo-
 engraving
 Dyckes, p.129 (b/w)

APOLLONIO, Marina (Italian, 1940-
)
 Aspazi (Non-Spaces), 1968-71,
 environment
 Popper, p.94 (b/w)
 Dinamica circolare 5cn, 1965
 UK2, pl.293 (b/w)
 Dinamica circolare 5cp, 1965
 UK2, pl.292 (b/w)
 Dynamic Circular 6S, 1966, Coll.
 Artist
 Barrett, p.17 (b/w)

APPEL, Karel (Dutch, 1921-)
 Angry Landscape, 1967, o/c UNNJ
 Arnason, col.pl.224
 Beach Life, 1958, o/c UDCHi
 Hh, pl.674 (b/w)
 Big Animal Devour Little Animal,
 1959, o/c SwZL
 Seuphor, no.489 (col)
 Blue Nude, 1957, o/c BBDo
 Selz, p.22 (b/w)
 Bright Sunshine, 1960 FPBet
 Ponente, p.159 (col)
 The Condemned, 1953, o/c NEA
 Selz, p.19 (b/w)
 Count Basie, 1957, o/c UAzPhA
 Selz, p.20 (b/w)
 Couple of Lovers, 1953 GCoAA
 Pellegrini, p.105 (col)
 Femme nue, 1962, o/c
 Metro, p.22 (b/w)
 Flight, 1954, oil UNBuA
 A-K, p.227 (col)
 Heads in the Tempest, 1958, o/c,
 SwThP
 Seuphor, no.485 (col)
 Hiroshima Child, 1958, o/c, Coll.
 Artist
 Fig.Art, pl.81 (col)

Oil, 1962 IRMe
 Pellegrini, p.58 (b/w)
Person in Grey, 1953, o/c NEA
 Selz, p.17 (b/w)
Portrait of Sandburg, 1956, o/c
 Selz, p.21 (col) UMBI
 Arnason, fig.944 (b/w) UMBA
Red Nude, 1960, oil, Priv.Coll.
 Haftmann, pl.917 (b/w)
Un Roi couronne, 1962, o/c
 Metro, p.23 (b/w)
Two Times, 1974, o/c -Rot
 Arnason 2, fig.991 (b/w)
Woman with Head, 1964, o/c,
 Coll.Artist
 New Art, col.pl.72
Women and Birds, 1958, o/c,
 Priv.Coll.
 L-S, pl.61 (col)
Zwei Kopfe, 1955, o/c
 1945, pl.86 (col)

APPLE, Billy (Barrie Bates) (New
 Zealandic, 1935-)
 2 Minutes, 3.3 Seconds, 1962,
 painted bronze UNNBia
 Lippard, pl.52 (b/w)

ARAEEN, Rasheed
 Canalevent, London, 1970
 Popper, p.190 (b/w)

ARAKAWA, Shusaku (Japanese, 1936-
)
 Card into Feather, Eternal Ma-
 gic, 1964, o/c UNNRoJ
 Lieberman, p.100 (b/w)
 The Communicating Vases, 1965,
 o/c with plastic assemblage,
 UCLD
 Lieberman, p.101 (b/w)
 Confusion, 1968, o/c IMSc
 Fig.Art, pl.332 (b/w)
 Critical Mistake: Do You Like
 This Painting?, 1969, o/c,
 Coll.Artist
 Hunter, pl.778 (b/w)
 Detail of..., 1969, o/c
 Calas, p.145 (b/w)
 Detail of..., 1969, o/c
 Calas, p.147 (b/w)
 The Error, 1968-69, o/c
 Calas, p.145 (b/w)
 Light Shines Through the Net
 Making Half an Umbrella,
 1964
 UK2, pl.198 (b/w)

A Narrow Chimney on a Flight of
 Stairs without Stairs, 1964,
 oil, pen and ink, collage,
 UCLD
 New Art, col.pl.90
Still Life, 1967
 UK2, pl.372 (b/w)
10 Reassembling, 1968-69, oil,
 pencil, magic marker on can-
 vas, Coll.Artist
 Walker, pl.38 (col)
Untitled, 1963, watercolor and
 gouache GDuG
 Kahmen, pl.347 (b/w)
Webster's Dictionary, Page 1,
 1965, pencil and ink on can-
 vas UNNDw
 Russell, pl.86 (b/w)

ARCAY, Wifredo (Cuban, 1925-)
 Luza, 1957
 Seuphor, no.423 (b/w)

ARCHITECTURE MACHINE GROUP
 Seek, 1970, environment with
 gerbils
 Henri, fig.57 (b/w)

ARDON, Mordecai (Polish-Israeli,
 1896-)
 In the Negev, 1962, o/c IsTK
 New Art, pl.230 (b/w)
 The Negev Desert, 1953, o/c NAS
 Fig.Art, pl.27 (b/w)
 Suares, 1956, oil NAS
 Haftmann, pl.955 (b/w)

ARICO, Rodolfo (Italian, 1930-)
 Qui e ora, 1962, o/c
 New Art, pl.128 (b/w)

ARIKHA, Avigdor (Rumanian, 1929-
)
 The Loggia Balcony, 1975, o/c,
 UNNMa
 Arnason 2, fig.1001 (b/w)
 Painting, 1961 FPFl
 Seuphor, no.318 (col)

ARMAJANI, Siah (Iranian-American,
 1939-)
 2,972,453 Project, 1970
 6 Yrs, p.204 (b/w)

ARMAN, Fernandez (French, 1928-)
 Accumulation IVL
 Pellegrini, p.254 (b/w)
 Accumulation, 1963, buttons on
 wood GDuG
 Kahmen, pl.309 (b/w)
 Accumulation. Bad Luck to the
 Bearded, 1960 FPK
 Fig.Art, pl.253 (b/w)
 Aeole's Prison, 1963
 UK1, pl.161 (b/w)
 Allure de Violon, 1962 NAS
 Fig.Art, pl.251 (b/w)
 Ampoules, 1962, assemblage,
 GKrefW
 Compton 2, fig.170 (b/w)
 Anger-Broken Table, 1961, as-
 semblage FPC
 Wilson, pl.54 (col)
 Anger. Spoilt Click Clack, 1963,
 GDuSc
 Fig.Art, pl.252 (b/w)
 Arteriosclerosis, 1961, forks
 and spoons in glass-covered
 box IMSc
 Seitz, p.84 (b/w)
 Chopin's Waterloo, 1962, de-
 stroyed piano
 Metro, p.25 (col)
 Clic-Clac Rate, 1960-66, accum-
 ulation of photographic ap-
 paratus IMSc
 L-S, pl.93 (b/w)
 The Colour of My Love (La cou-
 leur de mon amour), 1966,
 polyester UNNJa
 Kahmen, pl.210 (b/w)
 UK1, pl.18 (b/w)
 Arnason, fig.1065 (b/w)
 Glug-glug, 1961, accumulation
 of bottle caps IMSc
 Lippard, pl.164 (b/w)
 La jeune fille pauvre, 1962
 UK1, pl.23 (b/w)
 Little Hands (Ainsi font, font
 ...), 1960, dolls' hands
 glued in wooden drawer UNGS
 Seitz, p.127 (b/w)
 Manifestations of Garbage, Iris
 Clert Gallery, Paris, 1960
 Janis, p.279 (b/w)
 97/150
 Pellegrini, p.255 (b/w)
 "Ouf!", 1961, Coll.Artist
 Metro, p.24 (b/w)

Quintette a cordes, 1963, paint-
ing and collage on wood BBD
New Art, col.pl.31
A Rumble of Ramblers, 1964, ac-
cumulation of toy cars UIWMa
Janis, p.302 (b/w)
To Hell with Paganini, 1966,
burned violin in polyester,
UDCHi
Hh, pl.855 (b/w)
Voyage en France, 1963, metal
wine bottle sealers in poly-
ester UDCHi
Hh, pl.983 (col)

ARMANDO (Dutch, 1929-)
Composition with 24 Bolts, 1962,
panel with bolts, Coll.Artist
New Art, pl.158 (b/w)

ARMITAGE, Kenneth (British, 1916-
)
The Bed, 1965, fiberglass and
polyester resin, Coll.Artist
Arnason, fig.1003 (b/w)
Both Arms, 1974, bronze ELyR
Arnason 2, fig.1064 (b/w)
Diarchy, 1957, bronze UIWM
Selz, p.25 (b/w)
Trier, fig.53 (b/w)
Family Going for a Walk, 1951,
bronze UNNMMA
G-W, p.211 (b/w)
Figure Lying on its Side (ver-
sion 5), 1958-59, bronze,
ELBrC
L-S, pl.170 (b/w)
Model for Krefeld Monument,
1956, bronze UNNRoss
Selz, p.24 (b/w)
Model for Large Seated Group,
1957, bronze UNNHe
Selz, p.24 (b/w)
Monitor, 1961, bronze
Metro, p.27 (b/w)
Pandarus V, 1963, bronze
New Art, pl.98 (b/w)
Roly-Poly, 1955
UK1, pl.73 (b/w)
The Seasons, 1956, bronze UNNZ
Selz, p.26 (b/w)
Seated Woman with Arms Raised,
1953-57, bronze UNBuA
Selz, p.26 (b/w)
Sibyl II, 1961, bronze
Metro, p.26 (b/w)

Standing Group 2 (Large Ver-
sion), 1952-54, bronze UNNScha
G-W, p.210 (b/w)
Triarchy, 1958-59, bronze GBOp
Fig.Art, pl.44 (b/w)

ARNAL, Francois (French, 1924-)
The Blue Boy, 1954
Pellegrini, p.66 (b/w)
Bombardment of Objects Attract-
ed by the Cold FPSch
Pellegrini, p.288 (b/w)
Suggestion Nr.3: En regardant
Velazquez (F), 1963, o/c,
Priv.Coll., Paris
New Art, col.pl.23
Suggestions, 1963, o/c FPSch
Fig.Art, pl.273 (b/w)

ARNATT, Keith (British, 1930-)
Earth Plug, 1967, photographic
print, Coll.Artist
Eng.Art, p.351 (col)
Hot Pipe, 1968, photographic
print, Coll.Artist
Eng.Art, p.351 (col)
I'm a Real Artist
L-S, pl.243 (b/w)
An Institutional Fact-16 Secur-
ity Attendants, Hayward Gal-
lery, 1972
Eng.Art, p.322 (b/w)
Invisible Hole, 1968
Eng.Art, p.322 (b/w)
Liverpool Beach-Burial, 1968,
photographic print, Coll.
Artist
Eng.Art, p.350 (b/w)
6 Yrs, p.50 (b/w)
Self-Burial, 1969
UK4, pl.147 (b/w)
Visitors, 1975, photographic
print, Coll.Artist
Eng.Art, p.349 (b/w)

ARNESON, Robert (American, 1930-
)
Typewriter, 1965, ceramic UCBC
Andersen, p.168 (b/w)

ARNOLD, Anne (American, 1925-)
Charlie, 1969, acrylic over
wood
Busch, pl.X (col)
He and She (#27), 1969, acrylic
over wood
Busch, fig.46 (b/w)

La Maja de Torrejou, 1964, o/c
Fig.Art, pl.274 (b/w)
Neuf lendemains de Waterloo
(Nine Tomorrows from Waterloo),
1965 FPSch
Arnason, fig.951 (b/w)
Pellegrini, p.204 (b/w)
Velazquez, mon pere (vingt-cinq
annees de paix), 1964, o/c,
SwZMe
New Art, pl.63 (b/w)

ART AND LANGUAGE (see also names
of individual group members)
Histories, 1973-75
Eng.Art, pp.358-59 (col)
Map Not to Indicate..., 1967
Eng.Art, p.320 (b/w)
Poster Statement from the Ser-
ies "Them and Us", 1973,
poster GCoM
Walker, pl.63 (col)
'Surf' Work, 1974
Eng.Art, p.320 (b/w)

ARTSCHWAGER, Richard (American,
1924-)
Blp, New York City, 1969
6 Yrs, p.96 (b/w)
Diptych II, 1968, acrylic on
celotex in formica box
Battcock, p.240 (b/w)
Executive Table and Chair, 1964,
formica on wood
Alloway, fig.22 (b/w), Coll.
Artist
Lippard, pl.122 (b/w)
Russell, pl.15 (b/w)
Hydraulic Doorcheck, 1968
6 Yrs, p.32 (b/w)
Polish Rider IV, 1971, acrylic
on board
Battcock, p.241 (b/w)
Portrait I, 1962, mixed media,
GHN
Alloway, fig.18 (b/w)
Portrait II, 1964, formica on
wood, Coll.Artist
Alloway, fig.21 (b/w)
Ranch Style, 1964, liquitex on
canvas
Battcock, p.23 (b/w)
Untitled, 1966, formica on wood,
UNNC
Abstract, pl.256 (b/w)

ASHER, Michael (American, 1943-)
Environmental Project, Pomona
College, Feb.1970
6 Yrs, p.198 (b/w)

ASIS, Antonio
Spiral, 1966, metal FPRe
Barrett, p.109 (b/w)
Spirals en vibration, 1966
Popper 2, p.113 (b/w)

ASKEVOLD, David (American, 1940-
)
2,972,453 Project, 1970
6 Yrs, pp.204-05 (b/w)

ASSETTO, Franco (Italian, 1911-)
Presence on the White, 1961,
o/c, Coll.Artist
Seuphor, no.348 (col)

ATKINSON, Terry (British, 1939-)
Map, 1967 (in collaboration with
Michael Baldwin)
Meyer, p.8 (b/w)

ATLAN, Jean (Algerian, 1913-1960)
Oil, 1945
Pellegrini, p.41 (b/w)
Painting, 1951, pastel, chalk
and oil on Isorel FPRa
Abstract, pl.74 (b/w)
Urakan, 1957-58, o/c FPA
Seuphor, no.165 (col)

ATTERSEE, Christian Ludwig
Schonling mit Griff, 1968
UK2, pl.395 (b/w)

AUBERJONAIS, Rene (Swiss, 1872-
1957)
French Painters (Les peintres
francais), 1941, oil SwBBe
Haftmann, pl.470 (b/w)

AUBERTIN, Bernard
Book, Burnt or to Be Burnt,
1968
Popper, p.190 (b/w)
Disque de feu tournant, 1961
UK2, col.pl.XXX
Tableau-feu, 1961
UK1, pl.307 (b/w)
Tableu-feu, 1965
UK1, pl.306 (b/w)

AUERBACH, Frank (British, 1931-)
Head of E.O.W., 1955, oil on
 cardboard -UOF
 1945, pl.136 (b/w)
Head of E.O.W. IV, 1961, oil on
 board ELStu
 Stuyvesant, p.109 (b/w)
Head of Helen Gillespie III,
 1962-64, oil on board ELMa
 L-S., pl.38 (b/w)
Primrose Hill, Autumn, 1963-64,
 oil on board ELStu
 Stuyvesant, p.110 (b/w)
Sitting Model in the Studio II,
 1961
 Eng.Art, p.15 (b/w)

AVEDISIAN, Edward (American, 1936-
)
At Seven Brothers, 1964, liquitex
 on canvas ELK
 L-S, pl.86 (b/w)
Touch, 1971, a/c
 Rose, p.231 (b/w)
Untitled, 1965 UNNEl
 Pellegrini, p.147 (b/w)

AVERY, Milton (American, 1893-
1964)
Gaspe-Pink Sky, 1940, o/c,
 UNNGell
 Geldzahler, p.119 (b/w)
Morning Call, 1946, o/c UDCHi
 Hh, pl.537 (b/w)
Mother and Child, 1944, o/c,
 UMProK
 Geldzahler, p.119 (b/w)
 Rose, p.113 (col)
Russian Woman, c.1940, o/c,
 UDCHi
 Hh, pl.422 (b/w)
Sail, 1958, o/c UNNB
 Geldzahler, p.120 (b/w)
Sandbar and Boats, 1957, o/c,
 UDCHi
 Hh, pl.736 (col)
Sea Gulls-Gaspe, 1938, o/c UMAP
 Sandler, p.24 (b/w)
The Seine, 1953, oil UNNW
 Whitney, p.65 (b/w)
Speedboat's Wake, 1959, o/c CTM
 Geldzahler, p.66 (col)
Sunset Sea, 1958, o/c CTM
 Geldzahler, p.120 (b/w)
Swimmers and Sunbathers, 1945,
 o/c UNNMM

Hunter, pl.297 (col)
 Arnason, col.pl.198
Three Friends, 1944, o/c UNNNe
 Hunter, pl.312 (b/w)
White Sea, 1947, o/c UNNBra
 Sandler, p.152 (b/w)

AVRAMIDIS, Joannis (Russian-
Austrian, 1922-)
Group of Figures, 1959, bronze
 Trier, fig.45 (b/w)
Head, 1959, synthetic resin on
 aluminum structure
 Trier, fig.92 (b/w)
Sketches for Sculptures (dating
 from 1957), 1965, pencil GDuG
 Kahmen, pl.202 (b/w)

AYCOCK, Alice (American, 1946-)
Cloud Piece, 1971
 6 Yrs, p.253 (b/w)

AY-O (Japanese, 1931-)
Hydra, 1962, environmental
 sculpture
 Kaprow, nos.31-32 (b/w)
Put Finger in Hole, 1968
 UK4, pl.77 (b/w)
Rainbow Room, 1964, environment
 Henri, fig.50 (col)

AYRES, Gillian (British, 1930-)
Damask, 1967, a/c ELStu
 Stuyvesant, p.98 (b/w)
Pirhana, 1964, o/c ELStu
 Stuyvesant, p.99 (b/w)
Untitled Painting, 1964, o/c
 New Art, pl. 80 (b/w)

AZUMA, Kengiro (Japanese, 1926-)
MU S-56, 1962, bronze IMTon
 Lieberman, p.68 (b/w)
MU S-116, 1963, bronze IMTon
 Lieberman, p.69 (b/w)

BACON, Francis (British, 1904-)
Double Portrait of Lucien Freud
 and Frank Auerbach, 1964
 Pellegrini, p.285 (col)
Figure in a Landscape, 1946 ELT
 Pellegrini, p.198 (b/w)
Fragment of a Crucifixion, 1950,
 o/c -Gr
 1945, pl.128 (b/w)
Head of a Man-Study of Drawing
 by Van Gogh, 1959, o/c UCLCo
 Arnason, fig.936 (b/w)

Head Surrounded by Sides of
 Beef (Study After Velazquez),
 1954, o/c UICA
 Arnason, col.pl.223
Man in a Blue Box, 1949, o/c,
 UIOS
 Selz, p.31 (b/w)
Man on Black Couch, 1961
 Metro, p.31 (b/w)
Man with Dog, 1953, o/c UNBuA
 A-K, p.150 (col)
Nude, 1960, oil and tempera on
 canvas GDaS
 Kahmen, pl.113 (b/w)
Painting (The Butcher), 1946,
 oil and tempera UNNMMA
 Haftmann, pl.949 (b/w)
Red Pope on Dais, 1962, o/c
 Metro, p.30 (b/w)
Seated Figure, 1974, oil and
 pastel on canvas, Priv.Coll.
 Arnason 2, col.pl.230
Self-Portrait, 1964 ELStu
 Pellegrini, p.197 (b/w)
Self-Portrait, 1964
 UK2, pl.65 (b/w)
Study After Velazquez: Pope In-
 nocent X, 1953, o/c UNNBurd
 Selz, p.30 (b/w)
 L-S, p.41 (col)
 UK2, pl.2 (b/w)
Study for a Crucifixion (Magda-
 lena), 1945, oil EBatB
 Haftmann, pl.948 (b/w)
 Arnason, fig.934 (b/w)
Study for a Portrait, 1958, o/c,
 Priv.Coll., Brussels
 Fig.Art, pl.99 (b/w)
Study for a Portrait of van
 Gogh, No.1, 1956, o/c ELS
 Selz, p.32 (b/w)
Study for a Portrait of van
 Gogh, No.3, 1957, o/c UDCHi
 Selz, p.33 (col)
 Hh, pl.751 (col)
Study for Corrida No.2, 1969,
 o/c UNNA
 Fig.Art, pl.101 (col)
Study for Crouching Nude, 1952,
 o/c UMiD
 Hamilton, pl.340 (b/w)
Study for Portrait V, 1953, o/c,
 UDCHi
 Hh, pl.632 (b/w)
Study for Self-Portrait, 1964,
 o/c

New Art, col.pl.48 ELMa
 Stuyvesant, p.48 (col) ELStu
Study of a Figure in a Land-
 scape, 1952, o/c UDCP
 Selz, p.28 (b/w)
Three Studies for a Crucifixion,
 1962, o/c
 L-S, pl.45 (col) ELMa
 Arnason, figs.937-39 (b/w),
 UNNG
Triptych, 1967, oil and pastel
 on canvas UDCHi
 Hh, pl.1007 (col)
Two Figures (based on a photo-
 graph by Muybridge of two
 wrestlers), 1953, o/c
 Kahmen, pl.114 (b/w)
Two Figures in a Room 1958, o/c,
 ELS
 Fig.Art, pl.100 (b/w)

BAEDER, John (American, 1938-)
 10th Ave. Diner, 1973, o/c -H
 Battcock, p.242 (b/w)

BAER, Jo (American, 1939-)
 Tiered Horizontal, 1968, oil
 with lucite on canvas
 Calas, p.204 (b/w)
 Tiered Horizontals, Aluminum
 (Diptych), 1968-69, oil with
 lucite and aluminum on canvas,
 Coll.Artist
 Hunter, pl.772 (b/w)
 V. Speculum, 1970, Coll.Artist
 Rose, p.211 (b/w)
 Vertical Flanking: Small (Blue),
 1966-67, o/c
 Abstract, pl.244 (b/w)

BAERTLING, Olle (Swedish, 1911-)
 Ardian, 1963, o/c UNNG
 Arnason, fig.984 (b/w)
 Composition, 1955 FPRe
 Abstract, pl.176 (b/w)
 Kortar, 1960
 Pellegrini, p.191 (b/w)
 Ogri (plate from the album "Tri-
 angles"), 1961
 Popper 2, pl. 70 (col)
 Ogu, 1960, o/c FPRe
 Seuphor, no.395 (col)
 Sehu, 1960, o/c
 Seuphor, no.396 (col)
 XYH, 1967, steel UDCHi
 Hh, pl.944 (b/w)

BAIER, Jean (Swiss, 1932-)
 Composition, 1960, o/c, Coll.
 Artist
 Seuphor, no.394 (col)
 Komposition, 1965, cellulose
 painting, Coll.Artist
 New Art, pl.305 (b/w)

BAILEY, Clayton (American, 1939-
)
 Rubber Grub, 1966, mixed media,
 UCPoW
 Henri, fig.135 (b/w)

BAILEY, William (American, 1930-
)
 Egg Cup and Eggs, 1970, o/c,
 UNNScho
 UK3, pl.76 (b/w)
 Eggs, 1966
 UK2, pl.186 (b/w)
 French Room, 1967, p/c, Priv.
 Coll., United States
 Kahmen, pl.111 (b/w)
 Italian, 1966-68, o/c UNNScho
 Kahmen, pl.112 (b/w)
 Nude, 1967
 UK2, pl.27 (b/w)
 Seated Nude, 1967
 UK2, pl.26 (b/w)

BAINBRIDGE, David (British, 1941-
)
 Loop, 1967 (in collaboration
 with Harold Hurrell)
 Meyer, p.26 (b/w)

BAIZERMAN, Saul (American, 1889-
 1957)
 Esperance, 1953-56, hammered
 copper UDCHi
 Hh, pl.540 (b/w)
 The Miner, 1939-45, hammered
 copper UDCHi
 Hh, pl.459 (b/w)
 Mother and Child, 1931-39, cop-
 per UNNH
 Hunter, pl.497 (b/w)
 Nereid, 1955-57, hammered copper,
 UDCHi
 Hh, pl.586 (b/w)
 Nike, 1949-52, hammered copper,
 UMnMW
 Arnason, fig.701 (b/w)
 Old Courtesan, 1947-52, copper,
 UNNG
 Arnason, fig. 702 (b/w)

Slumber, 1948, hammered copper,
 UNNW
 Whitney, p.106 (b/w)

BAJ, Enrico (Italian, 1924-)
 L'abbe d'Olivet, 1966
 UK2, pl.119 (b/w)
 Adam and Eve, 1964, collage and
 oil on canvas IMSc
 Lippard, pl.177 (b/w)
 UK2, pl.40 (b/w)
 La belle Alice, collage
 Janis, p.230 (b/w)
 Count Joseph Tyszkiewicz, Gener-
 al of the Lanciers, 1961 IMSc
 Pellegrini, p.282 (b/w)
 General Inciting to Battle,
 1961, collage IMSc
 Fig.Art, pl.169 (b/w)
 Generale, 1961, collage IMSc
 New Art, pl.127 (b/w)
 Grande tavola, 1961, mixed med-
 ia IMS
 Metro, p.33 (col)
 Lady Fabricia Trolopp, 1964,
 collage IMSc
 L-S, pl.95 (b/w)
 Mirror, 1959, broken mirror
 glass on brocade fabric IMSc
 Seitz, p.113 (b/w)
 Parade, 1962, mixed media IMSc
 Metro, p.32 (b/w)
 Parade of Six, 1964 IMSc
 Pellegrini, p.282 (b/w)
 Reclining Nude (Nu couche),
 1960, collage and oil-based
 chalk on canvas GCoOp
 Kahmen, pl.100 (b/w)
 Shouting General, 1960, o/c with
 brocade, hemp, clock dials,
 etc. IMSc
 Seitz, p.104 (b/w)
 Ultracorpo in Svizzera, 1959
 UK2, pl.224 (b/w)

BAKATY, Mike (American, 1936-)
 Untitled, 1969, polyester im-
 pregnated muslin reinforced
 with fiberglass
 Busch, fig.56 (b/w)
 Untitled #00000, 1960s, plywood,
 polyester resin, vinyl and
 hardware
 Busch, fig.20 (b/w)

BAKER, George (American, 1931-)
 Dome-632, 1963, polished bronze,
 UNNW
 Ashton, pl.XXIX (b/w)
 Spiral, 1966
 UK1, pl.180 (b/w)
 Watcher, 1965
 UK1, pl.179 (b/w)

BAKIC, Vojin (Yugoslavian, 1915-
)
 Developed Form, 1958, plaster
 for bronze FPRe
 Trier, fig.124 (b/w)
 Head, 1956, marble, Coll.Artist
 G-W, p.281 (b/w)
 Leaf Form No.1 (Razlistana
 Forma I), 1958-59, plaster
 G-W, p.247 (b/w)
 Reflecting Forms 5, 1963 YZZS
 New Art, pl.266 (b/w)
 UK1, pl.258 (b/w)
 Superficie sviluppata XXIV, 1962
 Metro, p.34 (b/w)
 Superficie sviluppata XXXII,
 1962, bas relief
 Metro, p.35 (b/w)

BALADI, Roland
 Ephemeral Graffiti Wall, Sigma
 1971, Bordeaux
 Popper, p.218 (b/w)
 Snow, project for the Arc de
 Triomphe, Paris
 Popper, p.215 (b/w)

BALCAR, Jiri (Czechoslovakian,
 1929-)
 The Party, 1968, etching
 Fig.Art, pl.301 (b/w)

BALDACCINI, Cesar. See CESAR

BALDESSARI, John (American, 1931-
)
 The Best Way to Do Art
 6 Yrs, p.254 (b/w)
 Cremation Piece, June 1969
 Meyer, p.32 (b/w)
 Everything is Purged..., 1966-
 67
 6 Yrs, p.58 (b/w)
 Quality Material, 1967, oil and
 acrylic on canvas UNNFei
 Russell, pl.53 (b/w)

A Work with Only One Property,
 1966-67, a/c
 Meyer, p.33 (b/w)

BALDESSARI, Luciano (Italian,
 1896-)
 Architectural Construction for
 the Entrance to the Breda
 Works Exhibition, Milan In-
 dustrial Fair, 1952, concrete
 G-W, p.239 (b/w)

BALDWIN, Michael (British, 1945-
)
 Map, 1967 (in collaboration
 with Terry Atkinson)
 Meyer, p.8 (b/w)

BALLOCCO, Mario (Italian, 1913-)
 The Scale of Greys, 1960, o/c,
 Priv.Coll.
 Abstract, pl.207 (b/w)

BALLY, Theodore (German, 1896-)
 Composition No.1115, 1961, o/c,
 Coll.Artist
 Seuphor, no.418 (col)

BALTHUS (Balthasar Klossowski de
 Rola) (Polish-French, 1908-)
 The Bedroom, 1954, o/c, Priv.
 Coll.
 L-S, pl.44 (col)
 L'enfant aux pigeons, 1959-60,
 o/c
 Metro, p.37 (b/w)
 Figure in Front of Mantel,
 1959, oil
 Metro, p.36 (b/w)
 The Living Room, 1942, o/c,
 UNNWhit
 Arnason, fig.601 (b/w)
 Young Girl with Raised Arms,
 1951, Priv.Coll.
 Fig.Art, pl.20 (b/w)

BANNARD, Walter Darby (American,
 1931-)
 Allure-Allure, 1961, o/c, Coll.
 Artist
 Goossen, p.35 (b/w)
 Driving Through No.5, 1968, o/c,
 Priv.Coll., Boston
 Hunter, pl.744 (col)
 Green Grip I, 1965, alkyd resin
 on canvas
 Rose, p.210 (b/w)

1600 kc. Carrier Wave (AM),
1968, 1600 kilocycles, 60 mil-
liwatts, 110 volts AC/DC
Celant, p.117 (b/w)
0,5 Microcurie Radiation In-
stallation, Jan.1969, uranium
-238, 4.5 x 100 years dura-
tion
Celant, p.118 (b/w)

BART, Robert (American, 1923-)
Untitled 1965, aluminum alloy,
UNNW
Ashton, pl.LXII (b/w)

BARTHELME, Frederick (American,
1943-)
Instead of Making Art I..., 1970
Meyer, pp.42-43 (b/w)
6 Yrs, p.144 (b/w)

BARUCHELLO, Gianfranco (Italian,
1924-)
The Famous Armistice-Day Between
Variants and Constants, 1965,
IMSc
Pellegrini, p.289 (b/w)
Only Death, Sir, 1967, mixed
media on aluminum IMSc
Arnason, fig.1071 (b/w)
To All: Be Happy Staying Behind,
1967, mixed media on aluminum,
IMSc
Abstract, pl.137 (b/w)
Unavoidable Difficulties in the
Garden of Eden, 1964, paint on
plexiglass UDCHi
Hh, pl.873 (b/w)

BASALDELLA, Afro. See AFRO

BASALDELLA, Mirko. See MIRKO

BASCHET, Francois and Bernard
Amiens Monument, 1966, musical
sculpture
Busch, fig.123 (b/w)
French Monument Born on 57th
Street, 1965-66, steel and
aluminum, Coll.Artist
Janis, pp.292-93 (b/w)
Hemisfair Fountain, 1968, stain-
less steel
Busch, fig.122 (b/w)

BASCHLAKOW, Alexej Jljitsch
(Russian, 1936-)
Rikon I, 1964, oil on disc,
GHaB
New Art, pl.309 (b/w)

BASELITZ, Georg (German, 1937-)
Aus der Traum, 1964, o/c GBWer
New Art, pl.320 (b/w)

BASKIN, Leonard (American, 1922-
)
Francisco de Goya, 1963-64,
etching UMBMi
Castleman, p.101 (col)
The Great Dead Man, 1956, lime-
stone, Coll.Artist
Selz, p.37 (b/w)
The Guardian, 1956, limestone,
UDCHi
Hh, pl.663 (b/w)
Hephaestus, 1963, cast 1965,
bronze UDCHi
Hh, pl.909 (b/w)
Man of Peace, 1952, woodcut,
UNNMMA
Castleman, p.99 (col)
Man with a Dead Bird, 1954,
walnut UNNMMA
Selz, p.34 (b/w)
Nightmare, 1964, ink UNNB
Fig.Art, pl.83 (b/w)
Oppressed Man, 1960, painted
pine UNNW
Whitney, p.116 (b/w)
Owl, 1959, pine UNNKap
Ashton, fig.17 (b/w)
Owl, 1960, bronze UNNH
Hunter, pl.500 (b/w)
Poet Laureate, 1956, bronze,
UNNNe
Selz, p.36 (b/w)
Seated Man, 1956, bronze UNNHel
Selz, p.38 (b/w)
Walking Man, 1955, oak UMSpB
Selz, p.38 (b/w)

BAT-YOSEF, Myriam (German, 1931-
)
Le Telephone des sourds, 1964,
painted object
New Art, pl.65 (b/w)

BATES, Barrie. See APPLE, Billy

BATTAGLIA, Carlo (Italian, 1933–
)
 Libra, 1969, oil and tempera on
 canvas UDCHi
 Hh, pl.1017 (col)

BATTCOCK, Gregory (American, 1941–
)
 Art I Am Not Nor Have I Ever
 Been Gregory Battcock
 Meyer, p.44 (b/w)

BAUERMEISTER, Mary (German-Ameri-
 can, 1934–)
 All Broken Up, 1965–67, mixed
 media, Priv.Coll., New York
 City
 Arnason, fig.1017 (b/w)
 Four Quarters, 1964–65, mixed
 media UNBuA
 A–K, p.285 (b/w)
 Neither-Or, 1966
 UK2, col.pl.XXXI
 Pst...Who Knows Wh..., 1966,
 mixed media UDCHi
 Hh, pl.792 (b/w)

BAUMEISTER, Willi (German, 1889–
 1955)
 African Picture, 1942, o/c,
 Priv.Coll., Paris
 Seuphor, no.215 (col)
 Am Orontes, 1954
 Pellegrini, p.42 (b/w)
 Aru, 1954, o/c –Bau
 Seuphor, no.261 (col)
 Aru VIII, 1955, oil GStB
 Haftmann, pl.799 (b/w)
 Drumbeat, 1942, oil on card-
 board GStBa
 Arnason, col.pl.138
 Eidos V, oil and tempera GMB
 Haftmann, pl.797 (b/w)
 Euphor I, 1955, oil on card-
 board, Priv.Coll.
 New Art, col.pl.113
 Figures with Black Oval, 1935,
 oil on board, Coll.Artist's
 Family
 Haftmann, pl.796 (b/w)
 Growing, 1952, oil on masonite,
 UNBuA
 A–K, p.247 (b/w)
 Homage to Jerome Bosch, 1953,
 oil on composition board,
 GStBa
 Arnason, fig.511 (b/w)

Monturi, White disc 1B, oil and
 sand on hardboard GStB
 Haftmann, pl.798 (b/w)
 Safer, 1953 GStB
 Ponente, p.74 (col)
 Zwei Laternen, 1955, o/c
 1945, pl.75 (col)

BAUMGARTL, Monika
 Primary Demonstration, 1971
 (in collaboration with Klaus
 Rinke)
 6 Yrs, p.238 (b/w)

BAXTER, Iain and Ingrid (N. E.
 Thing Co.) (British)
 Act #83: Carl Andre's Unmodi-
 fied Rock Pile in Colorado
 and Shape of Rock in Flight
 (note arrow), 1968
 Meyer, p.193 (b/w)
 Act #113: Xerox Telecopier II
 and whole concept of trans-
 ceiving, 1969
 Meyer, p.194 (b/w)
 North American Time Zone Photo-
 V.S.I. Simultaneity, Oct.18,
 1970
 6 Yrs, p.197 (b/w)
 Paint into Earth, 1969
 Meyer, p.195 (b/w)
 A Portfolio of Piles, 1968
 6 Yrs, p.36 (b/w)
 Right 90 Degree Parallel Turn,
 Mt. Seymour, B.C., Canada,
 1968, ecological project
 6 Yrs, p.65 (b/w)

BAXTER, John (American, 1912–)
 Instruments at the Silence Re-
 finery, 1960, driftwood,
 shells, stones, etc. UCSaC
 Seitz, p.141 (b/w)

BAYRLE, Thomas
 Objekt Mao, 1967
 UK2, pls.123–25 (b/w)
 Regenmantel, 1967
 UK2, pl.202 (b/w)

BAZAINE, Jean (French, 1904–)
 Child and the Night, 1949
 Ponente, p.35 (col)
 The Clearing (La clariere), 1951,
 oil SwBBe
 Haftmann, pl.823 (col)

The Diver, 1949, o/c, Priv.Coll.
 Abstract, pl.48 (b/w)
Low Tide, 1955 FPMa
 Ponente, p.36 (col)
Maree basse, 1955, o/c FPMa
 1945, pl.6 (col)
 Arnason, fig.963 (b/w)
Midi, Trees and Rocks (Midi,
 arbes et roches), 1952, oil,
 SwZZum
 Haftmann, pl.824 (b/w)
Moon and the Night Bird (Lune et
 l'oiseau de nuit), 1947, oil,
 FPCa
 Haftmann, pl.822 (b/w)
The Painter and His Model, 1944,
 oil FPCa
 Haftmann, pl.821 (b/w)
Saint-Guenole, 1959 FPMa
 Ponente, p.37 (col)
Saint-Guenole, 1960, o/c FPMa
 Seuphor, no.195 (col)
The Sea Port, 1948
 Pellegrini, p.18 (b/w)
Shadows on the Hill, 1961, o/c,
 FPMa
 L-S, pl.48 (b/w)
Traversee de l'aube, 1975, o/c,
 FPMa
 Arnason 2, col.pl.236
Winter Evening (Soir de niege),
 1959, oil FPMa
 Haftmann, pl.826 (b/w)

BAZELON, Cecile Gray
 Studio Two, 1970, o/c UNNScho
 UK3, pl.90 (b/w)

BAZIOTES, William (American, 1912-
 1963)
 Autumn Leaf, 1959, o/c UNNWeit
 Tuchman, p.64 (b/w)
 The Balcony, 1944, o/c UCSBL
 Sandler, p.75 (b/w)
 The Beach, 1955, oil UNNW
 Whitney, p.61 (col)
 The Butterflies of Leonardo da
 Vinci, 1942, duco enamel on
 canvas UNNMa
 Sandler, p.73 (b/w)
 Congo, 1954, o/c UCLCM
 L-S, pl.17 (b/w)
 Rose, p.140 (col)
 Tuchman, p.63 (col)
 Cyclops, 1947, o/c UICA
 Sandler, p.75 (b/w)

Dawn, 1962, o/c UNNMa
 Sandler, p.77 (b/w)
The Drugged Balloonist, 1943,
 collage of mixed materials,
 UMdBM
 Janis, p.160 (b/w)
Dusk, 1958, o/c UNNG
 Pellegrini, p.137 (b/w)
 Arnason, col.pl.207
Dwarf, 1947, o/c UNNMMA
 Sandler, pl.III (col)
 Hunter, pl.371 (b/w)
Figure in Orange, 1947, o/c,
 UCBeW
 Tuchman, p.59 (b/w)
The Flesh Eaters, 1952, o/c,
 UNNMa
 Sandler, p.76 (b/w)
 Abstract, pl.26 (b/w)
Green Night, 1957, o/c UDCHi
 Hh, pl.735 (col)
The Juggler, 1947, o/c UCBeG
 Tuchman, p.58 (b/w)
Morning, 1959 UNNKo
 Metro, p.43 (b/w)
Night Landscape, 1947, o/c,
 UMdBR
 Hunter, pl.415 (b/w)
The Parachutists, 1944, duco on
 canvas UNNMa
 Sandler, p.74 (b/w)
Pompeii, 1955, o/c UNNMMA
 1945, pl.162 (b/w)
 Haftmann, pl.958 (b/w)
Primeval Landscape, 1953, o/c,
 UPPFl
 Tuchman, p.62 (b/w)
The Sea (La mer), 1959 UNNGro
 Ponente, p.104 (col)
 Metro, p.42 (b/w)
Toy, 1949, o/c UNUtM
 Tuchman, p.60 (b/w)
Toys in the Sun, 1951, o/c,
 UCLCM
 Tuchman, p.61 (b/w)
Untitled, c.1938-40, watercolor,
 pencil, gouache on paper,
 UNNMa
 Sandler, p.73 (b/w)
Untitled, c.1942-43, watercolor,
 ink, pencil on paper UNNMa
 Sandler, p.39 (b/w)
Untitled, 1946, o/c UCLPo
 Tuchman, p.57 (b/w)
The Web, 1946, o/c UNNMa
 Sandler, p.66 (b/w)

White Bird, 1957, o/c UNBuA
 A-K, p.28 (col)

BEAL, Jack (American, 1931-)
 Danae (second version), 1972,
 o/c
 Battcock, p.243 (b/w)
 Madison Nude, 1967, o/c UNNFru
 UK3, pl.25 (b/w)
 Peace, 1970, o/c UNNFru
 UK3, pl.24 (b/w)
 Sofa with Sondra, 1968, o/c,
 UNNFru
 UK3, pl.26 (b/w)

BEAL, Sondra (American, 1936-)
 Brule Reach, 1965, painted wood
 Busch, pl.VIII (col)
 Quest, 1963, wood
 Busch, fig.34 (b/w)

BEARDEN, Romare (American, 1914-
)
 Eastern Barn, 1968, collage of
 glue, lacquer, oil, paper on
 composition board UNNW
 Whitney, p.77 (b/w)
 The Persistence of Ritual: Bap-
 tism, 1964, collage on compo-
 sition board UDCHi
 Hh, pl.799 (b/w)
 Saturday Morning, 1969, collage
 on board UNNCor
 Hunter, pl.344 (col)
 Watching the Good Train Go By:
 Cotton, 1964, collage on com-
 position board UDCHi
 Hh, pl.974 (col)

BEASLEY, Bruce (American, 1939-)
 Apolymon, 1969, cast lucite
 Busch, fig.2 (b/w)
 Tintinuvin, 1970, cast lucite
 Busch, fig.1 (b/w)

BEAUCHAMP, Robert (American, 1923-
)
 Yellow Bird, 1968, o/c UDCHi
 Hh, pl.996 (col)

BEAUDIN, Andre (French, 1895-)
 The Palaces, 1955, o/c FPLei
 Seuphor, no.516 (col)

BECHER, Bernhard and Hilla (Ger-
 man)
 Cooling Towers
 Meyer, p.48 (b/w)
 Cooling Towers, 1959-72, photo
 6 Yrs, p.135 (b/w)
 Cooling Towers, 1961-70
 Meyer, p.47 (b/w)
 Doppelwasserturm in Hagen 1898
 Foto, 1962
 UK2, pl.232 (b/w)
 Gasbehalter bei Manchester 1886
 Foto, 1966
 UK2, pl.231 (b/w)
 Houses (Fachwerkhauser), 1959-
 64
 Meyer, p.49
 Wasserturm, photograph GBaden
 Kahmen, pl.221 (b/w)
 Wasserturm, photograph GDu
 Kahmen, pl.223 (b/w)
 Wasserturm, photograph GCo
 Kahmen, pl.224 (b/w)
 Winderhitzer, photograph GObG
 Kahmen, pl.54 (b/w)

BECHTLE, Robert (American, 1932-
)
 Foster's Freeze, 1970, o/c,
 UNNHarr
 UK3, pl.30 (b/w)
 French Doors, 1965, oil -UIW
 UK3, pl.43 (b/w)
 Four Palm Trees, 1969, o/c,
 UNNHarr
 UK3, pl.143 (b/w)
 Hoover Man, 1966, oil UNNNo
 Battcock, p.116 (b/w)
 1971 Buick, 1972, o/c -Cau
 Battcock (col)
 '60 Chevies, 1971 o/c -FPR
 Battcock, p.25 (b/w)
 '61 Pontiac, 1968-69, o/c UNNW
 UK3, pl.46 (b/w)
 '67 Chrysler, 1967, o/c UCKH
 UK3, pl.116 (b/w)
 '60 T-Bird, 1967-68 UCBC
 UK3, pl.117 (b/w)
 Xmas in Gilroy, 1971, o/c -G
 Battcock, p.244 (b/w)

BECK, Gustav (Austrian, 1902-)
 Noon, 1961, o/c, Coll.Artist
 Seuphor, no.405 (col)

BECKLEY, Bill
Music Stand with Songs, 1972
Popper, p.157 (b/w)

BECKMAN, William
Diana II, 1973, oil on board
Battcock, p.233 (b/w)

BECKMANN, Max (German, 1884-1950)
Artist, 1944, oil GHaS
Haftmann, pl.681 (b/w)
Blindman's Bluff, 1945, o/c,
UMnMI
Arnason, fig.493 (b/w)
Circus Caravan, 1940, oil GFS
Haftmann, pl.682 (b/w)
City of Brass, 1944, oil GSaaS
Haftmann, pl.683 (b/w)
Four Men Round a Table, 1943,
oil UMoSLWa
Haftmann, pl.687 (b/w)
Hotel Lobby, 1950 o/c UNBuA
A-K, p.245 (col)
Odysseus and Calypso, 1943, oil,
GHK
Haftmann, pl.686 (b/w)
Fig.Art, pl.7 (b/w)
Perseus Triptych, 1941, oil GEF
Haftmann, pl.685 (b/w)
The Prodigal Son, 1949, oil GHaL
Haftmann, pl.684 (b/w)
Still Life with Musical Instru-
ments, 1950, o/c UDCHi
Hh, pl.725 (col)

BEERY, Eugene (American, 1937-)
Note...(Planning for the Endless
Aesthetic Visualization), 1969,
a/c
6 Yrs, p.110 (b/w)

BELJON, J. J.
Hiroshima mon amour, 1964
UK1, pl.257 (b/w)

BELL, Charles (American, 1935-)
Gumball Machine #1, 1971, o/c,
Priv.Coll.
Battcock (col)

BELL, Larry (American, 1939-)
Cube No.2, 1967, colored glass,
GCoZ
Kahmen, pl.235 (b/w)
Death Hollow, 1963, glass and
mirrors
Andersen, p.234 (b/w)

Fort Worth, Pace Gallery, New
York, 1975
Arnason 2, fig.1211 (b/w)
Memories of Mike, 1967, vacuum-
plated glass UNNG1
Hunter, pl.791 (col)
Arnason, col.pl.244
Untitled, 1964, mirrored and
painted glass UNNLis
Ashton, fig.27 (b/w)
Untitled, 1965
UK1, pl.226 (b/w)
Untitled, 1966-67, vacuum-
plated glass and metal bind-
ing
Busch, pl.XXVIII (col)
Untitled, 1969-70, coated glass
Walker, pl.21 (col)
Untitled, 1970, glass with min-
eral coating UNNPac
Hunter, pl.938 (b/w)
Untitled, 1971, coated glass,
ELT
L-S, pl.216 (b/w)
Untitled, 1971, coated glass
Rose, p.275 (b/w)
Untitled (Terminal Series),
1968, vacuum-plated glass and
metal UNNPac
Hunter, pl.751 (b/w)
Calas, p.269 (b/w)

BELL, Leland (American, 1922-)
Self-Portrait, 1961, o/c UDCHi
Hh, pl.807 (b/w)

BELLEGARDE, Claude (French, 1927-
)
Typogram of Camille Bryen, 1963,
o/c, Priv.Coll.
Abstract, pl.122 (b/w)

BELLMER, Hans (Polish, 1902-1975)
After the Weekly Early Closing
(Apres la fermeture hebdoma-
daire), c.1965, pencil GCoZ
Kahmen, pl.69 (b/w)
Auto-portrait avec Unica, c.1960,
mixed media FPPoi
New Art, pl.48 (b/w)
The Doll, 1963, pen and ink
Kahmen, pl.71 (b/w)
The Doll (La poupee), 1936,
handcolored photo montage,
FPPet
Kahmen, pl.75 (b/w)

The Doll's Games XI, 1937, color
photograph
Kahmen, pl.67 (b/w)
The Doll's Games XII, 1937, col-
or photograph
Kahmen, pl.68 (b/w)
Drawing, 1942, pencil GCoGm
Kahmen, pl.72 (b/w)
Drawing, 1964, pencil GCoZ
Kahmen, pl.70 (b/w)
Untitled, 1960, pencil FPPeti
Fig.Art, pl.127 (b/w)
Untitled, 1968, engraving, Priv.
Coll., Fribourg
Castleman, p.93 (col)
Young Man (Self-Portrait) with
Two Female Nudes, 1923, pen-
cil and watercolor GBHa
Kahmen, pl.16 (b/w)

BEN (Ben Vautier) (Italian-French,
1935-)
Absolutely Anything is Art,
1966, o/c
Fig.Art, pl.309 (b/w)
Le Temps, 1971
Popper, p.270 (b/w)

BENGLIS, Lynda (American, 1941-)
Installation view, Walker Art
Center, Minneapolis, 1971
Arnason 2, fig.1084 (b/w)

BENGSTON, Billy Al (American,
1934-)
Birmingham Small Arms I (B.S.A.),
1961, o/c
Lippard, pl.125 (b/w) UCLF
Compton 2, fig.159 (b/w) UCLG1
Boris, 1964, oil lacquer on
board
Rose, p.217 (b/w)
Buster, 1962, oil and lacquer on
masonite, Coll.Artist
Compton 2, fig.144 (col)
Carburetor I, 1961, o/c UCVA
Alloway, fig.23 (b/w)
Gas Tank & Tachometer II, 1961,
o/c UCLRu
Alloway, fig.24 (b/w)
Ideal Exhaust, 1961, o/c UCVA
Alloway, fig.25 (b/w)
Skinny's 21, 1961, o/c UCBeS
Lippard, pl.126 (col)
Alloway, fig.26 (b/w)
Wilson, pl.26 (col)
Compton 2, fig.157 (b/w)

BENJAMIN, Anthony (British, 1931-
)
Nimbus V, 1970, chrome and
plastic UDCHi
Hh, pl.837 (b/w)

BENNER, Gerrit (Dutch, 1897-)
Farmhouse, 1954, o/c
1945, pl.141 (b/w)

BENNETT, John E.
Liason, 1966
UK1, pl.160 (b/w)

BENRATH, Frederic (French, 1930-
)
The Great Itinerants of the
Dream, 1961, o/c BBN
Abstract, pl.123 (b/w)
Lace, Interlace-What Interlaces
Infinity is Serpent, 1963,
FPF1
Pellegrini, p.71 (b/w)

BENTON, Fletcher (American, 1931-
)
Synchronetic C-637-S, 1968,
plexiglass, formica, steel,
electric circuitry UDCHi
Hh, pl.933 (b/w)
With Zonk, 1968, kinetic work
Busch, figs.100-02 (b/w)

BEOTHY, Etienne (Hungarian, 1897-
1962)
Couple, 1947, wood FPLan
G-W, p.229 (b/w)
Noctorno, 1956, avodive wood
Trier, fig.140 (b/w)

BERCKELAERS, Ferdinand Louis. See
SEUPHOR, Michel

BERCOT, Paul (French, 1898-)
Painting, 1960, Coll.Artist
Seuphor, no.502 (col)

BERGER-BERGNER, Paul
Composition, 1961, o/c
Fig.Art, pl.23 (b/w)

BERGMANN, Anna-Eva (Swedish, 1909-
)
Composition, 1956, o/c
1945, pl.144 (b/w)

Etching, 1953 FPHu
 Seuphor, no.468 (b/w)
Painting, 1959 FPFr
 Seuphor, no.407 (col)

BERLANT, Anthony (American, 1941-
)
The Marriage of New York and
 Athens, 1966, aluminum over
 plywood
 Andersen, p.176 (b/w)
Les Six, 1964, glued cloth and
 paint UCLStu
 Lippard, pl.141 (b/w)

BERMAN, Eugene (Russian-American,
1899-1972)
Muse of the Western World, 1942,
 o/c UNNMM
 Arnason, fig.592 (b/w)
Nike, 1943, o/c UDCHi
 Hh, pl.527 (col)

BERMAN, Wallace
You've Lost That Lovin' Feeling,
 1965, verifax
 Lippard, pl.129 (b/w)

BERNER, Bernd (German, 1930-)
Flachenraum, 1964, gouache,
 SwGrB
 New Art, pl.300 (b/w)

BERNI, Antonio (Argentinian, 1905-
)
La Amiga de Ramona, 1962, oil
 and collage FPBou
 New Art, col.pl.96
The Grand Illusion, 1962, o/c,
 Priv.Coll.
 Arnason, fig.956 (b/w)
 Pellegrini, p.229 (b/w)
Ramona's Dream, engraving
 Fig.Art, pl.269 (b/w)

BERNIK, Janez (Yugoslavian, 1933-
)
The Big Letter, 1964, oil and
 tempera
 New Art, col.pl.111

BERROCAL, Miguel (Spanish, 1933-)
Alfa and Romeo, 1964-68, bronze,
 GCoL
 Kahmen, pl.122 (b/w)
 Dyckes, p.88 (b/w)

Caryatid, 1966, bronze UDCHi
 Hh, pl.924 (b/w)
Mini-David, 1968, alloy
 Dyckes, p.89 (b/w)
Romeo and Juliet, 1964, bronze
 Dyckes, p.89 (b/w)
Samson, 1963, bronze GMT
 Trier, fig.215 (b/w)
Via Appia, 1961, iron
 Dyckes, p.89 (b/w)

BERRY, John
Untitled, 1966
 UK1, pl.197 (b/w)

BERTHOLLE, Jean (French, 1909-)
Composition, 1959, o/c FPRoq
 Seuphor, no.456 (col)

BERTHOLO, Rene (Portugese, 1935-)
The Doors, 1965, o/c FPFel
 Fig.Art, pl.279 (b/w)
Things, 1965 FPFel
 Pellegrini, p.284 (b/w)

BERTINI, Gianni (Italian, 1922-)
Il giorno che ha ucciso Christo,
 1967
 UK2, pl.270 (b/w)
Irrupting Erebus, 1965
 Fig.Art, pl.271 (b/w)
The Prayers of Tiresias, 1960,
 o/c, Coll.Artist
 Seuphor, no.514 (col)
Scampagnota, 1966
 UK2, pl.88 (b/w)
Stilmec, 1967
 UK2, pl.86 (b/w)
Striptease Poetique, 1960
 UK2, pl.16 (b/w)

BERTOIA, Harry (Italian-American,
1915-)
Screen Wall, steel and alloys,
 UNNMan
 Trier, fig.198 (b/w)
Steel Cones on Stems, gilded
 bronze UNNSt
 Trier, fig.118 (b/w)
Sunburst, 1962, bronze
 Metro, p.45 (b/w)
Untitled, 1961, stainless steel
 Metro, p.44 (b/w)
Untitled, 1965, stainless steel,
 UDCHi
 Hh, pl.820 (b/w)

BERTONI, Wander (Italian, 1925-)
 Ikarus, 1953, stainless steel,
 BAM
 G-W, p.269 (b/w)
 Trier, fig.69 (b/w)

BERTRAND, Gaston (Belgian, 1910-)
 Florence, 1956, o/c BVeM
 Abstract, pl.178 (b/w)
 Italie, 1956, o/c
 1945, pl.14 (col)
 Plaza Padro, 1955, o/c, Coll.
 Artist
 Seuphor, no.509 (col)
 The Spring, 1956, o/c BBE
 Seuphor, no.508 (col)

BERTRAND, Huguette Arthur (French,
 1925-)
 Cela qui va fraichissant, 1968,
 o/c
 Abstract, pl.64 (b/w)
 Lul, 1960, o/c, Coll.Artist
 Seuphor, no.497 (col)

BESSER, Arne (American, 1935-)
 Betty, 1973, o/c -Spe
 Battcock (col)

BETTENCOURT, Pierre
 The House of Eternity. High Re-
 lief No.17
 Fig.Art, pl.268 (b/w)

BEUYS, Joseph (German, 1921-)
 Aktionsplastik, 1962
 Celant, p.49 (b/w)
 Callas (Exquisite Corpse), 1961,
 pencil and ink (in collabora-
 tion with Konrad Klapheck et
 al) GDusKl
 Kahmen, pl.81 (b/w)
 Double Figure (Doppelfigur),
 c.1960, bronze figures and
 elastic band GDusG
 Kahmen, pl.283 (b/w)
 Dumb Record-Player (Stummer
 Plattenspieler), 1961 GDusG
 Kahmen, pl.299 (b/w)
 Eurasia, Copenhagen, 1966, hap-
 pening
 UK4, pl.110 (b/w)
 Eurasia, Vienna, 1967, action
 6 Yrs, p.17 (b/w)
 Eurasia, Berlin, 1968, action
 6 Yrs, p.17 (b/w)

Eurasien, 1964
 Celant, pp.52-53 (b/w)
Eurasienstab, 1967
 Celant, p.51 (b/w)
Eurasienstab, Antwerp, 1968,
 happening
 UK4, pl.109 (b/w)
Exquisite Corpse (Cadavre ex-
 quis), 1961, pencil and ink
 (in collaboration with Konrad
 Klapheck et al) GDusKl
 Kahmen, pl.78 (b/w)
Fat-Corner, 1963, mixed media
 Henri, fig.119 (b/w)
Fettplastik, 1952
 Trier, fig.173 (b/w)
Fond III, 1969
 Celant, p.55 (b/w)
Goethe Secretly Observed by Eck-
 ermann (Exquisite Corpse),
 1961, pencil and ink (in col-
 laboration with Konrad Klap-
 heck et al) GDusKl
 Kahmen, pl.79 (b/w)
Homogenous Infiltration for
 Grand Piano, 1966, assemblage,
 BAW
 Fig.Art, pl.176 (b/w)
How to Explain Pictures to a
 Dead Hare (Wie man einem toten
 Hasen die Bilder erklärt),
 Galerie Schmela, Dusseldorf,
 1964 or 1965
 Kahmen, pl.274 (b/w)
 Henri, fig.121 (b/w)
 Walker, p.48 (b/w)
The Intelligence of Swans (In-
 telligenz der Schwane), 1955,
 pencil GCoB
 Kahmen, pl.349 (b/w)
1961
 Celant, p.48
Odysseus Observing Circe (Ex-
 quisite Corpse), 1961, pencil
 and ink (incollaboration with
 Konrad Klapheck et al) GDusKl
 Kahmen, pl.80 (b/w)
Ostend
 Celant, p.48
The Pack, 1969, mixed media,-Her
 Henri, fig.123 (b/w)
Radio, 1961
 Celant, p.54 (b/w)
Scene from the Deer Hunt, 1961,
 assemblage
 Walker, pl.60 (col)

BLADEN, Ronald (American, 1918-)
 Barricade, 1968, construction
 lumber
 Busch, fig.80 (b/w)
 Black Triangle, 1966, painted
 wood
 UK1, pl.208 (b/w)
 Andersen, p.228 (b/w)
 The Cathedral Evening, 1969,
 wood mockup to be made in
 steel
 Calas, p.238 (b/w)
 3 Elements, 1965, painted
 aluminum
 Andersen, p.227 (b/w)
 Untitled, 1963-65, plywood and
 steel pipe, Coll.Artist
 Ashton, pl.LIX (b/w)
 Untitled, 1965, aluminum and
 wood (painted) UNNFis
 Kahmen, pl.236 (b/w)
 UK1, pl.209 (b/w)
 Untitled, 1966, wood for execu-
 tion in metal
 Abstract, pl.260 (b/w)
 Untitled, 1967, painted alumi-
 num UNNMMA
 Hunter, pl.814 (b/w)
 Untitled, 1969, painted plywood
 Busch, pl.XI (col)
 X, 1967, wood
 Arnason, fig.1080 (b/w) UNNFis
 Andersen, p.228 (b/w)
 Busch, fig.81 (b/w)
 Calas, p.237 (b/w)
 Rose, p.279 (b/w)
 Hunter, pl.782 (b/w) UFPL

BLAKE, Peter (British, 1932-)
 Alice in Wonderland, "and to
 show you I'm not proud, you
 may shake hands with me",
 1970-71, watercolor ELW
 Eng.Art, p.49 (b/w)
 Alice in Wonderland, "But it
 isn't old...", 1970-71, water-
 color ELW
 Eng.Art, p.44 (col)
 Alice in Wonderland, "Well this
 is grand," said Alice. "I nev-
 er expected I should be Queen
 so soon", 1970-71, watercolor,
 ELW
 Eng.Art, p.49 (b/w)

Baron Adolf Kaiser, 1961-63,
 oil and enamel on board ELAr
 Eng.Art, p.48 (b/w)
The Beach Boys, 1964
 UK2, pl.92 (b/w)
The Beatles, 1964, oil on board,
 Priv.Coll., London
 Amaya, p.112 (b/w)
 UK2, pl.93 (b/w)
 Eng.Art, p.49 (b/w)
Big Iron Bird She Come, 1965,
 ELFr
 Fig.Art, pl.201 (b/w)
Bo Diddley, 1964-65, cryla on
 board
 Amaya, p.111 (b/w)
Coco Chanel, 1967, acrylic on
 masonite UDCHi
 Hh, pl.884 (b/w)
Doktor K. Tortur, 1965, cryla,
 collage on cardboard
 L-S, pl.111 (b/w) ELFr
 Compton 2, fig.55 (col),
 UNNReina
Elvis Mirror (Elvis Wall), 1961,
 collage and oil on board
 Lippard, pl.30 (b/w) ELFr
 UK2, pl.90 (b/w)
 Fig.Art, pl.200 (b/w), Priv.
 Coll., Brussels
Fine Art Bit, 1969, collage and
 oil on board ELT
 Eng.Art, p.48 (b/w)
The First Real Target?, 1961,
 collage on board ELFr
 Lippard, pl.32 (b/w)
 Compton 2, fig.60 (b/w)
Girl with a Flower, 1966-68,
 cryla on hardboard ELJa
 Eng.Art, p.49 (b/w)
The Girlie Door, 1959
 Pellegrini, p.244 (b/w)
Got a Girl, 1960-61, collage on
 hardboard ELStu
 Stuyvesant, p.127 (b/w)
 Russell, pl.IV (col)
 Compton 2, fig.56 (col)
Jane and Cheeta, 1969, water-
 color ELFr
 Fig.Art, pl.202 (b/w)
Little Lady Luck, 1965, acrylic
 and collage on cardboard ELFr
 New Art, col.pl.37
The Love Wall, 1961 PoLG
 Wilson, pl.34 (col)

On the Balcony, 1955-57, o/c ELT
 Russell, p.39 (b/w)
 Arnason, fig.1028 (b/w)
 Compton 2, fig.41 (b/w)
 Wilson, pl.33 (col)
Pin-up Girl, 1965, acrylic on
 hardboard
 Finch, p.127 (b/w)
Pin-up Girl, 1965, oil on board,
 Priv.Coll., Brussels
 Fig.Art, pl.203 (b/w)
 Finch, p.128 (b/w)
Pub Door, 1962, collage con-
 struction ELBra
 Russell, pl.33 (b/w)
Self-Portrait, 1961, o/c ELFr
 New Art, pl.83 (b/w)
 Lippard, pl.31 (b/w)
 Eng.Art, p.22 (b/w)
 UK2, pl.68 (b/w)
Sir Conrad and Ricky da Vinci,
 1963, enamel on wood panel,
 Priv.Coll., Milan
 Eng.Art, p.47 (b/w)
Tattooed Lady, 1954 (now de-
 stroyed), oil on board
 Compton 2, fig.59 (b/w)
Tattooed Lady, 1958, black gou-
 ache and collage on paper ELV
 Eng.Art, p.47 (b/w)
Toy Shop, 1962, mixed media
 Compton 2, fig.58 (b/w), Coll.
 Artist
 Wilson, pl.35 (col) ELT
A Transfer, 1963, ink, crayon,
 pencil ELWh
 Russell, p.33 (b/w)
Zorine Queen of the Nudists and
 Her TV Gorilla, 1961-65, col-
 lage on panel ELStu
 Stuyvesant, p.126 (b/w)

BLECHER, Wilfried (German, 1930-)
 Zeitspiele, 1964, mixed media,
 Coll.Artist
 New Art, pl.302 (b/w)

BLOC, Andre (French, 1896-)
 Brass Sculpture, 1959
 Trier, fig.165 (b/w)
 Construction, 1953, plaster,
 Coll.Artist
 G-W, p.238 (b/w)

BLOCK, Irving (American, 1910-)
 Interior with Candle, 1963, o/c,
 UDCHi
 Hh, pl.890 (b/w)

BLOOM, Hyman (Lithuanian-American,
 1913-)
 Apparition of Danger, 1951, o/c,
 UDCHi
 Hh, pl.722 (col)

BLOSUM, Verne
 Telephone, 1964, o/c UNNC
 Lippard, pl.112 (b/w)

BLOW, Sandra (British, 1925-)
 Composition, 1963, oil and mixed
 media on canvas ELStu
 Stuyvesant, p.84 (b/w)
 No.4, 1965, o/c ELStu
 Stuyvesant, p.83 (b/w)
 Painting, 1957, o/c ELG
 1945, pl.135 (b/w)
 Painting in Black and White,
 c.1956 ELG
 Seuphor, no.477 (b/w)

BLUHM, Norman (American, 1920-)
 Memory Yellow, 1961, o/c
 Metro, p.52 (b/w)
 Sinbad's Grave, 1962, o/c, Priv.
 Coll.
 Abstract, pl.40 (b/w)

BLUHM, Ursula. See URSULA

BLUME, Peter (American, 1906-)
 Light of the World, 1932, oil on
 composition board UNNW
 Whitney, p.42 (b/w)
 Souvenir of the Flood, 1967-69,
 o/c UNNDan
 Fig.Art, pl.136 (b/w)

BOARDMAN, Seymour (American, 1921-
)
 Untitled, 1967
 UK2, pl.321 (b/w)

BOCHNER, Mel (American, 1940-)
 Compass: Orientation, 1968
 Meyer, p.51 (b/w)
 Eight Sets "4-Wall", 1966
 Meyer, p.58 (b/w)

Measurement Series: Group B
1967 (installation at Galerie
Heiner Friedrich, Munich,
1969), black tape on wall
6 Yrs, p.103 (b/w)
Measurement Series: Group "C",
1967
Meyer, p.59 (b/w)

BODMER, Walter (Swiss, 1903-)
Floating Sculpture, 1953,
painted wire and tin SwBeF
G-W, p.217 (b/w)
Sculpture, 1957-58, iron
Trier, fig.153 (b/w)
Wire Composition, 1936, Coll.
Artist
G-W, p.316 (b/w)
Wire Painting, 1951 SwBK
1945, pl.110 (b/w)

BOER, Saskia de
Mona Lisa, 1970 GLeK
UK3, pl.VI (col)

BOETTI, Alighiero (Italian, 1940-)
Legnetti colorati, 1968, dia
Celant, p.158 (b/w)
Non marsalarti, 1968, photograph
Celant, p.157 (b/w)
Senza titolo, 1966
UK1, pl.195 (b/w)
Senza titolo, 1966
UK1, pl.225 (b/w)
Twins, 1968
6 Yrs, p.54 (b/w)
Untitled, 1968, paper and iron
Celant, p.159 (b/w)
Untitled, 1968, stones, wood,
paper and glass
Celant, p.160 (b/w)
Untitled, 1968, water
Celant, p.161 (b/w)

BOEZEM, Marinus (Dutch)
Aerodynamic Object, 1967
Celant, p.200 (b/w)
Cortina di profumo evaporante,
1968
Celant, p.203 (b/w)
Iron Profile with Flying Nylon,
1968
Celant, p.201 (b/w)
Sand Fountain, 1969
UK4, pls.153-56 (b/w)

Untitled
Celant, p.202 (b/w)
Windtable, 1968, table and ven-
tilator
Celant, p.199 (b/w)

BOGART, Bram (Dutch, 1921-)
Gewepend, 1964, mixed media BBCa
New Art, col.pl.84
Joy of Orange, 1960, o/c
Seuphor, no.334 (col)
Pink-Yellow, 1965 BBH
Abstract, pl.60 (col)
Zomerhof, 1962 BBCa
Metro, p.53 (col)

BOGHOSIAN, Varujan (American,
Dead of Night, 1964, wood con-
struction UNNGold
Ashton, pl.XXVI (col)

BOHEMEN, Kees van (Dutch, 1928-)
Drowned Woman, 1964, o/c NRD
New Art, pl.150 (b/w)

BOHM, Hartmut
Light Direction no.135, 1967,
Coll.Artist
Barrett, p.97 (b/w)
Raumstruktur 5 (Spatial Struc-
ture), 1970, plexiglass
Popper, p.35 (b/w)

BOHNEN, Blythe (American, 1940-)
One Stroke-Simple Gesture, 1972,
acrylic on paper
Battcock, p.245 (b/w)

BOHROD, Aaron (American, 1907-)
The Shepherd Boy, 1957, oil on
panel UDCHi
Hh, pl.569 (b/w)

BOLLINGER, Bill (American, 1939-)
Graphite, Bykert Gallery, New
York, 1969
6 Yrs, p.116 (b/w)

BOLOTOWSKY, Ilya (Russian-Ameri-
can, 1907-)
Dark Diamond, 1971, a/c UNNB
Hunter, pl.349 (col)
Scarlet Diamond, 1969, o/c,
UNBuA
A-K, p.387 (col)

Trylon: Blue, Yellow and Red,
 1967, polychromed wood UDCHi
 Hh, pl.915 (b/w)
White Diamond, 1968, o/c UDCHi
 Hh, pl.916 (b/w)

BOLUS, Michael (British)
 7th Sculpture, 1975, painted
 chromium ELT
 Eng.Art, p.277 (b/w)
 Untitled, 1965
 UK1, pl.206 (b/w)

BOMBERG, David (British, 1890-
1957)
 Monastery of Ay Chrisostomos,
 Cyprus, 1948, o/c ELMa
 L-S, pl.37 (b/w)

BONA (Italian, 1926-)
 Naissances, 1965, o/c, Priv.
 Coll., Paris
 New Art, pl.67 (b/w)

BONALUMI, Agostino (Italian, 1935-
)
 Senza titolo, 1967
 UK1, pl.X (col)
 Untitled, 1963, canvas, Coll.
 Artist
 Abstract, pl.150 (b/w)

BOND, Douglas
 Ace I, 1968, a/c
 UK3, pl.55 (b/w)
 Bath Room, 1972-73, a/c -F
 Battcock, p.165 (b/w)
 Bath Room, 1973, a/c -J
 Battcock, p.167 (b/w)
 Dollie Ruth, 1970, a/c
 UK3, pl.56 (b/w)
 Girl's Waffle Party, 1973, a/c,
 -Hof
 Battcock, p.246 (b/w)
 Saguaro, 1970, a/c
 UK3, pl.144 (b/w)

BONFANTI, Arturo (Italian, 1905-)
 Apparent Calm, 1960, o/c IMLo
 Seuphor, no.298 (col)

BONIES (Dutch, 1937-)
 Blauw-Rood-Geel, 1966-67
 UK1, pl.213 (b/w)
 Untitled, 1966
 UK1, pl.212 (b/w)

BONNET, Anne (Belgian, 1908-1960)
 The City of Gold, 1955-56, o/c,
 BBRAM
 Seuphor, no.520 (col)
 The Golden City, 1955-56, o/c,
 BBR
 Abstract, pl.89 (b/w)
 Sacre oriental, 1956, o/c
 1945, pl.38 (b/w)

BONTECOU, Lee (American, 1931-)
 The 1960 Construction, 1960,
 canvas and welded steel UNNScu
 Janis, p.264 (b/w)
 Untitled, 1960, metal and can-
 vas UNBuA
 A-K, p.281 (b/w)
 Untitled, 1960, steel, canvas,
 cloth and wire UNGS
 Seitz, p.139 (b/w)
 Untitled, 1960, welded steel
 and canvas UNNDw
 Ashton, pl.LIII (col)
 Untitled, 1961, canvas and
 welded metal UNNW
 Whitney, p.120 (b/w)
 Untitled, 1962, stainless steel
 and canvas UNNLis
 New Art, pl.38 (b/w)
 Untitled, 1962
 UK1, pl.153 (b/w)
 Untitled, 1962, welded steel and
 canvas UNNJe
 Metro, p.54 (b/w)
 Untitled, 1962 -Bu
 Metro, p.55 (col)
 Untitled, 1962, welded steel and
 canvas SnSNM
 Hunter, pl.799 (b/w)
 Untitled, 1962, welded steel and
 canvas
 Rose, p.264 (b/w)
 Untitled, 1962, welded steel and
 canvas UNNSchw
 Trier, fig.225 (b/w)
 Untitled, 1964, steel and can-
 vas UNNC
 Kahmen, pl.265 (b/w)
 UK1, pl.154 (b/w)
 Untitled, 1964
 UK1, pl.152 (b/w)
 Untitled, 1964, welded steel and
 canvas UNNC
 Arnason, fig.1014 (b/w)
 Untitled, 1967, cloth and wood,
 UDCHi
 Hh, pl.895 (b/w)

Untitled, 1971, plastic UNNC
 Arnason 2, fig.1081 (b/w)

BORDUAS, Paul-Emil (Canadian, 1905-
1960)
 Black Star, 1957, o/c CMFA
 Abstract, pl.94 (b/w)
 Morning Candelabra, 1948, o/c,
 UNNMMA
 1945, pl.171 (b/w)

BORIANI, Davide (Italian, 1936-)
 Camera Stroboscopia Multidimen-
 sionale, 1965-67
 UK4, pl.100 (b/w)
 Magnetic Surface, 1962, magne-
 tized metal and glass UDCHi
 Hh, pl.864 (b/w)
 Maquette (for "Kunst Licht Kunst"
 exhibition, Eindhoven, 1966)
 Popper 2, p.235 (b/w)
 P.H. Scope, 1964-66
 Popper 2, p.178 (b/w)
 Superficie magnetica, 1960
 New Art, pl.119 (b/w)

BOROFSKY, Jonathon
 Time Thought #8 (page 7), 1969
 6 Yrs, p.69 (b/w)

BOSHIER, Derek (British, 1937-)
 Airmail Letter, 1961, o/c -Bl
 Russell, pl.20 (b/w)
 England's Glory, 1961, o/c,
 ELGra
 L-S, pl.112 (b/w)
 I Wonder What My Heroes Think of
 the Space Race, 1961 or 1962,
 o/c
 Amaya, p.50 (b/w) ELL
 Compton 2, fig.85 (b/w) ELGren
 The Identikit Man, 1962, o/c
 Compton 2, fig.84 (b/w) SwZBis
 Wilson, pl.41 (col) ELT
 Plaza, 1965, o/c ELStu
 Stuyvesant, p.149 (col)
 Re-think, Re-entry, 1962, o/c,
 ELGra
 Lippard, pl.41 (b/w)
 UK2, pl.158 (b/w)
 So Ad Men Became Depth Men,
 1963, o/c ELGul
 Fig.Art, pl.157 (b/w)
 Vista City, 1964, o/c ELStu
 Stuyvesant, p.150 (b/w)

BOTERO, Fernando (Colombian, 1932-
)
 Camera degli Sposi II, 1961,
 o/c UDCHi
 Hh, pl.875 (b/w)
 Portrait of a Family, 1974, o/c,
 -So
 Arnason 2, fig.1008 (b/w)
 Rubens's Woman, 1963, o/c UNNG
 Arnason, fig.957 (b/w)
 The Sisters, 1969, o/c FPB
 Fig.Art, pl.88 (b/w)
 The Studio of Rubens, 1963-64,
 o/c
 New Art, pl.223 (b/w)

BOTO, Martha (Argentinian, 1925-)
 Labyrinthe, 1965, aluminum and
 wood, lighted, Coll.Artist
 Hunter, pl.915 (b/w)
 Luminous Polyvision, 1965 FPRe
 Barrett, p.87 (b/w)
 Mouvement helicoidal lumineux,
 1967
 UK1, pl.315 (b/w)
 Optical Movement, 1966, animated
 box FPRe
 Abstract, pl.295 (b/w)
 Structure optique, 1962 FPRe
 Popper 2, p.159 (b/w)

BOTT, Francis (German, 1904-)
 Composition 18, 1961, o/c,
 SwBFe
 Seuphor, no.349 (col)

BOUDNIK, Vladimir (Czechoslova-
 kian, 1924-)
 Spontaneous Graphism, 1957
 Seuphor, no.500 (b/w)

BOUMEESTER, Christine (Dutch,
 1904-)
 Charcoal Drawing, 1960 FPAri
 Seuphor, no.475 (b/w)
 Drawing, 1948
 Seuphor, no.474 (b/w)
 Drawing, 1952
 Seuphor, no.476 (b/w)

BOURAS, Harry (American, 1931-)
 The D's Testament, 1961, wood,
 steel, plumbing fixtures and
 bicycle parts UICA1
 Seitz, p.121 (b/w)

BOURGEOIS, Louise (French, 1911-)
Attentive Figures, 1949, wood
Andersen, p.94 (b/w)
Black March, 1970, marble
Arnason 2, fig.1076 (b/w)
The Blind Leading the Blind,
1949, painted wood
Andersen, p.94 (b/w)
The Destruction of the Father,
1974, latex and stone, Coll.
Artist
Arnason 2, col.pl.245
Garden at Night, 1953, painted
wood UICM
Andersen, p.95 (b/w)
G-W, p.288 (b/w)
Installation, 1949
Andersen, p.93 (b/w)
Labyrinthine Tower, 1963, plas-
ter, Priv.Coll.
Arnason, fig.995 (b/w)
Noir Veine, 1968, marble UNNK
Hunter, pl.518 (col)
One and Others, 1955, painted
wood UNNW
Whitney, p.112 (b/w)
Ashton, fig.20 (b/w)
Trier, fig.82 (b/w)

BOUTHOORN, Wil L. (Dutch, 1916-)
Painting with Horizontal and
Vertical Movement, 1964, oil
on cardboard NHG
New Art, pl.149 (b/w)

BOYCE, Richard (American, 1920-)
Aged Hercules, 1966
UK1, pl.16 (b/w)

BOYD, Arthur (Australian, 1920-)
Shearers Playing for a Bride,
1957, oil and tempera on
board AuMGV
L-S, pl.120 (b/w)

BOYLE, Mark (British, 1934-)
Celebration of Intercourse (from
Son et Lumiere for Bodily Flu-
ids), London, 1966, action
Henri, fig.89 (b/w)
Disused Coal Siding Study-London
Series, 1967-72, earth, etc.
on fiberglass -IcR
Eng.Art, p.54 (b/w)

Institute of Contemporary Arch-
aeology's Annual Dig in Shep-
herd's Bush, London, 1966
Henri, fig.87 (b/w)
Liquid Light Environment, 1966-
67 (in collaboration with
Joan Hills)
Walker, pl.53 (col)
Random Self Portrait-Body Work
Series, 1969, electron micro-
photograph, Coll.Artist
Eng.Art, p.54 (b/w)
Rock & Sand Study-Rock Series,
1967-72, sand etc. on fiber-
glass, Coll.Artist
Eng.Art, p.55 (b/w)
Street Corner Study-London Ser-
ies, 1967-69, epikote on wood
frame IreBU
Eng.Art, p.53 (b/w)
Study for Tidal Series, 1969,
sand etc. on fiberglass ELWi
Eng.Art, p.52 (b/w)
Suddenly Last Supper, London,
1964, action
Henri, fig.88 (b/w)

BRAKHAGE, Stan
Lovemaking, 1967
UK4, pl.121 (b/w)

BRANCUSI, Constantin (Rumanian-
French, 1876-1957)
Bird (L'oiseau), 1940, burnished
bronze IVG
G-W, p.141 (b/w)

BRANDT, Warren (American, 1918-)
The Morning Paper, 1966, o/c,
UDCHi
Hh, pl.889 (b/w)

BRAQUE, Georges (French, 1882-
1963)
Atelier III, 1949, oil -SwH
Haftmann, pl.461 (b/w)
Atelier VI, 1952, oil FPMa
Haftmann, pl.462 (b/w)
Chariot (Char), 1954, engraved
and colored plaster FPMa
Haftmann, pl.457 (b/w)
La charrue, 1960, o/c
Metro, p.56 (b/w)
Horse's Head, 1943-46, bronze,
FPMa
G-W, p.295 (b/w)

Ibis, 1940–45, bronze FPMa
 G-W, p.294 (b/w)
Leaves, Color, Light (Feuilles,
 Couleur, Lumiere), 1953,
 lithograph FPMa
 Castleman, p.35 (col)
Marine, o/c
 Metro, p.57 (b/w)
L'oiseau et son nid, 1956, o/c
 1945, pl.15 (b/w)
Open Window, 1952, oil UNNPer
 Haftmann, pl.460 (b/w)
Red Still Life, 1955, oil GStSt
 Haftmann, pl.459 (b/w)
Still Life with Banjo (Nature
 morte: Banjo), 1941, oil FPF
 Haftmann, pl.452 (b/w)
Still Life with Black Fishes
 (Les poissons noirs), 1942,
 oil FPAM
 Haftmann, pl.450 (b/w)
Studio IX, 1952–56, o/c FPMa
 L-S, pl.34 (col)
The Varnished Chariot (Chariot
 III) (Le Char Varni, Char III),
 1955, lithograph FPMa
 Castleman, p.37 (col)

BRATBY, John (British, 1928–)
Three Self-Portraits ELBea
 Fig.Art, pl.26 (b/w)
Window, Self-Portrait, Jean and
 Hands, 1957, oil on board ELT
 L-S, pl.33 (b/w)

BRAUER, Erich (Austrian, 1929–)
Mit dem schwebenden Knollen,
 1965, watercolor, Priv.Coll.
 New Art, pl.284 (b/w)

BRAUNER, Victor (Rumanian, 1903–)
Les contraires..., 1947, bees-
 wax, etc. -Ku
 Janis, p.229 (b/w)
Endopromeneur, 1962, o/c
 Metro, p.59 (b/w)
Le guetteur, 1962, o/c
 Metro, p.58 (b/w)
I and Me (Je et moi), 1949, o/c
 Kahmen, pl.73 (b/w)
Petites announces, 1959, collage
 and cloth with encaustic -Bod
 Janis, p.91 (b/w)
Reve, 1964, o/c FPIo
 New Art, col.pl.30

BRAVO, Claudio (Chilean, 1936–)
Homage to St. Therese, 1969,
 o/c UNNPu
 Dyckes, p.62 (b/w)
Portrait of Antonio Cores, 1973,
 o/c FiHA
 Walker, pl.52 (col)

BREAKWELL, Ian
Episode in a Small Town Library,
 Taunton, 1970, action
 Henri, fig.100 (b/w)

BRECHT, George (American, 1926–)
Blair, 1959, rearrangeable as-
 semblage
 Kaprow, no.36 (b/w)
Chair Event, 1969, chair with
 objects, Coll.Artist
 Russell, pl.14 (b/w)
Clothes Tree, 1969, clothes tree
 with objects, Coll.Artist
 Russell, pl.XII (col)
Drip Music (Drip Event), second
 version, 1959–62
 Russell, p.20 (b/w)
Event Scores, 1960–61
 Russell, p.60 (b/w)
 Kaprow, pp.272–78 (b/w)
No Smoking, 1966, letters on
 canvas IMSc
 Russell, pl.93 (b/w)
Repository, 1961, movable ob-
 jects in constructed cabinet,
 UNNMMA
 Lippard, pl.56 (b/w)
 Seitz, p.155 (b/w)
 Hunter, pl.614 (b/w)
Silence, 1966, letters on can-
 vas IMSc
 Russell, pl.92 (b/w)

BREER, Robert (American, 1926–)
Table, 1967, styrofoam, canvas
 and metal
 Calas, p.296 (b/w)

BRETON, Andre (French, 1896–1966)
Objet-poeme (Poeme objet), 1941,
 wood and miscellaneous ob-
 jects -Ta
 Seitz, p.67 (b/w)
 Janis, p.143 (b/w)

BREUER, Leo (German, 1893-)
 Brush Drawing I, 1961
 Seuphor, no.220 (b/w)
 Brush Drawing III, 1961 FPHau
 Seuphor, no.221 (b/w)

BRISLEY, Stuart (British, 1946-)
 And For Today-Nothing, 1972,
 ELGal
 L-S, pl.236 (b/w)
 Artist as Whore; an Event, Gal-
 lery House, London, Christmas
 1971-72, action
 Walker, pl.57 (col)
 Moments of Decision/Indecision,
 Kunstforum, Rottweil, 1975,
 action (in collaboration with
 Leslie Haslam)
 Eng.Art, pp.418-19 (b/w)
 Ritual Murder Nodnol, London,
 1968
 UK4, pl.47 (b/w)
 6 Days, Warsaw, 1975 (in colla-
 boration with Leslie Haslam)
 Eng.Art, pp.420-21 (b/w)

BRODERSON, Morris (American, 1928-
)
 Angel and Holy Mary, After Leo-
 nardo da Vinci, 1960, o/c,
 UDCHi
 Hh, pl.672 (b/w)

BROODTHAERS, Marcel (Belgian,
 d.1976)
 Autoportrait, 1968
 UK2, pl.380 (b/w)

BROOKS, James (American, 1906-)
 Ainlee, 1957, o/c UNNMM
 1945, pl.166 (b/w)
 Bozrah, 1965, o/c UDCE
 Sandler, p.236 (b/w)
 Burwak, 1962, oil and acrylic
 emulsion
 Metro, p.61 (b/w)
 Casper, 1973, a/c UNNJ
 Arnason 2, fig.909 (b/w)
 Cooba, 1963, o/c UNBuA
 A-K, p.55 (col)
 Dialogue, 1947, oil on fiber-
 board, Coll.Artist
 Sandler, p.235 (b/w)
 Dobson, 1965, o/c UNPoK
 Abstract, pl.36 (b/w)

Floxurn, 1955, o/c, Coll.Artist
 Sandler, p.237 (b/w)
 Gordion, 1957, o/c UNNBro
 Hunter, pl.395 (col)
 K-1953, o/c, Coll.Artist
 Sandler, p.235 (b/w)
 Karrig, 1956, o/c UNNSta
 1945, pl.155 (col)
 Leonardo da Vinci (detail of
 Flight), 1938-42 (now de-
 stroyed), casein glyptol emul-
 sion on canvas
 Sandler, p.234 (b/w)
 Loring, 1958 UNNChas
 Ponente, p.155 (col)
 Lurry, 1962, acrylic emulsion
 Metro, p.61 (b/w)
 Number 36, 1950, oil on bemis
 cloth, Coll.Artist
 Sandler, pl.XXI (col)
 Octon, 1961, o/c UPA1A
 Arnason, fig.866 (b/w)
 Quagett, 1964, oil and acrylic
 on canvas UNNKo
 New Art, pl.3 (b/w)
 Pellegrini, p.121 (b/w)
 Rasalus, 1959, oil UNNW
 Whitney, p.85 (col)
 Rodado, 1961, o/c UMWaB
 Hunter, pl.439 (b/w)
 Sull, 1961, o/c UMdBP
 Sandler, p.237 (b/w)
 Tondo, 1951, o/c UNNRoc
 Hunter, pl.425 (b/w)
 Arnason, fig.865 (b/w)

BROWN, Aika (Israeli, 1936-)
 Drawing on Newspaper, 1961
 Seuphor, no.256 (b/w)
 Picture Relief with Puppets,
 1964
 New Art, pl.232 (b/w)
 Plastic Composition in Black
 and Gray, 1960, Priv.Coll.,
 United States
 Seuphor, no.257 (b/w)

BROWN, William Theo (American,
 1919-)
 White Dog, 1966
 UK2, pl.179 (b/w)

BROWNE, Byron (American, 1907-
 1961)
 Icon, 1949, oil and collage on
 canvas UDCHi
 Hh, pl.534 (b/w)

BRUDER, Harold (American, 1930–)
Canyon Encounter, 1967, o/c,
UNNStr
UK3, pl.61 (b/w)
Luncheon at Hay-Meadows, 1969,
o/c UNjRW
UK3, pl.50 (b/w)

BRUMMACK, Heinrich (German, 1936–
)
Galgenkonig, 1965, bronze GBSch
New Art, pl.296 (b/w)

BRUNING, Peter (German, 1929–)
Legendes No.8/64, 1964, o/c,
GCoAA
New Art, pl.272 (b/w)
Legends No.16/64, 1964, o/c,
GAaL
Abstract, pl.135 (b/w)
NY, NY, NY, NY, 1968
UK2, pl.238 (b/w)
Oil, 1960
Pellegrini, p.78 (b/w)

BRUNORI, Alberto (Italian, 1924–)
Mare bleu, 1957, o/c
1945, pl.60 (b/w)

BRUNOVSKY, Albin (Hungarian,
1933–)
Exmaster, 1965, etching
New Art, fig.5 (b/w)

BRUS, Gunther (Austrian, 1938–)
Silver, 1965
UK4, pls.129-33 (b/w)
Test to Destruction, Munich,
1970, action
Walker, pl.58 (col)

BRUSSE, Mark (Dutch, 1937–)
Hommage a Piet Mondrian, 1965,
wood and iron NAS
New Art, pl.166 (b/w)
Strange Fruits VI, 1965, wood
and iron
Kahmen, pl.253 (b/w)

BRYEN, Camille (French, 1907–)
Drawing, February 1960 FPCaz
Ponente, p.114 (col)
Hollande (Paysage No.30), 1957,
o/c
1945, pl.24 (b/w)

Ink Drawing, 1959 FPCaz
Seuphor, no.268 (b/w)
Poem-Object Exploded, 1956,
watercolor and India ink,
FPRes
Abstract, pl.121 (b/w)
Ribbons of Air, 1959, o/c, Priv.
Coll.
Abstract, pl.53 (b/w)

BRZOZOWSKI, Tadeusz (Polish, 1918–
)
Morning Star, 1964, o/c PWB
New Art, pl.233 (b/w)

BUBENIK, Gernot (German, 1942–)
Pfanze I, 1966
UK2, pl.274 (b/w)

BUCHHEISTER, Carl (German, 1890–
1964)
Composition, 1949
Pellegrini, p.280 (b/w)

BUCHHOLZ, Erich (German, 1891–)
Painting in Black, White, and
Gray, 1955, Coll.Artist
Seuphor, no.461 (b/w)

BUFFET, Bernard (French, 1928–)
Nature-morte, bouteille et
verre, 1951, o/c
1945, pl.29 (b/w)
Nude, 1959, o/c, Priv.Coll.
Fig.Art, pl.21 (b/w)
Self-Portrait, 1954, o/c ELT
L-S, pl.66 (b/w)
Woman with Chicken (Femme au
poullet), 1947, oil FPGa
Haftmann, pl.989 (b/w)

BULTMAN, Fritz (American, 1919–)
Vase of the Winds II, 1961-62,
bronze UNNW
Ashton, pl.XLI (b/w)

BURCHFIELD, Charles (American,
1893-1967)
An April Mood, 1946-55, water-
color UNNW
Whitney, p.52 (col)
Midsummer Afternoon, 1952, wa-
tercolor on paper UDCHi
Hh, pl.716 (col)

BUREN, Daniel (French, 1938-)
 Bradford College Project, 1970
 6 Yrs, p.192 (b/w)
 Photo/Souvenir, Paris, April,
 1968
 Walker, p.47 (b/w)
 Photo-Souvenir, Milan, Oct.1968
 6 Yrs, p.53 (b/w)
 Sandwichmen, Paris, 1968
 Meyer, p.60 (b/w)
 Untitled (Green and White
 Stripes), Bleeker St., New
 York, 1973
 Arnason 2, fig.1252 (b/w)
 Visible Recto Verso Painting,
 1971
 6 Yrs, p.246 (b/w)

BURGIN, Victor (British, 1941-)
 Lei Feng, 1974, photographic
 print
 Eng.Art, p.325 (b/w)
 Photopath, 1969
 Meyer, p.78 (b/w)
 Eng.Art, p.324 (b/w)

BURGY, Donald (American, 1937-)
 Art Idea for the Year 4000 #4,
 June 1970
 Meyer, p.91 (b/w)
 Lie Detector, 1969
 6 Yrs, p.101 (b/w)
 Name Idea #1, Sept.1969
 Meyer, p.90 (b/w)
 Rock Series #1, 1968
 6 Yrs, p.51 (b/w)
 Space Completion Ideas, Sept.
 1969
 Meyer, pp.88-89 (b/w)

BURI, Samuel
 Variation, 1967
 Fig.Art, pl.290 (b/w)

BURLIUK, David (Russian-American,
 1882-1967)
 Dreams About Travel, 1943, o/c,
 UDCHi
 Hh, pl.518 (col)

BURN, Ian (Australian, 1939-)
 Mirror Piece, 1967
 Meyer, p.92 (b/w)
 Xerox Book, 1968
 Meyer, p.94 (b/w)
 Walker, p.34 (b/w)

BURRI, Alberto (Italian, 1915-)
 Airflight, 1954, sacking, paint,
 etc. -Cab
 Janis, p.261 (b/w)
 All Black, 1956, vinavil, tem-
 pera and rags on canvas, Coll.
 Artist
 Seitz, p.136 (b/w)
 Bianco plastica, 1970, cellotex,
 Coll.Artist
 Liverpool, no.4 (b/w)
 Big Wood, 1959 IRN
 Pellegrini, p.79 (b/w)
 Black Bag (Sacco nero), 1956,
 fabric GCoZ
 Kahmen, pl.336 (b/w)
 Burnt Wood and Black (Combusti-
 one legno e nero), 1956 BBDo
 Haftmann, pl.935 (b/w)
 Combustione legno (Grande Com-
 bustione Legno), 1958, charred
 wood collage, Priv.Coll.
 1945, pl.58 (b/w)
 Janis, p.262 (b/w)
 Combustione M59 No.1, 1959,
 charred papers and vinyl
 Janis, p.262 (b/w)
 Ferro P.59, 1959, welded iron
 Janis, p.262 (b/w)
 Grande legno, 1958, wood on can-
 vas with charrings, Coll.
 Artist
 Liverpool, no.2 (b/w)
 Grande plastica, 1963, trans-
 parent plastic, Coll.Artist
 Liverpool, no.3 (b/w)
 Great Iron E (Grande Ferro E),
 1959, Coll.Artist
 Haftmann, pl.936 (b/w)
 Large Iron, 1960, Priv.Coll.,
 Rome
 Ponente, p.171 (col)
 New York, 1955, burlap collage,
 UNNJ
 Janis, p.261 (b/w)
 Rag Composition, 1952, cloth and
 burlap on board
 Janis, p.260 (b/w)
 The Real Umbria, 1952, oil and
 burlap, Priv.Coll., Brussels
 Abstract, pl.21 (b/w)
 Red Plastic Combustion, 1957,
 UICMar
 Seuphor, no.345 (col)
 Rosso plastic M3 IRMarl
 Metro, p.63 (col)

Rosso plastica 3, 1962, o/c,
 IRMarl
New Art, col.pl.52
S.C.2, 1953
 Metro, p.62 (b/w)
Sacco B.53, 1953, Coll.Artist
 Haftmann, pl.934 (col)
Sacco 4, 1954, burlap, etc. on
 cotton canvas ELDe
 L-S., pl.56 (col)
Sacco e oro, 1953, burlap, Coll.
 Artist
 Liverpool, no.1 (b/w)
Sacco e verde, 1956
 Wolfram, pl.75 (col)
Sack
 Pellegrini, p.80 (b/w)
Sack Number 5, 1953, vinavil and
 tempera on burlap, Coll.Artist
 Seitz, p.137 (col)
 Ponente, p.169 (col)
Sacking 56, oil on burlap FPV
 Seuphor, no.344 (col)
White, 1965
 Pellegrini, p.123 (col)
Wood and White, I, 1956, oil,
 tempera and wood on canvas,
 UNNG
 Arnason, fig.979 (b/w)

BURSSENS, Jan (Belgian, 1925-)
A Different Angel, 1958, o/c,
 BBC1
 Seuphor, no.458 (col)
The President, 1963, o/c,
 New Art, pl.187 (b/w), Priv.
 Coll.
 Fig.Art, pl.75 (b/w) BOsF

BURSTEIN, Pinchas. See MARYAN

BURT, Laurence (British, 1925-)
Weapon for Self Destruction of
 All Unimportant People, 1966,
 mixed media, Coll.Artist
 Wolfram, pl.97 (b/w)

BURTON, Dennis (Canadian, 1933-)
Rolled Hose Chick, 1965, o/c,
 CTI
 Lippard, pl.185 (b/w)

BURY, Pol (Belgian, 1922-)
Boules en mouvements, 1963
 Popper 2, p.129 (b/w)

18 Balls on 12 Planes Forming a
 Zigzag, 1966 BBM
 Trier, fig.237 (b/w)
The Erectile Entities, copper,
 SwLaSa
 L-S, pl.155 (b/w)
Erectile Punctuation, 1961,
 FPCle
 Pellegrini, p.171 (b/w)
Erectiles, 1962 ELH
 Brett, p.53 (b/w)
The Lectern, 1963
 Brett, p.54 (b/w)
19 Balls in an Open Volume, 1965,
 motorized wood construction
 Janis, p.293 (b/w)
1053 Dots, 1964, nylon wires in
 wood panel, motorized UDCHi
 Hh, pl.818 (b/w)
Punctuation (Ponctuation), 1961,
 wood, nylon and electric mo-
 tor ITSt
 Kahmen, pl.243 (b/w)
 UK2, pl.253 (b/w)
Rods (Les batons), 1964, wood,
 GDusSc
 Kahmen, pl.244 (b/w)
16 Balls, 16 Cubes on 7 Shelves,
 1966, wood,plywood,electric
 motor ELT
 Compton, pl.32 (b/w)
Sphere sur un Cylindre, 1969,
 stainless steel
 Calas, p.294 (b/w)
The Staircase, 1965, wood with
 motor UNNG
 Arnason, fig.1085 (b/w)
3069 Dots on an Oval Ground,
 1966, plastic, plywood, elec-
 tric motor ELT
 Compton, pl.31 (col)
25 Boules sur 10 Plans Inclines,
 1965, wood and cork
 Calas, p.293 (b/w)
23 Boules sur 5 Plans Inclines,
 1964 UNNG
 New Art, pl.193 (b/w)
2270 White Dots, 1965, wood and
 nylon FPMa
 Abstract, pl.287 (b/w)

BUSH, Jack (Canadian, 1908-1977)
Cerise Band, 1965, o/c UMMaH
 Carmean, p.48 (b/w)
Red Pink Cross, 1973, o/c, Priv.
 Coll., Boston
 Arnason 2, col.pl.284

BUSSE, Jacques (French, 1922-)
 Homage to Claude Nicolas Ledoux
 10, 1960, o/c FPMas
 Seuphor, no.198 (b/w)

BUTLER, Reg (British, 1913-)
 Boy and Girl, 1950, iron ELAr
 G-W, pl.213 (b/w)
 Figure in Space, 1957-58, bronze,
 UNNMat
 Selz, p.42 (b/w)
 Figure in Space, 1959, bronze
 Trier, fig.74 (b/w)
 Girl, 1953-54, bronze ELT
 L-S, pl.173 (b/w)
 Girl, 1954-56, bronze
 Arnason, fig.942 (b/w) UDCHi
 Hh, pl.626 (b/w)
 Selz, p.43 (b/w) UNNMat
 Girl Looking Down, 1956-57,
 bronze BAKO
 Fig.Art, pl.45 (b/w)
 Girl on a Long Base, 1953-54,
 bronze
 L-S, pl.226 (b/w)
 Girl on Back, 1968-72, painted
 bronze UNNMat
 Arnason 2, fig.988 (b/w)
 The Manipulator, 1954, bronze
 1945, pl.125 (b/w)
 Manipulator, 1956, bronze UDCHi
 Hh, pl.625 (b/w)
 Musee Imaginaire, 1963, bronze
 and wood UDCHi
 Hh, pl.880 (b/w)
 The Oracle, 1952, shell bronze
 on forged armature EHatT
 G-W, p.212 (b/w)
 Seated Girl, 1959-61, bronze,
 ELH
 New Art, pl.99 (b/w)
 Metro, p.65 (b/w)
 Tcheekle, 1960-61, bronze ELH
 Metro, p.64 (b/w)
 Torso, c.1950, iron UNBuA
 A-K, p.139 (b/w)
 The Unknown Political Prisoner
 (project for a monument),
 1951-53, bronze with stone
 base UNNMMA
 Selz, p.42 (b/w)
 Eng.Art, p.212 (b/w)
 UK1, pl.242 (b/w)
 Trier, fig.183 (b/w)
 Woman, 1949, forged iron ELT
 Selz, p.40 (b/w)

BUZZATTI, Dino
 Il visatore del Mattino, 1963,
 o/c, Coll.Artist
 Compton 2, fig.180 (b/w)

CAGLI, Corrado (Italian, 1910-)
 Bird in Cage, 1968, stainless
 steel, Coll.Artist
 Liverpool, no.44 (b/w)
 The Cock's Enigma, 1965, high-
 heddle tapestry, Coll.Artist
 Liverpool, no.43 (b/w)
 Concave and Convex, 1960, o/c,
 Coll.Artist
 Liverpool, no.41 (b/w)
 Memory of Castelmola above
 Taormina, 1963, o/c, Coll.
 Artist
 Liverpool, no.42 (b/w)

CAHN, Marcelle (French, 1895-)
 The Black Disk, 1960 BLG
 Seuphor, no.413 (b/w)
 Detachment, 1961, Coll.Artist
 Seuphor, no.415 (col)

CALAME, Genevieve
 Le Chant Rememore, 1975, video-
 tape (in collaboration with
 Jacques Guyonnet)
 L-S, pl.242 (b/w)

CALDER, Alexander (American,
 1898-1976)
 Antennae with Red and Blue Dots,
 1960, kinetic metal sculpture,
 ELT
 L-S, pl.149 (b/w)
 Compton, pl.24 (b/w)
 Black Beast, 1940, stabile in
 sheet steel
 G-W, p.209 (b/w) UNNV
 Andersen, p.40 (b/w)
 Arnason, fig.647 (b/w) UCtNcN
 Black Mobile with Hole, 1954,
 painted steel and metal rods,
 UCSacD
 Hunter, pl.504 (b/w)
 Bucephalus, 1963, sheet metal,
 FPMa
 Ashton, pl.II (b/w)
 The Cone, 1960, steel and alu-
 minum UNBuA
 A-K, p.307 (b/w)
 Conger, c.1950, iron and wire,
 UNBuA
 A-K, p.309 (b/w)

Relief: 'Chant du couple en 16
temps', 1966 ELKee
Brett, p.49 (b/w)

CAMARO, Alexander (German, 1901-)
Morgen am Fluss, 1953, o/c
1945, pl.87 (b/w)

CAMERON, Shirley (British, 1944-)
Agricultural Show, 1973, action
(in collaboration with Roland
Miller)
Eng.Art, p.430 (col)
Insides, Walcot Village, Bath,
1974, action (in collaboration
with Roland Miller)
Eng.Art, p.432 (b/w)
Lincolnshire Agricultural Show,
1975, action (in collaboration
with Roland Miller)
Eng.Art, p.433 (b/w)
Redman/Redwoman, Antwerp, 1974,
action (in collaboration with
Roland Miller)
Eng.Art, p.431 (col)
Untitled, Porto, Portugal, 1975,
action (in collaboration with
Roland Miller)
Eng.Art, p.431 (col)

CAMPIGLI, Massimo (Italian, 1895-
)
Girl, 1940, oil SwZK
Haftmann, pl.599 (b/w)
Staircase (La scala), 1941, oil,
IMC
Haftmann, pl.600 (b/w)

CAMPOLI, Cosmo (American, 1922-)
Birth, 1958, plaster model UICF
Selz, p.47 (b/w)
Birth of Death, 1950, bronze,
UICF
Selz, p.46 (b/w)
Jonah and the Whale, 1953, lead,
UNNGolu
Andersen, p.137 (b/w)
Mother and Child, 1949, plaster
Andersen, p.138 (b/w)
Mother and Child, 1958, marble,
UICF
Selz, p.48 (b/w)
Return of the Prodigal Son,
1957-59, plaster model UICF
Selz, p.49 (b/w)

CANE, Louis
Painting, 1973
Popper, p.246 (b/w)

CANEPA, Jack
Fold-Up 5, 1968
UK2, pl.280 (b/w)

CANIARIS, Vlassis (Greek, 1928-)
Ni accident, ni drame, 1964
New Art, col.pl.101

CANOGAR, Rafael (Spanish, 1934-)
The Conversation, 1965, a/c,
Priv.Coll., Madrid
Dyckes, p.27 (b/w)
Conversation, 1969, lithograph
Dyckes, p.145 (b/w)
The Couple, 1969, mixed media
Dyckes, p.63 (b/w)
Four Pictures of an Astronaut,
1960, o/c
New Art, col.pl.66
Learn to Be Absent, 1964, oil
Dyckes, p.27 (b/w)
Life is a Brief Journey, 1969
polyester resin, clothing and
wood -Ak
Dyckes, p.26 (b/w)
Mensula, 1962, o/c
Metro, p.68 (b/w)
Painting Nr.2, 1957, o/c
1945, pl.70 (b/w)
Painting No.48, 1959, o/c,
UNNMatC
Dyckes, p.26 (b/w)
Pintura 1962, 1962
Metro, p.69 (col)
Requiem II, 1963, oil
Dyckes, p.27 (b/w)
Self-Portrait, 1972, polyester
resin and fiberglass
Dyckes, p.93 (b/w)
Testing of the Future Astronaut,
1964
Pellegrini, p.108 (b/w)
The Tumult, 1966, o/c YSkM
Dyckes, p.111 (col)

CAPOGROSSI, Giuseppe (Italian,
1900-1972)
Oil, 1958 -Ar
Pellegrini, p.83 (b/w)
Painting, 1966 UNNBoni
Pellegrini, p.84 (b/w)

Painting on Paper No.13/B, 1950,
IVCar
 Seuphor, no.429 (b/w)
Surface 24, 1952 IMMar
 Seuphor, no.428 (col)
Surface 210, 1957, o/c UNNG
 Arnason, fig.978 (b/w)
Surface 249, 1957, oil and acry-
lic resin on canvas IMNav
 Liverpool, no.19 (b/w)
Surface 327, 1957, mixed media,
BBR
 Abstract, pl.104 (col)
Surface 253, 1958, synthetic
enamel and acrylic resin on
canvas IMNav
 Liverpool, no.20 (b/w)
Surface 325, 1959, synthetic
enamel and acrylic resin on
canvas IMNav
 Liverpool, no.21 (b/w)
Surface 333, 1959, oil acrylic
resin, pumice stone and saw-
dust on canvas IMNav
 Liverpool, no.22 (b/w)
Surface (Superficie), 1964, felt
pen on paper, Priv.Coll.
 Kahmen, pl.317 (b/w)
Surface 577, 1966 IVC
 Pellegrini, p.84 (b/w)
Surface R (Superficie R), 1950,
oil IBrC
 Haftmann, pl.970 (b/w)
Superficie, 1957, o/c
 1945, pl.49 (col)
Superficie N.389, 1960, o/c,
IMMa
 Metro, p.70 (b/w)
Superficie N.399, 1961, o/c,
IMNav
 Metro, p.71 (b/w)
Superficie 626, 1963-68
 UK2, col.pl.XV
Superficie 531, 1964, o/c IRBr
 New Art, col.pl.53

CAPPELO, Carmelo (Italian, 1912-)
 Eclipse, 1959, bronze
 Trier, fig.13 (b/w)

CARMASSI, Arturo
 Untitled, 1951, collage IRO
 Janis, p.229 (b/w)

CARMI, Eugenio
 Image: A662, 1966
 UK2, pl.377 (b/w)

Image: D255, 1966
 UK2, pl.375 (b/w)
SPCE Image: B424, 1966
 UK2, pl.374 (b/w)
SPCE Image: C256, 1966
 UK2, pl.376 (b/w)

CARO, Anita de (American, 1909-)
 Gouache, 1960 FPMS
 Seuphor, no.366 (col)

CARO, Anthony (British, 1924-)
 Bennington, 1964, painted steel
 Geldzahler, p.423 (b/w)
 Carriage, 1966, painted steel,
UNWoF
 Carmean, p.49 (b/w)
 Early One Morning, 1962, steel
and aluminum
 New Art, pl.91 (b/w)
 Giorgiana, 1969-70, painted
steel UNBuA
 A-K, p.99 (col)
 Homage to David Smith, 1966,
painted steel UDCSwi
 L-S, pl.198 (b/w)
 Hot Dog Flats, 1974, rusted and
varnished steel CTM
 Arnason 2, fig.1171 (b/w)
 LXI, 1968, steel painted brown,
ELHay
 Kahmen, pl.288 (b/w)
 Midday, 1960, painted steel
 Arnason, col.pl.243
 Eng.Art, p.210 (b/w)
 Monsoon Drift, 1975, steel,
UNNEm
 Arnason 2, fig.1170 (b/w)
 Orangerie, 1969, painted steel
 Busch, fig.45 (b/w)
 Eng.Art, p.215 (b/w)
 Prima Luce, 1966, steel painted
yellow -UWa
 Trier, fig.228 (b/w)
 Rainfall, 1964, painted steel,
UDCHi
 Hh, pl.920 (b/w)
 Riviera, 1971-74, rusted steel,
UWaSWri
 Arnason 2, fig.1169 (b/w)
 Sculpture XXII, 1967, Pacific-
grey steel, Priv.Coll.
 Abstract, pl.234 (b/w)
 Sleepwalk, 1965
 Eng.Art, p.315 (b/w)

Straight Flush, 1972, painted
 steel UMnMW
 Arnason 2, fig.1238 (b/w)
 Walker, pl.33 (col)
Sun-Feast, 1969-70, painted
 steel, Priv.Coll.
 L-S, pl.208 (col)
24 Hours, 1960
 Eng.Art, p.208 (b/w)
Verduggio Dream, 1972-73, steel,
 SwZE
 Eng.Art, p.236 (b/w)
Verduggio Fan, 1972-73, steel,
 SwZE
 Eng.Art, p.236 (b/w)
Verduggio Light, 1972-73, steel,
 Priv.Coll., Italy
 Eng.Art, p.238 (b/w)
Verduggio Sound, 1972-73, steel,
 SwZK
 Eng.Art, p.239 (b/w)
The Window, 1966-67, painted
 steel -Caro
 Abstract, pl.233 (b/w)
 Eng.Art, p.215 (b/w)
Yellow Swing, 1965, painted
 steel
 Geldzahler, p.423 (b/w)

CASCELLA, Andrea (Italian, 1920-)
 Geronimo, 1964, black Belgian
 marble UDCHi
 Hh, pl.824 (b/w)
 I Dreamed My Genesis..., 1964,
 granite UDCHi
 Hh, pl.823 (b/w)
 Leda, 1960, white marble IMAr
 Trier, fig.107 (b/w)
 Narcissus, 1967, black Belgian
 marble IMAr
 Arnason, fig.1021 (b/w)
 Un 'ora del passato, 1964, mar-
 ble
 New Art, pl.114 (b/w)
 Pensatore di stella, 1966
 UK1, pl.181 (b/w)
 Sculpture, 1970, diorite, Coll.
 Artist
 Liverpool, no.45 (b/w)
 Sculpture, 1971, white granite,
 Coll.Artist
 Liverpool, no.46 (b/w)
 Sculpture, 1971, marble, Coll.
 Artist
 Liverpool, no.47 (b/w)

The White Bride, 1962, marble,
 ELGro
 L-S, pl.179 (b/w)

CASSINARI, Bruno (Italian, 1912-)
 Paesaggio, 1957, o/c
 1945, pl.45 (col)

CASTELLANI, Enrico (Italian,
 1930-)
 Convergent Structure, 1966
 UK1, pl.271 (b/w)
 Divergent Structure no.4, 1966,
 UNNPa
 Barrett, p.92 (b/w)
 Pink Surface, 1963 IMAr
 Pellegrini, p.185 (b/w)
 Superficie blu, 1963, o/c IMAr
 New Art, col.pl.62
 White Surface 2, 1962, o/c,
 UDCHi
 Hh, pl.942 (b/w)
 White Surface No.32, 1966, var-
 nished canvas IMAr
 Abstract, pl.147 (b/w)

CASTORO, Rosemarie (American,
 1939-)
 Eclipse, March 7, 1970
 Meyer, pp.105-07 (b/w)
 Roomcracking, 1969
 Meyer, p.104 (b/w)
 Room Cracking #7, May 1969
 6 Yrs, p.100 (b/w)

CASTRO, Lourdes
 Beige et beige, 1966
 UK2, pl.162 (b/w)
 Cafe, 1964
 UK2, pl.144 (b/w)
 Ombre portee blanc negatif et
 positif, 1966
 UK2, pl.153 (b/w)

CASTRO-CID, Enrique
 Anthropomorphical I, 1964, mo-
 torized construction with
 skeletal drawing
 Janis, p.293 (b/w)

CAULFIELD, Patrick (British,
 1936-)
 Battlements, 1967, o/c ELT
 Compton 2, fig.80 (b/w)
 Black and White Flower Piece,
 1963, oil on board
 Finch, p.27 (b/w)

Cafe Interior Afternoon, 1970,
 o/c ELW
 Eng.Art, p.59 (col)
Dining Recess, 1972, a/c ELAr
 Eng.Art, p.60 (b/w)
Forecourt, 1975, a/c ELW
 Eng.Art, p.61 (b/w)
Greece Expiring on the Ruins of
 Missolonghi, 1963 or 1964, o/c,
 ELPow
 New Art, pl.93 (b/w)
 Russell, pl.70 (b/w)
 Compton 2, fig.82 (b/w)
Inside a Swiss Chalet, 1969, o/c,
 ELW
 Eng.Art, p.60 (b/w)
Interior with Room Divider, 1971,
 oil and acrylic on canvas ELW
 Eng.Art, p.60 (b/w)
Leaving Arabia, 1961
 Eng.Art, p.19 (b/w)
Parish Church, 1967, o/c ELStu
 Stuyvesant, p.139 (b/w)
Pottery, 1969, o/c ELT
 Wilson, pl.44 (col)
Ring, 1961, o/c EG1S
 Compton 2, fig.81 (b/w)
 Eng.Art, p.27 (b/w)
 Finch, p.26 (b/w)
Ruins, 1964, silkscreen print
 Finch, p.28 (b/w)
Sculpture in a Landscape, 1966,
 oil on hardboard ELAr
 Russell, pl.65 (b/w)
 Finch, p.25 (b/w)
Still Life on Table, 1964, oil
 on board
 Amaya, p.114 (b/w)
Still-life with Bottle, Glass
 and Drape, 1962, o/c
 Finch, p.28 (b/w)
Still Life with Dagger, 1963, oil
 on board
 Lippard, pl.51 (b/w)
Still-life with Red and White
 Pot, 1966, oil on board UNNAb
 L-S, pl.115 (b/w)
View of the Bay, 1964, oil on
 board ELBrC
 Amaya, p.113 (b/w)
 Compton 2, fig.79 (col)
View of the Bay, 1964, oil on
 wood PoLG
 Fig.Art, pl.159 (b/w)
View of the Chimneys, 1964, o/c,
 ELStu
 Stuyvesant, p.138 (b/w)

CAVALIERE, Alik (Italian, 1926-)
 La main et la rose, 1965
 UK1, pl.58 (b/w)
Tree in the Rain, 1968, bronze
 and glass, Coll.Artist
 Liverpool, no.48 (b/w)

CELANTANO, Francis (American,
 1928-)
 Kinetic Painting no.3, 1967,
 UNNWise
 Barrett, p.16 (b/w)

CELIC, Stojan (Yugoslavian, 1925-
)
 Typical Climate, 1962, o/c
 New Art, col.pl.112

CEROLI, Mario (Italian, 1938-)
 Butterflies, 1967
 UK1, pl.84 (b/w)
Cassa Sistina, 1966
 UK1, pl.27 (b/w)
Gabbia, 1967
 UK1, pl.337 (b/w)
The He-Man (Il mister), 1965,
 wood UNNBoni
 Kahmen, pl.143 (b/w)
 UK1, pl.25 (b/w)
Marcus, 1968, wood GDusSc
 Kahmen, p.242 (b/w)
Il mister, 1964 IRFra
 New Art, pl.124 (b/w)
La scala (Steps), 1965, wood,
 Coll.Artist
 Liverpool, no.62 (b/w)
Subliminal Cock, 1968, wood,
 GDusSc
 Kahmen, pl.247 (b/w)
L'uomo di Leonardo, 1964
 UK1, pl.26 (b/w)
Venus (Venere), 1965, wood,
 UNNBoni
 Kahmen, pl.142 (b/w)
 UK1, pl.24 (b/w)

CESAR (Cesar Baldaccini) (French,
 1921-)
 Bird, 1954, soldered brass and
 crackle-finished iron FPFue
 Fig.Art, pl.41 (b/w)
Cesar's Thumb (Le pouce de Ce-
 sar), 1965 or 1967, bronze
 Kahmen, pl.215 (b/w) FPB
 UK1, pl.57 (b/w)
 Hh, pl.852 (b/w) UDCHi

Chateau magique, 1960, iron
 Janis, p.245 (b/w)
Compression, 1960 FPDur
 Fig.Art, pl.265 (b/w)
Compression, 1960 FPAN
 Wilson, pl.57 (col)
Dauphine, 1961, bronze FPB
 L-S, pl.194 (b/w)
Facade Nr.1, 1961, collage with
 automobile parts, Priv.Coll.
 New Art, col.pl.32
Governed Compression I, 1960,
 pressed copper
 Janis, p.244 (b/w)
Homage, 1958, iron FPMai
 G-W, p.308 (b/w)
Homme de Draguignan, 1957-58,
 bronze FPB
 Trier, fig.98 (b/w)
Insecte, 1956
 UK1, pl.75 (b/w)
Large Expansion, 1967, aluminum
 Fig.Art, pl.267 (b/w)
La Main FPB
 Wolfram, pl.94 (b/w)
La Maison de Davotte, 1960,
 iron UNNHi
 Arnason, fig.920 (b/w)
La maison de Roel, 1961, iron
 Janis, p.245 (b/w)
Marseille, 1960, cast 1963,
 bronze UDCHi
 Hh, pl.690 (b/w)
Molten Egg (Coulee a l'oeuf),
 1966, polyester
 Kahmen, pl.192 (b/w)
Moteur No.3, welded iron and
 copper
 Janis, p.246 (b/w)
Motor 4, 1960, welded metal,
 UNNSai
 Seitz, p.145 (b/w)
Nude, bronze -Roth
 Fig.Art, pl.40 (b/w)
Nude, 1958, bronze UNNHi
 Arnason, fig.919 (b/w)
Nude of Saint-Denis I, 1956,
 forged and welded iron UNNEl
 Selz, p.52 (b/w)
Nude of Saint-Denis IV, 1957,
 bronze ELH
 Selz, p.54 (b/w)
On est 3, 1961, compressed metal
 Janis, p.245 (b/w)
Petit panneau, 1958
 UK1, pl.149 (b/w)

Petite Tete de Radiateur, 1960,
 iron FPB
 Trier, fig.144 (b/w)
Thumb, 1967, bronze, Coll.Artist
 Fig.Art, pl.266 (b/w)
Tiroir N.2, 1962, iron
 Metro, p.73 (b/w)
Torso, 1954, welded iron, Priv.
 Coll., New York
 Selz, p.51 (b/w)
The Two of Us (On est deux),
 1961 GCoZ
 Kahmen, pl.269 (b/w)
 Metro, p.72 (b/w)
Victoire de Villetaneuse, 1960,
 bronze
 UK1, pl.6 (b/w)
The Victory of Villetaneuse,
 1965, iron FPB
 Arnason, fig.922 (b/w)
Venus of Villetaneuse, 1960,
 bronze UDCHi
 Hh, pl.809 (b/w)
Viens ici que j't'esquiche,
 1961, pressed copper
 Janis, p.245 (b/w)
Winged Figure, c.1957, cast
 iron UMoSLWe
 Selz, p.53 (b/w)
The Yellow Buick, 1959, com-
 pressed automobile UNNMMA
 Arnason, fig.921 (b/w)

CHADWICK, Lynn (British, 1904-)
 Balanced Sculpture, 1951
 Eng.Art, p.209 (b/w)
 Beast XII, 1957
 UK1, pl.72 (b/w)
 Dragonfly, 1951, iron ELT
 Compton, pl.25 (b/w)
 The Inner Eye, 1952, iron, wire
 and glass UNNMMA
 G-W, p.215 (b/w)
 Maquette for Two Winged Figures,
 1956, iron
 1945, pl.126 (b/w)
 Moon of Alabama, 1957, iron
 composition, Coll.Artist
 G-W, p.248 (b/w)
 The Stranger II, 1956, iron and
 conglomerate
 Trier, fig.97 (b/w)
 Tokyo I, 1962, welded steel
 Metro, p.74 (b/w)
 Trigon, 1961, steel frame and
 composition filling
 Metro, p.75 (b/w)

Two Dancing Figures No.6, 1955,
 iron and mixed composition,
 ELG
 Fig.Art, pl.43 (b/w)
Two Seated Figures II, 1973,
 bronze ELMa
 Arnason 2, fig.1062 (b/w)
Two Watchers, 1958, iron and
 plaster with iron chips GWupZ
 Trier, fig.42 (b/w)
The Watchers, 1960, bronze
 New Art, pl.100 (b/w)
Winged Figures, 1955, bronze,
 ELT
 L-S, pl.171 (b/w)
Winged Figures, 1962, painted
 iron, Coll.Artist
 Arnason, fig.1002 (b/w)

CHAGALL, Marc (Russian-French,
 1887-)
 Abdullah the Fisherman (from
 Four Tales of the Arabian
 Nights), 1948, lithograph,
 Priv.Coll., Fribourg
 Castleman, p.33 (col)
 The Blue Circus, 1950-52, oil,
 Coll.Artist
 Haftmann, pl.504 (b/w)
 Clock with Blue Wing, oil on
 panel, Priv.Coll.
 Fig.Art, pl.15 (b/w)
 The Flayed Ox, 1947, oil, Priv.
 Coll., Paris
 Haftmann, pl.501 (b/w)
 Jacob's Dream, 1962, o/c, Priv.
 Coll, Paris
 Fig.Art, pl.14 (b/w)
 Moses Breaks the Tables of the
 Law, 1955-56, oil on canvas-
 backed paper GCoW
 Haftmann, pl.506 (b/w)
 Roofs, 1953, oil on canvas-
 backed paper, Coll.Artist
 Haftmann, pl.503 (b/w)
 Self-Portrait with Clock, 1947,
 oil, Coll.Artist
 Haftmann, pl.505 (b/w)

CHAMBERLAIN, John (American, 1921-
)
 Beezer, 1964, auto lacquer,
 metal flake and chrome on ma-
 sonite. UDCHi
 Hh, pl.930 (b/w)

Big E, 1962
 UK1, pl.147 (b/w)
Ca-d'Oro, 1964, auto metal
 Busch, pl.V (col)
Char-Willie, 1974, chrome and
 painted auto parts IRLo
 Arnason 2, fig.1079 (b/w)
Colonel Splendid, 1964, painted
 steel plate
 Ashton, pl.XXV (col)
Dandy Dan-D, 1963, welded auto
 parts UNNSon
 Calas, p.52 (b/w)
Dolores James, 1962, welded auto
 metal UNNG
 Andersen, col.pl.1
Dolores James, 1962, welded auto
 metal UNNC
 Geldzahler, p.68 (col)
Essex, 1960, painted metal UNNC
 Seitz, p.138 (col)
Fantail, 1961, painted steel,
 UNNJohn
 Geldzahler, p.124 (b/w)
Funburn, 1967, foam rubber and
 cord GDaS
 Kahmen, pl.268 (b/w)
Heng, 1967, urethane UNNRu
 Hunter, pl.802 (b/w)
Huzzy, 1961, welded metal UMoKB
 Metro, p.77 (b/w)
I-Chiang, 1967, urethane
 Calas, p.52 (b/w)
Kroll, 1961, steel UNBuA
 A-K, p.278 (b/w)
Madam Moon, 1964, stainless
 steel and painted metal UNNC
 New Art, pl.39 (b/w)
Mr. Press, 1961, metal relief,
 UNNGel
 Rose, p.262 (b/w)
Nutcracker, 1960, crushed metal,
 UNNJ
 Janis, p.248 (b/w)
El Reno, 1961, soldered metal
 Metro, p.76 (b/w)
Silverheels, 1963, welded auto
 metal UNNC
 Arnason, fig.1013 (b/w)
Slauson, 1964
 UK1, pl.148 (b/w)
Sweet William, 1962, metal,
 UCLCM
 Hunter, pl.552 (col)
 Wolfram, pl.96 (b/w)

Tippecanoe, 1967, galvanized
steel and aluminum UNNWh
Hunter, pl.801 (b/w)
Untitled, 1960, welded metal,
UDCHi
L-S, pl.192 (b/w)
Untitled, 1960, welded scrap
metal UNNH
Hamilton, pl.356 (b/w)
Velvet White, 1962, welded
steel UNNW
Geldzahler, p.125 (b/w)
Whitney, p.121 (b/w)
Wildroot, 1959, welded and
painted steel
Andersen, p.126 (b/w) GDaS
Hunter, pl.597 (b/w) UNNSto

CHAMBERLAIN, Wynn (American, 1929-
)
Group Portrait, 1964
UK2, pl.73 (b/w)
Homage to Manet, 1964
UK2, pl.130 (b/w)

CHARCHOUNE, Serge (Russian, 1888-
)
The Sea, 1950, o/c FPCre
Seuphor, no.217 (col)
Small Picture, 1955, o/c FPCre
Seuphor, no.218 (col)

CHARLTON, Alan (British, 1948-)
Channel Painting, Aug.1971,
acrylic emulsion on cotton
duck IVaPa
Eng.Art, p.64 (b/w)
Channel Painting, Aug.1971,
acrylic emulsion on cotton
duck IVaPa
Eng.Art, p.66 (b/w)
Channel Painting, Sept.1971,
acrylic emulsion on cotton
duck IVaPa
Eng.Art, p.65 (b/w)
Channel Painting, Jan.1972,
acrylic emulsion on cotton
duck IVaPa
Eng.Art, p.67 (b/w)
Double Channel Painting, 1972,
IVaPa
Eng.Art, p.63 (b/w)

CHICAGO, Judy (American, 1939-)
Aluminum Game, 1967, sandblasted
aluminum
Busch, fig.12 (b/w)

Cubes and Cylinders-Rearrange-
able, 1967, gold-plated
steel -Lan
Busch, fig.11 (b/w)
Gold-Plated Game, 1967
Busch, fig.21 (b/w)

CHILLIDA, Eduardo (Spanish, 1924-
)
Abesti Gogora III, 1962-64,
wood UICA
Dyckes, p.73 (b/w)
Abesti Gogora IV, 1960-64,
wood SpCuM
Dyckes, p.74 (b/w)
Abesti Gogora V, 1966, granite,
UTxHA
Trier, fig.242 (b/w)
Dyckes, p.74 (b/w)
Anvil of Dreams No.1, 1954-58,
iron
Dyckes, p.73 (b/w)
Collage No.1, 1959, papier colle
Janis, p.152 (b/w)
Enclume de reve N.9, 1960
Metro, p.78 (b/w)
Field, Space of Peace (Champ,
espace de paix), 1965, iron
Kahmen, pl.292 (b/w)
Ikaraundi (The Great Tremor),
1957, bronze UDCHi
Hh, pl.669 (b/w)
Dyckes, p.75 (b/w)
Ilarik, Sepulchral Stele, 1951,
iron SwBeMe
G-W, p.315 (b/w)
Inguru IV, 1968, etching
Dyckes, p.142 (b/w)
Modulation of Space, 1963,
metal ELT
L-S, pl.200 (b/w)
Murmur of Boundaries No.3 (Ru-
mor de limites No.3), 1959,
steel FPMa
G-W, p.203 (b/w)
Mute Music (La Musica callada),
1955, iron, Priv.Coll., Basel
G-W, p.202 (b/w)
Relief, 1965, wood
Dyckes, p.75 (b/w)
Rumour de limites N.4, 1960,
forged iron
Metro, p.79 (b/w)
Space Modulation IV, 1966, iron,
FPMa
Arnason, fig.1020 (b/w)

Fragments for the Gates to Times Square II, 1966, neon and plexiglass UNNPac
Hamilton, pl.373 (b/w)
The Gates to Times Square, 1966, steel,neon and plexiglass
UK1, pl.332 (b/w)
Andersen, p.202 (b/w)
Neon Bird, 1969, neon and plexiglass, Coll.Artist
Calas, p.306 (b/w)
Newspaper (Stock exchange quotations), 1959-60, o/c, Coll. Artist
Calas, p.305 (b/w)
Nonfunctioning Electrodes No.1, 1967, neon, electrodes, and plexiglass UNNPac
Arnason, fig.1096 (b/w)
Positive-Negative, 1965, neon lights and stainless steel, UNCheW
Hunter, pl.920 (b/w)
Study for the Gates #15 (Flock of Morning Birds from "Iphigenia in Aulis" by Euripedes), 1967, black neon tubing UDCHi
Hh, pl.931 (b/w)
Untitled (Never on Sunday), 1962, lithograph UNNW
Whitney, p.136 (b/w)

CIBULA, Ellen
Wave Series No.8, 1969, liquitex on canvas UNNHarr
Hunter, pl.737 (col)

CILLERO, Andres (Spanish)
Green and Red, 1964, o/c SpMel
New Art, pl.147 (b/w)

CIMIOTTI, Emil (German, 1927-)
Group of Figures, 1958, bronze, GBrSM
Trier, fig.81 (b/w)
Pineta, 1959, bronze GDuK
Metro, p.81 (b/w)
Rocks and Clouds, 1959, bronze, Priv.Coll.
Trier, fig.170 (b/w)
Untitled, 1964, bronze, Coll. Artist
New Art, pl.324 (b/w)
Der Wald, 1960, bronze GML
Metro, p.80 (b/w)

CITYARTS WORKSHOP
Anti-Drug Abuse, mural UNNSmit
Popper, p.251 (col)
Arise from Oppression, mural, UNNHen
Popper, p.265 (b/w)
History of Chinese Immigration to the United States, mural, UNNCat
Popper, p.266 (b/w)

CIVITICO, Bruno
Florence-San Lorenzo, 1968, o/c, UNNFis
UK3, pl.140 (b/w)

CLARET, Joan (Spanish, 1934-)
882F, 1968, o/c
Dyckes, p.55 (b/w)
786A, 1966, o/c
Dyckes, p.125 (b/w)
Wall Composition, 1963, o/c
New Art, pl.136 (b/w)

CLARK, Lygia (Brazilian, 1921-)
Air & Stone, 1966
Brett, p.64 (b/w)
Cannibalism, Paris, 1973
Popper, p.15 (b/w)
La casa e il corpo, 1968
UK2, pl.405 (b/w)
Cellular Architecture, Paris, 1973
Popper, p.16 (b/w)
Clothing-Body-Clothing "taglio cezario", 1968
UK4, pls.80-81 (b/w)
Dialogue of Hands, 1966, elastic moebius band (in collaboration with Helio Oiticica)
Brett, p.63 (b/w)
UK4, pl.83 (b/w)
Grub, 1964, green rubber, Priv. Coll.
Brett, p.62 (b/w)
Monument in All Situations, 1964, aluminum
Brett, pp.6-7 (b/w)
Moveables, 1960s, aluminum
Busch, figs.92-93 (b/w)
Reliefs and Articulated Metal Sculptures ('Animals'), 1959-64
Brett, p.60 (b/w)
Sensory Cowl, 1968
UK4, pl.82 (b/w)

Untitled, 1958
 UK2, pl.391 (b/w)
Water & Shells, 1966
 Brett, p.58 (b/w)

CLARKE, John Clem (American, 1937-
)
 Copley-Governor and Mrs. Thomas
 Miffin, 1969, o/c UDCHi
 Hh, pl.877 (b/w)
 Judgment of Paris, 1969, a/c,
 UCBC
 Hunter, pl.689 (col)
 Judgment of Paris IV, 1969, o/c,
 UWiMA
 UK3, pl.49 (b/w)
 Judgment of Paris, 1970, o/c
 Battcock, p.39 (b/w)
 Liberty Leading the People (Af-
 ter Delacroix), 1968, o/c,
 UNNBake
 Russell, pl.69 (b/w)
 "Maids of Honor" Velazquez,
 1972, o/c
 Battcock, p.247 (b/w)
 Rembrandt-The Night Watch, 1967
 UK2, pl.77 (b/w)
 Small Bacchanale, 1970, o/c,
 UNNHarr
 UK3, pl.50 (b/w)
 Three Graces, 1970, o/c GAaN
 UK3, pl.47 (b/w)
 Three Graces, 1970, o/c UNNHarr
 UK3, pl.48 (b/w)
 Untitled, 1970 UNNHarr
 UK3, pl.III (col)
 Vermeer-Woman with Jug, 1970,
 o/c UNNKor
 UK3, pl.75 (b/w)

CLAUS, Carlfriedrich (German,
 1930-)
 Paracelsische Denklandschaft,
 1962, pen GFreiR
 New Art, pl.285 (b/w)

CLERICI, Fabrizio (Italian, 1913-
)
 The Labyrinth, 1966, o/c, Priv.
 Coll.
 Fig.Art, pl.141 (b/w)

CLOAR, Carroll (American, 1913-)
 Day Remembered, 1955, casein and
 tempera on masonite UDCHi
 Hh, pl.570 (b/w)

CLOSE, Chuck (American, 1941-)
 Frank, 1969, a/c UMnMI
 UK3, pl.7 (b/w)
 Keith, 1970, a/c, Priv.Coll.,
 New York
 UK3, pl.8 (b/w)
 Kent, 1971, colored drawing,
 FPDelo
 Walker, pl.51 (col)
 Nancy, 1960, a/c -By
 UK3, pl.4 (b/w)
 Nat, 1971, a/c
 Battcock, p.153 (b/w)
 Nat, 1972, watercolor on paper,
 GAaN
 L-S, pl.224 (b/w)
 Phil, 1969, a/c UNNW
 UK3, pl.6 (b/w)
 Portrait, 1970, a/c
 Popper, p.247 (b/w)
 Richard, 1969, a/c GAaN
 UK3, pl.9 (b/w)
 Richard, 1973, a/c
 Rose, p.237 (b/w)
 Self Portrait, 1968, a/c UMnMW
 UK3, pl.5 (b/w)
 Battcock, p.148 (b/w)
 Arnason 2, fig.1248 (b/w)
 Hunter, pl.692 (b/w)
 Self Portrait, 1973, ink and
 pencil
 Battcock, p.159 (b/w)

CLOUGH, Prunella (British, 1919-)
 Electrical Landscape, 1960, o/c,
 ELStu
 Stuyvesant, p.72 (b/w)

COETZEE, Christo (South African,
 1930-)
 Butterfly Lighting in a Diamond,
 1960, o/c UCtNcJ
 Seitz, p.131 (b/w)

COHEN, Bernard (British, 1933-)
 Fable, 1965, a/c ELStu
 Stuyvesant, p.129 (b/w)
 Fall, 1964, oil and egg tempera
 on canvas ELT
 Eng.Art, p.71 (b/w)
 Floris, 1964, o/c, Coll.Artist
 New Art, col.pl.36
 Matter of Identity I, 1972, oil,
 tempera and metallic aerosol
 paint on canvas ELT
 Eng.Art, p.70 (b/w)

Mist, 1963 ELGul
 Pellegrini, p.290 (b/w)
Painting 96, 1960
 Eng.Art, p.16 (b/w)
Red One, 1965, a/c ELW
 Eng.Art, p.73 (b/w)
Resting Place, 1975, acrylic on
 linen ELW
 Eng.Art, p.72 (col)
Three Sprayed Spots, 1970, a/c,
 ELT
 Eng.Art, p.73 (b/w)
Two Quite Different Things,
 1973-74, acrylic on linen,
 ELBrC
 Eng.Art, p.73 (b/w)
When White, 1963, oil and tem-
 pera on canvas ELStu
 Stuyvesant, p.130 (b/w)

COHEN, George (American, 1919-)
 Anybody's Self-Portrait, framed
 mirror mounted on masonite
 with other objects UICFe
 Seitz, p.112 (b/w)
 Game of Chance, 1954, metal,
 plastic, etc. on wood -UH
 Janis, p.231 (b/w)
 Set IIA, 1966
 UK2, pl.160 (b/w)
 Set IIB, 1966
 UK2, pl.161 (b/w)

COHEN, Harold (British, 1928-)
 Consul, 1966, a/c ELStu
 Stuyvesant, p.90 (b/w)
 Landfall, Summer, 1960, o/c,
 ELStu
 Stuyvesant, p.90 (b/w)
 Pandora, 1964, o/c ELFr
 New Art, col.pl.35
 Seated Figure, 1955, o/c ELG
 1945, pl.131 (b/w)
 Secret, 1964, oil and acrylic
 on canvas ELStu
 Stuyvesant, p.91 (b/w)

COLLA, Ettore (Italian, 1899-1968)
 Agreste, 1952, welded parts of
 farm implements, Coll.Artist
 Seitz, p.149 (b/w)
 Continuity, 1951, welded con-
 struction of wheels, Coll.
 Artist
 Seitz, p.148 (b/w)

Cupid and Psyche, 1962, iron,
 Priv.Coll., Rome
 Liverpool, no.25 (b/w)
Dioscuri, 1961, iron, Priv.Coll.
 New Art, pl.112 (b/w)
Divinita industriale, 1966
 UK1, pl.145 (b/w)
Grande Spirale, 1962
 UK1, pl.252 (b/w)
Magic Circle, 1958, iron -A1
 Trier, fig.142 (b/w)
Orpheus, 1957, iron, Priv.Coll.,
 Rome
 Liverpool, no.23 (b/w)
Penelope, 1961, iron, Priv.Coll.,
 Rome
 Liverpool, no.24 (b/w)

COLLINS, James
 Introduction Piece No.5, 1970
 6 Yrs, p.177 (b/w)

COLLINS, Jess (American, 1923-)
 Nadine, 1955, collage on board,
 UCSFDi
 Seitz, p.111 (b/w)
 Tricky Cad (Case VII), 1959,
 newspaper collage UCLCM
 Lippard, pl.131 (b/w)
 Russell, pl.78 (b/w)
 Compton 2, fig.95 (b/w)

COLMENAREZ, Asdrubal
 Tactiles Psychomagnetiques, Bi-
 ennale of Paris, 1971, wall
 with magnetic ribbons
 Popper, p.187 (b/w)

COLOMBO, Gianni (Italian, 1937-)
 Plastic Statement, Eindhoven,
 1966
 Popper 2, p.178 (b/w)
 Pulsating Structure, 1959, poly-
 styrene blocks, Coll.Artist
 Brett, p.55 (b/w)
 Roto-optic, 1964-66, fast moving
 points, Coll.Artist
 Brett, p.56 (b/w)

COLVILLE, Alex (Canadian, 1920-)
 Truck Stop, 1966
 UK2, pl.260 (b/w)

CON, Rob (Robert Conybeare) (British, 1949-)
Liquid Boots (Visual Display
 Devices), Wolverhampton, 1969
 Henri, fig.98 (b/w)
Untitled, Southampton, 1975,
 action
 Eng.Art, p.411 (b/w)
The White Men, Wolverhampton,
 1970, action
 Henri, fig.97 (b/w)

CONNER, Bruce (American, 1933-)
Child, 1959, wax, wood and ny-
 lon UNNMMA
 Andersen, p.156 (b/w)
 Janis, p.232 (b/w)
Couch, 1963, assemblage UCPaM
 L-S, pl.99 (b/w)
The Last Supper, 1960, wax, wood,
 metal, etc.
 Andersen, p.157 (b/w)
Last Supper, 1961, wax, rags,
 etc. on wooden table UNNA1
 Seitz, p.89 (b/w)
Medusa, 1960, wax, nylon, etc.,
 UNNW
 Hunter, pl.804 (b/w)
Mirror Collage, 1960, steel en-
 graving on mirror
 Janis, p.231 (b/w)
Untitled, 1961, assemblage,
 UNNLa
 Ashton, pl.XLIX (b/w)

CONSAGRA, Pietro (Italian, 1920-)
Carmine, 1964, painted wood,
 Coll.Artist
 Liverpool, no.10 (b/w)
Colloquio libero, 1961, bronze,
 Coll.Artist
 New Art, pl.113 (b/w)
Conversation Piece, 1958, wood,
 UNNG
 Arnason, fig.1024 (b/w)
Human Colloquium, 1958, wood
 Trier, fig.26 (b/w)
Impronta solare, 1961, bronze
 Metro, p.83 (b/w)
Little Colloquy, 1955, bronze,
 UDCHi
 Hh, pl.753 (col)
Pale Violet, 1964, painted alu-
 minum, Coll.Artist
 Liverpool, no.10 (b/w)

Red, 1964, painted wood, Coll.
 Artist
 Liverpool, no.10 (b/w)
Specchio ulteriore, 1961
 Metro, p.82 (b/w)
Transparent Turquoise Iron,
 1966, painted iron
 Hh, pl.839 (b/w) UDCHi
 Liverpool, no.11 (b/w) IRMarl
White, 1964, painted wood, Coll.
 Artist
 Liverpool, no.10 (b/w)

CONSTANT (Constant Anton Nieuwen-
 huys) (Dutch, 1920-)
New Babylon (model of a concert
 building for electronic music),
 1960, metal, plexiglass and
 wood, Coll.Artist
 New Art, pl.162 (b/w)
Projected Monument for Amster-
 dam, 1955, iron wire
 Trier, fig.182 (b/w)
Scorched Earth II, 1951, o/c,
 NAS
 Fig.Art, pl.80 (b/w)

CONYBEARE, Robert. See CON, Rob

COOPER, Austin (British, 1890-)
Apache, hoarding collage
 Janis, p.178 (b/w)
Tal-lee, 1948, paper, ink, wax,
 ELG
 Seitz, p.102 (b/w)

COPLEY, Alfred Lewin. See ALCOP-
 LEY

COPLEY, William Nelson (Cply)
 (American, 1919-)
Casey Strikes Out, 1966, o/c,
 FPIo
 Kahmen, pl.39 (b/w)
 UK2, pl.112 (b/w)
Model for 'American Flag', 1961,
 o/c UIWMa
 Lippard, pl.12 (b/w)

COPPEL, Jean
Collage, 1955
 Janis, p.153 (b/w)

CORBERO, Xavier (Spanish, 1935-)
Construction and Motion, 1965,
 stainless iron, glass, bronze,
 UNNSt
 New Art, pl.145 (b/w)
Micromacromaniac-maker, 1965,
 stainless steel, brass and
 wire UNNSt
 Dyckes, p.85 (b/w)

CORNEILLE (Cornelis van Beverloo)
 (Belgian, 1922-)
Antilles I, 1961 FPAri
 Metro, p.84 (b/w)
Beginning of Summer, 1962, o/c,
 UNBuA
 A-K, p.233 (col)
Composizione, 1962 IMF
 Metro, p.85 (col)
Ete catalan, 1965. gouache GGmH
 New Art, col.pl.76
The Great Rock Wall, 1961, o/c,
 FPAri
 Seuphor, no.494 (col)
Heads, 1951, gouache on paper,
 NSchSt
 Fig.Art, pl.78 (b/w)
Night at Antibes, 1964, oil,
 UNNLef
 Haftmann, pl.918 (b/w)
Night Falls on a Garden, 1964
 Pellegrini, p.59 (b/w)
Souvenir of Amsterdam, 1956,
 o/c, Priv.Coll., Paris
 L-S, pl.63 (b/w)
Spanish City, 1958, o/c
 1945, pl.140 (b/w)
Tropic of Cancer, 1958, o/c,
 Priv.Coll.
 Abstract, pl.55 (b/w)

CORNELL, Joseph (American, 1903-
1972)
Apothecary, 1950, wooden cab-
 inet containing glass jars,
 etc. UTxHMeni
 Seitz, p.71 (b/w)
Bleriot, 1956, box containing
 trapeze and steel spring,
 UNNWard
 Seitz, p.70 (b/w)
 Janis, p.135 (b/w)
Bootes, mid-1950s, box con-
 struction UDCHi
 Hh, pl.601 (b/w)

Chocolat Menier, 1950, wood
 with collage
 Rose, p.265 (b/w)
Chocolat Menier, 1952
 UK1, pl.81 (b/w)
Cockatoo: "Keepsake Parakeet",
 1949-53, wood UNNWin
 Geldzahler, p.128 (b/w)
Compartmentalized Cubes, con-
 struction UNNWard
 Janis, p.254 (b/w)
Composizione
 Metro, p.86 (b/w)
Eclipse Series C., 1962, con-
 struction UNNSto
 L-S, pl.94 (b/w)
L'Egypte de Mlle. Cleo de Me-
 rode; cour elementaire d'
 histoire naturelle, 1940,
 wood, cork, glass, etc.,
 UNNFeig
 Geldzahler, p.126 (b/w)
 Hunter, pl.545 (b/w)
 Finch, p.37 (b/w)
Grand Hotel Semiramis, 1950,
 wood, glass, etc. UNNFrum
 Geldzahler, p.128 (b/w)
Habitat Grouping for a Shooting
 Gallery, 1943, cabinet con-
 taining colored cutouts
 Seitz, p.70 (b/w) UCLF
 Geldzahler, p.69 (b/w) UCLB1
Hotel Boule-D'Or, c.1957, box
 construction UDCHi
 Hh, pl.600 (b/w)
Hotel de l'Etoile, c.1956-57,
 painted wood UNNWard
 Geldzahler, p.129 (b/w)
 Hunter, pl.546 (b/w)
Hotel du Nord, c.1953, wood,
 glass and paper UNNW
 Geldzahler, p.129 (b/w)
Hotel goldene Sonne, c.1955-57,
 box construction UDCHi
 Hh, pl.598 (b/w)
Medici Slot Machine, 1942,
 wooden box with various ob-
 jects
 Calas, p.23 (b/w) UNNRe
 Seitz, p.69 (b/w)
 Arnason, fig.1008 (b/w)
 Geldzahler, p.126 (b/w)
 Fig.Art, pl.137 (b/w) UCLPo
Memories Inedits de Madame La
 Comtesse de G, 1940, mixed
 media UNNFeig
 Finch, p.36 (b/w)

Multiple Cubes, 1946-48 UICBe
 Andersen, p.101 (b/w)
Night Skies: Auriga, 1954
 painted wood UICBer
 New Art, pl.14 (b/w)
Night Skies: Auriga, c.1954, box
 containing construction UICBe
 Seitz, p.71 (b/w)
Ocean Hotel (Hotel de l'Ocean),
 1959-60, wooden box GCoB
 Kahmen, pl.46 (b/w)
A Pantry Ballet (for Jacques
 Offenbach), Summer 1942, wood,
 paper, plastic, etc. UNNFeig
 Geldzahler, p.127 (b/w)
 Finch, p.36 (b/w)
Pavillion: Soap Bubble Set,
 1953, assemblage UNNFerb
 Wolfram, pl.101 (b/w)
Pharmacy, 1943, wooden box and
 glass bottles UNNDu
 Geldzahler, p.127 (b/w)
 Arnason, fig.1009 (b/w)
 Hunter, pl.613 (b/w)
Portrait (from Medici Slot Ma-
 chine Series), date unknown,
 constructed box, Coll.Artist
 Ashton, pl.XVIII (col)
Postage Stamp Box, 1960-65
 UK1, pl.138 (b/w)
Rapport de Contreras (Circe),
 c.1965, collage UDCHi
 Hh, pl.989 (col)
Rose Castle, 1945, glass, mirror,
 paper and wood UNNW
 Whitney, p.106 (b/w)
Sand Fountain, late 1950s, box
 construction UDCHi
 Hh, pl.602 (b/w)
Shadow Box, mid-1950s, box
 construction UDCHi
 Hh, pl.599 (b/w)
Soap Bubble Set (Ostend Hotel),
 c.1958, construction and
 collage UNBuA
 A-K, p.298 (b/w)
The Sorrows of Young Werner,
 1966, collage UDCHi
 Hh, pl.872 (b/w)
Space Object Box, 1959, con-
 struction of various mater-
 ials UCLF
 Seitz, p.68 (b/w)
Suite de la longitude, c.1957,
 box construction UDCHi
 Hh, pl.732 (col)

Sun Box, c.1955, painted wood,
 metals, cork UNNFrei
 Hunter, p.554 (col)
T. Lucretti, mid-1950s, box
 construction UDCHi
 Hh, pl.603 (b/w)
The Uncertainty Principle, 1966,
 collage UDCHi
 Hh, pl.871 (b/w)
Untitled, 1952
 UK1, pl.95 (b/w)
Untitled (The Medici Boy), late
 1950s, box construction
 Calas, p.24 (b/w)

CORPORA, Antonio (Italian,
 1909-)
La dolce vita, 1964, o/c
 New Art, col.pl.57
"Drawing," 1959 IRPo
 Ponente, p.121 (col)
Labyrinth, 1960 IRPo
 Pellegrini, p.98 (b/w)
Mediterranean (Mediteraneo),
 1953, oil IBrC
 Haftmann, pl.852 (b/w)
Painting, 1952 FPFr
 Abstract, pl.86 (b/w)
Pittura, 1958, o/c IRBu
 1945, pl.43 (col)
Surface and New Symptoms, 1960,
 o/c FPCah
 Seuphor, no.340 (col)

CORSI, Carlo (Italian, 1879-)
Skyscraper, 1948, paper and
 cardboard collage, Coll.Artist
 Seitz, p.156 (b/w)

COSTA, Giovanni Antonio (Italian,
 1935-)
Optical-Dynamic Structure, 1961,
 polyethylene and wood, Priv.
 Coll.
 Barrett, p.101 (b/w)
Visione dinamica n.25, 1964,
 o/c UMBPol
 New Art, pl.121 (b/w)
Visual Dynamic, No.21, 1963,
 FPRe
 Abstract, pl.265 (b/w)
Visual Dynamics IRN
 Pellegrini, p.179 (b/w)

COTTINGHAM, Robert (American, 1935-)
Art, 1971, o/c
 Battcock, p.128 (b/w) UNNKar
 Rose, p.235 (b/w)
 Hunter, pl.685 (col)
C.h., 1970
 UK3, pl.VII (col) & pl.135
 (b/w)
Discount Store, 1970 UCLHo
 UK3, pl.137 (b/w)
Holiday's, 1970, o/c UCLHom
 UK3, pl.138 (b/w)
Newberry, 1974, o/c
 Battcock (col)
Roxy, 1971, o/c UNNStei
 Battcock, p.26 (b/w)
 Walker, pl.48 (col)
Untitled, 1969, o/c
 UK3, pl.132 (b/w)
Untitled, 1969, o/c
 UK3, pl.133 (b/w)
Untitled (Broadway), 1969, o/c
 UK3, pl.134 (b/w)
 Battcock, p.248 (b/w)
Woolworth's (Broadway), 1970,
 o/c UNNBi
 UK3, pl.136 (b/w)
 Battcock, p.244 (b/w)

COULENTIANOS, Costas (Greek, 1918-
)
Folgore VI, 1964, iron
 New Art, pl.226 (b/w)

COUM
Caterpiller, Nottingham, 1973,
 action
 Eng.Art, p.409 (b/w)
Copy Dementaria, Louvain Cathe-
 dral, 1973, action
 Eng.Art, p.409 (b/w)
Jusqu'a la Balle Crystal, Paris
 Biennale, 1975, action
 Eng.Art, pp.424-25 (b/w)
Omissions, Keele, 1975, action
 Eng.Art, p.424 (b/w)
The Revolutionary Spirit, Lou-
 vain University, 1973, action
 Eng.Art, p.409 (b/w)
Studio of Lust, Nuffield Founda-
 tion, Southampton, 1975,
 action
 Eng.Art, pp.424 & 426 (b/w)

COURTIN, Pierre (French, 1921-)
Trujillo, etching FPBer
 Seuphor, no.332 (col)

COUSINS, Harold B. (American,
 1916-)
Sculpture, 1959, iron
 Trier, fig.122 (b/w)

COUZIJN, Wessel (Dutch, 1912-)
Corporate Entity, 1962, bronze,
 NRU
 New Art, pl.164 (b/w)
Flying Figure, 1958, bronze,
 NAS
 Trier, fig.104 (b/w)

COX, Jan (Dutch, 1919-)
Coming Up the Staircase, 1963,
 o/c -BB
 Fig.Art, pl.76 (b/w)
Le Miroir, 1951, o/c, Priv.Coll.
 New Art, pl.196 (b/w)

CPLY. See COPLEY, William Nelson

CRAWFORD, Ralston (American,
 1906-)
Grain Elevators From the Bridge,
 1942, oil UNNW
 Whitney, p.48 (b/w)
 Hunter, pl.245 (b/w)
 Rose, p.87 (b/w)
Torn Signs #2, 1967-68, o/c,
 UDCHi
 Hh, pl.835 (b/w)
Tour of Inspection, Bikini, 1946,
 o/c UNNMi
 Arnason, fig.684 (b/w)

CREMONINI, Leonardo (Italian,
 1925-)
Bathers Amongst the Rocks, 1955-
 56, o/c UDCHi
 Hh, pl.671 (b/w)
Blindman's Bluff, 1963-64 FPDr
 Pellegrini, p.209 (b/w)
First Class, 1955, o/c
 Fig.Art, pl.131 (b/w)

CRIPPA, Roberto (Italian, 1921-
 1972)
Consistenza sicura, 1958, o/c
 1945, pl.64 (b/w)
Personage, 1966 IMSc
 Pellegrini, p.90 (b/w)

Lo schermo, 1961–62, collage,
 IMSc
 Metro, p.88 (b/w)
Volo della Materia, 1962, relief
 Metro, p.89 (col)

CROSS, Chris
 Macrae, 1973, a/c
 Battcock, p.250 (b/w)
 P-38, 1974, a/c
 Battcock, p.251 (b/w)

CRUZ-DIEZ, Carlos (Venezuelan,
 1923-)
 Chromatic Ambiance, Hydroelec-
 tric Centre, Santo Domingo,
 Venezuela, 1973
 Popper, p.106 (col)
 Chromosaturation Pour un Lieu
 Public/Sortie du metro Odeon,
 Paris, 1969
 Barrett, p.82 (b/w)
 Popper, p.106 (col)
 Physichromie no.1, 1959, plastic
 and wood, Coll.Artist
 L-S, pl.141 (b/w)
 Physichromie No.127, 1964 -Es
 Brett, p.83 (b/w)
 Physichromie no.260, 1966, plas-
 tic, wood, celluloid, Coll.
 Artist
 Barrett, p.80 (b/w)
 Popper 2, p.100 (col)
 Physichromy No.177, 1965, wood
 and plastic FPRe
 Abstract, pl.272 (b/w)
 Physiochrome
 Pellegrini, p.168 (b/w)
 Physiochromie 267, 1966
 UK2, col.pl.XXIX
 Tour Chromointerferente, 1971,
 VC
 Popper, p.72 (b/w)
 Transchromie, 1965, Coll.Artist
 Barrett, p.81 (b/w)

CUEVAS, Jose Luis (Mexican, 1934-
)
 Assaulted Woman VII, 1959, gou-
 ache on paper UDCHi
 Hh, pl.580 (b/w)
 The Giant, from Cuevas' Come-
 dies, 1972, lithograph UNNBre
 Castleman, p.109 (col)

CUIXART, Modesto (Spanish, 1925-)
 Apparition of Nalter, 1965, o/c,
 -Wo
 Dyckes, p.57 (b/w)
 Arrabel Character, 1965, mixed
 media on paper, Priv.Coll.,
 Madrid
 Dyckes, p.18 (b/w)
 Canvas-object, 1960
 Pellegrini, p.101 (b/w)
 Composizione, 1960
 Metro, p.91 (b/w)
 Composizione, 1961, o/c
 Metro, p.90 (b/w)
 Cover for Dau al Set magazine,
 1950
 Dyckes, p.9 (b/w)
 Illustration for Dau al Set
 magazine, 1950
 Dyckes, p.10 (b/w)
 Maascro, 1949, oil on card-
 board SpBaMe
 Dyckes, p.18 (b/w)
 Nameless Children, 1963, mixed
 media SpBaMe
 Dyckes, p.19 (b/w)
 Painting, 1959, mixed media,
 UNNMMA
 Dyckes, p.99 (col)
 Painting, 1960, o/c, Priv.Coll.
 Abstract, pl.79 (b/w)
 Painting No.25, 1960, mixed
 media -Bon
 Dyckes, p.18 (b/w)
 Ratacat, 1961 SpBaMe
 Pellegrini, p.101 (b/w)
 Vespertine Adulation, 1964, oil,
 UNNSwe
 Dyckes, p.18 (b/w)

CUMMING, Robert (American, 1943-)
 Spot with a Nice View, 1973
 Popper, p.260 (b/w)

CUNNINGHAM, Ben (American, 1904-)
 Equivocation, 1964, o/c UNNMMA
 Janis, p.312 (b/w)
 The Tesseract, 1966 UNEaE
 Pellegrini, p.181 (b/w)

CUNNINGHAM, John Jr. (American,
 1940-)
 Rock Candy Mountain, 1971,
 plexiglass UDCHi
 Hh, pl.834 (b/w)

CURNOE, Gregg (Canadian, 1936-)
 The Greatest Profile in the
 World, 1963, o/c CTM
 Lippard, pl.188 (b/w)

CUTFORTH, Roger (British, 1944-)
 The Empire State Building, A
 Reference Work, 1969
 Meyer, pp.108-15 (b/w)
 "Long Distance Vision" Card
 (cover of The Visual Book),
 1970
 6 Yrs, p.138 (b/w)

CYCLAMEN CYCLISTS
 Action, Swansea Docks, 1971
 Henri, fig.99 (col)

CYRSKY, Frank
 Masai Warriors, 1972, o/c
 Battcock, p.252 (b/w)
 Pelekan, 1973, o/c
 Battcock, p.253 (b/w)

DADO, Miodrag Djuric (Yugoslavian,
 1933-)
 The Big Farm or Homage to Ber-
 nard Requichot, o/c
 Fig.Art, pl.270 (b/w)
 HRouv, 1968, pen and Indian
 ink GCoZ
 Kahmen, pl.159 (b/w)

DAHMEN, Karl Friedrich (German,
 1917-)
 Composition
 Pellegrini, p.79 (b/w)
 Ohne Illusion, 1964, mixed
 media UNNLef
 New Art, pl.313 (b/w)
 Terrestrial Formation, o/c,
 Priv.Coll.
 Abstract, pl.92 (b/w)

DALEY, Dakota
 Adam and Eve, 1965 (in colla-
 boration with Nicholas Quen-
 nell)
 UK2, pl.20 (b/w)
 Eve 2, 1965 (in collaboration
 with Nicholas Quennell)
 UK2, pl.57 (b/w)

DALI, Salvador (Spanish, 1904-)
 Christ of St. John of the Cross
 (The Crucifixion), 1951, o/c,
 ScGG
 L-S, pl.8 (b/w)
 Haftmann, pl.558 (b/w)
 Arnason, fig.575 (b/w)
 Head of Dante, 1965
 UK1, pl.50 (b/w)
 Mao-Marilyn, 1967
 UK2, pl.100 (b/w)
 The Maximum Speed of Raffael's
 Madonna, 1954
 UK2, pl.385 (b/w)
 Paranoic-Critical Study of Ver-
 meer's Lacemaker, 1955
 UK2, pl.384 (b/w)
 Portrait of My Dead Brother,
 1963
 UK2, pl.56 (b/w)
 Skull of Zurbaran, 1956, o/c,
 UDCHi
 Hh, pl.754 (col)

DALWOOD, Hubert (British, 1924-
 1976)
 Ark, 1960, aluminum
 Metro, p.92 (b/w)
 Minos, 1962, aluminum
 New Art, pl.90 (b/w)
 OAS Assassins, 1962, aluminum
 Metro, p.93 (b/w)

DAMEN, Herman (Dutch, 1945-)
 Cow Poem, 1969, mixed media
 Henri, fig.68 (b/w)

DAMIAN, Horia (Rumanian, 1922-)
 Composition blanche au centre
 gallee, 1961, oil on poly-
 ester cloth
 Metro, p.94 (b/w)
 Petites ogives rouges, 1962
 Metro, p.95 (b/w)

DAMNJANOVIC, Radomir (Yugosla-
 vian, 1936-)
 Vertical Composition, 1965, o/c,
 YLMa
 New Art, pl.258 (b/w)

DANTZIGER, Ytshak (Israeli, 1916-
)
 The Burning Bush, c.1960, iron,
 IsHM
 New Art, pl.227 (b/w)

"The Lord Is My Shepherd"(Negev
 Sheep), 1964, bronze UDCHi
 Hh, pl.804 (b/w)

DAPHNIS, Nassos (Greek-American,
 1914-)
 11-67, 1967, epoxy on canvas,
 UNBuA
 A-K, p.399 (col)
 4-J30-63, 1963
 UK1, pl.172 (b/w)
 17-61MT, 1961
 UK2, pl.316 (b/w)
 10-64-5, 1965
 UK1, pl.169 (b/w)

DARBOVEN, Hanne (German, 1941-)
 One Century in One Year, 1971
 6 Yrs, p.216 (b/w)
 Permutational Drawing, 1966,
 pencil on graph paper
 6 Yrs, p.19 (b/w)
 24 Songs: B Form, Sonnabend
 Gallery, New York, 1974, ink
 on paper
 Arnason 2, fig.1251 (b/w)
 Untitled, 1971, ink on paper
 6 Yrs, p.256 (b/w)
 Yearbook Page: January 23, 1968
 6 Yrs, p.38 (b/w)

D'ARCANGELO, Allan (American,
 1930-)
 Airfield, 1963, liquitex on
 canvas with cyclone fencing,
 UNNFis
 Lippard, pl.110 (b/w)
 Composition 14, 1965 FPLam
 Abstract, pl.133 (b/w)
 Constellation #16, 1970, a/c
 Calas, p.130 (b/w)
 Flint Next, 1963, liquitex on
 canvas UMiDL
 Lippard, pl.151 (b/w)
 Full Moon, 1963, a/c UNNPow
 Arnason, fig.1054 (b/w)
 Guard Rail, 1963, a/c UNNAb
 Calas, p.129 (b/w)
 Highway No.2, 1963, a/c UMCheW
 Hunter, pl.678 (col)
 Compton 2, fig.146 (b/w)
 Wilson, pl.25 (col)
 Highway Series, 1963, a/c
 Compton 2, figs.145-48 (b/w)
 Hypostasis, 1974, a/c UNNMa
 Arnason 2, fig.1138 (b/w)

Madonna and Child, 1963, a/c,
 Coll.Artist
 Alloway, fig.4 (b/w)
Marilyn, 1962, a/c, Coll.Artist
 Alloway, fig.3 (b/w)
Number One of Road Series 2,
 1965, a/c UDCHi
 Hh, pl.838 (b/w)
Road Block, 1964, a/c with con-
 struction UMnMF
 Hunter, pl.667 (b/w)
Road Series, 1965, a/c UNNFis
 Lippard, pl.109 (col)
Smoke Screen No.2, 1963, o/c,
 Priv.Coll.
 Compton 2, fig.131 (col)
US Highway No.1, 1963
 UK2, pl.219 (b/w)
Untitled, 1965
 UK2, pl.216 (b/w)
Untitled 81, 1964 FPSon
 Pellegrini, p.238 (b/w)

DARIE, Sandu
 Cosmorama, Eindhoven, 1966
 Popper 2, p.173 (b/w)

DAVIDSON, Michael John
 Big Stripper, 1967
 UK1, pl.22 (b/w)
 Viva Maria, 1967
 UK1, pl.21 (b/w)

DAVIE, Alan (British, 1920-)
 Female, Male, 1955, oil on ma-
 sonite UNBuA
 A-K, p.141 (b/w)
 The Golden Drummer Boy No.2,
 1962, o/c IVG
 New Art, col.pl.44
 Golden Pig, 1963, o/c, Priv.
 Coll.
 Arnason, fig.941 (b/w)
 Heavenly Bridge No.3, 1960, o/c,
 ELG
 Abstract, pl.98 (col)
 The Horse That Has Visions of
 Immortality, 1963
 Pellegrini, p.282 (b/w)
 Image of the Fish God, 1956,
 oil on hardboard, Priv.Coll.
 Haftmann, pl.951 (b/w)
 Image of the Fish God, 1956,
 ELBrC
 Pellegrini, p.281 (b/w)

The Martyrdom of St. Catherine,
 1956, o/c —Davi
 L-S, pl.60 (col)
Pomo, 1962, o/c GCoZ
 Kahmen, pl.343 (b/w)
A Round in Gray, 1959, o/c ELG
 Seuphor, no.325 (col)
Rub the Lamp, 1961, o/c GCoZ
 Kahmen, pl.346 (b/w)
Sacrifice, 1956, o/c
 1945, pl.119 (col)
Sacrifice, 1956, oil on hard-
 board, Coll.Artist
 Haftmann, pl.950 (b/w)
Thoughts for a Giant Bird, Octo-
 ber 1963, oil on 2 canvases,
 ELStu
 Stuyvesant, p.74 (b/w)
Transformation of the Wooden
 Horse No.1, 1960, o/c UICW
 Metro, p.96 (b/w)
The True Meaning of the Wheel
 No.1, 1961, o/c ELGom
 Metro, p.97 (b/w)
White Magician, 1956, o/c ELStu
 Stuyvesant, p.75 (col)

DAVIES, John (British, 1946-)
 Head of William Jeffrey, painted
 polyester resin, fiberglass
 and inert fillers ELT
 L-S, pl.225 (col

DAVIS, Gene (American, 1920-)
 Anthracite Minuet, 1966, syn-
 thetic polymer paint on can-
 vas UNNMMA
 Hamilton, pl.368 (b/w)
 Legato in Red, 1965 UNNPoi
 Pellegrini, p.145 (b/w)
 Moon Dog, 1966, o/c UMWaB
 Hunter, pl.734 (col)
 Arnason, col.pl.250
 Raspberry Icicle, 1967, a/c,
 UDCNMSC
 Hunter, pl.719 (b/w)
 Red Frenkant, 1966
 UK2, pl.279 (b/w)
 Satan's Flag, 1970-71, a/c UDCN
 Rose, p.208 (b/w)

DAVIS, Ron (American, 1937-)
 Blue and Brown, 1967
 UK2, pl.326 (b/w)
 Paolo, 1968, fiberglass UMoSLH
 Hunter, pl.749 (b/w)

Plane Sawtooth, 1970, polyester
 resin and fiberglass UNBuA
 A-K, p.400 (col)
Radial, 1968
 UK2, pl.324 (b/w)
Red Top, 1968-69, polyester
 resin and fiberglass
 Rose, p.216 (b/w)
Rings Skew, 1968
 UK2, pl.323 (b/w)
Untitled, 1968, fiberglass GCoW
 Walker, pl.35 (col)
Vector, 1968, fiberglass ELT
 Hunter, pl.743 (col)

DAVIS, Stuart (American, 1894-
1964)
 Blips and Ifs, 1963-64, o/c,
 UTxFA
 Hunter, pl.347 (col)
 Arnason, col.pl.194
 Colonial Cubism, 1954, o/c,
 UMnMW
 Geldzahler, p.131 (b/w)
 Hunter, pl.346 (col)
 Arnason, col.pl.193
 Hot Stillscape in Six Colors,
 1940 UNND
 Geldzahler, p.70 (col)
 Rose, p.119 (b/w)
 Little Giant Still Life, 1950,
 o/c UVRMu
 Arnason, fig.682 (b/w)
 The Mellow Pad, 1945-51, o/c,
 UNNLow
 Arnason, fig.681 (b/w)
 Owh! in San Pao, 1951, o/c UNNW
 1945, pl.157 (b/w)
 Geldzahler, p.130 (b/w)
 Whitney, p.58 (col)
 The Paris Bit, 1959 UNNW
 Rose, p.117 (col)
 Pochade, 1958 UNND
 Pellegrini, p.30 (b/w)
 Geldzahler, p.131 (b/w)
 Premiere, 1957, o/c UCLCM
 New Art, pl.25 (b/w)
 Rapt at Rappaport's, 1952, o/c,
 UDCHi
 Hh, pl.760 (col)
 Arnason, col.pl.192
 Report from Rockfort, 1940,
 oil UNNLow
 Haftmann, pl.820 (b/w)
 Arnason, fig.680 (b/w)

Switchsky's Syntax, 1961-64,
 tempera on canvas UNNDa
 Geldzahler, p.132 (b/w)
Tropes de Teens, 1956, o/c,
 UDCHi
 Hh, pl.761 (col)

DAWS, Lawrence (Australian, 1927-
)
 Anima Mundi, 1961, o/c ELStra
 Seuphor, no.271 (col)

DE ANDREA, John (American, 1941-)
 Boys Playing Soccer, 1971, poly-
 ester and fiberglass, poly-
 chromed UNSyE
 Battcock, p.189 (b/w)
 Couple on Floor, 1973, polyester
 and fiberglass, polychromed
 Battcock, p.99 (b/w)
 Freckled Woman, 1974, polyester
 and fiberglass, polychromed,
 UNNHarr
 L-S, pl.227 (b/w)
 Reclining Figure, 1970, polyes-
 ter resin polychromed in oil,
 Priv.Coll., New York
 Hunter, pl.686 (col)
 Sitting Woman, 1972, polyester
 and fiberglass, polychromed,
 -Be
 Battcock, p.254 (b/w)
 Two Women, 1972, polyester and
 fiberglass, polychromed
 Battcock, p.195 (b/w)
 Untitled, 1970 GAaN
 UK3, pl.I (col)
 Untitled, 1970, polyester resin
 polychromed UNNHarr
 UK3, pl.10 (b/w)
 Untitled, 1970, polyester resin,
 polychromed in oil UNNHarr
 UK3, pl.13 (b/w)
 Untitled, 1971, polyester resin,
 polychromed in oil
 UK3, pl.12 (b/w)
 Untitled, 1971, polyester resin,
 FPB
 UK3, pl.14 (b/w)
 Battcock, p.191 (b/w)
 Untitled, 1971, polyester resin
 UK3, pl.15 (b/w)
 Woman No.2 (Black), 1969-70,
 latex GCoZ
 Kahmen, pl.110 (b/w)
 UK3, pl.11 (b/w)
 Popper, p.248 (b/w)

Woman Sitting on Stool, 1975,
 polyester resin and fiberglass,
 UNNHarr
 Arnason 2, fig.1246 (b/w)

DEBOURG, Narcisco
 Perception, 1967, painted wood,
 FPRe
 Barrett, p.96 (b/w)
 Relief, 1959
 Brett, p.82 (b/w)

DEBRE, Olivier (French, 1920-)
 Cerulean Blue, 1960, o/c FPKn
 Seuphor, no.377 (col)
 Ocher Tree, 1959, o/c, Coll.
 Artist
 Seuphor, no.378 (col)

DECHAR, Peter
 Pears, 1967
 UK2, pl.184 (b/w)

DE CREEFT, Jose (Spanish-Ameri-
 can, 1884-)
 Dancer, 1943-54, chestnut UDCHi
 Hh, pl.450 (b/w)
 Himalaya, 1942, beaten lead,
 UNNW
 Whitney, p.105 (b/w)

DEEM, George (American, 1932-)
 An American Vermeer, 1970, o/c
 UK3, pl.74 (b/w)
 Eight Women, 1967
 UK2, pl.104 (b/w)
 Untitled, 1967
 UK2, pl.228 (b/w)

DE FOREST, Roy (American, 1930-)
 Moe Journeys East, 1960,
 painted wood construction
 Janis, p.207 (b/w)

DEGOTTEX, Jean (French, 1918-)
 En Shira (En Shinra), 1961,
 o/c BBR
 Abstract, pl.108 (b/w)
 Ken-Do, 1961, o/c BBI
 Metro, p.98 (b/w)
 The Sky and the Earth Are One
 Finger, 1958, o/c FPInt
 Seuphor, no.400 (col)
 Suite rose-noire (XVI), 1964,
 oil on paper, Priv.Coll.
 New Art, pl.50 (b/w)
 Pellegrini, p.68 (b/w)

Void of Void, 1959, o/c FPInt
 Seuphor, no.399 (col)
Yugen I, 1961, o/c BBI
 Metro, p.99 (b/w)

DEIRA, Ernesto (Brazilian, 1928-)
 What's Needed, 1965
 Pellegrini, p.227 (b/w)

DEKKERS, Ad (Dutch, 1938-)
 Variatie op cirkels, 1965
 UK1, pl.183 (b/w)

DE KOONING, Elaine (American,
 1920-)
 Condemned Man, 1960, torn paper,
 paint and crayon on paper,
 Coll.Artist
 Janis, p.234 (b/w)

DE KOONING, Willem (Dutch-Ameri-
 can, 1904-)
 Asheville Collage, 1949, paper
 and thumbtacks with oil,
 UNNSoli
 Janis, p.222 (b/w)
 Ashville, 1949, o/c UDCP
 Sandler, p.129 (b/w)
 Tuchman, p.71 (b/w)
 Attic, 1949, oil and tempera on
 canvas UICNe
 Sandler, p.130 (b/w)
 Backyard on Tenth Street, 1956,
 o/c UMdBM
 Tuchman, p.75 (b/w)
 Bill-Lee's Delight, c.1946, oil
 on paper UNNEas
 Geldzahler, p.71 (col)
 Black and White, 1959, oil on
 paper
 Metro, p.100 (b/w)
 Clown, c.1941, oil on masonite,
 UCBeK
 Tuchman, p.67 (b/w)
 Composition, 1955, o/c UNNG
 Arnason, col.pl.204
 Dark Pond, 1948, oil on masonite
 Sandler, p.127 (b/w) UNNWei
 Tuchman, p.70 (b/w) UCBeW
 Door to the River, 1960, o/c,
 UNNW
 Geldzahler, p.141 (b/w)
 Whitney, p.89 (col)
 Sandler, p.136 (b/w)

Easter Monday, 1956, o/c UNNMM
 1945, pl.161 (b/w)
 Geldzahler, p.139 (b/w)
Excavation, 1950, o/c UICA
 Sandler, pl.VII (col)
 Hunter, pl.388 (col)
Figure in Landscape, No.2, 1951,
 o/c UNNH
 Selz, p.90 (b/w)
Gotham News, 1955, o/c UNBuA
 A-K, p.33 (col)
 Andersen, p.184 (b/w)
 Abstract, pl.31 (b/w)
 Ponente, p.150 (col)
 Sandler, p.135 (b/w)
July Fete in Plattsburgh, 1964,
 UNNSto
 Pellegrini, p.160 (col)
Labyrinth (backdrop for), 1946,
 calcimine, charcoal on can-
 vas UNNSto
 Sandler, p.126 (b/w)
Light in August, c.1946, oil and
 enamel on paper, mounted on
 canvas UAzSD
 Geldzahler, p.137 (b/w)
Little Attic, 1949, oil on com-
 position board UMdBR
 Tuchman, p.72 (b/w)
Marilyn Monroe, 1954, o/c UNNNe
 Selz, p.95 (b/w)
The Marshes, c.1945, charcoal
 and oil on composition board,
 UCBC
 Geldzahler, p.136 (b/w)
 Sandler, p.125 (b/w)
Merritt Parkway, 1959 UNNJa
 Ponente, p.151 (col)
Montauk I, 1969, o/c UCtHWA
 Arnason 2, fig.893 (b/w)
Montauk Highway, 1958, o/c,
 UCLB1
 Tuchman, p.76 (b/w)
Night Square, 1948, oil on ma-
 sonite UNNJ
 Geldzahler, p.401 (b/w)
 Hunter, pl.398 (b/w)
 Abstract, pl.13 (b/w)
 Arnason, fig.853 (b/w)
Painting, 1948 UNNMMA
 Geldzahler, p.399 (b/w)
Parc Rosenberg, 1957, o/c,
 UNNGros
 Sandler, pl.VIII (col)

Pink Angel, c.1947, o/c UCBeW
 Sandler, pl.VI (col)
 Hunter, pl.420 (b/w)
 Rose, p.158 (b/w)
 Tuchman, p.69 (b/w)
Pink Lady, c.1944, oil and char-
 coal on masonite composition
 board UCStbS
 Geldzahler, p.135 (b/w)
Police Gazette, 1954-55, o/c,
 UNNScu
 Geldzahler, p.138 (b/w)
Queen of Hearts, 1943-46, oil
 and charcoal on composition
 board UDCHi
 Geldzahler, p.134 (b/w)
 Sandler, p.124 (b/w)
 Rose, p.155 (b/w)
 Hh, pl.502 (col)
Reclining Figure in Marsh Land-
 scape, 1967, oil on paper,
 UNLarB
 Arnason, fig.855 (b/w)
Related to Attic, 1949, oil on
 paper UMdBR
 Hunter, pl.399 (b/w)
Sailcloth, c.1949
 Rose, p.157 (col)
Seated Figure (Classic Male),
 1939, o/c, Priv.Coll., New
 York
 Hunter, pl.463 (b/w)
Seated Man, c.1939, o/c UDCHi
 Hh, pl.501 (col)
Seated Woman, c.1940, oil and
 charcoal on composition board,
 UPPG
 Geldzahler, p.133 (b/w)
Seated Woman on a Bench, 1972,
 bronze UNNFou
 Arnason 2, fig.894 (b/w)
Secretary, 1948, oil and char-
 coal on composition board,
 UDCHi
 Hh, pl.699 (col)
Special Delivery, 1946, oil,
 enamel and charcoal on paper
 mounted on cardboard UDCHi
 Hh, pl.531 (b/w)
Spike's Folly I, 1959, o/c,
 UNNScu
 Geldzahler, p.140 (b/w)
Standing Man, 1942, o/c UCtHWA
 Sandler, p.123 (b/w)
Still Life, 1930-40, oil on
 board UNNSto
 Hunter, pl.358 (b/w)

Study for Woman, 1950, oil on
 paper with pasted color
 photo-engraving, Priv.Coll.,
 New York
 Seitz, p.75 (b/w)
Suburb in Havana, 1958, oil,
 BBDo
 Haftmann, pl.900 (col)
Two Standing Women, 1949, oil on
 board UCLS
 Tuchman, p.73 (col)
Two Women in the Country, 1954,
 oil, enamel and charcoal on
 canvas UDCHi
 Hh, pl.727 (col)
Two Women's Torsos, 1952, pas-
 tel UICA
 Selz, p.94 (b/w)
Untitled, 1937, oil on board,
 UMBP
 Rose, p.123 (b/w)
Untitled, c.1943, oil on mason-
 ite UCBeW
 Tuchman, p.68 (col)
Untitled, 1948, oil on paper,
 mounted on masonite UMBP
 Geldzahler, p.138 (b/w)
Untitled, 1960, lithograph,
 UNNMMA
 Castleman, p.67 (col)
Untitled, 1961, o/c UMWaB
 New Art, col.pl.3
Untitled, 1963 UNNSto
 Pellegrini, p.116 (b/w)
Untitled, 1963, o/c UDCHi
 Hh, pl.794 (b/w)
Untitled Painting, c.1942, oil
 on masonite, Priv.Coll., New
 York
 Sandler, p.124 (b/w)
Villa Borghese, 1960, o/c,
 UCtMeT
 Seuphor, no.386 (col)
Whose Name Was Writ in Water
 (formerly Untitled II), 1975,
 o/c UNNFou
 Arnason 2, col.pl.206
Woman, 1948, oil and enamel on
 composition board UDCHi
 Rose, p.155 (b/w)
 Hh, pl.532 (b/w)
Woman, 1950, o/c UNcGrU
 Selz, p.88 (b/w)
Woman I (early state), c.1950,
 paper collage with oil on can-
 vas
 Janis, p.221 (b/w)

Woman I, 1950-52, o/c UNNMMA
 Fig.Art, pl.62 (col)
 Sandler, p.131 (b/w)
 Selz, p.91 (b/w)
 Rose, p.156 (b/w)
 Compton 2, fig.15 (b/w)
Woman II, 1952, o/c UNNMMA
 1945, pl.149 (col)
 Haftmann, pl.900 (b/w)
 Hunter, pl.590 (b/w)
Woman IV, 1952-53, o/c UMoKNG
 Hamilton, col.pl.56
Woman V, 1952-53, o/c UICRo
 Tuchman, p.74 (b/w)
Woman, 1953, oil and charcoal on
 paper mounted on canvas UDCHi
 Hh, pl.591 (b/w)
Woman VI, 1953, oil and enamel
 on canvas UPPiC
 Sandler, p.135 (b/w)
 Arnason, fig.854 (b/w)
Woman XI, 1961, oil
 Metro, p.101 (b/w)
Woman Acabonic, 1966, oil on
 paper mounted on canvas UNNW
 Sandler, p.136 (b/w)
Woman and Bicycle, 1952-53, o/c,
 UNNW
 L-S, pl.23 (col)
 Selz, p.93 (col)
 Sandler, p.132 (b/w)
Woman in Landscape III, 1968,
 oil on paper, mounted on can-
 vas
 Hunter, pl.421 (b/w)
Woman, Sag Harbor, 1964, oil on
 wood UDCHi
 Hunter, pl.393 (col)
 Hh, pl.971 (col)

DELAHAUT, Jo (Belgian, 1911-)
 Pomegranate, 1952, o/c, Priv.
 Coll.
 Abstract, pl.179 (b/w)
 Vast Infinite, 1960, o/c, Coll.
 Artist
 Seuphor, no.423 (col)

DELAHAYE, Jacques (French, 1928-)
 The Cat, 1952, bronze FPSt
 Trier, fig.108 (b/w)
 Cavalier, bronze
 Metro, p.102 (b/w)
 Tete de Meduse, 1962, bronze
 Metro, p.103 (b/w)

DELAP, Tony (American, 1927-)
 Sharpy, 1969, aluminum
 Busch, fig.15 (b/w)
 Zingone, 1969, wood, fiberglass,
 lacquer, aluminum UDCHi
 Hh, pl.943 (b/w)

DELAUNAY, Sonia (Russian, 1885-)
 Colored Rhythm No.698, 1958,
 o/c UNBuA
 A-K, p.219 (col)
 Ink Drawing, 1923-61 FPMS
 Seuphor, no.214 (b/w)
 Painting, 1960 FPV
 Seuphor, no.219 (col)
 Poesie de mots, poesie de cou-
 leurs (plate from the album),
 1962
 Popper 2, p.87 (col)

DELHEZ, Victor (Belgian, 1901-)
 Wood Engraving, 1958 FPMS
 Seuphor, no.213 (b/w)

DELVAUX, Paul (Belgian, 1897-)
 Crucifixion, 1951-52, oil on
 wood BBR
 Fig.Art, pl.125 (b/w)
 Entrance to the City, 1940, o/c,
 BBGi
 Arnason, col.pl.166
 The Girls at the Water's Edge
 (Les filles au bord de l'eau),
 1966, o/c GCoZ
 Kahmen, pl.1 (b/w)
 The Great Sirens, 1947, oil on
 unalit UNNA
 Fig.Art, pl.124 (b/w)
 La Mise au Tombeau, 1951, o/c
 1945, pl.36 (i.e.37) (b/w)
 Night Train, 1947, oil on wood,
 UTxDG
 Arnason, fig.598 (b/w)
 Pygmalion, 1939, oil on wood,
 BBR
 Kahmen, pl.120 (b/w)
 Venus Asleep, 1944, o/c ELT
 Arnason fig.597 (b/w)

DEMARCO, Hugo Rodolfo (Argentin-
 ian, 1932-)
 Animated Table, 1966 FPRe
 Barrett, p.108 (b/w)
 Continual Movement, 1966, Priv.
 Coll.
 Abstract, pl.271 (b/w)

Relief de placement continuel,
1966
UK1, pl.314 (b/w)
Relief with Changing Reflec-
tions, 1966 FPRe
Popper 2, p.117 (b/w)
Spatial Dynamization, 1964 -Ren
Pellegrini, p.186 (b/w)

DE MARIA, Walter (American, 1935-
)
Art Yard
Celant, p.13 (b/w)
Bed of Spikes, 1968, stainless
steel
Celant, p.16 (b/w)
Bed of Spikes, 1969, stainless
steel SwBKM
Hunter, pl.845 (b/w)
Calas, p.274 (b/w)
Cross, 1965, aluminum
Celant, p.14 (b/w)
Death Wall, 1965, stainless
steel UNNScu
Kahmen, pl.291 (b/w)
Celant, p.17 (b/w)
50 m³ (1600 cubic feet) Level
Dirt, 1968 GMFr
Celant, p.16 (b/w)
Hunter, pl.853 (b/w)
4-6-8, 1966, solid stainless
steel GDaS
Andersen, p.214 (b/w)
Half-Mile Long Drawing, Mojave
Desert, Calif., April 1968,
two chalk lines
Andersen, p.248 (b/w)
UK4, pl.160 (b/w)
Mile Long Drawing, Mojave De-
sert, 1968 (now destroyed),
parallel chalk lines
Hunter, pl.856 (b/w)
6 Yrs, p.55 (b/w)
70" of Tape, 1967
Celant, p.13 (b/w)
Two Lines Three Circles on the
Desert, 1969
UK4, pl.159 (b/w)

DEMARTINI, Hugo
Structure, 1965
UK1, pl.269 (b/w)

DE MOULPIED, Deborah (American,
1933-)
Palamos, 1965-67, plexiglass,
UDCHi
Hh, pl.832 (b/w)

DENES, Agnes (Hungarian-American)
Dialectic Triangulation: A
Visual Philosophy, Series No.
3, 1970, original sepia print
(blueprint) UNNW
Whitney, p.136 (b/w)

DENNY, Robyn (British, 1930-)
Aday One, 1968-73, o/c IVeS
Eng.Art, p.79 (b/w)
Baby is Three, 1960, emulsion
on canvas ELT
Eng.Art, p.79 (b/w)
Collage, 1957, oil, torn paper,
cloth, etc., Coll.Artist
Seitz, p.106 (b/w)
Crosspatch, 1964, o/c
New Art, pl.79 (b/w)
For Ever, 1965, o/c ELStu
Stuyvesant, p.102 (b/w)
Growing, 1966-67, o/c ELStu
L-S, pl.90 (col)
Stuyvesant, p.102 (b/w)
Gully Foyle, 1961, o/c ELStu
Stuyvesant, p.101 (col)
Head on II, 1975, o/c IVeS
Eng.Art, p.77 (col)
Jones's Law, 1964, o/c PoLG
Eng.Art, p.78 (b/w)
Life Line II, 1963
Pellegrini, p.156 (b/w)
Off Side (Painting 12), 1961
Eng.Art, p.18 (b/w)
Over Reach, 1965-66, o/c ELAr
Eng.Art, p.79 (b/w)

DE RIVERA, Jose (American, 1904-)
Construction 8, 1954, wrought
chrome-nickel steel UNNMMA
Trier, fig.164 (b/w)
Construction No.48, 1957,
chrome-nickel steel UNNSt
G-W, p.221 (b/w)
Construction #76, 1961, bronze,
UDCHi
Hh, pl.785 (b/w)
Construction #85, 1964, bronze,
UNScB
Rose, p.267 (b/w)

Construction #88, 1965, forged
bronze UNNB
Ashton, pl.XXVIII (col)
Construction No.103, 1967,
bronze UNNBau
Hunter, pl.540 (b/w)
Construction #107, 1969, stain-
less steel UDCHi
Hh, pl.947 (b/w)
Construction #117, 1969, stain-
less steel
Busch, fig.31 (b/w)
Construction #158, 1974-75,
stainless steel, Coll.Artist
Arnason 2, fig.1049 (b/w)
Construction "Blue and Black",
1951, painted aluminum UNNW
Whitney, p.111 (b/w)
Form Synthesis in Monel Metal,
1930, monel metal
Andersen, p.29 (b/w)
Red and Black (Double Element),
1938, painted aluminum -Schu
Andersen, p.30 (b/w)
Yellow Black, 1946-47, painted
aluminum
Andersen, p.85 (b/w)

DE STAEBLER, Stephen (American,
1933-)
A Man, 1964, fired clay, Coll.
Artist
Andersen, p.166 (b/w)
Ashton, pl.L (col)

DEWASNE, Jean (French, 1921-)
L'Art de vivre, 1962, enamel on
board BBSta
New Art, col.pl.34
Dangerous Games, stage sets
Popper, p.128 (b/w)
La Demeure antipode, 1965, ena-
mel on masonite UNNG
Arnason, fig.983 (b/w)
Don Juan, 1953, o/c FPRe
Seuphor, no.207 (col)
Empedocle, 1962
Metro, p.107 (col)
Grenoble '70, 1970, model FGreM
Popper, p.255 (col)
The Little Trophy, 1952, o/c,
Priv.Coll.
Abstract, pl.177 (b/w)
La Muraille Antipode, 1973-74,
model for the new "Italie-Go-
belins" district, Paris
Popper, p.66 (col)

L'or antipode, 1959
Metro, p.106 (b/w)

DEWEY, Kenneth (American, 1940-)
In Memory of Big Ed, Edinburgh,
Sept.1964, happening
Kaprow, pp.282-84 (b/w)
Museum Piece, Stockholm, April
1964, happening
Kaprow, pp.286-92 (b/w)
UK4, pl.115 (b/w)
Summer Scene, Jyvaskyla, Fin-
land, 1964, happening
Kaprow, pp.294-96 (b/w)

DEYROLLE, Jean (French, 1911-)
Bala Huc, 1956, o/c FPFr
1945, pl.21 (b/w)
Croy, 1957, o/c FPRe
Seuphor, no.199 (col)
1-2-3-4, cloth and paint
Janis, p.198 (b/w)

DIBBETS, Jan (Dutch, 1941-)
Corrected Perspective (on studio
wall), Amsterdam, 1969
6 Yrs, p.123 (b/w)
Correction of Perspective, 1967-
68
Celant, p.108 (b/w)
Correction of Perspective, 1968,
photograph on canvas
Celant, p.106 (b/w)
Dutch Mountain-Big Sea, 1971,
color photos on aluminum,
UNNMMA
Walker, pl.45 (col)
Forest Piece, Ithaca, N.Y., 1969
UK4, pl.152 (b/w)
Grass Roll, 1967
Celant, p.104 (b/w)
1 Grass Roll, 1967
UK4, pl.151 (b/w)
Perspective Correction, 1969
Meyer, p.120 (b/w)
Walker, p.39 (b/w)
Robin Redbreast's Territory,
1969
Meyer, pp.117-19 (b/w)
6 Yrs, p.139 (b/w)
Shadow Piece, Haus Lange, Kre-
feld, 1969
6 Yrs, p.132 (b/w)

Sticks with Neon, Branches
 (Green) (13 Faggots with Neon
 Branch), 1968
 Celant, p.105 (b/w)
 UK4, pl.151 (b/w)
Untitled, 1969
 Meyer, p.116 (b/w)
Water (Mud) Puddle (3 Water
 Puddles and Tape Recorder),
 1968
 Celant, p.105 (b/w)
 UK4, pl.151 (b/w)
White Line on the Sea, Amalfi,
 1968
 Celant, p.107 (b/w)
White Wall, 1971, photograph
 6 Yrs, p.210 (b/w)

DICKINSON, Edwin (American, 1891-
)
The Fossil Hunters, 1926-28,
 oil UNNW
 Whitney, p.35 (b/w)
Self-Portrait, 1954, o/c UDCHi
 Hh, pl.584 (b/w)

DIEBENKORN, Richard (American,
 1922-)
Girl Looking at a Landscape,
 1957, oil UNNW
 Whitney, p.69 (b/w)
Girl on a Terrace, 1956, o/c,
 UNNNe
 Selz, p.56 (col)
Girl with Cups, 1957, o/c,
 UNNBake
 Selz, p.57 (b/w)
Man and Woman in a Large Room,
 1957, o/c UDCHi
 Selz, p.58 (b/w)
 Hunter, pl.407 (b/w)
 Hh, pl.759 (col)
 Arnason, fig.952 (b/w)
Man and Woman Seated, 1958, o/c,
 UNNZe
 Selz, p.59 (b/w)
Nude on a Blue Background, 1967,
 o/c UNNPoi
 Fig.Art, pl.90 (b/w)
Ocean Park No.67, 1973
 Rose, p.230 (b/w)
Ocean Park #79, 1975, o/c UNNMa
 Arnason 2, fig.1003 (b/w)
Woman in a Window, 1957, o/c,
 UNBuA
 A-K, p.69 (b/w)

DIENES, Sari (Hungarian-American,
 1899-)
Construction No.11, 1961, glass
 bottle, mirror glass, wood,
 etc., Coll.Artist
 Seitz, p.157 (b/w)

DIENST, Rolf-Gunter (German,
 1939-)
Apropos Eduardo I, 1964, tem-
 pera, Coll.Artist
 New Art, pl.308 (b/w)
Diary of a Moment, 1964
 Pellegrini, p.158 (b/w)

DILLER, Burgoyne (American, 1906-
 1965)
Color Structure No.2, 1963,
 formica on wood UNNGol
 Hunter, pl.348 (col)
Composition, 1950, collage on
 cardboard UNNCh
 Janis, p.148 (b/w)
Construction #16, 1938, painted
 wood
 Andersen, p.85 (b/w)
First Theme, 1933-34, o/c -UD
 Hunter, pl.356 (b/w)
First Theme-35, 1955-60, o/c,
 UNNCh
 Seuphor, no.370 (col)
 Arnason, col.pl.242
First Theme, 1962, o/c UICA
 Geldzahler, p.142 (b/w)
First Theme, 1963-64, o/c UNBuA
 A-K, p.391 (col)
 Geldzahler, p.144 (b/w)
First Theme, 1964 UNNCh
 Pellegrini, p.32 (b/w)
First Theme, 1965-66 UNjAD
 Rose, p.134 (b/w)
No.2, First Theme, 1955-60, o/c,
 UDCHi
 Hh, pl.743 (col)
No.33, First Theme, 1962, o/c,
 UNNHo
 Geldzahler, p.72 (col)
No.5, First Theme, 1963, o/c,
 UNNGol
 Geldzahler, p.143 (b/w)
No.10, First Theme, 1963-64,
 o/c UNNGol
 Geldzahler, p.144 (b/w)

DINE, Jim (American, 1935-)
 All in One Lycra Plus Attach-
 ments, 1965, o/c with objects,
 NEA
 Russell, p.23 (b/w)
 Finch, p.85 (b/w)
 Angels for Lorca, 1966, fiber-
 glass and aluminum GCoL
 Kahmen, pl.38 (b/w)
 UK1, pl.116 (b/w)
 Bedspring, 1960, assemblage
 Kaprow, no.17 (b/w)
 Black Bathroom No.2, 1962, o/c
 with china wash-basin CTO
 Russell, pl.7 (b/w)
 Black Bathroom No.11, 1962, o/c,
 porcelain and metal UNNJa
 Fig.Art, pl.234 (b/w)
 Black Hand Saw, 1962, collage
 and oil on canvas FPSom
 Kahmen, pl.276 (b/w)
 UK1, pl.94 (b/w)
 Bow Tie, 1961, crayon and water-
 color
 Finch, p.79 (b/w)
 The Car Crash, 1960, happening
 L-S, pls.234-35 (b/w)
 Henri, figs.78-80 (b/w)
 Russell, p.17 (b/w)
 Janis, p.278 (b/w)
 Kaprow, nos.100-01, 107 (b/w)
 Child's Blue Wall, 1962, oil on
 canvas and mixed media UNBuA
 A-K, p.385 (col)
 Alloway, fig.36 (b/w)
 Double Red Self-Portrait (The
 Green Lines), 1964, oil and
 collage on canvas UNNJa
 L-S, pl.124 (b/w)
 Eleven Part Self-Portrait (Red
 Pony), 1965, lithograph,
 UNNMMA
 Castleman, p.129 (col)
 Five Feet of Colorful Tools,
 1962, o/c and tools UNNMMA
 Calas, p.93 (b/w)
 5 Toothbrushes on Black Ground,
 1962, o/c and toothbrushes,
 UNNJa
 Arnason, fig.1042 (b/w)
 Flesh Striped Tie, 1961, oil and
 collage on canvas UDCHi
 Hh, pl.967 (col)
 Flower Coat, 1963
 UK1, pl.113 (b/w)

 4 Designs for a Fountain of the
 Painter Balla, 1961, oil and
 rope on canvas GDusSc
 Kahmen, pl.305 (b/w)
 Pellegrini, p.238 (b/w)
 Four Rooms, 1962, o/c with chair
 Russell, pl.5 (b/w) UNNJa
 Alloway, fig.27 (b/w) UNNSo
 Compton 2, fig.151 (b/w),
 Coll.Artist
 Green Suit, 1959, oil and cloth
 on canvas, Coll.Artist
 Compton 2, fig.90 (b/w)
 The Gypsy, 1959, assemblage
 Kaprow, no.19 (b/w)
 Harry Mathews Skis the Vercoeur,
 1973
 Wolfram, pl.76 (col)
 Hat, 1961, o/c
 Russell, p.22 (b/w)
 Hatchet with Two Palettes, State
 No.2, 1963, o/c, wood and
 metal UNNAb
 Hunter, pl.611 (b/w)
 Alloway, pl.4 (col)
 Arnason, fig.1041 (b/w)
 Hercules Bellville, 1969, a/c
 with objects CThW
 Hunter, pl.610 (b/w)
 The House, 1960, environment
 Kaprow, nos.15, 23-24, 68 (b/w)
 Large Shower Number 1, 1962, o/c
 with metal and rubber -Mayer
 Amaya, p.82 (b/w)
 Metro, p.111 (b/w)
 Lawn-Mower, 1961 or 1962,
 painted wood, metal and o/c,
 -Te
 Fig.Art, pl.235 (b/w)
 Compton 2, fig.152 (b/w)
 Long Island Landscape, 1963, oil,
 collage and metal UNNW
 Calas, p.94 (b/w)
 Long Right Arm with a Candy Ap-
 ple Hand, 1965
 UK1, pl.59 (b/w)
 My Tuxedo Makes and Impresses
 Blunt Edge to the Light, 1965,
 oil and objects
 Finch, pp.76-77 (b/w)
 Nancy and I at Ithaca (Straw
 Heart), 1966-69, sheet iron
 covered with straw UNNSo
 Hunter, pl.612 (b/w)
 Alloway, fig.104 (b/w)

The Natural History of Dreams,
New York Theater Rally
Russell, p.17 (b/w)
A Nice Pair of Boots, 1965,
painted cast aluminum ELFr
Russell, pl.115 (b/w)
Finch, p.50 (b/w)
Paintbox No.1, 1961, watercolor,
BBrP
Russell, pl.56 (b/w)
Pearls, 1961 UNNG
Pellegrini, p.238 (b/w)
Pink Bathroom, 1962, o/c with
metal, glass, plastic UNNDin
Metro, p.110 (b/w)
Ray Gun, 1960 (in collaboration
with Claes Oldenburg)
Janis, p.275 (b/w)
Red Robe, 1964, o/c and col-
lage UNNJa
Amaya, p.48 (col)
Red Robe with Hatchet (Self-
Portrait), 1964, o/c, metal,
wood
Alloway, fig.38 (b/w) UVRL
Calas, p.95 (b/w) UIWMa
Saw Horse Piece, 1968-69, oil,
canvas, wood, metal UNNSo
Hunter, pl.636 (col)
Fig.Art, pl.237 (b/w)
Russell, pl.VI (col)
The Shining Bed, 1960, happening
Janis, p.278 (b/w)
Kaprow, no.70 (b/w)
Shoe, 1961
UK2, pl.199 (b/w)
Shovel, 1962, shovel against
painted panel UNNSol
Lippard, pl.83 (b/w)
The Smiling Workman, 1960, hap-
pening
Kaprow, no.67 (b/w)
The Studio (Landscape Painting),
1963, o/c UNNJa
New Art, col.pl.15
Talking with Paolozzi, 1966,
mixed media UNNJa
Compton, fig.178 (b/w)
Test in Art (from Art News, Nov.
1963)
Russell, pp.64-65 (b/w)
Three Palettes, 1964, oil and
canvas with objects, Priv.
Coll., Dusseldorf
Compton 2, fig.153 (b/w)

Tie Tie, 1961, o/c -Cul
Alloway, fig.28 (b/w)
Toaster, 1962, oil and electric
toaster UNNW
Whitney, p.72 (b/w)
Russell, pl.26 (b/w)
Tool Box No.1, 1966, screen
print and collage
Wolfram, pl.110 (b/w)
Two Palettes (International
Congress of Constructivists
and Dadaists), 1963, o/c and
collage UNNSh
Alloway, fig.37 (b/w)
Two Tumblers (One Real Tooth-
brush), 1962, pencil, water-
color and toothbrush
Finch, p.82 (b/w)
Two Washy Palettes, 1963, water-
color and pencil
Finch, p.81 (b/w)
The Universal Tie, 1961, etch-
ing -Lie
Finch, p.75 (b/w)
Untitled, 1961, watercolor and
pencil
Finch, p.73 (b/w)
Untitled, 1965, silkscreen
print GCoZ
Kahmen, pl.41 (b/w)
Untitled #8, 1966, photo (in
collaboration with Michael
Cooper)
Finch, p.87 (b/w)
The White Suit, 1964, oil on
panel UNNJa
Fig.Art, pl.236 (b/w)
White Teeth, 1963, lithograph,
GStSt
Castleman, p.127 (col)

DISTEL, Herbert
Kegelplastik VII, 1965-66
UK1, pl.184 (b/w)

DI SUVERO, Mark (Italian-American,
1933-)
The "A" Train, 1965, wood and
painted steel UDCHi
Hh, pl.892 (b/w)
Big Piece, 1964, wood and steel
Arnason, fig.994 (b/w)
Elohim Adonai, 1966, iron and
wood UMoSL
Andersen, p.129 (b/w)

For Giacometti, 1962, wood and
 steel UCtHWA
 New Art, pl.40 (b/w)
For Robling, 1971, welded steel,
 UNNNewh
 Rose, p.282 (b/w)
For Sabatere, 1961, wood
 Calas, p.55 (b/w)
Hankchampion, 1960, wood and
 iron UNNW
 Andersen, p.128 (b/w)
Hankchampion, 1960, wood and
 chain UNNScu
 Geldzahler, p.145 (b/w)
 Hunter, pl.781 (b/w)
 Rose, p.261 (b/w)
Ik Ook, 1971-72, painted steel,
 Coll.Artist
 Rose, p.281 (b/w)
 Arnason 2, fig.1052 (b/w)
Mohican, 1967, steel and wood,
 UICMa
 Geldzahler, p.73 (col)
New York Dawn (for Lorca), 1965,
 wood, steel and iron UNNW
 L-S, pl.190 (b/w)
 UK1, pl.146 (b/w)
 Whitney, p.110 (b/w)
Stuyvesantseye, 1965, mixed
 media
 Hunter, pl.809 (b/w), Coll.
 Artist
 Arnason 2, fig.1051 (b/w),
 UMnMW
Swing (Kinetic Playground Sculp-
 ture), 1963-64, steel, auto-
 mobile parts and tires
 Janis, p.291 (b/w)
Tom, 1961, wood and steel UICGi
 Andersen, p.129 (b/w)
 Geldzahler, p.146 (b/w)
Untitled, 1971, steel, Coll.
 Artist
 Hunter, pl.553 (col)
Yes, 1968-69, steel
 Calas, p.55 (b/w)

DOBES, Milan (Yugoslavian, 1929-)
 Der kleine blaue Brennpunkt,
 1966
 UK2, pl.290 (b/w)
 Light Kinetic Work for Symphony
 Orchestra
 Popper, pp.170-71 (b/w)
 Pulsating Rhythm
 Abstract, pl.302 (b/w)

Pulsating Rhythm II, 1967
 UK1, pls.309-10 (b/w)
Visual Participation, Osaka
 World Exhibition, 1970
 Popper, p.21 (b/w)
White Lighthouse, 1967
 UK1, pl.316 (b/w)

DOCKLEY, Peter (British, 1944-)
 Wax Event, 1971
 Henri, fig.32 (col)

DODEIGNE, Eugene (Belgian, 1923-)
 The Couple (Le couple), 1963,
 granite FPBu
 Kahmen, pl.116 (b/w)
 The Couple (Les deux), 1965,
 bronze GCoZ
 Kahmen, pl.127 (b/w)
 Pregnant Woman, 1961, Belgian
 limestone UDCHi
 Hh, pl.811 (b/w)
 Sculpture, 1958, bluestone
 Trier, fig.134 (b/w)
 Torso (Torse), 1962, granite,
 GDuK
 Kahmen, pl.95 (b/w)

DOMBEK, Blanche (American, 1914-)
 Figure, 1956, pine and mahogany
 Andersen, p.102 (b/w)

DOMINGUEZ, Oscar (Spanish, 1905-
 1957)
 The Clown, 1956, o/c FPAu
 Fig.Art, pl.111 (b/w)
 Arnason, fig.589 (b/w)
 Happy New Year, 1954, sheet
 brass and key mounted over
 paper on plywood IMSc
 Seitz, p.114 (b/w)

DOMOTO, Hisao (Japanese, 1928-)
 Solution of Continuity, 22, 1964,
 o/c UCOJ
 Lieberman, p.74 (b/w)
 Solution of Continuity, 24, 1964,
 o/c UNNMMA
 Lieberman, p.75 (b/w)
 Solution of Continuity, 57, 1963,
 aluminum and canvas, Coll.
 Artist
 Lieberman, p.13 (col)

DONAGH, Rita (British, 1939-)
 Aftermath, 1975, collage and
 pencil, Coll.Artist
 Eng.Art, p.84 (b/w)
 Car Bomb, 1973, collage and pen-
 cil, Coll.Artist
 Eng.Art, p.82 (b/w)
 Daily Mirror, 1973, collage and
 pencil, Coll.Artist
 Eng.Art, p.82 (b/w)
 Evening Papers Ulster, 1972-74,
 oil, collage and pencil on
 canvas ELBrC
 Eng.Art, p.81 (b/w)
 First Study, 1972-73, pencil on
 paper, Coll.Artist
 Eng.Art, p.83 (b/w)
 Megalithic Cemetery, 1973, col-
 lage and pencil, Coll.Artist
 Eng.Art, p.84 (b/w)
 Talbot Street, 1974, collage
 and pencil ELCont
 Eng.Art, p.85 (b/w)

DONALDSON, Anthony (British,
 1939-)
 Bring It to Jerome, 1964, a/c,
 ELStu
 Stuyvesant, p.157 (b/w)
 Girl Sculpture (Gold and Or-
 ange), 1970, Coll.Artist
 Wilson, pl.43 (col)
 It Won't Be Long, 1964, o/c,
 ELRo
 Lippard, pl.44 (b/w)
 Amaya, p.14 (b/w)
 Pix Hollywood Boulevard, 1968,
 o/c ELRo
 Compton 2, fig.77 (col)
 Take Away No.2, 1963, o/c ELMcA
 L-S, pl.116 (b/w)
 Zigzag Towards an Aurelia, 1963,
 a/c
 New Art, col.pl.39 ELRo
 Stuyvesant, p.156 ELStu

DONARSKI, Ray
 Lions International, 1964, o/c,
 Coll.Artist
 Lippard, pl.120 (b/w)

DONATI, Enrico (Italian, 1909-)
 Maya Sandstone, 1965 UNNSt
 Pellegrini, p.96 (b/w)

DORAZIO, Piero (Italian, 1927-)
 Berlin Air, 1962, oil GBSp
 Metro, p.112 (b/w)
 Beyond Two Meters, 1964 -Marl
 Pellegrini, p.151 (b/w)
 Cut D, I, 1971, o/c IRMarl
 Liverpool, no.38 (b/w)
 Eye Numerator, 1953, wood and
 plastic box construction,
 UDCHi
 Hh, pl.565 (b/w)
 Fa Giorno Vassily, 1971, o/c,
 UNNMa
 Arnason 2, fig.1217 (b/w)
 Few Roses, 1963, o/c IRMarl
 New Art, col.pl.56
 In the Long Run, 1965, o/c,
 IRMarl
 Abstract, pl.227 (col)
 Jeux de distance, 1962, oil,
 IRMarl
 Metro, p.113 (col)
 The Litany of the Thimbles,
 1964 -Marl
 Pellegrini, p.249 (col)
 Mano della clemenza, 1963, oil,
 GBSp
 Haftmann, pl.977 (b/w)
 Meco I, 1970-71, o/c IRMarl
 Liverpool, no.35 (b/w)
 Miles I, 1971, o/c IRMarl
 Liverpool, no.37 (b/w)
 Molto a Punta, 1965, o/c ELT
 L-S, pl.140 (b/w)
 Supernova, 1958, o/c
 1945, pl.53 (b/w)
 Untitled, 1963, o/c IRMarl
 Abstract, pl.228 (b/w)

DOUKE, Dan
 Untitled (Reseda), 1973, a/c,
 -Kra
 Battcock, p.255 (b/w)

DOVA, Gianni (Italian, 1925-)
 Personage, 1962
 Pellegrini, p.276 (b/w)
 Ucello a la finestra, 1957, o/c,
 IMBl
 1945, pl 63 (b/w)

DOWIS, David
 Sculpture III, marble, Coll.
 Artist
 Busch, fig.134 (b/w)
 Untitled, 1969, marble
 Busch, fig.133 (b/w)

DOWNEY, Juan (Chilean, 1940-)
 With Energy Beyond These Walls,
 1971, drawing
 Henri, fig.58 (b/w)

DOWNING, Thomas (American, 1928-)
 Green Bias, 1963 UNNSta
 Pellegrini, p.146 (b/w)
 Sixteen, 1967
 UK2, pl.325 (b/w)

DOWNSBROUGH, Peter
 Staple on Graph Paper Piece,
 1968
 6 Yrs, p.41 (b/w)

DOYLE, Tom (American, 1928-)
 "La Vergne", 1965, masonite,
 wood, steel and polychrome
 Busch, fig.44 (b/w)

DRAGO
 La Lupa di Roma, 1966
 UK2, pl.127 (b/w)
 Proust, 1967
 UK2, pl.69 (b/w)

DREIBAND, Laurence (American,
 1944-)
 Untitled, 1969, oil and acrylic
 UK3, pl.28 (b/w)

DREXLER, Rosalyn (American, 1926-
)
 Chubby Checker, 1964, liquitex,
 oil and collage on canvas,
 UNNKor
 Lippard, pl.117 (b/w)
 The Connoisseurs, 1963
 UK2, pl.72 (b/w)
 The Overcoat, 1963, liquitex,
 oil and collage on canvas
 board UOOC
 Russell, pl.120 (b/w)
 The Syndicate, 1964, pasted pa-
 per and paint on canvas,
 UIaDAm
 Janis, p.283 (b/w)

DUARTE, Angel (Spanish)
 C17, 1961 SwBG
 Barrett, p.14 (b/w)
 Composition FPRe
 Abstract, pl.291 (b/w)
 Popper 2, p.225 (b/w)
 E 7 A.G., 1964-70, plaster and

fiberglass
 Dyckes, p.80 (b/w)
 E 16 A 1, 1966-70, stainless
 steel
 Dyckes, p.80 (b/w)
 Prototype for an Edition, 1967,
 etched glass, illuminated
 Dyckes, p.39 (b/w)
 V10, 1963, glass, neon and alu-
 minum IRMas
 Barrett, p.105 (b/w)

DUBUFFET, Jean (French, 1901-)
 Actor in a Ruff, 1961, o/c,
 UDCHi
 Hh, pl.793 (b/w)
 L'africain, 1959, assemblage of
 dried leaves
 Janis, p.226 (b/w)
 L'ane egare, 1959, assemblage of
 burdock and pumpkin, Priv.
 Coll.
 Janis, p.225 (b/w)
 Archetypes, 1945, mixed media on
 canvas UNNC
 Selz, p.63 (b/w)
 L'Automobile Fleur de l'Indus-
 trie, 1961, o/c
 Janis, p.302 (b/w)
 Barbe des dynasties regnantes,
 1959, Chinese ink, torn papers
 Janis, p.226 (b/w)
 The Beard of Computations, 1959,
 Priv.Coll., Paris
 Ponente, p.165 (col)
 Borne au logos VII, 1967, cast
 polyurethane UNBuA
 A-K, p.188 (col)
 Business Lunch, 1946, o/c, Priv.
 Coll.
 Abstract, pl.17 (b/w)
 Business Prospers, 1961, o/c,
 UNNMMA
 Arnason, fig.912 (b/w)
 Calamuchon, 1973-74, epoxy paint
 on polyurethane UWiMY
 Arnason 2, fig.955 (b/w)
 Childbirth, 1944, o/c UNNMatC
 Selz, p.61 (col)
 Compagnonnage, 1959, canvas and
 oil on canvas
 Janis, p.227 (b/w)
 Corps de Dame, 1950, watercolor,
 ELCoc
 L-S, pl.65 (col)
 'Corps de dame-1'oursonne',

DUFY, Raoul (French, 1877-1953)
 Atelier (L'atelier au champ de
 ble), 1942, oil FPCa
 Haftmann, pl.491 (b/w)
 Ball at the Moulin de la Galette
 After Renoir (Le Moulin de la
 Galette d'apres Renoir), 1943,
 oil FPCa
 Haftmann, pl.492 (b/w)
 Homage to Bach, 1950, oil SwLaMe
 Haftmann, pl.493 (b/w)
 The Red Violin, 1948, oil on
 Pavatex SwGA
 Haftmann, pl.494 (b/w)

DUGGER, John (American, 1948-)
 Body Conductor, 1969
 Popper, p.189 (b/w)

DUMITRESCO, Nathalie (Rumanian,
 1915-)
 Harmony in Yellow, 1958, o/c,
 FPV
 Seuphor, no.306 (col)

DUNFORD, Michael (British, 1946-)
 Still Life with Pear, 1974, film
 Eng.Art, p.445 (b/w)

DUPUY, Jean
 "Heart Beat Machine" Ceremony,
 New York, 1969
 UK4, pls.105-06 (b/w)
 Heart Beats Dust, 1968
 Popper, p.219 (b/w)

DURAN, Robert (American, 1938-)
 Untitled, 1971, liquitex on
 canvas
 Rose, p.210 (b/w)

DURCHANEK, Ludvik (Austrian-Amer-
 ican, 1902-)
 Homo Derelicto, 1964-65
 UK1, pl.11 (b/w)

DURKEE, Stephen (American, 1937-)
 Small Canticle, 1962, o/c,
 UNNSto
 Lippard, pl.54 (b/w)

DUVILLIER, Rene (French, 1919-)
 Aerial Cycle. Saturn's Moon,
 1964 FPSch
 Pellegrini, p.73 (b/w)
 Averse de Feu, 1961

Metro, p.118 (b/w)
 Diable de Mer II, 1962
 Metro, p.119 (b/w)

DWORKOWITZ, Alan
 BSA, 1971, o/c
 UK3, pl.102 (b/w)
 BSA, 1971, o/c
 UK3, pl.103 (b/w)

DWOSKIN, Stephen
 Take Me, 1968
 UK4, pl.141 (b/w)

DYE, David (British, 1946-)
 Confine, 1972, hand-held pro-
 jector piece
 Eng.Art, p.447 (b/w)
 Five Framelines Framed, 1975,
 colored photographs, Coll.
 Artist
 Eng.Art, p.371 (col)
 Installation Diagram-Unsigning:
 For Eight Projectors, 1972
 Eng.Art, p.338 (b/w)
 Light Effects Not Seen During
 Projection, 1974, colored
 photographs ELLi
 Eng.Art, p.370 (b/w)
 Mirror Film, 1971
 Eng.Art, p.338 (b/w)
 Screen, 1972, hand-held projec-
 tor piece
 Eng.Art, p.447 (b/w)
 Unsigning: For Eight Projectors,
 Hayward Gallery, 1972
 Eng.Art, p.338 (b/w)
 Western Reversal: Still Version,
 1974, black-and-white photo-
 graphs ELLi
 Eng.Art, pp.372-73 (b/w)

DZAMONJA, Dusan (Yugoslavian,
 1928-)
 Sculpture, 1963 YZSt
 New Art, pl.265 (b/w)
 Sculpture en metal, 1961
 Metro, p.120 (b/w)
 Sculpture en metal, 1961
 Metro, p.121 (b/w)

DZUBAS, Friedel (American, 1915-)
 De Chelly, 1969, magna on can-
 vas UNNKn
 Carmean, p.15 (col)
 One Times One, 1961, o/c UNNG
 Carmean, p.50 (b/w)

ECONOMOS, Michael
 Untitled, 1973, o/c UMdBG
 Battcock, p.256 (b/w)

EDDY, Don (American, 1944-)
 Jeep L.P., 1970, o/c
 UK3, pl.111 (b/w)
 Rosen Bros. Strictly Kosher
 Meats & Poultry, 1973, a/c
 Battcock, p.258 (b/w)
 Tom Williams Used Cars, 1972,
 a/c
 Battcock, p.257 (b/w)
 Untitled, 1969, o/c
 UK3, pl.120 (b/w)
 Untitled, 1969, o/c
 UK3, pl.121 (b/w)
 Volkswagen: R.F., 1970, o/c
 UK3, pl.108 (b/w)
 Volkswagen: R.F., 1970, o/c
 UK3, pl.109 (b/w)

EDELHEIT, Martha
 Frabjous Day, 1960, construction
 Kaprow, no.10 (b/w)

ECUCHI, Shyu (Japanese, 1932-)
 Monument No.1, 1963, cherry,
 UNNCha
 Lieberman, p.82 (b/w)
 Monument No.4, 1964, cherry,
 UNNMMA
 Lieberman, p.83 (b/w)

EHLERS, Karl (German, 1904-)
 Buttressing Wall, 1957, concrete,
 GBadL
 Trier, fig.192 (b/w)

EIELSON, Jorge
 Angolare 4, 1966
 UK2, pl.12 (b/w)
 Requiem, 1962
 UK2, pl.101 (b/w)

ELK, Ger van (Dutch, 1941-)
 Cords, 1967-68
 Celant, p.71 (b/w)
 Paul Klee-um den fisch, 1926,
 1970
 6 Yrs, p.217 (b/w)
 Piece made in one hour, with
 assistance, 1968
 Celant, p.69 (b/w)
 Some sparetime floor enjoyment,
 1968

 Celant, p.72 (b/w)
 To a first stone to be first,
 1968
 Celant, p.68 (b/w)
 Untitled (street scene), 1968
 Celant, p.70 (b/w)

ELLER, Jim
 Scrabble Board, 1962, mixed
 media, Priv.Coll.
 Lippard, pl.140 (b/w)

ELLIOTT, Ronnie (American, 1916-)
 Carnival III, 1957, paper col-
 lage
 Janis, p.181 (b/w)
 Rag Collage, 1957
 Janis, p.193 (b/w)

EMSHWILLER, Ed
 Thanatopsis, 1962
 UK4, pl.142 (b/w)

ENGELMAN, Martin (Dutch, 1936-)
 Urtier, 1964-65, o/c, Priv.
 Coll., England
 New Art, pl.153 (b/w)

ENGLERT, Rudolf (German, 1932-)
 T.Z. 144/1965, ink drawing
 New Art, p.305 (b/w)

ENGMAN, Robert (American, 1927-)
 Untitled, 1969, bronze UDCHi
 Hh, pl.917 (b/w)

EQUIPO CRONICA
 Capitalist, 1966, serigraph
 Dyckes, p.67 (b/w)
 Easter Egg, 1967, wood and
 papier-mache
 Dyckes, p.93 (b/w)
 Guernica in Spain, 1970, o/c,
 SpMaMu
 Dyckes, p.68 (b/w)
 High Society, 1966, oil on wood,
 SpSM
 Dyckes, p.129 (b/w)
 Joan Antoni Toledo, 1969,
 acrylic on wood
 Dyckes, p.67 (b/w)
 The Living Room, 1970, o/c,
 SpCuZ
 Dyckes, p.129 (b/w)
 The Salon, 1970, oil SpCuZ
 Dyckes, p.117 (b/w)

1945, pl.93 (b/w)
A Sad Specimen, 1967, assem-
blage, Priv.Coll., Paris
Wolfram, pl.54 (b/w)
Sign for a School for Gulls,
1957, Priv.Coll., Paris
Fig.Art, pl.105 (b/w)
Soliloquy, 1965, collage on ply-
wood, Coll.Artist
Arnason, fig.555 (b/w)
Surrealism and Painting, 1942,
o/c, Priv.Coll., New York City
Arnason, fig.553 (b/w)
The Table is Set, 1944, bronze,
UTxHMenil
Andersen, p.113 (b/w)
The Table is Set, 1944, bronze,
UDCHi
Hh, pl.482 (b/w)
The Temptation of St. Anthony,
1945, oil GDuK
Haftmann, pl.536 (b/w)
Three Young Dionysaphrodites,
1957
Fig.Art, pl.106 (b/w)
Under the Bridges of Paris, 1961,
bronze UDCHi
Hh, pl.853 (b/w)
Untitled Collage, 1949, scienti-
fic engravings and ink draw-
ing −Bod
Janis, p.108 (b/w)
Young Man Intrigued by the
Flight of a Non-Euclidean Fly,
1947, o/c SwZLo
Hamilton, pl.341 (b/w)

ERRO, Gudmundur (Icelandic, 1932−
)
American Idols, 1964
UK2, pl.111 (b/w)
The American Interieurs, 1968
UK2, pl.245 (b/w)
The American Interieurs, 1968
UK2, pl.246 (b/w)
L'Appetit est une crime, 1963,
o/c FPDel
New Art, col.pl.29
Le decollage de Bosch, 1964
UK2, pl.107 (b/w)
Foodscape, 1964
UK2, pl.194 (b/w)
Mecamorphoses, 1962, film decor
UK4, pl.52 (b/w)
Papa Capogrossi, 1965
UK2, pl.122 (b/w)

Professional Portrait−Leonardo,
1969, o/c, Priv.Coll.
Fig.Art, pl.317 (col)
Stalingrad, 1964, oil, Coll.
Artist
Haftmann, pl.1004 (b/w)

ESCHER, Maurits Cornelis (Dutch,
1898−1972)
Three Spheres I, 1945, wood
engraving
Fig.Art, pl.139 (b/w)

ESCOBAR, Marisol. See MARISOL

ESTES, Richard (American, 1936−)
Booths, 1967, o/c −Cu
Battcock (col)
Nedicks, 1970, o/c
Calas, p.156 (b/w)
No.2 Broadway, 1968 or 1969, oil
on masonite UNNGroo
UK3, pl.129 (b/w)
Calas, p.156 (b/w)
Oriental Restaurant, 1972, seri-
graph UNNW
Whitney, p.137 (b/w)
Paris Street−Scene, 1972, o/c,
−Lew
L−S, pl.220 (col)
Stationery, 1976, o/c UNNSto
Arnason 2, fig.1240 (b/w)
Store Front, 1968, oil on mason-
ite UNNSto
UK3, pl.112 (b/w)
Subway Stairway, 1970 UNNSto
UK3, pl.V (col)
Untitled, 1967, o/c
UK3, pl.128 (b/w)
Untitled, 1970, o/c
UK3, pl.113 (b/w)
Untitled, 1970, o/c
UK3, pl.130 (b/w)
Untitled, 1970, o/c
UK3, pl.131 (b/w)
Valet, 1972, o/c
Battcock, p.89 (b/w)

ESTEVE, Maurice (French, 1904−)
Composition, 1959, charcoal and
colored pencil FPVG
Seuphor, no.483 (b/w)
Composition 166, 1957, oil on
wood ELT
L−S, pl.47 (b/w)

Fleuriel, 1956 SwGB
 Ponente, p.56 (col)
The Lock at Haut-pont, 1953, o/c,
 IBrC
 Abstract, pl.52 (b/w)
Tacet, 1956, o/c
 1945, pl.4 (col)
Vermeuse, 1958, o/c FPVG
 Seuphor, no.482 (col)

ETIENNE-MARTIN (French, 1913-)
 Anemone, 1955, elm UNNG
 Arnason, fig.997 (b/w)
 Demeure Nr.3, 1960, plaster,
 Priv.Coll.
 New Art, pl.72 (b/w)
 D'Eux (From Them), 1955-56, wood,
 FPSp
 G-W, p.291 (b/w)
 Grand Couple (Large Couple),
 1947, elm wood, Priv.Coll.,
 Paris
 Metro, p.124 (b/w)
 Trier, fig.65 (b/w)

ETROG, Sorel (Rumanian, 1933-)
 Mother and Child, 1962-64,
 bronze UDCHi
 Hh, pl.786 (b/w)
 The Source, 1964, bronze UDCHi
 Hh, pl.784 (b/w)

EVANS, Garth
 Rose bed, 1966
 UK1, pl.217 (b/w)

EVERETT, Bruce
 Doorknob, 1970, o/c UCTC
 UK3, pl.94 (b/w)
 Doorknob, 1971, o/c
 Battcock, p.259 (b/w)
 Gum Wrapper, 1971, o/c UCtNhYA
 Battcock, p.260 (b/w)
 Towel Rack, 1970, o/c UCCoG
 UK3, pl.95 (b/w)
 Untitled, 1969, o/c UCCoG
 UK3, pl.96 (b/w)

EVERGOOD, Philip (American, 1901-
 1973)
 American Shrimp Girl, 1954, o/c
 mounted on board UDCHi
 Hh, pl.582 (b/w)
 Juju as a Wave, 1935-42, o/c,
 UDCHi
 Hh, pl.442 (b/w)

Lily and the Sparrows, 1939,
 oil on composition board UNNW
 Whitney, p.50 (col)
The New Lazarus, 1927-54 UNNW
 Rose, p.110 (b/w)

EVERSLEY, Fred (American, 1941-)
 Oblique Prism II, cast polyester
 resin UCOA
 Busch, pl.XXVI (col)
 Untitled, 1970, cast polyester
 resin
 Busch, pl.XXVII (col)

FABRO, Luciano (Italian, 1936-)
 De Italia: a) Golden Italy,
 b) Glass Italy, 1968, gilt
 bronze and tempered glass,
 IMGal
 Liverpool, no.71 (b/w)
 Felce, 1968, glass, fern and
 lead
 Celant, p.86 (b/w)
 Italia, 1968, map and wood
 Celant, p.85 (b/w)
 Lenzuola, 1968
 Celant, p.88 (b/w)
 Lenzuola, 1968
 Celant, p.89 (b/w)
 Il pupo, 1969, swaddling bands
 and light
 Celant, p.87 (b/w)
 Senza Titolo, 1967
 UK2, pl.404 (b/w)

FAHLSTROM, Oyvind (Swedish, 1928-
 1976)
 Blue Pool, 1969, mixed media
 Calas, p.321 (b/w)
 The Cold War, Phase 5, 6, 7,
 1963-65
 UK2, pl.358 (b/w)
 The Cold War (phase 3), 1963-64,
 FPDi
 Lippard, pl.167 (b/w)
 The Cold War, Phase 3, 1964,
 tempera on plastic and metal,
 UNNBaker
 Amaya, p.70 (b/w)
 The Cold War (Variable Points,
 1964), Phase I, 1964, tempera
 on plastic and metal UNNBaker
 Amaya, p.70 (b/w)
 Dr. Schweitzer's Last Mission,
 1964-66, mixed media UNNJa
 UK2, pl.360 (b/w)

Henri, fig.51 (b/w)
Compton 2, fig.173 (b/w)
Arnason, fig.1070 (b/w)
Eddie in the Desert, 1966, col-
lages on painted wood UNNMMA
Fig.Art, pl.283 (i.e.282) (b/w)
Eddie in the Desert...4 Phases,
1966
UK2, pl.359 (b/w)
ESSO-LSD, 1967
UK2, pl.371 (b/w)
Fahlstrom's Corner, Stockholm,
1964
UK4, pl.64 (b/w)
Feast on Themes of Mad, 1958-59
Pellegrini, p.283 (b/w)
Green Pool, 1968-69, variable
structure in plexiglass pool,
UNNJa
Russell, pl.79 (b/w)
Life Curve No.2, 1967, mixed
media UNNJa
Compton 2, fig.172 (b/w)
The Little General (Pinball Ma-
chine), 1967, mixed media,
UNNJa
Fig.Art, pl.281 (col)
Wilson, pl.61 (col)
Notes for Night Music I, 1975,
ink and acrylic on paper
Arnason 2, fig.1162 (b/w)
Performing Krazy Kat No.2, Sun-
day Edition, 1963-64, tempera
on paper on canvas UCtGO
Russell, pl.III (col)
Performing Krazy Kat III, 1965,
tempera on canvas and metal,
magnetic elements UNNRau
Russell, pl.81 (b/w)
The Planetarium, 1963, tempera
and vinyl on canvas FPCor
Calas, p.320 (b/w)
Roulette-Variable Painting, 1966
UK2, pl.357 (b/w)
Sitting...Six Months Later
(phase 4), 1962, tempera and
canvas on plastic UNNHay
Lippard, pl.168 (b/w)
Sitzen (Sitting), 1962 or 1964,
tempera on paper mounted on
canvas SnSNM
New Art, col.pl.80
Fig.Art, pl.283 (i.e.282) (b/w)
Compton 2, fig.174 (b/w)

FALK, Hans (Swiss, 1918-)
Petrified Light II, 1960, o/c,
SwZCoh
Seuphor, no.350 (col)

FALKENSTEIN, Claire (American,
1909-)
Planet Mars, 1962, polyester,
plastic, iron, bronze
Metro, p.127 (b/w)
Point as a Set #10, 1962,
welded metal FPCor
Ashton, fig.22 (b/w)
Portrait of the Painter Karel
Appel, 1956-59, iron wire,
FPSt
Trier, fig.93 (b/w)
Sun #5, 1954, iron brazed with
brass FPTap
Andersen, p.150 (b/w)

FANGOR, Wojciech (Polish-Ameri-
can, 1922-)
B15, 1964
UK2, col.pl.XXV
E.10, 1966 ELGra
Barrett, p.131 (b/w)
NJ15, 1964, o/c UNNCh
Abstract, pl.213 (b/w)
No.35, 1963, o/c
New Art, pl.239 (b/w)
UK2, pl.309 (b/w)
Untitled, 1959
UK1, pl.330 (b/w)
Untitled, 1961
UK1, pl.331 (b/w)
Untitled, 1964
UK1, pl.332 (b/w)

FARRERAS, Francisco (Spanish)
Collage, 1960
Janis, p.157 (b/w)
Collage, 1960 -Har
Janis, p.158 (b/w)
Collage No.120, 1960, mixed
media
Dyckes, p.21 (b/w)
Picture No.212, 1963, paper and
paint on board, Priv.Coll.,
Chicago
Dyckes, p.33 (b/w)
Tableau No.399, 1970, collage
Dyckes, p.53 (b/w)

Cage, 1954, lead UNNEm
Hunter, pl.539 (b/w)
Environmental Sculpture, 1967,
fiberglass and polyester res-
in UNjNBR
Arnason, fig.993 (b/w)
Flame, 1949, brass, lead, soft
solder UNNW
Andersen, p.73 (b/w)
Green Sculpture II, 1954, cop-
per UNBuA
A-K, p.113 (b/w)
Hazardous Encounter II, 1947,
bronze
Andersen, p.71 (b/w)
He Is Not a Man, 1950, bronze,
UNNMMA
Andersen, p.73 (b/w)
Hunter, pl.538 (b/w)
Homage to Piranesi, 1962-63,
copper, Coll.Artist
L-S, pl.182 (b/w)
Homage to Piranesi IV, 1965,
beaten and welded copper,
UNNEm
Ashton, pl.XI (b/w)
Labors of Hercules, 1948, lead,
UNNNYU
Andersen, p.72 (b/w)
Metamorphsis I, 1946, bronze
Andersen, p.69 (b/w)
Portrait of Jackson Pollock II,
1949, lead and brass UNNMMA
Andersen, p.71 (b/w)
Reclining Woman II, 1945, bronze,
UNjNBR
Andersen, p.68 (b/w)
Relief on the B'nai Israel Syna-
gogue, Millburn, N.Y., 1952,
lead on copper
Trier, fig.195 (b/w)
Spherical Sculpture, 1954-62,
bronze
Rose, p.256 (b/w)
Spheroid 2, 1952, copper and
lead UNNKo
G-W, p.261 (b/w)
Sun Wheel, 1956, brass, copper,
silver solder UNNW
Whitney, p.113 (b/w)
Hunter, pl.514 (col)
Three Arches, 1966, epoxy UNNEm
Hunter, pl.541 (b/w)
Three-Legged Woman I, 1945,
bronze
Andersen, p.70 (b/w)

The Unknown Political Prisoner,
1953
UK1, pl.244 (b/w)
Wall Sculpture, 1953, soldered
copper and lead UMWiB
Hamilton, pl.347 (b/w)

FERGUSON, Gerald (American, 1937-
)
The Standard Corpus of Present
Day English Language Usage,
1971
6 Yrs, p.209 (b/w)

FERNANDEZ MURO, Jose Antonio
(Spanish, 1920-)
Al gran pueblo argentino
Pellegrini, p.190 (b/w)
Medalla escarlata, 1963, oil
and mixed media UNNBoni
New Art, col.pl.93
Nine Situations of a Theme,
1970, oil on aluminum
Dyckes, p.52 (b/w)

FERNBACH-FLARSHEIM, Carl
Boolean Image (excerpts from
The Boolean Package), 1969
Meyer, p.122 (b/w)
The Boolean Image, Conceptual
Typewriter, 1970
Meyer, p.123 (b/w)
The Conceptual Cloud, Game Book
1, 1967
Meyer, pp.124-25 (b/w)

FERREN, John (American, 1905-1970)
Construction in Wood: Daylight
Experiment, 1968, painted
wood UDCHi
Hh, pl.1005 (col)
Maquette, 1967, construction,
Coll.Artist
Arnason, col.pl.249

FERRER, Rafael (American, 1933-)
4500 Lbs. of Ice, 28 Bushels of
Leaves, 1969
UK4, pl.148 (b/w)
Staircase-3 Landings-Leaves,
Leo Castelli's Warehouse,
Dec.4, 1968
6 Yrs, p.64 (b/w)

FESTA, Tano (Italian, 1938-)
 Detail of the Sistine Chapel,
 1963, oil and collage on can-
 vas IMSc
 Lippard, pl.159 (b/w)
 From Michelangelo, 1965 IRTar
 Pellegrini, p.248 (b/w)
 La grande odalisca, 1964
 UK2, pl.33 (b/w)
 Souvenir of London, 1964, o/c,
 IRTar
 New Art, pl.131 (b/w)

FILKO, Stanislav (Yugoslavian,
 1937-)
 Cosmos, Bratislava, 1968, en-
 vironment
 Popper, p.169 (b/w)
 Universal Environment, 1966-67
 Popper 2, p.208 (b/w)

FILLIOU, Robert (German, 1926-)
 Hand-Show. The key to art (in
 collaboration with Scott
 Hyde)
 UK2, pl.139 (b/w)

FINE, Perle (American, 1915-)
 Sudden Encounter, 1961, pasted
 papers, watercolor, charcoal,
 UNNGrah
 Seitz, p.98 (b/w)

FINK, Raymond (American, 1922-)
 Society Entrance, 1956, steel
 and bronze
 Andersen, p.142 (b/w)

FINKELSTEIN, Max (American, 1915-
)
 Square Plus 300, 1967, aluminum,
 UDCHi
 Hh, pl.830 (b/w)

FINLAY, Ian Hamilton
 Poem Inscribed on Slate, Coll.
 Artist
 Popper, p.142 (b/w)

FISCHER, Lothar (German, 1933-)
 El Cid II, 1965, mixed media,
 GML
 New Art, pl.319 (b/w)

FISH, Janet
 Five Calves Foot Jelly, 1971,

 o/c
 Battcock, p.50 (b/w)
 Skowhegan Water Glasses, 1973,
 o/c
 Battcock, p.67 (b/w)
 Smirnoff's Vodka and Don Q Rum,
 1973, o/c UNNHeu
 Battcock, p.261 (b/w)
 Tanqueray Gin, 1973, o/c -Ko
 Battcock, p.5 (b/w)

FLACK, Audrey (American, 1931-)
 Dolores, 1971, o/c
 Battcock, p.9 (b/w)
 Family Portrait, 1969-70, o/c,
 UNNRiv
 UK3, pl.45 (b/w)
 Lady Madonna, 1972, o/c
 Battcock, p.262 (b/w)
 Macarena Esperanza, 1971, o/c
 Battcock, p.53 (b/w)
 Solitaire, 1974, a/c -D
 Battcock (col)
 War Protest March, 1969, o/c
 UK3, pl.62 (b/w)

FLANAGAN, Barry (British, 1941-)
 Bundle, 1967, hessian and paper
 Celant, p.134 (b/w)
 4 casb 2 '67, 1967, sand and
 canvas ELRo
 Walker, pl.25 (col)
 Eng.Art, pp.242-43 (b/w & col)
 Four rahbs, 1967, resin, hessian
 and sand
 Celant, p.136 (b/w)
 Hole in the Sea, Scheveningen,
 Holland, 1969, TV film
 Henri, fig.65 (b/w)
 6 Yrs, p.94 (b/w)
 Light on Light on White on White,
 1969
 Eng.Art, p.227 (b/w)
 1 ton corner piece, 1967-68
 Celant, p.138 (b/w)
 Pile, 1967, hessian
 Celant, p.135 (b/w)
 Pile, 1968
 Eng.Art, p.241 (b/w)
 R N '66, 1966, sand ELRo
 Eng.Art, p.245 (b/w)
 Ringl 1 '67, 1967, linoleum,
 ELRo
 Walker, pl.25 (col)
 Eng.Art, pp.242-43 (b/w &col)

Rope (gr 2sp60) 6 '67, 1967,
 sisal ELRo
 Eng.Art, pp.242-43 (b/w & col)
 Walker, pl.25 (col)
rsbtworahsbbsharowtbsr·5 '67,
 1967, a sack, plastic and
 sand GDusSc
 Kahmen, pl.267 (b/w)
Sand Muslin, 1966
 Eng.Art, p.244 (b/w)
3 ton sandbag, Cornwall, Easter
 1967
 Celant, p.137 (b/w)
Two rsb 3 '67 khite, 1967, a
 sack, plastic and sand GDusSc
 Kahmen, pl.262 (b/w)
2 space rope, 1967
 Celant, p.138 (b/w)
Untitled '70, 1970
 Eng.Art, p.227 (b/w)

FLAVIN, Dan (American, 1933-)
 Alternative Diagonals, 1964
 UK1, pl.325 (b/w)
 Coran's Broadway Flash, 1962,
 incandescent lights, oil on
 board UNNWeb
 Hunter, pl.840 (b/w)
 The Diagonal of May 25, 1963,
 1963, daylight fluorescent
 light
 Andersen, p.220 (b/w)
 Monument 7 for V. Tatlin, 1964-
 65, cool white fluorescent
 light
 Andersen, p.220 (b/w)
 The nominal three (to William
 of Ockham), 1963, cool white
 fluorescent light CON
 Geldzahler, p.74 (col)
 Pink and Gold, 1968, neon lights
 Hunter, pl.842 (b/w) UICC
 Arnason, fig.1094 (b/w) UNNDw
 Pink Out of a Corner
 UK1, pl.326 (b/w)
 Primary Pictures Series, 1966,
 fluorescent tubes UCLWi
 Abstract, pl.239 (b/w)
 Primary Structure, 1964, fluo-
 rescent lights FPSon
 Hunter, pl.904 (col)
 (to Shirley), 1965-69, pink and
 blue neon lighting tubes GCoZ
 Kahmen, pl.230 (b/w)
 Untitled, 1965, drawing UNNDw
 Geldzahler, p.147 (b/w)

Untitled, 1966
 UK1, pl.327 (b/w)
Untitled, 1966, cool white flu-
 orescent light UNNSte
 Geldzahler, p.147 (b/w)
Untitled, 1966, cool white flu-
 orescent light UCLB1
 Geldzahler, p.148 (b/w)
Untitled (In Memory of My Father
 D. Nicholas Flavin), 1974,
 daylight fluorescent light,
 UNNC
 Arnason 2, col.pl.264
Untitled September 13, 1966,
 fluorescent light GCoZ
 Brett, p.88 (b/w)
Untitled (To a Man George Mc-
 Govern), 1972
 Popper, p.87 (b/w)
Untitled (to Alexandra), 1973,
 pink fluorescent lights
 Walker, pl.19 (col)
Untitled (to Jane and Brydon
 Smith), 1969, blue, daylight
 fluorescent light UNNC
 Arnason 2, col.pl.265
 Calas, p.304 (b/w)
Untitled (to Karin) September 9,
 1966, warm white and cool
 white fluorescent light
 Brett, p.89 (b/w)
Untitled (to S.M.), 1969, fluo-
 rescent light
 Busch, fig.113 (b/w)
Untitled (to S.M.), 1969, fluo-
 rescent lights
 Walker, pl.20 (col)
 Rose, p.275 (b/w)
Untitled (to the 'innovator'
 wheeling beach blow), 1968,
 fluorescent light UNNDw
 L-S, pl.215 (b/w)

FLEISCHMAN, Adolf Richard (German,
 1892-)
 Composition No.11, 1954, o/c,
 Coll.Artist
 Seuphor, no.511 (col)
 Relief Painting No.15 in Black
 and White, 1960-61 UNNPar
 Seuphor, no.513 (b/w)

FLINT, Armand
 The Queen and Sherbourne, 1950,
 o/c CTM
 Lippard, pl.184 (b/w)

FLONDOR-STRAINU
Aerial Mobile Mirage, 1968,
 striated glass and India ink
 on P.A.L.
 Abstract, pl.304 (b/w)

FOLDES, Peter (Hungarian, 1924-)
I Hate Them, 1961, Priv.Coll.
 Abstract, pl.128 (b/w)
Open Space, 1958, o/c FPRi
 Seuphor, no.343 (col)

FOLLETT, Jean (American, 1917-)
Gulliver, 1956, assemblage
 Kaprow, no.80 (b/w)
Lady with Open-Door Stomach,
 1955, assemblage
 Kaprow, no.2 (b/w)
Many-Legged Creature, 1955,
 mixed media
 Kaprow, no.62 (b/w)
Untitled, 1955(?), assemblage
 Kaprow, no.35 (b/w)
Untitled, 1958, metal hardware,
 rope, mirror, etc. on wood,
 UNNGree
 Seitz, p.124 (b/w)

FONTANA, Lucio (Italian, 1899-
1968)
Baroque Venice, 1961, o/c,
 IRMarl
 Liverpool, no.13 (b/w)
Concetto spaziale, 1958, o/c
 1945, pl.62 (b/w)
Concetto spaziale, 1959
 UK2, pl.328 (b/w)
Concetto spaziale, 1959, tem-
 pera, Coll.Artist
 Metro, p.130 (b/w)
Concetto spaziale, 1962, Coll.
 Artist
 Metro, p.131 (col)
Concetto spaziale, 1964, canvas
 Brett, p.71 (b/w)
Concetto spaziale, 1964 -Marl
 Pellegrini, p.124 (col)
Concetto spaziale 'La fine di
 Dio', 1962-63 IRMarl
 Wolfram, pl.99 (b/w)
Concetto spaziale, La Fine di
 Dio, 1963, o/c
 New Art, col.pl.51
Concetto spaziale (Space Con-
 cept), 1960-61, mixed media on
 canvas IMGal

Liverpool, no.12 (b/w)
Concetto spaziale (Space Con-
 cept), c.1965-66, green-gold
 ceramic IRMarl
 Liverpool, no.16 (b/w)
Concetto spaziale (Space Con-
 cept), c.1965-66, red-gold
 ceramic IRMarl
 Liverpool, no.17 (b/w)
Concetto spaziale (Space Con-
 cept), 1966, lacquered wood
 and tempera on canvas IRMarl
 Liverpool, no.15 (b/w)
Concetto spaziale (Space Con-
 cept) (Nature), 1967, brass,
 Priv.Coll., Rome
 Liverpool, no.18 (b/w)
Concetto spaziale (Waiting),
 1965, tempera on canvas, Priv.
 Coll., Milan
 Liverpool, no.14 (b/w)
Concrete Spaziale-Nature, 1965,
 bronze NOK
 Trier, fig.119 (b/w)
Green Oval Concept, 1963, o/c,
 IMAr
 Arnason, col.pl.230
Natura, 1959
 UK1, pl.174 (b/w)
Natura, 1959
 UK1, pl.176 (b/w)
Nature, bronze, Priv.Coll.,
 Brussels
 Abstract, pl.145 (b/w)
Quanta-Spatial Concept, 1959,
 IRMarl
 Abstract, pl.142 (b/w)
Sei Acqueforti originali, 1964,
 etching IRMarl
 Castleman, p.75 (col)
Spatial Concept, 1950, o/c IMFo
 Abstract, pl.139 (b/w)
Spatial Concept, 1957 IRSal
 Pellegrini, p.81 (b/w)
Spatial Concept, 1960, o/c,
 ELMcR
 L-S, pl.105 (b/w)
Spatial Concept, 1962-63, yellow
 cementite on canvas IMFo
 Abstract, pl.140 (col)
Spatial Concept, 1963, o/c,
 Priv.Coll.
 Abstract, pl.141 (col)
Spatial Concept, 1965
 Pellegrini, p.82 (b/w)

Spatial Concept, 1967, lacquered
 wood, 4 plaques UDCHi
 Hh, pl.1013 (col)
Spatial Concept (Concetto spazi-
 ale), c.1956
 Haftmann, pl.979 (b/w)
Spatial Concept 'End of God',
 1963, oil IBrD
 Abstract, pl.143 (col)
Spatial Concept-Expectations
 (Concetto spaziale-attese),
 c.1965, canvas GCoMu
 Kahmen, pl.200 (b/w)
Spatial Concept-Nature (Concetto
 spaziale-natura), 1965,
 bronze NOG
 Kahmen, pl.189 (b/w)
Spatial Concept (White and
 White), 1965, canvas and lac-
 quered wood, Coll.Artist
 Arnason, fig.977 (b/w)
Untitled, 1955, o/c GWurS
 Kahmen, pl.337 (b/w)
Untitled, c.1965, ceramic with
 polychrome glazing GCoZ
 Kahmen, pl.191 (b/w)

FORAKIS, Peter (American, 1927-)
 Double Exeter III (Mirror Image
 Series), painted cold-rolled
 steel UDCHi
 Hh, pl.935 (b/w)
 Laser Lightening, 1966, painted
 cardboard
 Busch, fig.16 (b/w)
 Outline, 1966
 UK1, pl.233 (b/w)
 Port and Starboard List, 1966,
 stainless steel UNNLi
 Andersen, p.232 (b/w)

FORRESTER, John (New Zealandic,
 1922-)
 Glenrowan, 1964
 Pellegrini, p.272 (b/w)
 Mark Black Two, 1961, o/c ELMc
 Abstract, pl.119 (b/w)
 Occurrence at Parlton Magna,
 1963, oil, Coll.Artist
 Haftmann, pl.998 (b/w)

FOUJINO, Paul (Japanese, 1925-)
 Painting, 1960 FPMas
 Seuphor, no.317 (col)

FOULKES, Llyn (American, 1934-)
 The Canyon, 1964
 UK2, pl.225 (b/w)
 Seal Rock, 1963, o/c UCLM
 Compton 2, fig.164 (b/w)
 Untitled, 1966
 UK2, pl.226 (b/w)

FRANCHINA, Nino (Italian, 1912-)
 Icaro, 1963, sheet metal, Priv.
 Coll.
 New Art, pl.111 (b/w)
 Nike, 1958, iron and brass
 Trier, fig.149 (b/w)
 Roncevaux, 1970, iron, Coll.
 Artist
 Liverpool, no.53 (b/w)
 Spoleto '62, 1962, iron ISpP
 Metro, p.133 (b/w)
 L'uccello di fioco, 1960, iron
 Metro, p.132 (b/w)

FRANCIS, Sam (American, 1923-)
 Black and Yellow Composition,
 1954, o/c GDusKN
 Abstract, pl.39 (b/w)
 Blue and Black, 1954 ELPo
 Ponente, p.139 (col)
 Blue Balls, 1961, gouache SwBFe
 Haftmann, pl.871 (b/w)
 Blue on a point, 1958, o/c,
 UNRyD
 L-S, pl.25 (col)
 Rose, p.192 (col)
 Blue Out of White, 1958, o/c,
 UDCHi
 Hh, pl.742 (col)
 Bright Jade Gold Ghost (Varia-
 tion I), 1963, color litho-
 graph SwBeKor
 New Art, col.pl.7
 Composition, 1960, o/c FPDu
 Seuphor, no.448 (col)
 Deep Orange on Black, 1955, oil,
 Priv.Coll., Basel
 Haftmann, pl.870 (b/w)
 Cross, 1960 UNNJ
 Metro, p.135 (b/w)
 Oil, 1953 GCoAA
 Pellegrini, p.196 (col)
 The Over Yellow, 1957-58, oil,
 GStSt
 Haftmann, pl.869 (col)
 Red and Black, 1954, o/c UNNG
 Hunter, pl.453 (b/w)
 Arnason, fig.1109 (b/w)

Sesame, 1970, a/c, Coll.Artist
 Carmean, p.52 (b/w)
Svengali, 1961, o/c UNNEm
 Seuphor, no.495 (col)
Tangerine, 1964, a/c UNNEm
 Carmean, p.18 (col)
Weather Change, 1963 UNNEm
 Pellegrini, p.134 (b/w)
Yellow Caterpillar, 1961, o/c,
 Priv.Coll., New York
 Geldzahler, p.75 (b/w)

FRASER, Donald Hamilton (British,
 1929-)
 Landscape (City III), 1957, o/c
 1945, pl.130 (b/w)
 Landscape, Sea and Wind, 1957,
 o/c UDCHi
 Hh, pl.763 (col)

FRAZIER, Charles R. (American,
 1930-)
 Aero-Dynamic, 1968, inflatable
 kite
 Busch, fig.109 (b/w)
 American Nude, 1963, bronze,
 UNNKorn
 Russell, pl.101 (b/w)
 Black Vinyl Rocket/Skyscraper,
 Coast Guard Beach, Amagansett,
 N.Y., summer 1966, polyethy-
 lene
 Busch, fig.54 (b/w)
 Cow, 1965
 UK1, pl.78 (b/w)
 Drag Racer, 1966
 UK1, pl.130 (b/w)
 Drift Structure, 1969-70
 Busch, fig.28 (b/w)
 Ecology, Amagansett, N.Y.,
 spring 1969
 Busch, fig.64 (b/w)
 Flying Sculpture (models), Sea-
 cliff, N.Y., winter, 1965-66,
 wood, plastic, rubber, Coll.
 Artist
 Busch, fig.87 (b/w)
 Hunter, pl.916 (b/w)
 Gas (2 ground-effect machines
 for this series of events,
 South Hampton, N.Y., summer
 1966)
 Busch, fig.57 (b/w)
 Heli-Sculpture. Early Radio Con-
 trolled Flying Sculpture, 1966,
 balsa wood, sild, airplane mo-

tor, heliocoptor blades
 Busch, fig.103 (b/w)
 Isadora, Jan.1970, parachute and
 wind socks
 Busch, fig.96 (b/w)
 Jump, 1969, wind sock, fan and
 parachute
 Busch, fig.132 (b/w)
 The Lotus, 1969
 Busch, fig.22 (b/w)
 Pacific Electric (model), begun
 1967
 Busch, fig.95 (b/w)
 Scout, 1962, bronze -Scu
 Janis, p.302 (b/w)
 Snow Paintings, Paul Schiele's
 Woods, Buck's County, Pa.,
 Jan.1969
 Busch, figs.23A-B (b/w)
 Stutz Bearcat Pre-World War I,
 1962, bronze
 Janis, p.302 (b/w)
 The Underground Tube Co., begun
 fall 1966, inner tubes and
 vacuum cleaner motors
 Busch, fig.94 (b/w)
 Untitled, ducted fan, wood and
 silk
 Busch, fig.97 (b/w)
 Untitled, 1964-65, bronze,
 UNNKor
 Ashton, pl.LXVI
 Untitled, 1965
 UK1, pl.61 (b/w)
 Untitled, 1965
 UK1, pl.62 (b/w)
 Untitled, 1965
 UK1, pl.64 (b/w)

FRAZIER, Paul
 Cuboid Shift No.2, 1967, painted
 plywood, Coll.Artist
 Hunter, pl.826 (b/w)

FREUD, Lucien (British, 1922-)
 Portrait of Stephen Spender,
 1958, o/c -Sp
 1945, pl.138 (b/w)

FRINK, Elisabeth (British, 1930-)
 Fallen Bird Man, 1961, bronze,
 UDCHi
 Hh, pl.803 (b/w)

FROST, Terry (British, 1915-)
 Blue, Black Arrow, 1962, o/c,

ELStu
Stuyvesant, p.61 (b/w)
Red and Black No.3, 1961, o/c,
EKStu
New Art, pl.97 (b/w)
Stuyvesant, p.62 (b/w)

FRUHTRUNK, Gunter (German, 1923-)
Composition, 1965
Pellegrini, p.183 (b/w)
Hommage a Arp ET II, 1962,
acrylic on canvas BBCoq
New Art, pl.307 (b/w)
One of Six Screenprints, 1967,
GCoSp
L-S, pl.138 (col)
Vibration, 1967, a/c GCoSp
Abstract, pl.225 (b/w)

FRY, Anthony (British, 1927-)
Nude 8, 1966, collage and mixed
media on paper and canvas,
ELStu
Stuyvesant, p.88 (b/w)

FUCHS, Ernst (Austrian, 1930-)
Anti Laokon, 1965, pencil, Coll.
Artist
New Art, pl.283 (b/w)
Death and the Girl (Der Tod und
das Madchen), 1967, etching,
GMKe
Kahmen, pl.158 (b/w)
Job and the Judgement of Paris,
1965-66, o/c and grisaille,
Coll.Artist
Fig.Art, pl.149 (b/w)
Pan, 1969, colored poster GMKe
Kahmen, pl.161 (b/w)

FULLARD, George
Woman with Flowers, 1959, wood,
ELFu
Wolfram, pl.98 (b/w)

FULLER, Sue (American, 1936-)
Sonnet, silk cloth collage
Janis, p.192 (b/w)
String Composition, 1964, plas-
tic threads, cloth, wood,
etc. ELT
Barrett, p.144 (b/w)
Compton, pl.6 (b/w)

FULTON, Hamish (British, 1946-)
The Pilgrim's Way, April 1971

6 Yrs, p.260 (b/w)

GABO, Naum (Russian-American,
1890-1977)
Construction, 1954-57, steel
and bronze wire NRB
Arnason, figs.500-500a (b/w)
Construction in Space, 1953,
phosphor bronze, Coll.Artist
Metro, p.139 (b/w)
Construction in Space with Red,
1953
UK1, pl.166 (b/w)
Construction Suspended in Space,
1951, aluminum, plastic, gold
wire, etc. UMdBM
Arnason, fig.501 (b/w)
Linear Construction, nylon
threads and plastic NAS
Abstract, pl.70 (b/w)
Linear Construction, 1942-43,
plastic ELT
Compton, pl.13 (b/w)
Linear Construction in Space,
1949, plastic and nylon, Coll.
Artist
G-W, pp.182-83 (b/w)
Linear Construction in Space,
Number 4, 1958, plastic,
stainless steel UNNW
Whitney, p.115 (b/w)
Linear Construction No.1 (small-
er version), 1942-43, plastic
and nylon thread UDCHi
Hh, pl.464 (b/w)
Linear Construction No.2 (small-
er version), 1949, plastic,
nylon thread UDCHi
Hh, pl.656 (b/w)
Linear Construction No.4, 1959-
61, aluminum, stainless steel
wire UDCHi
Hh, pl.655 (b/w)
Linear No.2, Variation, 1962-65,
stainless steel coil on plas-
tic UNBuA
A-K, p.183 (b/w)
Linear Construction, Variation,
1942-43, plastic and nylon
thread UDCP
Arnason, fig.499 (b/w)
Model for Entrance Hall of the
Esso Building, Rockefeller
Center, New York, 1949, iron
wire and plastic UNNMMA
G-W, p.179 (b/w)

Rotterdam Construction, 1954-57,
concrete, steel, bronze wire,
NRB
Trier, figs.212-13 (b/w)
UK1, pl.254 (b/w)
Spiral Theme, 1941, plastic ELT
Compton, pl.12 (b/w)
Spiral Theme, 1941, plastic,
UNNMMA
Trier, fig.162 (b/w)
Variation Linear #2, 1965,
stainless steel wire on plas-
tic UNNMa
Ashton, pl.X (b/w)
Vertical Construction No.1,
1964-65, brass, stainless
steel wire UDCHi
Hh, pl.921 (b/w)

GALI, Jordi (Spanish, 1944-)
Peinture collage, 1964, oil and
collage, Coll.Artist
New Art, col.pl.68

GALLINA, Pietro (Italian, 1937-)
Bambino, 1966
UK2, pl.156 (b/w)
Ritratto di Carl Laszlo, 1967
UK2, pl.67 (b/w)

GALLO, Frank (American, 1933-)
Girl on Couch, 1967, epoxy,
UNjPA
Hunter, pl.653 (b/w)
Head of a Fighter, 1965
UK1, pl.54 (b/w)
Love Object, 1966
UK1, pl.29 (b/w)
Quiet Nude, 1966, plastic UCLL
Kahmen, pl.109 (b/w)
UK1, pl.28 (b/w)

GAMARRA, Jose (Uruguayan, 1934-)
Pintura M 63509, 1963, o/c
New Art, pl.217 (b/w)

GARCIA NUNEZ, Luis. See LUGAN

GARCIA ROSSI, Horacio (Argentini-
an, 1929-)
Boite lumineuse, 1964
Popper 2, p.182 (b/w)
Luminous Box, 1963 FPRe
Abstract, pl.290 (b/w)
Unstable Light Structure, 1965,
FPRe

Barrett, p.104 (b/w)

GARELLI, Franco (Italian, 1909-)
Figure Ema, 1958, iron
Trier, fig.145 (b/w)

GASIOROWSKI, Gerard
Dans les campagnes on voit par-
tout des bicyclettes, 1966,
a/c
UK3, pl.53 (b/w)
Dix secondes conscientes, 1970,
o/c GCoT
UK3, pl.52 (b/w)
Untitled, 1965, o/c
UK3, pl.54 (b/w)
Le voyage de Mozart a Prague,
1969, o/c GCoT
UK3, pl.51 (b/w)

GATCH, Lee (American, 1902-1968)
The Dancer, 1955, o/c UDCHi
Hh, pl.605 (b/w)
Kissing the Moon, 1959, cloth
and oil on canvas
Janis, p.202 (b/w)
Tapestry to a Square, 1959,
cloth and oil on canvas,
UNNWo
Janis, p.202 (b/w)

GAUDNEK, Walter
Metro, 1953, pasted paper and
gouache GIN
Janis, p.152 (b/w)
Unlimited Dimensions, 1961, 29
oil-painted panels
Janis, p.275 (b/w)

GAUL, Winfred (German, 1928-)
"Hande Hoch", 1964, oil and lac-
quer on canvas GBBl
New Art, pl.316 (b/w)
Highway of the Sun, 1962, Coll.
Artist
Lippard, pl.180 (b/w)
Homage to Berlin, 1964, painting
on metal panels
Wilson, pl.62 (col)
Object of Contemplation, 1961,
o/c, Coll.Artist
Seuphor, no.408 (col)
Schwarz und Weiss, oil on paper
and canvas
1945, pl.101 (b/w)
Three Little Roses, 1965, lac-

quer on wood GDusW
Abstract, pl.132 (col)

GEAR, William (British, 1915-)
 Spring Study, 1951, o/c, Coll.
 Artist
 Seuphor, no.322 (col)
 Structure White Element, 1955,
 o/c ELG
 1945, pl.134 (b/w)

GEIGER, Rupprecht (German, 1908-)
 E/240, 1955, egg tempera, Coll.
 Artist
 Seuphor, no.505 (col)
 E245, 1957, o/c
 1945, pl.105 (b/w)
 560/69, 1969, a/c, Coll.Artist
 Abstract, pl.211 (b/w)
 Gagarin, 1961, o/c, Coll.Artist
 New Art, pl.314 (b/w)

GEIS, William (American, 1940-)
 Chic 'y of Insult un, 1966,
 painted plaster
 Andersen, p.162 (b/w)
 Untitled #3, 1964, plaster,
 paint, fiberglass, Coll.Artist
 Ashton, pl.LXXI (col)

GEIST, Sidney (American, 1914-)
 Figure, 1953, wood
 Andersen, p.114 (b/w)
 Landscape, 1940, wood and nails
 Andersen, p.114 (b/w)

GEITLINGER, Ernst (German, 1895-)
 Black Ledges, 1960, wood relief
 construction
 Janis, p.241 (b/w)
 Black on White, 1958, painted
 wire collage
 Janis, p.210 (b/w)

GENOVES, Juan (Spanish, 1930-)
 Beyond the Limit, 1966, o/c,
 ELMa
 Fig.Art, pl.306 (b/w)
 Calendario Universal, 1967
 UK2, pl.142 (b/w)
 Cara a la pared, 1967
 UK2, pl.143 (b/w)
 Man Alone, 1967, o/c UNNSef
 Arnason, fig.1073 (b/w)
 The Prisoner, 1968, acrylic and
 oil on canvas UDCHi

Hh, pl.927 (b/w)
Rupture, 1965, o/c
Dyckes, p.69 (b/w)
Sobre la Represion Politica,
1973, a/c UNNMa
Arnason 2, fig.1166 (b/w)
Under Arrest, 1973, a/c
Dyckes, p.69 (b/w)

GENTILINI, Franco (Italian,
1909-)
 Figure e tavoli, 1957, o/c IRLu
 1945, pl.66 (b/w)

GENTILS, Victor A. (Belgian,
1919-)
 Berlin-Leipzig, 1963, burnt
 wood and piano parts, Coll.
 Artist
 Haftmann, pl.1010 (b/w)
 Chartres, 1964, assemblage BBVe
 New Art, pl.194 (b/w)
 Pan, 1965, wood and ivory BBG
 Fig.Art, pl.164 (b/w)

GEORGES, Claude (French, 1929-)
 February 1960, o/c FPG
 Seuphor, no.202 (col)
 Rouge et noir, 1958, o/c GCoAA
 1945, pl.31 (b/w)

GEORGIADIS, Nicholas (Greek,
1923-)
 Tympanum, 1964, mixed media,
 ELHam
 New Art, pl.224 (b/w)

GERMAIN, Jacques (French, 1915-)
 Summer 1960, o/c FPMas
 Seuphor, no.525 (col)

GERSTNER, Karl (Swiss, 1930-)
 Bull's-Eye Picture No.11, 1962-
 63, glass, wood, plastic and
 neon tube
 Abstract, pl.208 (b/w)
 Color Glasses -Ren
 Pellegrini, p.187 (b/w)
 Lens Picture, 1962-64, plastic
 lens and transparency of con-
 centric circles UNNSt
 Arnason, fig.1103 (b/w)
 Lens Picture, 1962-65
 Popper 2, p.195 (b/w)
 Lens Picture no.15, 1964, con-
 centric circles behind plexi-

glass UNBuA
 Barrett, pp.88-89 (b/w)
Linsenbild, 1962-64, plastic
 lenses and transparent con-
 centric circles UNBuA
 New Art, pl.303 (b/w)
Texture Picture, 1962-65
 Popper, p.17 (b/w)

GERTSCH, Franz (Swiss, 1930-)
 Franz and Luciano, 1973, a/c
 Battcock, p.263 (b/w)

GETMAN, William (American, 1916-)
 Collage, 1960, torn poster col-
 lage -Gos
 Janis, p.183 (b/w)
 Collage, 1960, torn poster col-
 lage -Cha
 Janis, p.184 (b/w)
 Maria, 1958, torn paper posters
 on masonite UCPacA
 Seitz, p.107 (b/w)

GETZ, Ilse (German-American,
 1917-)
 Spanish Landscape, 1959, collage
 with oil on canvas UNNRa
 Janis, p.174 (b/w)

GHERMANDI, Quinto (Italian,
 1916-)
 L'eclisse, 1962, bronze, Coll.
 Artist
 Metro, p.141 (b/w)
 Momento del volo, 1960, bronze
 Metro, p.140 (b/w)

GHINEA, Virgil
 Action with Green Plastic Net,
 Graz, 1972
 Popper, p.194 (b/w)

GIACOMETTI, Alberto (Swiss, 1901-
 1966)
 Annette, 1961, o/c UDCHi
 Hh, pl.778 (b/w)
 Annette Seated, 1957, o/c, Priv.
 Coll.
 Fig.Art, pl.9 (b/w)
 The Artist's Mother, 1950, o/c,
 UNNMMA
 Selz, p.74 (b/w)
 Arnason, fig.636 (b/w)
 Bust of a Man (Diego), 1954,
 bronze UDCHi

Hh, pl.677 (b/w)
Bust of Diego, 1957, bronze,
 UDCHi
 Hh, pl.678 (b/w)
Bust of Diego on a Stele (Stele
 II), 1958, bronze UDCHi
 Hh, pl.679 (b/w)
Chariot, 1950, bronze UNNMMA
 Arnason, fig.633 (b/w)
City Square, 1940, bronze,
 UNNMatC
 Selz, p.71 (b/w)
City Square, 1948-49, bronze,
 IVG
 G-W, p.103 (b/w)
Composition with Seven Figures
 and a Head (The Forest),
 1950, painted bronze -Rea
 Hamilton, pl.353 (b/w)
 Trier, fig.78 (b/w)
 Arnason, fig.634a (b/w)
Composition with Three Figures
 and a Head (The Sand), 1950,
 painted bronze UCtNcJ
 Selz, p.71 (b/w)
Dog, 1951 (cast 1957), bronze,
 UDCHi
 Hh, pl.680 (b/w)
 Arnason, fig.635 (b/w)
Female Figure, 1948, bronze,
 Coll.Artist
 G-W, p.104 (b/w)
Figure on a Pedestal, 1953,
 oil SwBBe
 Haftmann, pl.980 (b/w)
The Hand, 1947, bronze, Coll.
 Artist
 G-W, pp.100-01 (b/w)
Head of a Man, 1961, o/c UDCHi
 Hh, pl.779 (b/w)
Head of a Man on a Rod, 1947,
 bronze UMoSLE
 Arnason, fig.631 (b/w)
Head of Diego, 1954, bronze,
 UCLB
 Selz, p.75 (b/w)
Head of the Sculptor's Brother,
 1950, plaster, Coll.Artist
 G-W, p.107 (b/w)
Homme qui marche I, bronze
 Popper 2, p.88 (b/w)
Large Nude, 1962, oil UNNMat
 Haftmann, pl.983 (b/w)
The Leg, 1959, gilt bronze GDuK
 Trier, fig.48 (b/w)
Man Pointing (L'Homme au Doigt),

L-S, pl.238 (b/w)
Singing Sculpture, 1971
 Popper, p.242 (b/w)

GILCHRIST, Bruce
The Walk, 1957, found objects in
 plaster
 Janis, p.250 (b/w)

GILIOLI, Emile (French, 1911-)
Bell Tower, 1958, bronze UDCHi
 Hh, pl.606 (b/w)
Celebration of the Sphere (Cele-
 bration de la boule), 1968,
 painted bronze
 Kahmen, pl.185 (b/w)
La mendiante, 1962, black bronze
 Metro, p.145 (b/w)
Paquier, 1951, bronze, Coll.
 Artist
 G-W, p.240 (b/w)
Priere et force (Monument for
 the Unknown Political Prison-
 er), 1953, marble ELT
 G-W, p.235 (b/w)

GILL, James (American, 1934-)
Felix Landau, 1964
 UK2, pl.66 (b/w)
John Wayne Triptych (left-hand
 panel), 1964, grease crayon on
 masonite UNNA1
 Lippard, pl.146 (b/w)
Marilyn, Each Panel, 1962
 UK2, pl.97 (b/w)

GILLES, Werner (German, 1894-1961)
Eurydice with the Head of the
 Dead Orpheus, 1950
 Haftmann, pl.929 (b/w)
Fischer am Strand von Ischia,
 1954, o/c
 1945, pl.80 (col)

GILLESPIE, Gregory (American,
 1936-)
Exterior Wall with Landscape,
 1967, mixed media UDCHi
 Hh, pl.1009 (col)

GILLET, Roger Edgar (French,
 1924-)
Painting, 1960 FPFr
 Seuphor, no.295 (col)

GILLIAM, Sam (American, 1933-)
Carousel Form II, 1969, a/c,
 UDCJ
 Hunter, pl.731 (col)
 Rose, p.209 (b/w)
 Walker, pl.10 (col)

GINNEVER, Charles (American,
 1931-)
Project 2, 1959-61, steel rail-
 road ties
 Andersen, p.130 (b/w)
Untitled, 1968, Cor-Ten steel,
 UDCHi
 Hh, pl.934 (b/w)

GIRONA, Julio (Cuban-American,
 1914-)
Collage No.8, 1960, pasted paper
 with paint
 Janis, p.173 (b/w)

GIRONELLA, Alberto (Mexican,
 1929-)
Francisco Lezcano's Atelier,
 1964
 Pellegrini, p.279 (b/w)

GISCHIA, Leon (French, 1903-)
Le grand arbre, 1956, o/c
 1945, pl.16 (b/w)

GISIGER, Hans Jorg (Swiss, 1909-)
Sphinx, 1955, collage
 Janis, p.166 (b/w)
Totem, 1956-58, steel, Coll.
 Artist
 G-W, p.305 (b/w)

GLARNER, Fritz (Swiss-American,
 1899-1972)
Charcoal sketches, 1959, Coll.
 Artist
 Seuphor, no.446 (b/w)
Relational Painting, 1946, o/c,
 Coll.Artist
 Hunter, pl.345 (col)
Relational Painting 80, 1954,
 o/c SwZLo
 1945, pl.110 (b/w)
Relational Painting No.83, 1957,
 o/c UDCHi
 Hh, pl.615 (b/w)
Relational Painting #93, 1962,
 o/c UNBuA
 A-K, p.389 (col)

Relational Painting, Tondo No.
 20, 1951-54, oil on masonite,
 UDCHi
 Abstract, pl.172 (b/w)
 Hh, pl.711 (col)
Relational Painting: Tondo #43,
 1956, oil on panel UNHunG
 Rose, p.136 (col)
Rhythm of New York, 1951, oil
 Haftmann, pl.971 (b/w)
Tondo No.38, 1955 FPCa
 Seuphor, no.447 (col)

GNOLI, Domenico (Italian, 1933-
1970)
 Busto di donna, 1965
 UK1, pl.201 (b/w)
 Illustration for Ranke Graves,
 engraving
 Fig.Art, pl.143 (b/w)
 Man: back and front view (Homme
 double-face), 1964, oil and
 sand on canvas GCoL
 Kahmen, pl.43 (b/w)
 Neck Size 15½, 1966, o/c SwGK
 Fig.Art, pl.142 (b/w)
 Waist Line, 1969, o/c GMulK
 Kahmen, pl.311 (b/w)

GOEPFERT, Hermann (German, 1926-)
 Optophonium, 1960
 Abstract, pl.286 (b/w)
 Optophonium II, 1972
 Popper, p.47 (b/w)
 Restaurant on a Lake, Karlsruhe,
 1967, environment (in colla-
 boration with John Holzinger)
 Popper, p.74 (b/w)
 Wassergarten, 1967 (in colla-
 boration with Peter Hoelzin-
 ger) GKarBu
 UK1, pl.281 (b/w)

GOERITZ, Mathias (German, 1915-)
 Automex Towers, 1963-64
 UK1, pl.274 (b/w)
 Ciudad Satelite Towers (The
 Square of the Five Towers),
 1957, painted concrete Me
 UK1, pl.275 (b/w)
 Arnason, fig.1007 (b/w)
 Popper, p.63 (b/w)
 El Eco, 1952-53, iron MeME
 UK1, pl.276 (b/w)
 Trier, fig.19 (b/w)
 Arnason, fig.1006 (b/w)

Golden Echo, 1961
 UK1, pl.264 (b/w)
Message No.14: "And thy heaven
 that is over thy head shall be
 brass, and the earth that is
 under thee shall be iron."
 (Deuteronomy 28:23), 1959,
 metal and paint on wood UNNCa
 Seitz, p.129 (b/w)

GOETZ, Henri (American, 1900-)
 Drawing, 1959
 Seuphor, no.515 (b/w)
 Pastel, 1960 FPAri
 Seuphor, no.518 (col)

GOINGS, Ralph (American, 1928-)
 Airstream, 1970, o/c GAaN
 L-S, pl.223 (b/w)
 UK3, pl.114 (b/w)
 Arnason 2, fig.1242 (b/w)
 Bank of America, 1971, o/c -Kra
 Battcock, p.130 (b/w)
 Burger Chef Chevy, 1970, o/c,
 UNNCoh
 UK3, pl.122 (b/w)
 Burger Chef Interior, 1970, o/c,
 -Lew
 Battcock, p.264 (b/w)
 Dick's Union General, 1971, o/c,
 -Lew
 Battcock (col)
 Jeep, 1969, o/c FPQ
 Battcock, p.91 (b/w)
 McDonald's, 1970, o/c UNNHarr
 UK3, pl.123 (b/w)
 Untitled, 1969, o/c GCoZ
 UK3, pl.115 (b/w)
 Untitled, 1970 UNNHarr
 UK3, pl.VIII (col)

GOLDBERG, Michael (American,
 1929-)
 Murder, Inc., 1960, pasted paper
 with oil
 Janis, p.154 (b/w)
 Red Bank, 1960, o/c UNNJ
 Seuphor, no.330 (col)

GOLFINOPOULOS, Peter (American,
 1928-)
 Number 15: Homage to Joyce, 1967,
 oil and acrylic on canvas,
 UNNKro
 Arnason 2, fig.1234 (b/w)
 Number 4, 1963, o/c UDCHi

Hh, pl.962 (col)
#4, 1972-75, oil and acrylic on
 canvas UNNKro
 Arnason 2, col.pl.286
Number 34, 1971, oil and acrylic
 on canvas, Priv.Coll.
 Arnason 2, fig.1235 (b/w)

GOLLER, Bruno (German, 1901-)
The Bridal Veil (Der Braut-
 schleier), 1952, o/c, Coll.
 Artist
 Kahmen, pl.121 (b/w)
Brother and Sister (Die Ge-
 schwister), 1931, o/c GMGe
 Kahmen, pl.99 (b/w)
Female Nude (Weiblicher Akt),
 1962, o/c, Priv.Coll.
 Kahmen, pl.V (col)
Girl with a Rose (Madchen mit
 Rose), 1970, o/c, Coll.Artist
 Kahmen, pl.6 (b/w)
Large Female Head (Grosser Frau-
 enkopf), 1959, pencil on card-
 board, Priv.Coll.
 Kahmen, pl.97 (b/w)
Zwei Hute, 1956, o/c GCoZ
 New Art, pl.275 (b/w)

GOLUB, Leon (American, 1922-)
Clank Head, 1953, wood, rubber,
 iron
 Andersen, p.140 (b/w)
Colossal Head, 1958, oil and
 lacquer on canvas UICF
 Selz, p.78 (b/w)
Combat (VIII), a/c
 Fig.Art, pl.84 (b/w)
Damaged Man, 1955, oil and lac-
 quer on masonite UICF
 Selz, p.77 (b/w)
Head VII, 1963, plastic color on
 canvas GG1W
 Haftmann, pl.902 (b/w)
Horseman, 1958, oil and lacquer
 on canvas UICG
 Selz, p.80 (b/w)
Orestes, 1956, oil and lacquer
 on canvas UICMa
 Selz, p.81 (col)
Reclining Youth, 1959, oil and
 lacquer on canvas UICMa
 Selz, p.82 (b/w)

GOODE, Joe
Happy Birthday, 1962, o/c,

UCThoJ
 Alloway, pl.7 (col)
Leroy, 1962, o/c with painted
 milk bottles UCLWi
 Lippard, pl.137 (b/w)
Painting, 1962, mixed media
 Finch, p.70 (b/w)
Staircase, 1970, mixed media,
 Coll.Artist
 Alloway, fig.19 (b/w)
Staircase, 1970, mixed media,
 UCVC
 Alloway, fig.20 (b/w)
Untitled Construction, 1966,
 mixed media
 Finch, p.71 (b/w)

GOODMAN, Sam (American, 1919-)
The Cross, c.1960, assemblage,
 UNNStein
 Lippard, pl.82 (b/w)
Psyche and Vanity, 1960-61,
 mixed media
 Henri, fig.144 (b/w)

GOODNOUGH, Robert (American,
 1917-)
White Intervals, 1960, painted
 pasted paper UNNNag
 Janis, p.173 (b/w)

GOODYEAR, John
Black and White Waves, 1964,
 Priv.Coll.
 Barrett, p.143 (b/w)

GORDIN, Sidney (Russian-American,
 1918-)
#3, 1950, steel and silver,
 brazed
 Andersen, p.83 (b/w)
7-65, 1965, wood and acrylic,
 UCSFDi
 Ashton, pl.LXXIX (b/w)

GORIN, Jean (French, 1899-)
Composition No.4 with Recessed
 Line, 1931, oil on wood, Priv.
 Coll.
 Abstract, pl.173 (b/w)
Composition No.8, 1964, painted
 wood BLG
 Arnason, fig.655 (b/w)

Seuphor, no.479 (col)

GRANT, James
Circus Wheel, 1969, cast poly-
ester resin
Busch, pl.XIV (col)
Flabellum, cast polyester resin,
UCOG
Busch, pl.XII (col)
The Golden West Rainbow, poly-
ester and acrylic sheet, neon
tubes UCMoC
Busch, pl.XIII (col)

GRANT, Keith
Idomeneo
Popper, p.217 (b/w)

GRAUBNER, Gotthard (German,
1930-)
Coloured body on a silver-grey
background (Farbleib auf sil-
bergrauen Grund), 1964-65,
painted foam rubber and alumi-
num GCoOp
Kahmen, pl.206 (b/w)
Grausilberkissen, 1963-64, oil
and canvas over foam rubber,
Coll.Artist
New Art, pl.299 (b/w)
Stylit I, 1968, painted foam
rubber, polyester, Perlon,
Coll.Artist
Kahmen, pl.229 (b/w)
Untitled, 1960, watercolor, Priv.
Coll.
Kahmen, pl.319 (b/w)
Untitled, 1965, gouache, Coll.
Artist
Kahmen, pl.209 (b/w)

GRAVES, Gloria
Little Clara's Room, 1960, as-
semblage
Kaprow, no.4 (b/w)

GRAVES, Morris (American, 1910-)
Bird in the Spirit, c.1940-41,
gouache UNNW
Whitney, p.31 (col)
Hunter, pl.334 (b/w)
Rose, p.111 (b/w)
Blind Bird, 1940, gouache,
UNNMMA
Haftmann, pl.818 (b/w)
Hunter, pl.341 (col)

Arnason, fig.693 (b/w)
Snake, Moon, and Rock, 1939,
UNNG
Pellegrini, p.133 (b/w)

GRAVES, Nancy (American, 1940-)
Indian Ocean Floor I, 1972,
a/c UTxHF
Rose, p.235 (b/w)

GRAZIANI, Sante (American, 1920-)
Rainbow over Inness "Kakavanna
Valley", 1965
UK2, pl.223 (b/w)
Red, White and Blue, 1966
UK2, pl.128 (b/w)

GREAT GEORGES PROJECT
Gifts to the City: Six Memorials,
Liverpool, 1971, action
Henri, fig.93 (b/w)

GRECO, Emilio (Italian, 1904-)
Bather, 1956, bronze BAKO
Fig.Art, pl.55 (b/w)
Large Female Bather No.2, 1957,
plaster for bronze
Trier, fig.55 (b/w)
Seated Figure, 1951, bronze ELT
L-S, pl.174 (b/w)

GREENE, Balcomb (American, 1904-)
Anguish, 1956, o/c UNNScha
Selz, p.87 (b/w)
Gertrude II, 1956-58, o/c,
UNNWeins
Selz, p.85 (col)
Rain in Summer, 1975, o/c UVtWW
Arnason 2, fig.1249 (b/w)
Seated Woman, 1954, o/c UNNScha
Selz, p.84 (b/w)

GREENE, Stephen (American, 1918-)
The Burial, 1947 UNNW
Rose, p.110 (b/w)

GREENHAM, Lily
Green Cubes in Movement (copy
after), 1967
Barrett, p.106 (b/w)
Triangles, Diamonds and Squares
in Movement, 1966, wood and
colored bulbs
Abstract, pl.301 (b/w)

Looking, 1964, o/c, Coll.Artist
　Sandler, p.267 (b/w)
Martial Memory, 1941, o/c　UMoSL
　Sandler, p.260 (b/w)
The Mirror, 1957, o/c　UNNPark
　1945, pl.154 (col)
Native's Return, 1957, o/c　UDCP
　Hunter, pl.437 (b/w)
Nil, 1958, o/c　UNNJa
　Seuphor, no.364 (col)
Oasis, 1957, o/c　UDCHi
　Hh, pl.764 (col)
Painter's City, 1957, o/c,
　UNNGros
　Sandler, pl.XXIV (col)
Porch No.2, 1947, o/c　UNUtM
　Sandler, p.262 (b/w)
Red Painting, 1950, o/c, Coll.
　Artist
　Tuchman, p.103 (b/w)
Review, 1948-49, o/c, Coll.
　Artist
　Sandler, p.263 (b/w)
　Tuchman, p.102 (b/w)
The Room, 1954-55, o/c　UCLCM
　Sandler, p.265 (b/w)
　Tuchman, p.106 (b/w)
The Studio, 1969, o/c　UNNMa
　Hunter, pl.438 (b/w)
To B.W.T., 1952, o/c　UMSpBr
　Geldzahler, p.170 (b/w)
To Fellini, 1958, Priv.Coll.,
　New York
　Ponente, p.152 (col)
The Tormentors, 1947-48, o/c,
　Coll.Artist
　Sandler, p.262 (b/w)
　Tuchman, p.101 (b/w)
Traveler II, 1960, o/c　UNNJa
　Seuphor, no.363 (col)
Untitled, 1954, o/c　UWasSWr
　Geldzahler, p.171 (b/w)
Untitled, 1958, o/c　UNNG
　Sandler, p.266 (b/w)
Voyage, 1956, o/c　UNBuA
　A-K, p.54 (col)
White Painting No.1, 1951, o/c,
　Priv.Coll., Los Angeles
　Sandler, p.263 (b/w)
　Tuchman, p.104 (b/w)
Winter Flower, 1959, o/c
　Metro, p.151 (b/w)
Zone, 1953-54, o/c　UNNHell
　1945, pl.165 (b/w)
　Geldzahler, p.171 (b/w)
　Sandler, p.264 (b/w)

GUTTOSO, Renato (Italian, 1912-)
　Crucifixion, 1942, oil　IGenR
　Haftmann, pl.991 (b/w)
　The Discussion, 1959-60, tempera,
　oil and collage on canvas　ELT
　L-S, pl.42 (b/w)
　Maffia, 1948, oil　UNNMMA
　Haftmann, pl.992 (b/w)
　Paese del latifondo siciliano,
　1956, o/c
　1945, pl.40 (col)
　Le Visite (Welcome Guests),
　1970, oil on paper, Coll.
　Artist
　Liverpool, nos.40a-d (b/w)
　Woman at the Telephone, 1959,
　o/c　BBLa
　Fig.Art, pl.64 (b/w)

GUYONNET, Jacques
　Le Chant Rememore, 1975, video-
　tape (in collaboration with
　Genevieve Calame)
　L-S, pl.242 (b/w)

GWATHMEY, Robert (American,
　1903-)
　Portrait of a Farmer's Wife,
　1951, o/c　UDCHi
　Hh, pl.578 (b/w)

HAACKE, Hans (German, 1936-)
　Brett Klar/Klar, 1965
　UK1, pl.284 (b/w)
　Cast iron disk in frozen envi-
　ronment, Dec.16, 1968
　Celant, p.180 (b/w)
　Chickens Hatching, Forsgate
　Farms, N.J., 1969
　Henri, fig.63 (b/w)
　6 Yrs, p.122 (b/w)
　Communication System-UP1, 1969
　Meyer, p.134 (b/w)
　Condensation Cube, 1963-65,
　acrylic plastic and water,
　UNNSha
　Hunter, pl.943 (b/w)
　Calas, p.299 (b/w)
　Floating Ice Rings, 1970-71
　Walker, pl.43 (col)
　Grass, 1967
　Celant, p.183 (b/w)
　Grass grows, 1969　UNIC
　Kahmen, pl.272 (b/w)
　Ice Stick, 1966, mixed media in
　copper refrigeration unit,

Sculpture in Walnut, 1962, wal-
nut UDCHi
Hh, pl.780 (b/w)
Walnut-1949, 1949, walnut UNNNe
Rose, p.259 (b/w)

HAINS, Raymond (French, 1926-)
C'est ca la renouveau? (from the
series "La France dechiree"),
1958, torn poster
New Art, col.pl.28
Cet homme est dangereux, 1965,
collage
Amaya, p.76 (b/w)
Le Cochon, 1950, decollage,
Priv.Coll., Milan
Fig.Art, pl.248 (b/w)
"De Gaulle compte sur vous,
aidez-le", 1961, torn paper
posters UNGS
Seitz, p.109 (b/w)
Il est ne le Divin Enfant, 1950,
torn posters
Janis, p.180 (b/w)
Lacerated Biennale, 1964 IRSal
Pellegrini, p.258 (b/w)
Le 13 Mai, torn posters
Janis, p.180 (b/w)

HAJDU, Etienne (Rumanian-French,
1907-)
Adolescence, 1957, marble UDCHi
Hh, pl.654 (b/w)
Bird Lyre, 1956, marble BBL
G-W, p.271 (b/w)
The Bird, Uranus II, 1957,
bronze UDCHi
Hh, pl.652 (b/w)
Field of Forces, 1956, copper,
UNNG
Arnason, fig.996 (b/w)
Head, 1946, marble, Coll.Artist
G-W, p.270 (b/w)
Helene, 1960 -UIC
Metro, p.153 (b/w)
N Y X, black marble UICHok
Metro, p.152 (b/w)
Small Figure, 1957, Pentelic
marble
Trier, fig.46 (b/w)
The Wolves, 1953, chased copper
Trier, fig.30 (b/w)

HAJEK, Otto Herbert (Czechoslova-
kian, 1927-)
Grosses Relief, 1962 GCoAA

Metro, p.155 (b/w)
Plastik 65/32, 1965, bronze,
Coll.Artist
New Art, pl.295 (b/w)
Raumliche Schichtung 117, 1959,
bronze GCoAA
Metro, p.154 (b/w)
Space Knot 64, 1958, bronze,
GRavC
Trier, fig.117 (b/w)
Spatial Wall, 1959, molded con-
crete GViF
Trier, fig.193 (b/w)

HAKONARSON, Einar (Icelandic,
1945-)
Puls timans, 1968, o/c IcRN
Arnason 2, fig.996 (b/w)

HALL, David (British, 1937-)
Duo II, 1966
UK1, pl.223 (b/w)
Nine, 1967, lamin board and
polyurethane paint, Coll.
Artist
L-S, pl.208 (b/w)

HALL, Nigel (British, 1943-)
Cross, 1975
Eng.Art, p.228 (b/w)
Envelope, 1971, painted alumi-
num, Coll.Artist
Eng.Art, p.249 (b/w)
Precinct III, 1975, painted
aluminum, Coll.Artist
Eng.Art, p.251 (b/w)
Silver Picket, 1971, painted
aluminum ELAr
Eng.Art, p.248 (b/w)
Soda Lake, 1968
Eng.Art, p.228 (b/w)
Spike III, 1972-75, painted
aluminum, Coll.Artist
Eng.Art, p.250 (b/w)

HALLER, Vera (Hungarian)
Tiznit, 1964, i/c, Coll.Artist
New Art, pl.311 (b/w)

HALPRIN, Ann
Automobile Event, 1963
UK4, pl.87 (b/w)
Expositions, San Francisco, 1963
UK4, pl.71 (b/w)
Lunch, 1968
UK4, pls.137-38 (b/w)

UK3, pl.32 (b/w)
Vietnam Scene, 1969, polyester,
 resin GDuK
 Battcock, p.199 (b/w)
 Rose, p.219 (b/w)
War, 1967, fiberglass and poly-
 ester resin UNNHarr
 UK3, pl.63 (b/w)
Woman Eating, 1971, fiberglass
 and polyester -May
 Battcock, p.209 (b/w)
Woman Reading, 1970, polyester
 resin, fiberglass, mixed
 media GBO
 UK3, pl.35 (b/w)

HANTAI, Simon (Hungarian, 1922-)
 87, 1957, o/c FPFo
 Abstract, pl.58 (b/w)
 Homage to G.M. Hopkins, 1958,
 o/c FPKl
 Seuphor, no.410 (col)
 St. Francis Xavier in the In-
 dies, 1958 FPKl
 Ponente, p.123 (col)

HARE, David (American, 1917-)
 Catch, 1947, bronze UNNKo
 G-W, p.296 (b/w)
 Crab, 1951, welded bronze,
 UNNMMA
 Ashton, fig.15 (b/w)
 Heatage, 1944
 Janis, p.141 (b/w)
 Juggler, 1950-51, steel UNNW
 Whitney, p.109 (b/w)
 Hunter, pl.526 (b/w)
 Rose, p.256 (b/w)
 The Magician's Game, 1944,
 bronze UNNMMA
 Andersen, p.78 (b/w)
 Hunter, pl.511 (b/w)
 Man with Drum, 1948, bronze
 Trier, fig.101 (b/w)
 Suicite, 1946, bronze UICCh
 Andersen, p.79 (b/w)
 Sunrise, 1954-55, bronze and
 steel UNBuA
 A-K, p.93 (b/w)

HARMON, Leon D.
 Computerized Nude, 1971, comput-
 er generated picture (in col-
 laboration with K.C. Knowlton),
 UNjMuB
 Hunter, pl.911 (b/w)

Gull-Studies in Perception 11,
 1968, computer generated pic-
 ture (in collaboration with
 K.C. Knowlton)
 UK2, pl.182 (b/w)
The Telephone-Studies in Per-
 ception 1, 1968, computer
 generated picture (in colla-
 boration with K.C. Knowlton)
 UK2, pl.208 (b/w)

HARRIS, Paul (American, 1925-)
 Woman Smelling Her Roses, 1966,
 acrylic paint, material, wood,
 dye GAaL
 Kahmen, pl.77 (b/w)

HARTIGAN, Grace (American, 1922-)
 Billboard, 1957, o/c UNNNag
 1945, pl.170 (b/w)
 City Life, 1956, o/c, Priv.
 Coll., New York
 Hunter, pl.408 (b/w)
 New England, October, 1957, o/c,
 UNBuA
 A-K, p.63 (col)
 The Phoenix, 1962, o/c
 Metro, p.157 (b/w)
 Still Life (Sweden), 1959, oil,
 UNNMMA
 Haftmann, pl.919 (b/w)
 The Study N.2, 1962, oil
 Metro, p.156 (b/w)

HARTUNG, Hans (German, 1904-)
 Aquarelle, 1922, Coll.Artist
 Abstract, pl.14 (b/w)
 Composition, 1962
 Metro, p.158 (b/w)
 Composition 750/7, 1950
 Pellegrini, p.51 (col)
 Drawing, 1947, Priv.Coll., Paris
 Seuphor, no.469 (b/w)
 Drawing, 1960, Priv.Coll., Paris
 Seuphor, no.470 (b/w)
 436-11
 Pellegrini, p.24 (b/w)
 L 102, 1963, lithograph, Coll.
 Artist
 Castleman, p.65 (col)
 Painting, 1950 FPCa
 Pellegrini, p.24 (b/w)
 Painting T 54-16, 1954, o/c,
 FPAM
 L-S, pl.51 (b/w)
 T.1947.25, o/c, Priv.Coll.,

Paris
Seuphor, no.473 (col)
T1948-19, 1948, o/c UNNSw
Abstract, pl.15 (b/w)
T 1949-9, oil GStD
Haftmann, pl.874 (b/w)
T-50 Painting 8, 1950, o/c UNNG
Arnason, fig.968 (b/w)
T 1951-12, 1951 SwBKM
Ponente, p.64 (col)
Haftmann, pl.873 (b/w)
T 1955-10, oil FPAM
Haftmann, pl.876 (b/w)
T 1956-9, 1956 FPBerg
Ponente, p.65 (col)
T.56-21, 1957, o/c FPFr
1945, pl.9 (col)
T 1956-22, 1956 SwZBe
Ponente, p.62 (col)
T1958-4, 1958, o/c UNNSai
Abstract, pl.107 (col)
T 1962-R, 1962
Metro, p.159 (col)
T 1963-R28, mixed media SwSGE
Haftmann, pl.875 (b/w)
T-1965-E33, 1965, o/c FPFr
New Art, col.pl.19
Untitled, 1963, o/c, Priv.Coll.
Arnason, col.pl.227

HARTUNG, Karl (German, 1908-)
Flugelsaule, bronze
Metro, p.160 (b/w)
Primeval Branchings, 1950, plas-
ter for bronze, Coll.Artist
G-W, p.267 (b/w)
Relief, 1963, bronze GBG
New Art, pl.323 (b/w)
Sculpture, 1947, mahogany
Trier, fig.141 (b/w)
Sculpture, 1959, gips and
bronze GBH
Metro, p.161 (b/w)
Thronoi, 1958-59, plaster for
bronze GDuK
Trier, fig.51 (b/w)

HASELDEN, Ron (British, 1944-)
Lady Dog, 1975, film
Eng.Art, p.451 (b/w)

HAUKELAND, Arnold (Norwegian,
1920-)
Dynamik I, 1960, forged iron,
NoOB
New Art, pl.175 (b/w)

HAUSER, Erich (German, 1930-)
Freiplastik, 1964, Nirosta
(stainless) steel GStR
New Art, pl.292 (b/w)
Space Column 7/68, 1968, steel,
GStM
L-S, pl.109 (b/w)
Steel 3/67, 1967, stainless
steel
Trier, fig.230 (b/w)

HAUSNER, Rudolf (Austrian, 1914-)
Adam and His Judges, 1965, dis-
temper on cloth-backed paper,
Priv.Coll., Vienna
Fig.Art, pl.148 (b/w)
Die Arche des Odysseus, 1956,
tempera and oil on plywood,
YZMG
New Art, col.pl.120

HAWKES, Julian (British, 1944-)
Dawn, 1975
Eng.Art, p.271 (b/w)
Kami, 1973, wood, leather, and
steel rods, Coll.Artist
Eng.Art, p.253 (b/w)
Solo, 1973
Eng.Art, p.256 (b/w)
Source, 1974, wood and rubber,
Coll.Artist
Eng.Art, p.255 (b/w)
Untitled, 1975, wood and sheet
steel, Coll.Artist
Eng.Art, p.257 (b/w)

HAWORTH, Jann (American, 1942-)
Calendula's Cloak, 1967
UK2, pl.200 (b/w)
Fig.Art, pl.193 (b/w)
L.A. Times Bedspread, 1965,
fabric, Priv.Coll.
Russell, pl.II (col)
Lucifer Costume
Fig.Art, pl.193 (b/w)
Mae West, 1965, mixed media,
ELFr
Russell, pl.43 (b/w)
Mae West, W.C. Fields, Shirley
Temple, 1967, cloth and hard-
board
Finch, p.59 (b/w)
Maid, 1966, nylon and kapok,
ELFr
Kahmen, pl.66 (b/w)
UK3, pl.27 (b/w)

Russell, pl.126 (b/w)
Pom-Pom Girl, 1964, calico
 Fig.Art, pl.194 (b/w)
Rainbow Costume
 Fig.Art, pl.193 (b/w)
Ring, 1965, kapok and cloth
 Finch, p.58 (b/w)

HAY, Alex (American, 1930-)
 Graph Paper, 1967, spray lacquer
 and stencil on canvas UNNKor
 Russell, pl.XIII (col)
 Grass Field, New York, 1966,
 action
 Henri, fig.56 (b/w)
 Label, 1967, spray lacquer and
 stencil on canvas UNNRos
 Russell, pl.16 (b/w)
 Leadville Description, Stock-
 holm, 1964
 UK4, pl.36 (b/w)
 Paper Bag, 1968, paper, epoxy,
 fiberglass, paint UNNW
 Russell, pl.32 (b/w)
 Toaster, 1964, o/c
 Lippard, pl.113 (b/w) UNNC
 Russell, pl.24 (b/w), Coll.
 Artist

HAYTER, Stanley William (British,
 1901-)
 Amazon, 1945, engraving and
 soft-ground etching UNNMMA
 Castleman, p.63 (col)
 Au fil de l'eau, 1961, o/c
 Metro, p.162 (b/w)
 Dionysus, 1959, o/c, Coll.Artist
 Seuphor, no.308 (col)
 Orpheus, 1949, o/c SwBKHa
 1945, pl.139 (b/w)
 Spring N.585, 1958, o/c
 Metro, p.163 (b/w)

HEAD, Tim (British, 1946-)
 Displacements, Rowan Gallery,
 London, 1975
 Eng.Art, pp.337 & 383 (b/w)
 Installation, Gallery House,
 London, 1973
 Eng.Art, p.382 (b/w)
 Installation, Garage Gallery,
 London, 1974
 Eng.Art, p.383 (b/w)
 Installation, Whitechapel Gal-
 lery, London, 1974
 Eng.Art, p.383 (b/w)

Installation Piece, Palazzo
 Reale, Milan, 1976
 Eng.Art, pp.384-85 (b/w)
Installment Diagram—Museum of
 Modern Art, Oxford, 1972
 Eng.Art, p.337 (b/w)

HEALEY, John
 Box 3, 1963 or 1967
 Busch, figs.116-17 (b/w)
 Popper 2, p.160 (b/w)

HEATH, Adrian (British, 1920-)
 Brown Painting, 1961, o/c,
 Coll.Artist
 Seuphor, no.324 (col)
 Guercif, 1965-66, o/c ELStu
 Stuyvesant, p.77 (b/w)
 Oval Theme I, 1956, sailcloth
 and paint on composition
 board ELH
 Janis, p.201 (b/w)

HEDRICK, Wally (American, 1927-)
 Ceiling Wings of Brew '52, 1958,
 welded beer cans
 Andersen, p.155 (b/w)
 His Master Voice, 1954, metal
 Andersen, p.155 (b/w)
 Peace, 1953, o/c, Coll.Artist
 Lippard, pl.14 (b/w)

HEERICH, Erwin (German, 1922-)
 Cardboard Sculpture, 1960,
 cardboard GCoB
 Kahmen, pl.245 (b/w)
 Cylindrical doll–John XXIII on
 his deathbed (Walzenpuppe-
 Johannes XXIII auf dem Toten-
 bett), 1963, cardboard GCoB
 Kahmen, pl.256 (b/w)

HEERUP, Henry (Danish, 1907-)
 The Bird and Spring, 1963, oil
 on wood DCG
 New Art, pl.169 (b/w)
 Horn of Plenty, 1935, granite,
 DHuL
 Fig.Art, pl.71 (b/w)

HEFFERTON, Phillip
 The Line, 1962, o/c UNNBoni
 Lippard, pl.143 (b/w)
 Sinking George, 1962, o/c UCLFa
 Alloway, fig.100 (b/w)
 The White House, 1963, o/c,

UCPaR
Compton 2, fig.96 (b/w)

HEGEDUSIC, Krsto (Yugoslavian, 1901-)
The Courtyard, 1958, o/c with distemper
Fig.Art, pl.67 (b/w)
Water Corpses, 1956, tempera and oil on canvas
New Art, pl.255 (b/w)

HEILIGER, Bernhard (German, 1915-)
Flamme, 1962-63, bronze GBBe
New Art, pl.325 (b/w)
Portrait of Ernst Reuter, 1954, cement
Trier, fig.89 (b/w)

HEINEMANN, Jurgen
Siesta in Kamerun, 1967
UK2, pl.177 (b/w)

HEISTER-KAMP, Peter. See PALERMO, Blinky

HEIZER, Michael (American, 1944-)
Abstraction/dissipate
Celant, p.63 (b/w)
Circumflex, Massacre Creek Dry Lake, 1968
Celant, p.62 (b/w)
Compression Line, El Mirage Dry Lake, Mojave Desert, Calif., 1968
Andersen, p.246 (b/w)
Coyote, 1969
UK4, pl.157 (b/w)
Double Compression, Aug.1968
Celant, p.65 (b/w)
Double Negative, Virgin River Mesa, Nev., 1969, reworked 1970
Andersen, p.247 (b/w)
Hunter, pl.870 (b/w)
6 Yrs, p.78 (b/w)
Walker, pl.42 (col)
Gesture, Mojave Desert, April 1968
Celant, p.64 (b/w)
#1 of Nine Nevada Depressions, Las Vegas, 1968-70 (third deteriorated condition)
Calas, p.328 (b/w)
#2/3. Fifty-two Ton Granite Mass

in Cement Depression, Silver Springs, Nev., Aug.1969
Hamilton, pl.378 (b/w)
#8 of Nevada Depressions, Black Rock Desert, Nev., 1968
Calas, p.328 (b/w)
Slot, El Mirage, Mojave Desert, Calif., 1968, backfill
Hunter, pl.851 (b/w)
Two Stage Line, Sierra Mountains, Dec.1967
Celant, p.66 (b/w)
Untitled Furrow, 1969, cement and earth SwBe
Kahmen, pl.198 (b/w)
Winter Project for Nevada, California: Conic Trail, 1968, ink on paper
Popper, p.236 (b/w)

HELD, Al (American, 1928-)
B/W XVI, 1968, a/c UNSyE
Hunter, pl.767 (b/w)
Blue Moon Greets Green Sailor (Marine), 1965, acrylic on paper on masonite UNNEm
Pellegrini, p.148 (b/w)
Abstract, pl.252 (b/w)
Echo, 1966, a/c UNNEm
L-S, pl.72 (b/w)
Flemish I, 1972, a/c
Rose, p.214 (b/w)
Flemish IX, 1974, a/c CTS
Arnason 2, fig.1231 (b/w)
Ivan the Terrible, 1961, a/c, UNNEm
Hunter, pl.766 (b/w)
Arnason, fig.1113 (b/w)
Mercury Zone II, 1975, a/c, UNNEm
Arnason 2, fig.1232 (b/w)
Phoenicia X, 1969, a/c
Calas, p.175 (b/w)
Promised Land, 1969-70, a/c
Calas, p.174 (b/w)
Venus Arising, 1963, a/c
Rose, p.198 (b/w)

HELDT, Werner (German, 1904-1955)
Oktober nachmittag, 1952, o/c, GBSp
1945, pl.88 (b/w)

HELION, Jean (French, 1904-)
La Brabant, 1958, o/c FPZ
New Art, pl.47 (b/w)

HENDERIKSE, Jan (Dutch, 1937-)
Box with Puppet Parts, 1965,
 wood and puppets, Coll.Artist
New Art, pl.155 (b/w)

HENDERSON, Nigel (British)
Drawing for Patio and Pavilion
 (for This Is Tomorrow, London,
 1957)
 Henri, fig.15 (b/w)
'Habitat' (pages from This Is
 Tomorrow catalogue, White-
 chapel Art Gallery, London,
 1956)
 Lippard, pl.27 (b/w)

HENDRICKS, Don (American, 1914-)
Shannon, 1972, pencil on paper
 Battcock, p.270 (b/w)

HEPWORTH, Barbara (British, 1903-
1975)
Ancestor II: Nine Figures on a
 Hill, 1970, bronze -EHep
 Arnason 2, fig.1059 (b/w)
Conversation with Magic Stones,
 1973, bronze -EHep
 Arnason 2, fig.1058 (b/w)
Curved Form (Delphi), 1955,
 carved Nigerian scented guarea
 1945, pl.124 (b/w)
Figure: Churinga, 1952, mahoga-
 ny UMnMW
 Arnason, fig.903 (b/w)
Figure for Landscape, 1960,
 bronze UDCHi
 Hh, pl.630 (b/w)
Figure in Landscape, 1952, ala-
 baster UMNorS
 Trier, fig.137 (b/w)
Forms in Movement
 UK1, pl.170 (b/w)
Group III (Evocation), 1952, Ser-
 ravezza marble -EG
 Arnason, fig.904 (b/w)
Head (Elegy), 1952, mahogany and
 string UDCHi
 Hh, pl.627 (b/w)
Hollow form (Penwith), 1955,
 Lagos wood 36 UNNMMA
 L-S, pl.168 (b/w)
Meridian, 1960, bronze ELStH
 Arnason, fig.906 (b/w)
Pendour, 1947, painted wood
 G-W, p.153 (b/w), Coll.Artist
 Hh, pl.628 (b/w) UDCHi

Pierced Form, 1963, Greek mar-
 ble
 New Art, pl.102 (b/w)
Porthmeor: Sea Form, 1958,
 bronze UNNHi
 Arnason, fig.905 (b/w)
Single Form, 1961, walnut, Coll.
 Artist
 Metro, p.164 (b/w)
Single Form (Memorial), 1961-62,
 bronze ELBat
 New Art, pl.101 (b/w)
Totem, 1961-62, white marble,
 Priv.Coll.
 Metro, p.165 (b/w)
Two Figures, 1947-48, painted
 elm UMnMU
 L-S, pl.167 (b/w)
Wave, 1943-44, plane wood, col-
 or, strings -EH
 Arnason, fig.902 (b/w)

HERBIN, Auguste (French, 1882-
1960)
Being Born, 1958, o/c, Priv.
 Coll., Brussels
 Abstract, pl.169 (col)
Clarte, 1961
 Popper 2, p.70 (col)
Lier, 1958, o/c
 Calas, p.164 (b/w)
Midnight, 1953 FPRe
 Ponente, p.14 (col)
Rain, 1953 or 1956, o/c FPRe
 Seuphor, no.390 (col)
 Arnason, fig.654 (b/w)
Vie No.1, 1950, o/c UNBuA
 A-K, p.241 (col)

HERMS, George (American, 1935-)
Poet, 1960, wood, paper, string,
 etc. UICN
 Seitz, p.133 (b/w)

HEROLD, Jacques (Rumanian-French,
1910-)
Derade, 1960, o/c, Priv.Coll.
 Fig.Art, pl.109 (b/w)

HERON, Patrick (British, 1920-)
Big Violet with Red and Blue,
 March 1965, o/c ELStu
 Stuyvesant, p.80 (b/w)
Blue in Blue: with Red and
 White, 1964, o/c
 New Art, col.pl.42

Manganese in deep violet: Janu-
ary 1967, o/c
L-S, pl.26 (col)
November Blue Painting, Nov.
1963, o/c ELStu
Stuyvesant, p.78 (col)
Three Cadmiums, Jan.-April 1966,
o/c ELStu
Stuyvesant, p.80 (b/w)

HESSE, Eva (German, 1936-1970)
Accretion, 50 tubes, 1968,
fiberglass
Celant, p.59 (b/w)
Contingent, 1969, fiberglass
and rubberized cheesecloth
Busch, fig.14 (b/w)
Ennead, 1966, wood, plastic
cord and acrylic UNNGan
Andersen, p.254 (b/w)
Expanded Expansion, 1969, rubber-
ized cheesecloth and fiber-
glass UNNK
Hunter, pl.880 (b/w)
On the Floor, 1968, latex rubber
on canvas
Celant, p.60 (b/w)
On the Walls, 1968, double rub-
ber sheets and plastic
Celant, p.60 (b/w)
Repetition 19 (III), 1968,
fiberglass UNNMMA
Celant, p.58 (b/w)
Rose, p.270 (b/w)
Sans I, 1967-68, rubber and
plastic
Celant, p.57 (b/w)
Sequel, 1967-68, latex
6 Yrs, p.57 (b/w)
Untitled (7 Poles), 1970, fiber-
glass over polyurethane
Walker, pl.44 (col)

HEYBOUR, Anton (Dutch, 1924-)
Composition with Three Angels
and Figures, 1957, etching,
NAS
Castleman, p.89 (col)
Lesbian, 1964, etching, Priv.
Coll., New York City
Arnason, fig.1117 (b/w)

HIGGINS, Dick (American, 1938-)
Graphis 82, Living Theater, New
York, 1962
Henri, fig.129 (b/w)

Graphis 82: Diagram from Jeffer-
son's Birthday and Postface,
1962
Henri, fig.128 (b/w)

HIGGINS, Edward (American, 1930-)
Dinghy, 1960, welded steel and
plaster, Priv.Coll.
Janis, p.255 (b/w)
Manifold IV, steel and plaster,
UNNMMA
Hunter, pl.797 (b/w)
Untitled, n.d., stainless steel
and plaster UNNC
New Art, pl.36 (b/w)
Untitled, 1961, welded metal and
epoxy UCBeW
Metro, p.167 (b/w)
Untitled, 1961, welded steel and
epoxy UNNP
Metro, p.166 (b/w)
Untitled, 1964
UKl, pl.182 (b/w)
Untitled, 1967, welded steel and
epoxy UNNC
Trier, fig.216 (b/w)

HILL, Anthony (British, 1930-)
Low Relief 2, 1963, rigid vinyl
laminate ELStu
Stuyvesant, p.106 (b/w)
Parity Study (Version 1), 1974,
perspex and paint, Coll.Artist
Eng.Art, p.97 (b/w)
Relief Construction (Dec '56),
1956-66, polystyrene and
brass, Coll.Artist
Eng.Art, p.94 (b/w)
Relief Construction, 1958-61,
copper, aluminum and perspex,
Coll.Artist
Eng.Art, p.96 (b/w)
Relief Construction, 1959, per-
spex, sheet vinyl and alumi-
num
Janis, p.240 (b/w)
Relief Construction, 1959-60,
rigid vinyl laminate
Janis, p.240 (b/w)
Relief Construction, 1960 ELT
Pellegrini, p.189 (b/w)
Relief Construction D1, 1961,
polystyrene, vinyl, aluminum
and stainless steel, Coll.
Artist
Eng.Art, p.96 (b/w)

Jean-Paul Sartre, 1962, ink
 drawing
 L-S, pl.2 (b/w)

HOFLEHNER, Rudolf (Austrian,
 1916-)
 Condition Humaine, 1960, iron,
 -Se
 Metro, p.173 (b/w)
 The Couple (Figure 101), 1966,
 solid steel
 Trier, fig.66 (b/w)
 Doric Figure, 1958, iron SwZK
 Trier, fig.62 (b/w)
 Figur 85 and Figur 86, 1964,
 iron UNNOd
 New Art, pl.328 (b/w)
 Figure (Figur), 1961, iron
 Kahmen, pl.254 (b/w)
 Monofer, 1961-62, iron AVK
 Metro, p.172 (b/w)
 Sysiphus (Homage to Albert Ca-
 mus), 1959, iron, Coll.Artist
 G-W, p.306 (b/w)

HOFMANN, Hans (German-American,
 1880-1966)
 Agrigento, 1961, o/c UCBC
 Geldzahler, p.176 (b/w)
 Sandler, p.146 (b/w)
 And Summer Clouds Pass, 1961,
 o/c UNNKo
 New Art, col.pl.4
 Bacchanale, 1946, oil on card-
 board -Hofm
 Hunter, pl.364 (b/w)
 Bird-Cage Variation II, 1956-58,
 o/c UNLarC
 Sandler, pl.X (col)
 Black Demon, c.1944, o/c UMAP
 Sandler, p.139 (b/w)
 Blue Balance, 1949, o/c UNNNYU
 Sandler, p.143 (b/w)
 Blue Moonlit, 1964, o/c UNNEm
 Carmean, p.21 (col)
 Blue Rhythm, 1950, o/c UICA
 Sandler, p.142 (b/w)
 Capriccioso, 1956, o/c CSU
 Sandler, p.143 (b/w)
 Cathedral, 1959, o/c UNNRub
 Rose, p.137 (col)
 Combinable Wall I and II, 1961,
 o/c UCBC
 Sandler, p.144 (b/w)
 Composition No.III, 1953, o/c,
 UDCHi

UDCHi
Hh, pl.737 (col)
Ecstasy, 1947, o/c UCBC
 Sandler, p.140 (b/w)
Effervescence, 1944, mixed
 media on canvas UCBC
 Tuchman, p.111 (b/w)
 Rose, p.136 (b/w)
 Hamilton, col.pl.55
 Sandler, p.141 (b/w)
 Hunter, pl.387 (col)
 Abstract, pl.33 (b/w)
Equinox, 1958, o/c UCBC
 Tuchman, p.118 (b/w)
Exuberance, 1955, o/c UNBuA
 A-K, p.50 (col)
 1945, pl.146 (col)
Fairy Tale, 1944, oil on ply-
 wood -Hofm
 Hunter, pl.465 (b/w)
Flight, 1952, o/c UCLCM
 Tuchman, p.116 (col)
Flowering Swamp, 1957, oil on
 wood panel UDCHi
 Hh, pl.738 (col)
Fragrance, 1956, o/c UHHA
 Hunter, pl.383 (b/w)
Gate, 1960, o/c UNNG
 Arnason, col.pl.202
Idolatress I, 1944, oil and
 aqueous media on upsom board,
 UCBC
 Sandler, p.67 (b/w)
Ignotium per Ignotius, 1963,
 o/c UCLJo
 Hunter, pl.396 (col)
In Sober Ecstasy, 1965, o/c,
 CTMi
 Geldzahler, p.180 (b/w)
In the Wake of the Hurricane,
 1960, o/c UCBC
 Geldzahler, p.174 (b/w)
Joy Sparks of the Gods, 1964,
 UNNKo
 Pellegrini, p.121 (b/w)
Libration, 1947, o/c UNNKo
 Tuchman, p.114 (b/w)
Little Cherry (Renata Series
 No.1), 1965, o/c -Hofm
 Geldzahler, p.181 (b/w)
Lust and Delight (Renata Series
 No.2), 1965, o/c -Hofm
 Geldzahler, p.81 (col)
Magenta and Blue, 1950, o/c,
 UNNW
 Tuchman, p.115 (b/w)

The Magician, 1959, Coll.Artist
 Ponente, p.148 (col)
Memoria in Aeterne, 1962, o/c,
 UNNMMA
 Geldzahler, p.177 (b/w)
Oceanic, 1958, o/c UDCHi
 Hh, pl.739 (col)
Olive Grove, 1960, o/c, Priv.
 Coll., New York
 Hunter, pl.384 (b/w)
Orchestral Dominance in Green,
 1954, o/c UICMar
 Seuphor, no.460 (col)
Palimpsest, 1946, oil on board,
 Coll.Artist
 Tuchman, p.112 (b/w)
Pink Table, 1936, oil on ply-
 wood -Hofm
 Hunter, pl.361 (b/w)
Pre-Dawn, 1960, oil
 Metro, p.175 (b/w)
The Prey, 1956, oil on plywood,
 UNNMMA
 Haftmann, pl.905 (b/w)
Rising Moon, 1964, o/c UNNEm
 L-S, pl.16 (col)
Rising Sun, 1958 UNNKo
 Ponente, p.149 (col)
Snow White, 1960, oil
 Metro, p.174 (b/w)
Song of a Nightingale, 1964,
 o/c UNNSchwar
 Geldzahler, p.179 (b/w)
Sparks, 1957, o/c UTxHL
 Sandler, p.145 (b/w)
Spring, 1940, oil on wood panel
 Hunter, pl.424 (b/w) UNNMMA
 Arnason, fig.850 (b/w) -URu
Still Life, Yellow Table in
 Green, 1936, oil on plywood,
 -Hofm
 Sandler, p.138 (b/w)
Summer Night's Bliss, 1969, o/c,
 UMdBM
 Geldzahler, p.175 (b/w)
 Arnason, fig.851 (b/w)
Summer Night's Dream, 1957, o/c,
 UNBuA
 A-K, p.51 (b/w)
Sun in the Foliage, 1964 UNNKo
 Pellegrini, p.120 (b/w)
The Third Hand, 1947, o/c
 Sandler, p.141 (b/w) UCBC
 Tuchman, p.113 (b/w), Coll.
 Artist
Transfiguration, 1947, o/c,

Sandler, pl.IX (col)
Veluti in Speculum, 1962, o/c,
 UNNMM
 Geldzahler, p.80 (col)
X-1955, 1955, o/c UNNRube
 Tuchman, p.117 (b/w)

HOKE, Bernhard
 Folien-Bett, 1965
 UK1, pl.124 (b/w)
 36 Puppen, 1962
 UK1, pl.96 (b/w)

HOLLAND, Tom (American, 1936-)
 Stoll, 1972, epoxy on fiberglass
 Rose, p.225 (b/w)

HOLLAND, Von Dutch
 Helmet, 1962, oil on paint on
 motorcycle helmet UCLE1
 Lippard, pl.139 (b/w)

HOLMGREN, Martin (Swedish, 1921-)
 Forms Seeking a Common Center,
 1955-60, bronze SnSNM
 New Art, pl.179 (b/w)

HOLT, Sara
 Twelve Cones, 1971-72, painted
 steel FPBag
 Popper, p.70 (col)

HOLTY, Carl (American, 1900-)
 Of War, 1942, tempera on canvas,
 UNNGra
 Hunter, pl.360 (b/w)
 Rose, p.121 (b/w)

HOLWECK, Oskar
 Mobile, 1963-64 GSaaU
 UK1, pl.261 (b/w)

HOLZINGER, John
 Restaurant on a Lake, Karsruhe,
 1967, environment (in colla-
 boration with Hermann Goep-
 fert)
 Popper, p.74 (b/w)

HONEGGER, Gottfried (Swiss,
 1917-)
 Cayuga, 1959, painted collage
 relief on canvas
 Janis, p.220 (b/w)
 Permanence, 1961, oil and card-
 board collage on canvas UNBuA

A-K, p.239 (col)
Reciprocite, 1961
 UK1, pl.175 (b/w)
Relief Study, 1960, o/c, Coll.
 Artist
 Seuphor, no.427 (col) .
Tableau-relief Plll
 UK2, col.pl.XIX
Tableau-Relief (P.Z.29), 1963,
 oil on plastic UICFl
 New Art, pl.304 (b/w)
Tableau-Relief. Z-470, 1963-67,
 collage and acrylic on canvas,
 UDCHi
 Hh, pl.828 (b/w)

HOPPER, Edward (American, 1882-
1967)
 City Sunlight, 1954, o/c UDCHi
 Hh, pl.718 (col)
 First Row Orchestra, 1951, o/c,
 UDCHi
 Geldzahler, p.183 (b/w)
 Hh, pl.717 (col)
 Gas, 1940, o/c UNNMMA
 Geldzahler, p.182 (b/w)
 Hotel by a Railroad, 1952, o/c,
 UDCHi
 Hh, pl.571 (b/w)
 Nighthawks, 1942, o/c UICA
 Andersen, p.195 (b/w)
 Hunter, pl.303 (b/w)
 Arnason, fig.686 (b/w)
 Office in a Small City, 1953,
 o/c UNNMM
 Geldzahler, p.183 (b/w)
 Second-Story Sunlight, 1960, o/c,
 UNNW
 Rose, p.104 (b/w)
 Western Motel, 1957, o/c,
 UCtNhYA
 Geldzahler, p.82 (b/w)

HORNAK, Ian
 The Backyard-Variation III,
 1973, a/c
 Battcock, p.272 (b/w)

HORWITT, Will (American, 1934-)
 Far and Near, 1962-64, bronze,
 UNNRa
 Ashton, pl.LXI (b/w)

HOSIASSON, Philippe (Russian-
 French, 1898-)
 Gray Painting, 1960 FPFl

Seuphor, no.493 (b/w)
 Oil, 1962 FPFl
 Pellegrini, p.68 (b/w)
 Painting, 1960 FPFl
 Seuphor, no.352 (col)

HOWARD, Robert (American, 1896-)
 Custodian, 1952, fiberglass
 Andersen, p.146 (b/w)

HOYLAND, John (British, 1934-)
 22-11-61, 1961
 Pellegrini, p.155 (b/w)
 Eng.Art, p.18 (b/w)
 21.8.63, o/c ELStu
 Stuyvesant, p.138 (b/w)
 17.5.64, 1964, a/c
 New Art, col.pl.40
 21.2.66, acrylic on cotton duck,
 ELStu
 Stuyvesant, p.137 (col)
 Eng.Art, p.106 (b/w)
 28.5.66, 1966, a/c ELT
 L-S, pl.87 (b/w)
 9.11.68, 1968, acrylic on cotton
 duck, Coll.Artist
 Eng.Art, p.106 (b/w)
 6.11.69, 1969, acrylic on cotton
 duck, Coll.Artist
 Eng.Art, p.107 (col)
 18.9.73, 1973, a/c ELAr
 Eng.Art, p.108 (b/w)
 17.5.75, a/c ELW
 Eng.Art, p.109 (b/w)

HUDSON, Robert (American, 1938-)
 Inside Out, 1964, painted metal
 Andersen, p.160 (b/w)
 Skeptical Space, 1965, painted
 metal
 Andersen, p.161 (b/w)
 Space Window, 1966, painted
 steel -Lil
 Busch, fig.43 (b/w)
 Untitled, 1965, polychromed
 metal UNNFru
 Ashton, pl.LXX (b/w)

HUEBLER, Douglas (American,
 1924-)
 Duration Piece #15, 1969
 Meyer, p.138 (b/w)
 Duration Piece #7, New York
 City, April 1969
 6 Yrs, p.82 (b/w)
 Duration Piece #14, Bradford,

Mass., May 1, 1970
6 Yrs, p.120 (b/w)
Haverhill-Windham-New York Mark-
er Piece, 1968
Celant, pp.44-46 (b/w)
The line above is rotating on
its axis at a speed of one
revolution each day, 1970
6 Yrs, p.167 (b/w)
Location Piece #1, New York-Los
Angeles, Feb.1969
6 Yrs, p.128 (b/w)
Location Piece #14, 1969, "mod-
el" photograph
Meyer, p.141 (b/w)
(Site Sculpture Project) New
York Variable Piece #1, 1968
6 Yrs, p.61 (b/w)
Untitled, 1968, drawing
Meyer, p.136 (b/w)
Variable piece 1, 16 oval stick-
ers
Celant, p.47 (b/w)

HUGHES, Malcolm (British, 1920-)
Three Dimensional Maquette,
1975, wood and PVA, Coll.Art-
ist
Eng.Art, p.115 (b/w)
White Relief A,B,C,D, 1975,
wood, hardboard and PVA, Coll.
Artist
Eng.Art, p.114 (b/w)
White Relief/Paintings No.1,2,3,
4, 1975, wood, hardboard, PVA
and oil, Coll.Artist
Eng.Art, p.113 (b/w)

HULTBERG, John (American, 1926-)
Cinema Frames, 1960 FPDr
Pellegrini, p.205 (b/w)
Collage I, 1952, cut paper with
gouache
Janis, p.254 (b/w)
Moving Windows, 1961, o/c UNNJ
Seuphor, no.356 (col)
Tilted Horizon, 1955, oil,
UNNMMA
Haftmann, pl.956 (b/w)

HUMPHREY, Ralph (American, 1932-)
Alma Court, 1958, o/c UNNPa
Goossen, p.51 (b/w)

HUNDERTWASSER (Fritz Stowasser)
(Austrian, 1928-)
The Big River, 1956, o/c FPF1
Seuphor, no.278 (col)
Cette fleur aura raison des
hommes, 1957, o/c
1945, pl.107b (b/w)
Good Morning City! Bleeding
Town, 1970-71, embossed silk-
screen GMLe
Castleman, p.91 (col)
The Hokkaido Steamer, 1961,
watercolor on rice paper with
chalk ground GHPo
L-S, pl.64 (col)
Kaaba Penis (Oriental Ritual
Sexual Act), 1959, oil and
tempera on canvas GHPo
Haftmann, pl.1000 (b/w)
Leone di Venezia, 1962, oil and
egg on paper and canvas
Metro, p.176 (b/w)
Maison nee a Stockholm, morte a
Paris und die Beweinung meiner
Selbst (House born in Stock-
holm), 1965, o/c UNNA
Arnason, col.pl.222
Rain of Blood Falling in Japan-
ese Waters Located in an Aus-
trian Garden, 1961, egg and
oil JTY
Pellegrini, p.281 (b/w)
Metro, p.177 (col)
Soleil et Epoque spiraloide de
la mer rouge, Nr.430/1960,
1960, o/c, Priv.Coll.
New Art, col.pl.119
Sun and Moon, 1966, o/c UNNA
Fig.Art, pl.147 (col)

HUNT, Richard (American, 1935-)
Construction, 1958, bronze and
steel UDCHi
Hh, pl.653 (b/w)
Organic Construction #10, 1961,
welded steel UICSt
Andersen, p.142 (b/w)
Wing Forms, 1963, steel UCLL
Ashton, pl.XXXI (b/w)

HUOT, Robert
Two Blue Walls (Pratt and Lam-
bert #5020 Alkyd), Sanded
Floor Coated with Polyurethane,
Paula Cooper Gallery, New York,
March-April, 1969

6 Yrs, p.92 (b/w)
Wieland, 1968
UK2, pl.317 (b/w)

HURRELL, Harold (British, 1940-)
Loop, 1967 (in collaboration
with David Bainbridge)
Meyer, p.26 (b/w)

HUTCHINSON, Peter (American,
1930-)
Arc, Tobago, West Indies, 1969
UK4, pl.167 (b/w)
Dissolving Clouds, Aspen, Colo.,
1970
6 Yrs, p.203 (b/w)
Edge of Active Volcano, Mauna
Loa, Hawaii, 1969
UK4, pl.168 (b/w)
Iceberg Project, Greenland, 1969
UK4, pl.170 (b/w)
Paricutin Volcano, 1970, bread
and mold UNNGi
Hunter, pl.855 (b/w)
6 Yrs, p.145 (b/w)
Storm King Mountain Project, New
York, 1969
UK4, pl.169 (b/w)
Threaded Calabash, Tobago, West
Indies, 1969
UK4, pl.166 (b/w)

HUXLEY, Paul (British, 1938-)
Estuary, 1963, o/c ELSh
Eng.Art, p.118 (b/w)
Untitled No.32, 1964, a/c ELAr
Eng.Art, p.118 (b/w)
Untitled, No.33, 1964, a/c,
ELStu
Stuyvesant, p.154 (b/w)
Untitled No.46, 1965, a/c,
ELStu
Stuyvesant, p.155 (b/w)
Untitled, No.51, 1966, a/c ELRo
Eng.Art, p.118 (b/w)
Untitled, No.92, 1968, a/c ELT
Eng.Art, p.119 (col)
Untitled, No.103, 1969, a/c,
ELBrC
Eng.Art, p.120 (b/w)
Untitled No.130, 1972-73, a/c,
ELRo
Eng.Art, p.120 (b/w)
Untitled No.136, 1974, acrylic
on paper ELCont
Eng.Art, p.121 (b/w)

Untitled No.155, 1975, acrylic
on paper ELRo
Eng.Art, p.121 (b/w)

HYDE, Scott
Hand-Show. The key to art (in
collaboration with Robert Fil-
liou)
UK2, pl.139 (b/w)

IKEDA, Masuo (Japanese, 1934-)
Romantic Scene, 1965, drypoint,
roulette, etching UNNMMA
Castleman, p.111 (col)

IKEDA, Tatsuo (Japanese, 1934-)
Size Is Size, 1963, etching
New Art, fig.2 (b/w)

IKEWADO, Juuko
Aiuto, non c'e ossigeno, 1966
UK2, pl.394 (b/w)

INDIANA, Robert (American, 1928-)
Alabama, 1965, o/c UICNet
Lippard, pl.103 (col)
The American Dream (from 'Decade'
portfolio), silkscreen
Wolfram, pl.106 (col)
The American Dream I, 1961, o/c,
UNNMMA
Russell, pl.84 (b/w)
The Beware-Danger American Dream
#4, 1963, o/c UDCHi
Hh, pl.867 (b/w)
The Black Yield Brother 3, 1963,
o/c -UNjP
Amaya, p.81 (col)
The Calumet, 1961, o/c UMWaB
Alloway, fig.102 (i.e.101)
(b/w)
Cuba, 1961, painted wood and
metal UNNY
Lippard, pl.55 (b/w)
The Demuth American Dream No.5,
1963, o/c CTA
Hamilton, pl.361 (b/w)
Compton 2, fig.138 (b/w)
The Demuth Five, 1963, o/c,
UNNScu
Russell, pl.VIII (col)
Arnason, fig.1052 (b/w)
Wilson, pl.23 (col)
Eat-Die, 1962, o/c, Coll.Artist
Amaya, p.81 (b/w)
Alloway, fig.30 (b/w)

Exploding Numbers, 1964-66, o/c,
 Coll.Artist
 Calas, p.143 (b/w)
Father, 1963-67, o/c, Coll.Art-
 ist
 Hunter, pl.666 (b/w)
 Compton 2, fig.196 (b/w)
 Calas, p.142 (b/w)
 Janis, p.302 (b/w)
God is a Lily of the Valley,
 1961, o/c UNNWard
 Lippard, pl.101 (b/w)
Louisiana, 1965 or 1966, o/c,
 UIChUK
 Alloway, fig.31 (b/w)
 Compton, fig.133 (col)
Love, 1966, aluminum GDusSc
 Kahmen, pl.324 (b/w)
 UK1, pl.185 (b/w)
Love, 1966, polychrome aluminum
 Andersen, p.188 (b/w)
Love, 1966-67, aluminum UDCHi
 Hh, pl.865 (b/w)
Love, 1967 UWaSWri
 Wilson, pl.24 (col)
Love, 1969, carved aluminum
 Calas, frontispiece (b/w)
Love, 1972, polychrome aluminum,
 UNNRen
 Arnason 2, fig.1136 (b/w)
The Marine Works, 1960-62, wood,
 mixed media UNNChas
 Hunter, pl.664 (b/w)
 Compton 2, fig.89 (b/w)
The Metamorphosis of Norma Jean
 Mortenson, 1967, a/c UTxSAT
 Hunter, pl.629 (col)
Moon, 1960, wood beam, iron and
 wood wheels UNNAn
 Seitz, p.141 (b/w)
Mother, 1963-67, o/c, Coll.Art-
 ist
 Hunter, pl.665 (b/w)
 Compton 2, fig.196 (b/w)
 Calas, p.142 (b/w)
 Janis, p.302 (b/w)
The Red Diamond Die, 1962, o/c,
 UMnMW
 Arnason, fig.1053 (b/w)
Six, 1965, o/c NAS
 Fig.Art, pl.243 (b/w)
Star, 1962, oil and gesso on
 wood, iron wheels UNBuA
 A-K, p.291 (b/w)
USA 666, 1964, o/c
 Lippard, pl.102 (b/w) UNNSta

Pellegrini, p.240 (b/w)
 Calas, p.140 (b/w), Coll.Art-
 ist
USA 666, 1966
 UK2, pl.370 (b/w)
The X-5, 1963, oil UNNW
 Whitney, p.74 (b/w)
 Alloway, pl.2 (col)
Year of Meteors, 1961, o/c,
 UNBuA
 A-K, p.383 (col)
 Alloway, fig.101 (i.e.102)
 (b/w)
Yield Brother, II, 1963, o/c,
 UNNAb
 New Art, pl.24 (b/w)

INFANTE, Francisco
 Soul of Crystal, 1963, kinetic
 object
 Popper 2, p.186 (b/w)

INNOCENTI, Pierluca degli. See
 PIERLUCA

INOKUMA, Genichiro (Japanese,
 1902-)
 Wall Street, 1964, o/c UCSFM
 Lieberman, p.16 (col) &
 p.25 (b/w)

INSLEY, Will (American, 1929-)
 Wall Fragment, 1966, acrylic on
 masonite, Coll.Artist
 Hunter, pl.773 (b/w)

IPOUSTEGUY, Jean (French, 1920-)
 Alexander Before Ecbatana, 1965,
 bronze FPB
 Arnason, fig.924 (b/w)
 The Crab and the Bird, 1958,
 bronze UDCHi
 Hh, pl.670 (b/w)
 David, 1959, bronze UDCHi
 Hh, pl.673 (b/w)
 Arnason, fig.923 (b/w)
 Death in the Egg (La mort dans
 l'oeuf), 1968, marble
 Kahmen, pl.187 (b/w)
 Goliath, 1959, bronze UDCHi
 Hh, pl.673 (b/w)
 La Grande Regle, 1968, marble,
 UNNG
 Arnason 2, fig.965 (b/w)
 Homme poussant la porte, 1966,
 plaster for bronze FPB

Seitz, p.146 (b/w)

JACOBSEN, Egill (Danish, 1910-)
 Green Masks, 1942, o/c DCSt
 Fig.Art, pl.70 (b/w)

JACOBSEN, Robert (Danish, 1912-)
 Construction, 1950-54, iron NAS
 Trier, fig.156 (b/w)
 Le crapaud amoureux, 1959, iron,
 SnSN
 New Art, pl.170 (b/w)
 Head with Keys, 1957, iron UICM
 Seitz, p.146 (b/w)
 Hengist, 1953, wrought iron,
 BLMB
 G-W, p.250 (b/w)
 Jaser 2, 1956, metal FPFr
 Arnason, fig.998 (b/w)
 Mecanique inerte, 1974, iron
 Arnason 2, fig.1055 (b/w)
 Message a l'espace, 1961-63
 Metro, p.181 (b/w)
 Problem of Movement, 1954, iron,
 DHuL
 Abstract, pl.183 (b/w)
 Sculpture, 1962
 Metro, p.180 (b/w)

JACQUET, Alain (French, 1939-)
 Le dejeuner sur l'herbe (Picnic),
 1964, silkscreen on canvas
 Wilson,.pl.50 (col) IRN
 Compton 2, fig.175 (b/w) FPLam
 UK2, pl.132 (b/w)
 Grey Smoke, 1967
 UK1, pls.289-90 (b/w)
 Leda. Camouflage, 1963, plaster-
 cast on panel, Priv.Coll.,
 Paris
 Fig.Art, pl.275 (b/w)
 Man's Portrait (from Dejeuner
 sur l'Herbe), 1964, silkscreen
 Amaya, p.67 (b/w)
 Peinture-Souvenir, 1963
 UK2, pl.193 (b/w)
 La source, 1965
 UK1, pl.38 (b/w)
 La vierge et l'enfant, 1966
 UK2, col.pl.V
 Wood Boards, 1968
 Battcock, p.xxiii (b/w)

JACQUETTE, Yvonne (American,
 1934-)
 Airplane Window, 1973, water-

color
 Battcock, p.70 (b/w)
The Barn Window Sky, ·1970, o/c,
 UNNFis
 UK3, pl.89 (b/w)
 Battcock, p.274 (b/w)
New York City Sky I, 1970, o/c
 Battcock, p.12 (b/w)
Underspace, 1967, acrylic on
 masonite
 Battcock, p.273 (b/w)

JAMES, Keith
 Keith and Marie, Southampton,
 1975
 Eng.Art, p.412 (b/w)

JANOUSEK, Vladimir (Czechoslova-
 kian, 1922-)
 Boats, 1965, polyester
 New Art, pl.249 (b/w)

JANSSEN, Horst (German, 1929-)
 Akrobaten, 1958, etching
 New Art, pl.286 (b/w)
 Blot, 1964, black crayon and
 color on paper, Coll.Artist
 Fig.Art, pl.153 (b/w)
 Geile Milli 30.7.1968, colored
 pencil on paper GHBr
 Kahmen, pl.157 (b/w)
 Melancholic Self-Portrait
 (Selbst Elegisch), 1965, etch-
 ing UNNMMA
 Castleman, p.103 (col)
 Souvenir, 10.10.1965, pencil,
 GCoZ
 Kahmen, pl.163 (b/w)

JARAY, Tess (Austrian-British,
 1937-)
 Capitol Blue, 1965, oil on 2
 canvases ELStu
 Stuyvesant, p.147 (b/w)
 Garden of Allah, 1966, o/c,
 Coll.Artist
 L-S, pl.88 (col)
 St. Stephen's Green, 1964, o/c,
 ELStu
 Stuyvesant, p.146 (b/w)

JARDEN, Richards (American,
 1947-)
 Facial Angle, 1970, photo series
 6 Yrs, p.140 (b/w)

JAVACHEFF, Christo. See CHRISTO

JEANNERET, Charles Edouard (Le
 Corbusier) (Swiss, 1887-1965)
 La main ouverte, 1964
 UK1, pl.56 (b/w)
 The Open Hand, 1952, sketch
 G-W, p.233 (b/w)
 Ozon 2, 1948, painted wood,
 Coll.Artist
 G-W, p.232 (b/w)
 Totem, 1945, wood, Priv.Coll.,
 Paris
 G-W, p.303 (b/w)

JEFFRIES, Carson
 KS2, 1967-68
 Popper, p.206 (b/w)

JEMEC, Andrej (Yugoslavian,
 1934-)
 Landscape XXXIV, 1965, o/c YLMo
 New Art, pl.264 (b/w)

JENDRITZKO, Guido (German, 1925-)
 Composition II, 1959, plaster
 for bronze
 Trier, fig.114 (b/w)

JENKINS, Paul (American, 1923-)
 Night Wool, Yellow and Blue,
 1963, oil GStSt
 Haftmann, pl.909 (b/w)
 Phenomena Big Blue, 1960, can-
 vas NAS
 Metro, p.182 (b/w)
 Phenomena Fly Sandman, 1960,
 o/c FPF1
 Seuphor, no.498 (col)
 Phenomena in Heaven's Way, 1967,
 a/c UNNJ
 Arnason, fig.111 (b/w)
 Phenomena Long Shield, 1962, o/c,
 FPGe
 Abstract, pl.41 (b/w)
 Phenomena Nether Near, 1965,
 FPF1
 Pellegrini, p.131 (b/w)
 Phenomena: Play of Trance, 1962,
 o/c FPF1
 Metro, p.183 (col)
 Phenomena Reverse Spell, 1963,
 a/c UDCHi
 Hh, pl.961 (col)

JENSEN, Alfred (American, 1903-)
 The Acroatic Rectangle, Per 12,
 1967, o/c, Coll.Artist
 Hunter, pl.771 (b/w)
 A Circumpolar Journey, 1973, o/c
 Rose, p.231 (b/w)
 No.1: Windows in Heaven (panel
 of 4-part mural "The Integer
 Rules the Heavens"), 1960,
 o/c UCBeSi
 Seuphor, no.254 (col)
 The Reciprocal Relation of
 Unity-20, 1969, o/c
 Calas, p.133 (b/w)

JENSEN, Leo (American, 1926-)
 Lure of the Turf, 1964, painted
 metal and wood UNNAme
 Lippard, pl.80 (b/w)

JIMENEZ, Luis (American, 1940-)
 Barfly (Statue of Liberty),
 1970, fiberglass, resin and
 epoxy
 Battcock, p.275 (b/w)
 Statue of Liberty, 1971-72,
 polyester fiberglass, Coll.
 Artist
 Hunter, pl.676 (b/w)

JIROUDEK, Frantisek (Czechoslova-
 kian, 1914-)
 Drama, 1965, o/c
 New Art, pl.241 (b/w)

JOCHIMS, Reimer (German, 1935-)
 Chromatic Blue-Violet, o/c IMM
 Abstract, pl.218 (col)

JOHANNESSON, Johannes (Icelandic,
 1921-)
 Fugue, 1967-68, o/c IcRN
 Arnason 2, fig.995 (b/w)

JOHANSON, Patricia (American,
 1940-)
 William Clark, 1967, o/c UNNNag
 Goossen, p.55 (col)

JOHN, Jiri (Czechoslovakian,
 1923-)
 Water and Earth, 1964, o/c
 New Art, col.pl.109

JOHN BULL'S PUNCTURE REPAIR KIT
 Action, Serpentine Gallery, Lon-

U.S. Flag, 1958, encaustic on
 canvas UCPaM
 Wilson, pl.4 (col)
Voices Two, 1971, collage and
 oil on canvas SwBKM
 Arnason 2, col.pl.252
Weeping Women, 1975, encaustic
 on canvas UMBeL
 Arnason 2, fig.115 (b/w)
White Flag, 1955, encaustic and
 collage on canvas, Coll.
 Artist
 Geldzahler, p.185 (b/w)
White Flag, 1955-58, o/c UNNC
 Seuphor, no.277 (col)
White Flag, 1965
 UK2, pl.10 (b/w)
White Numbers, 1957, encaustic
 on canvas UNNMMA
 Goossen, p.20 (b/w)
White Numbers, 1959, encaustic
 on canvas UNNGan
 Alloway, fig.49 (b/w)
0 to 9, 1958, collage with en-
 caustic on canvas FPRi
 Janis, p.252 (b/w)
0 through 9, 1961, charcoal and
 pastel on paper UNNScu
 Geldzahler, p.195 (b/w)
0 through 9, 1961, collage,
 plastic paint and encaustic on
 paper -E
 Calas, p.76 (b/w)

JOHNSON, Guy
 Men Smoking, 1974, o/c
 Battcock, p.276 (b/w)

JOHNSON, Lester (American, 1919-)
 Three Crouching Figures, 1968,
 o/c UNNJ
 Hunter, pl.426 (b/w)

JOHNSON, Ray (American, 1927-)
 Bridget Riley's Comb, 1966,
 collage UNNFei
 Russell, pl.60 (b/w)
 Elvis Presley No.1, 1955, col-
 lage UNNWil
 Russell, pl.50 (b/w)
 Elvis Presley No.2, 1955, col-
 lage UNNWil
 Russell, pl.49 (b/w)
 Guess Who's Coming to Dinner?,
 1968, collage UNNFei
 Russell, pl.48 (b/w)

Homage to Magritte, 1962, col-
 lage UNNTo
 Russell, pl.62 (b/w)
Letter Collage, 1964
 Wolfram, pl.131 (b/w)
Mondrian, 1967, collage -Bo
 Russell, pl.61 (b/w)
Morticos, 1955, assemblage
 Henri, fig.28 (b/w)
Overhang, 1958, collage
 Janis, p.152 (b/w)
Picasso, 1966
 UK2, pl.63 (b/w)
Shirley Temple II, 1967, col-
 lage UNNFei
 Russell, pl.47 (b/w)

JONES, Allen (British, 1937-)
 Back Beauty, 1975
 Eng.Art, p.126 (col)
 Bare Me, 1970, o/c SnGV
 Eng.Art, p.126 (b/w)
 Battle of Hastings, 1961-62,
 o/c, Priv.Coll., London
 Compton 2, fig.70 (b/w)
 Bikini Baby, 1962, oil, Priv.
 Coll., London
 Haftmann, pl.1006 (b/w)
 Buses, 1964, o/c ELStu
 Amaya, p.122 (b/w)
 Stuyvesant, p.153 (b/w)
 Concerning Marriages 7, 1964,
 ELBrC
 Pellegrini, p.221 (b/w)
 Curious Woman, 1964-65, oil on
 wood UNNFei
 Lippard, pl.20 (col)
 Dance With Head and Legs, 1963,
 o/c PoLG
 Eng.Art, p.124 (b/w)
 Female Medal, 1964, o/c UNNFei
 Amaya, p.25 (col)
 Figure Falling, 1964, o/c
 Kahmen, pl.19 (b/w) GCoL
 Eng.Art, p.125 (b/w) GCoW
 Gallery Gasper, 1966-67, o/c,
 SwZBis
 Compton 2, fig.73 (col)
 Green Dress, 1964, o/c UNNFei
 Lippard, pl.48 (b/w)
 Arnason, fig.1029 (b/w)
 Hatstand, 1969
 Fig.Art, pl.190 (b/w)
 Hermaphrodite, 1963, o/c ELivW
 L-S, pl.122 (col)
 Lippard, pl.47 (b/w)

Battcock, p.29 (b/w)
Untitled (Post-Card View), 1970,
o/c UNNBene
Hunter, pl.687 (col)

KADISHMAN, Menashe (Israeli,
1932-)
Open Suspense, 1968, Cor-Ten
steel UDCHi
Hh, pl.958 (b/w)
Segments, 1968, painted metal
and glass UDCHi
Hh, pl.956 (b/w)
Wave, 1969, stainless steel and
glass UDCHi
Hh, pl.957 (b/w)

KAFKA, Cestmir (Czechoslovakian,
1922-)
Sea, 1961, o/c
New Art, pl.251 (b/w)

KALINOWSKI, Horst Egon (German,
1924-)
Diptyque "Plessis-les-Tours",
1960-62, wood, leather and
iron, Priv.Coll.
New Art, pl.290 (b/w)
Ostensoire de la volupte, 1958
New Art, col.pl.27
The prey (La proie), 1970, alumi-
num, leather and rope
Kahmen, pl.277 (b/w)
Rose thorn (Epine de rose),
1968, caisson, leather and
wood
Kahmen, pl.278 (b/w)
Stele pour une Antilope, 1965,
leather over wooden frame
Trier, fig.105 (b/w)
Torso for ablutions (Torse pour
les ablutions), 1968, caisson,
crocodile skin and wood
Kahmen, pl.279 (b/w)

KALLOS, Paul (Hungarian, 1928-)
Painting, 1961 FPP
Seuphor, no.459 (col)

KALTENBACH, Stephen (American,
1940-)
Brass Plaque, unfinished
Celant, p.27 (b/w)
4 Brass Plaques (Air, Fire,
Earth, Water)
Celant, p.28 (b/w)

4 Brass Plaques (Skin, Flesh,
Bone, Blood)
Celant, p.29 (b/w)
Lip Stamp
Meyer, p.142 (b/w)
Time Capsule, Nov.1967-Nov.1968
Celant, p.26 (b/w)
Unannounced Public Panam Build-
ing Spectrum Lightshow
Celant, p.25 (b/w)
Untitled, 1968, felt
Celant, p.30 (b/w)

KAMPMANN, Utz (German, 1935-)
Exposition Zurich, 1966
UK1, pl.IX (col)
Farbobjekt 64/65, 1964, wood,
GStP
New Art, pl.329 (b/w)

KAMYS, Walter (American, 1917-)
Untitled No.3, 1959, pasted
paper with oil
Janis, p.222 (b/w)

KANAYAMA, Akira
"The enormous balloon became
bigger and bigger..." (from
First Gutai Theater Art),
Tokyo and Osaka, 1957
Kaprow, p.212 (b/w)

KANAYAMA, Ashira
White Vinyl with Footprints,
1956 JA
Janis, p.271 (b/w)

KANO, Mitsuo (Japanese, 1933-)
Star-rumination, 1962, etching,
JTMi
New Art, pl.205 (b/w)

KANOVITZ, Howard (American, 1929-
)
Canvas Backs, 1967, o/c
UK3, pl.78 (b/w)
Crown Jewel, 1970, polymer resin,
GCoT
UK3, pl.79 (b/w)
A Death in Treme, 1970-71, a/c
on wood
UK3, pls.57-59 (b/w)
The Dinner, 1965
UK2, pl.75 (b/w)
Drinks, 1966
UK2, col.pl.IV

Raining, 1965, happening
 Kaprow, pp.340-41 (b/w)
Record II, Austin, Tex., 1968
 UK4, pl.74 (b/w)
Runner, St. Louis, 1968
 UK4, pl.73 (b/w)
A Service for the Dead, 1962
 UK4, pl.143 (b/w)
 Kaprow, nos.57-60,72-76 (b/w)
Soap, Sarasota, Fla., Feb.1965,
 happening
 Kaprow, pp.338-39 (b/w)
A Spring Happening, 1961
 Kaprow, nos.93 & 95 (b/w)
Tree, 1963, happening
 Kaprow, nos.50-54 (b/w)
Wall, 1957-59, assemblage
 Kaprow, no.37 (b/w)
Words, 1961 or 1962, environ-
 ment UNNSm
 Pellegrini, p.243 (b/w)
 Metro, p.188 (b/w)
 Kaprow, nos.38 & 40 (b/w)
Yard, Martha Jackson Gallery,
 New York, 1961, environment
 Metro, p.189 (col)
 Kaprow, nos.108-09,112-13 (b/w)

KARSKAYA, Ida (Russian, 1905-)
 Collage, wood and cloth collage
 Janis, p.195 (b/w)
 Grisaille, 1960, o/c FPFl
 Seuphor, no.492 (b/w)

KATAYAMA, Toshihiro (Japanese,
 1928-)
 Untitled
 Pellegrini, p.182 (b/w)

KATZ, Alex (American, 1927-)
 Ada with Sunglasses, 1969, o/c,
 UNNFis
 UK3, pl.29 (b/w)
 British Soldiers, 1961, painted
 wood UNNFis
 Lippard, pl.155 (b/w)
 Cocktail Party, 1965, o/c,
 MeTaxU
 Hunter, pl.672 (b/w)
 Good Morning #2, 1974, o/c,
 UNNMa
 Arnason 2, fig.1243 (b/w)
 Iris, 1967, o/c UMiDF
 UK3, pl.99 (b/w)
 Kenneth Koch, 1967
 UK2, pl.60 (b/w)

One Flight Up, 1968, oil on
 aluminum
 Calas, p.153 (b/w)
Paul Taylor Dance Company, 1969,
 o/c UNNFis
 Hunter, pl.679 (col)
Swamp Maple II, 1970, color
 lithograph UNNW
 Whitney, p.138 (b/w)
Tulips, 1967
 UK2, pl.211 (b/w)
The Wedding, 1969-70, oil on
 aluminum
 Calas, p.155 (b/w)

KATZEN, Lila (American)
 Light Floor, plastic, mirrors
 and ultraviolet light
 Busch, fig.98 (b/w)

KAUFFMAN, Craig (American, 1932-)
 Untitled, 1967, a/c ELT
 Compton 2, fig.7 (col)
 Untitled, 1968, vacuum formed
 plexiglass UCPaM
 Andersen, p.237 (b/w)
 Untitled, 1969, sprayed acrylic
 lacquer on heat-rolled plexi-
 glass UNNPac
 Hunter, pl.750 (b/w)
 Untitled (Magenta), 1968, va-
 cuum-formed plexiglass and
 sprayed acrylic lacquer,
 UNNPac
 Hunter, pl.745 (col)

KAUFMAN, Donald (American, 1935-)
 Plink II, 1968, a/c UDCHi
 Hh, pl.1014 (col)

KAUFMANN, Herbert (German, 1924-)
 Litfass-Saulen, 1964, collage
 and oil on plywood, Coll.
 Artist
 New Art, pl.318 (b/w)

KAWABATA, Minoru (Japanese,
 1911-)
 Dark Oval, 1964, o/c UNNRoJ
 Lieberman, p.20 (col) & p.36
 (b/w)
 March, 1964, o/c UNNPa
 Lieberman, p.37 (b/w)

KAWARA, On (Japanese, 1933-)
 Bathroom, 1953, drawing on pa-

Priv.Coll., New York
Geldzahler, p.207 (b/w)
Orange and Green, 1966, o/c,
UNNJa
Arnason, fig.1112 (b/w)
Orange White, 1964, o/c UNNJa
Geldzahler, p.201 (b/w)
Painting for a White Wall, 1952,
o/c, Coll.Artist
Goossen, p.25 (col)
Pony, 1959, painted aluminum,
UMnMD
Hunter, pl.824 (b/w)
Red Blue, 1964, o/c
Walker, pl.6 (col)
Red Blue Green, 1963, o/c
Rose, p.197 (col)
Red Blue Green Yellow, 1965, o/c
Geldzahler, p.85 (col) UIWMa
Hunter, pl.704 (b/w)
Abstract, pl.251 (b/w) UNNJ
Red-Blue Rocker, 1963, painted
aluminum NAS
Andersen, p.209 (b/w)
Red White, 1961, o/c UDCHi
Hh, pl.999 (col)
Red Yellow, 1968, o/c UNLarF
Hunter, pl.753 (b/w)
South Ferry, 1956, o/c ELW
Andersen, p.209 (b/w)
Study for Untitled Painting,
1968, painted papers on card-
board
Goossen, p.53 (b/w)
3 Panels: Red, Yellow, Blue,
1963, a/c FStPM
Geldzahler, p.200 (b/w)
Tulip, 1958, pencil on paper,
Priv.Coll., New York
Geldzahler, p.206 (b/w)
Two Panels: Black with Red Bar,
1971, o/c UNNJa
Hunter, pl.728 (col)
2 Panels: White Dark Blue, 1968,
o/c UNNJa
Geldzahler, p.202 (b/w)
2 Panels: White over Black,
1966, o/c
Calas, p.201 (b/w)
Untitled, 1960, o/c UMiHK
Hunter, pl.754 (b/w)
Untitled, 1968, painted alumi-
num UNNRub
Geldzahler, p.204 (b/w)
Untitled, 1974, painted alumi-
num UNNC

Arnason 2, fig.1229 (b/w)
Water Lily, 1968, pencil on pa-
per, Priv.Coll., New York
Geldzahler, p.208 (b/w)
White-Dark Blue, 1962, o/c ELTo
L-S, pl.71 (b/w)
White on White, 1950, oil on
wood, Coll.Artist
Hunter, pl.752 (b/w)
White Relief-Arch and Its Shadow
(Pont de la Tournelle, Paris),
1952-53, painted wood, Priv.
Coll., London
Goossen, p.23 (b/w)
White Relief with Blue, 1950,
oil on wood, Priv.Coll., New
York
Geldzahler, p.199 (b/w)
White Ring, 1963, epoxy on alumi-
num, Priv.Coll., New York
Geldzahler, p.202 (b/w)
Window (Museum of Art, Paris),
1949, o/c and wood
Goossen, p.13 (b/w)
Yellow Orange and Yellow Black,
1963, o/c
Calas, p.201 (b/w)

KELLY, J. Wallace (American
The Unknown Political Prisoner,
1953
UK1, pl.243 (b/w)

KEMENY, Zoltan (Hungarian, 1907-
1965)
Banlieu des Anges, 1958, copper,
FPFa
Trier, fig.29 (b/w)
Conception du Temps, 1967, cop-
per FPAM
Wolfram, pl.92 (b/w)
Jonction de la pensee et du re-
el, 1962, copper
Metro, p.191 (col)
Mural Relief, 1963, brass SwSGH
Trier, fig.241 (b/w)
Nature, 1958 FPFa
Pellegrini, p.273 (b/w)
Neither Beginning Nor End, 1951,
steel, Priv.Coll., Brussels
Fig.Art, pl.166 (b/w)
Sun Suite, 1960 FPFa
Pellegrini, p.274 (b/w)
Visualization of the Invisible,
1960, brass UDCHi
Hh, pl.766 (col)

wood, metal, cloth, etc. UCLF
 Janis, p.233 (b/w)
Roxy's, 1961, mixed media
 L-S, pl.98 (b/w), Coll.Artist
 Henri, fig.31 (b/w)
 Fig.Art, pl.172 (b/w) UNNDw
The State Hospital, 1964-66,
 mixed media tableau
 Arnason, fig.1062 (b/w) UNNDw
 Andersen, p.174 (b/w)
 Calas, p.43 (b/w)
 Henri, fig.33 (col)
 Hamilton, pl.376 (b/w)
 Hunter, pl.803 (b/w) SnSNM
The Wait, 1964-65, epoxy, glass,
 wood, found objects UNNW
 Whitney, p.123 (b/w)
 Hunter, pl.624 (col)
Walter Hopps, Hopps, Hopps,
 1959, construction UCThoJ
 Russell, pl.76 (b/w)
While Visions of Sugar Plums
 Danced in Their Heads, 1965,
 mixed media
 UK1, pls.127-28 (b/w)
 Calas, p.45 (b/w)

KIESLER, Frederick (Austrian-Amer-
 ican, 1896-1965)
Art of This Century Gallery,
 1942, interior design
 Hunter, pl.367 (b/w)
Endless House (model), 1924-59,
 reinforced concrete
 Metro, pp.192-93 (b/w)
Galaxy, c.1951, wood, Priv. Coll.,
 New York
 Hunter, pl.525 (b/w)
The Last Judgment, 1955-59,
 metal and lucite UNNKi
 Arnason fig. 1010 (b/w)
The Shrine of the Book, 1965,
 IsJI
 Ashton, pl.XIII (b/w)

KIKUHATA, Mokuma (Japanese, 1935-
)
Roulette: Number Five, 1964,
 enamel paint and assemblage
 on wood UNNMMA
 Lieberman, p.20 (col)
Roulette: Target, 1964, enamel
 paint and assemblage on wood
 Lieberman, p.94 (b/w)
Untitled (Roulette: Ancient
 Shield), 1963, paint on wood

New Art, col.pl.88 JTMi
 Lieberman, p.95 (b/w) UNNRoJ

KIMURA, Reiji (Japanese, 1926-)
No.164, 1964, oil and metal
 paint on paper and canvas,
 Coll.Artist
 Lieberman, p.71 (b/w)
No.S.A., 1964, oil and metal
 paint on paper and composition
 board UNNMo
 Lieberman, p.70 (b/w)

KING, Philip (British, 1934-)
Blue Between, 1971, painted
 steel
 Walker, pl.27 (col)
Brake, 1966, fiberglass
 Fig.Art, pl.160 (b/w) ELBrC
 Arnason, fig.1074 (b/w) ELRo
Call, 1967
 Eng.Art, p.223 (b/w)
Genghis Khan, 1963, bakelite and
 fiberglass ELStu
 New Art, pl.92 (b/w)
 L-S, pl.203 (b/w)
 UK1, pl.218 (b/w)
 Eng.Art, p.273 (b/w)
Green Streamer, 1970
 Eng.Art, p.223 (b/w)
Open-Bound, 1973, steel, wood,
 aluminum NOK
 Eng.Art, p.263 (b/w)
Slant, 1966, arborite ELRo
 Eng.Art, p.262 (b/w)
Slit, 1965
 UK1, pl.XI (col)
Span, 1967, metal AuMGV
 L-S, pl.210 (col)
Through, 1965, fiberglass
 Walker, pl.28 (col) UNNFei
 UK1, pl.219 (b/w)
 Eng.Art, p.261 (b/w) ITLe
 Trier, fig.229 (b/w) IMAr
Tra-la-la, 1963, polyester,
 GDusSc
 Kahmen, pl.193 (b/w)

KING, William (American, 1925-)
Fitzie, 1953, pine and wire
 Andersen, p.108 (b/w)
Love, 1963, bronze UNNDi
 Ashton, pl.XLVII (b/w)
Marisol, 1955, plaster UNNDi
 Lippard, pl.81 (b/w)
 UK1, pl.53 (b/w)

New People, 1966, vinyl UNNAb
 Hunter, pl.640 (b/w)
Sheba, 1950, bronze
 Andersen, p.108 (b/w)
Sick Man, 1956, wood
 Andersen, p.189 (b/w)
Venus, 1956, bronze UDCHi
 Hh, pl.623 (b/w)

KINMONT, Robert
 Eight Natural Handstands, plate
 #1, 1969
 6 Yrs, p.70 (b/w)

KINOSHITA, Toshiko
 Untitled, 1958, chemical reac-
 tion painting on paper
 Janis, p.270 (b/w)

KIPP, Lyman (American, 1929-)
 Boss Unco, 1967 (now destroyed),
 painted plywood
 Hunter, pl.816 (b/w)
 Dolmen, 1965, painted wood
 Andersen, p.225 (b/w)
 Ebenezer, 1970, painted steel
 Busch, fig.78 (b/w)
 Flat Rate I, 1968, painted steel
 Andersen, col.pl.8
 Flat Rate II, 1969, painted
 steel UNBuA
 A-K, p.111 (col)
 Model for Albatross, 1968,
 painted wood
 Goossen, p.44 (b/w)
 Stack II, 1962, bronze
 Andersen, p.224 (b/w)
 Tobasco, 1970, painted steel
 Busch, fig.83 (b/w)

KIRBY, Michael
 Pont Neuf: The Construction of a
 Tetrahedron in Space, 1970
 6 Yrs, p.142 (b/w)

KIRILI, Alain
 Champ relationnel de la linguis-
 tique
 Meyer, p.151 (b/w)
 1970: 20.-Ecole ou (et) epoque
 preferees selon les categories
 socioprofessionnelles
 Meyer, p.150 (b/w)

KIRSCHENBAUM, Bernard (American,
 1924-)
 Spectrum III, 1968, painted wood
 Busch, fig.18 (b/w)
 Untitled, 1967-70, welded alumi-
 num, painted -Lann
 Busch, fig.19 (b/w)

KITAJ, Ron B. (American, 1932-)
 Articles and Pamphlets by Maxim
 Gorky (from In Our Time ser-
 ies), 1969, screen print
 Russell, pl.87c (b/w)
 The Autumn of Central Paris (Af-
 ter Walter Benjamin), 1973,
 o/c
 Arnason 2, fig.1101 (b/w) ELMa
 Eng.Art, p.132 (b/w), Priv.
 Coll., France
 An Early Europe, 1964, o/c,
 UNNAb
 New Art, col.pl.38
 Fighting the Traffic in Young
 Girls (from In Our Time ser-
 ies), 1969, screen print
 Russell, pl.87b (b/w)
 Four in America by Gertrude
 Stein (from In Our Time ser-
 ies), 1969, screen print
 Russell, pl.87a (b/w)
 Helle Bore: For George Trakl,
 1964, collage
 Finch, p.107 (b/w)
 Kennst du das Land?, 1962, oil
 and collage on canvas ELW
 Eng.Art, p.132 (b/w)
 London by Night, Part I, 1964,
 o/c ELMa
 Arnason, fig.1030 (b/w)
 Man of the Woods and Cat of the
 Mountains, 1973, o/c ELT
 Eng.Art, p.133 (b/w)
 The Murder of Rosa Luxemburg,
 1960, o/c with collage
 Lippard, pl.40 (b/w) ELMa
 Eng.Art, p.130 (b/w) ELPo
 The Nice Old Man and the Pretty
 Girl, 1964, o/c
 Amaya, p.136 (col)
 Notes Towards a Definition of
 Nobody ELNL
 Pellegrini, p.215 (b/w)
 The Ohio Gang, 1964, o/c UNNMMA
 Amaya, p.135 (b/w)
 Kahmen, pl.155 (b/w)
 Compton 2, fig.46 (col)

Pariah, 1960, o/c ELCoc
 Compton 2, fig.44 (b/w)
Portrait of Robert Creeley, 1966
 UK2, pl.64 (b/w)
Primo de Rivera, 1969, o/c ELMa
 Fig.Art, pl.177 (b/w)
Randolph Bourne in Irving Place,
 1963-64, oil and collage on
 canvas ELMa
 Haftmann, pl.1005 (b/w)
The Republic of the Southern
 Cross, 1964, collage
 Finch, p.105 (b/w)
Specimen Musings of a Democrat,
 1961, o/c with collage
 Compton 2, fig.45 (b/w) UNNMa
 Eng.Art, p.131 (b/w), Priv.
 Coll., London
Synchromy with F.B.-General of
 Hot Desire, 1968-69, o/c ELMa
 L-S, pl.121 (col)
 Fig.Art, pl.204 (col)
 Wilson, pl.38 (col)
Trout for Factitious Bait, sum-
 mer 1965, o/c ELStu
 Stuyvesant, p.121 (col)
Untitled, 1961, o/c, Priv.Coll.,
 London
 Eng.Art, p.132 (b/w)
Untitled, 1963, pencil and col-
 lage UNNMa
 Lippard, pl.39 (b/w)
An Urban Old Man, 1964, o/c,
 UNNRee
 Lippard, pl.37 (col)
Walter Lippman, 1966, o/c UNBuA
 A-K, p.147 (col)
Where the Railroad Leaves the
 Sea (first draft), 1964, oil
 and pencil on canvas
 Kahmen, pl.31 (b/w)
Work in Progress 21, 1962, vari-
 ous materials on wood (in col-
 laboration with Eduardo Pao-
 lozzi) -Kei
 Amaya, p.37 (b/w)

KJARVAL, Johannes S. (Icelandic,
 1885-1972)
 Fantasia, 1940, o/c IcRN
 Arnason 2, col.pl.234

KLAPHECK, Konrad (German, 1935-)
 Alphabet of Passion (Alphabet
 der Leidenschaft), 1961, o/c,
 GDusK1

Kahmen, pl.VII (col)
Exquisite Corpses (Cadavres ex-
 quis), 1961, pencil and ink
 (in collaboration with Joseph
 Beuys et al) GDusK1
 Kahmen, pls.78-81 (b/w)
The Ideal Husband, 1964, o/c,
 Priv.Coll., Brussels
 Fig.Art, pl.155 (b/w)
Die Intrigantin, 1964, o/c,
 UNNLevy
 New Art, pl.276 (b/w)
Life in Society, 1964
 Pellegrini, p.291 (b/w)
The Logic of Women, 1965
 Pellegrini, p.292 (b/w)
Love-Song (Liebeslied), 1968,
 o/c
 Kahmen, pl.47 (b/w)
Patriarchate, 1963, oil, Coll.
 Artist
 Haftmann, pl.1011 (b/w)
Procreation (Zeugung), 1960,
 o/c IMBaj
 Kahmen, pl.190 (b/w)
Proud Women, 1961, Priv.Coll.,
 Essen
 Lippard, pl.183 (b/w)
Die Schweigermutter-Mother in
 Law, 1967, o/c IMSc
 UK2, pl.203 (b/w)
 Compton 2, fig.188 (b/w)
Der Supermann-Superman, 1962
 UK2, pl.205 (b/w)
Untitled, c.1960, black and
 white chalk on grey paper,
 Priv.Coll.
 Kahmen, pl.205 (b/w)

KLASEN, Peter (German, 1935-)
 Bus Stop, 1966, o/c BAMa
 Compton 2, fig.181 (b/w)
 Water-Heater, 1968
 Fig.Art, pl.288 (b/w)

KLEEMAN, Ron
 Leo's Revenge, 1971, a/c
 Battcock, p.280 (b/w)
 23 Skidoo, 1973, a/c, Priv.Coll.
 Battcock, p.281 (b/w)

KLEIN, Yves (French, 1928-1962)
 Anthropometrie, 1960
 UK2, pl.8 (b/w)
 Anthropometry, March 9, 1960,
 happening

Tuchman, p.123 (b/w)
Composition in Black-White, 1955,
 oil UNNJa
 Haftmann, pl.889 (b/w)
Delaware Gap, 1958, o/c UDCHi
 Hh, pl.687 (b/w)
Elisabeth, 1961, o/c UNNSh
 Abstract, pl.112 (b/w)
Figure Eight, 1952, o/c UNNRub
 Geldzahler, p.211 (b/w)
Horizontals Two, 1952, o/c,
 UNNMa
 Geldzahler, p.210 (b/w)
Initial, 1959 UNGS
 Ponente, p.78 (col)
King Oliver, 1958, o/c UNNGros
 Sandler, pl.XXIII (col)
 Tuchman, p.128 (col)
Mahoning, 1956, o/c UNNW
 New Art, pl.2 (b/w)
 Whitney, p.66 (b/w)
 Sandler, p.258 (b/w)
 Hunter, pl.411 (b/w)
 Arnason, fig.863 (b/w)
Man on a Horse, c.1944, ink on
 paper UNNMa
 Sandler, p.248 (b/w)
New York, N.Y., 1953, o/c UNBuA
 A-K, p.47 (b/w)
Nijinsky (Petrushka), 1948 or
 1949, o/c UNNO
 Geldzahler, p.209 (b/w)
 Hunter, pl.400 (b/w)
 Rose, p.174 (b/w)
 Arnason, fig.862 (b/w)
Nijinsky (Petrushka), c.1950,
 o/c UICNew
 Hunter, pl.401 (b/w)
 Rose, p.174 (b/w)
 Arnason, fig.862a (b/w)
1960 New Year Wall: Night UNNJa
 Ponente, p.79 (col)
Orange and Black Wall, 1959, o/c,
 UNNScu
 Geldzahler, p.214 (b/w)
Painting, 1957, oil UNNJa
 Haftmann, pl.890 (b/w)
Painting (Untitled), 1948, oil
 and collage on panel UDCHi
 Hh, pl.530 (b/w)
Painting in Black, White and
 Gray, 1951 UNNC
 Seuphor, no.258 (b/w)
Palladio, 1961, o/c UDCHi
 Hh, pl.772 (b/w)
Palmertown, Pa., 1941, o/c,

UNNEd
 Hunter, pl.291 (b/w)
Pennsylvania, 1954, o/c UNNPoin
 Sandler, p.256 (b/w)
Reds Over Blacks, 1961, o/c,
 UNNSh
 Hunter, pl.394 (col)
Requiem, 1958, o/c UNBuA
 A-K, p.48 (b/w)
Riverbed, 1961, o/c UNNWhi
 Geldzahler, p.214 (b/w)
Seated Woman Doing Needlework,
 1945, pencil on paper UNNMa
 Sandler, p.248 (b/w)
Siegfried, 1958, o/c UPPiC
 Sandler, p.259 (b/w)
Study for Harleman, 1960, oil
 and ink on paper, Priv.Coll.,
 New York
 Arnason, fig.864 (b/w)
Sumi Ink, 1952 UNNSto
 Pellegrini, p.119 (b/w)
Untitled, 1947, o/c UNNBol
 Tuchman, p.121 (b/w)
Untitled, c.1948, oil on paper,
 UCLA
 Tuchman, p.122 (b/w)
Untitled, c.1950, ink on paper,
 UNNMa
 Sandler, p.249 (b/w)
Untitled, c.1950, oil on tele-
 phone paper UNNMa
 Sandler, p.252 (b/w)
Untitled, 1952, o/c UCLSpe
 Tuchman, p.124 (b/w)
Untitled, 1953-54, o/c UCLHa
 Geldzahler, p.212 (b/w)
 Tuchman, p.125 (b/w)
Untitled, 1953-54, o/c UNNO
 Geldzahler, p.212 (b/w)
Vawdavitch, 1955, o/c UMoKNG
 Abstract, pl.32 (b/w)
Wall Collage, 1960, pasted paper
 with oil
 Janis, p.154 (b/w)
Wanamaker Block, 1955, o/c,
 UNNBake
 1945, pl.167 (b/w)
 Hunter, pl.430 (b/w)
 Tuchman, p.126 (b/w)
 Hamilton, pl.344 (b/w)
White Forms, 1955, o/c UCtNcJ
 Geldzahler, p.213 (b/w)
Wotan, 1950, o/c UNNScu
 Geldzahler, p.210 (b/w)

KOLAR, Jiri (Czechoslovakian,
 1914-)
 Apple and Pear, 1964
 UK1, pl.91 (b/w)
 Brancusi, 1966
 UK2, pl.382 (b/w)
 Collage, 1967
 Fig.Art, pl.310 (b/w)
 Gesichte, 1963
 UK2, pl.83 (b/w)

KOLOS-VARY, Sigismond (Hungarian,
 1899-)
 Discovery, 1960, o/c -SwJ
 Seuphor, no.406 (col)

KOMMODORE, Bill (American, 1932-)
 Sun City, 1966 UNNWise
 Barrett, p.139 (b/w)

KONPANEK, Vladimir (Czechoslovaki-
 an, 1927-)
 Two Village Women, 1963, bronze
 New Art, pl.248 (b/w)

KOROMPAY, Giovanni (Italian,
 1904-)
 Elements in Space, 1959, etch-
 ing, Coll.Artist
 Seuphor, no.281 (b/w)

KOSICE, Gyula (Hungarian-Argen-
 tinian, 1924-)
 Hommage a ma femme Diyi, 1964
 Popper 2, p.139 (b/w)
 Sculpture, 1958, plexiglass,
 FPRe
 Trier, fig.166 (b/w)

KOSSOFF, Leon (British, 1926-)
 Profile of Rachel, 1965, oil on
 board ELMa
 L-S, pl.39 (b/w)
 York Way Railway Bridge From Cal-
 edonian Road, winter 1966-67,
 oil on board ELStu
 Stuyvesant, p.86 (col)

KOSUTH, Joseph (American, 1945-)
 Art as Idea as Idea, 1966,
 mounted photostat UNNLic
 Hunter, pl.779 (b/w)
 The Eighth Investigation (AAIAI),
 Proposition Three, 1971, 24
 clocks, 12 notebooks IMPan
 Empty, 1967

Popper, p.240 (b/w)
 Existence (Art as Idea as Idea),
 1968
 Celant, p.102 (b/w)
 Information Room, 1970
 Meyer, p.171 (b/w)
 Matter in General (Art as Idea
 as Idea), 1968
 Meyer, p.153 (b/w)
 One and Three Chairs, 1965,
 UNNMMA
 Meyer, p.152 (b/w)
 Walker, p.55 (b/w)
 Arnason 2, fig.1253 (b/w)
 Time (Art as Idea as Idea), 1968
 Celant, p.102 (b/w)
 Titled (Art as Idea as Idea),
 1967, photographic process
 Celant, p.100 (b/w)
 Meyer, p.154 (b/w)
 Titled (Art as Idea as Idea),
 1967
 Celant, p.101 (b/w)
 "Titled" (Art as Idea as Idea),
 1967, negative photostat
 6 Yrs, p.31 (b/w)

KOTHE, Fritz
 Allison, 1966
 UK2, pl.81 (b/w)

KOTIK, Jan (Czechoslovakian,
 1916-)
 Burratino al pincio, 1965, o/c
 New Art, col.pl.108

KOUNELLIS, Jannis (Italian,
 1936-)
 Carboniera, 1967-68
 Celant, p.78 (b/w)
 Cavalli (Horses), 1969 IRAt
 Celant, pp.76-77 (b/w)
 Fig.Art, pl.315 (b/w)
 Cotoniera, 1967, steel and cot-
 ton
 Celant, p.74 (b/w)
 Epico I, 1960
 UK2, pl.381 (b/w)
 Margherita con fuoco, 1967
 UK1, pls.304-05 (b/w)
 9 May 1969-I shall paint a tree
 black...
 Celant, p.73 (b/w)
 Pappagallo, 1967, live parrot
 and steel
 Celant, p.75 (b/w)

KRUSHENICK, Nicholas (American, 1929-)
Battle of Vicksburg, 1963, liquitex on canvas UNNFisc
 Lippard, pl.119 (b/w)
Godzilla, 1970, a/c UNNPac
 Hunter, pl.762 (b/w)
Lotus Europa, 1969, a/c UNBuA
 A-K, p.397 (col)
Measure of Red, 1971, a/c UDCHi
 Hh, pl.1018 (col)

KUCHENMEISTER, Rainer (German, 1926-)
Rote Komposition, 1963, oil on wood GMSta
 New Art, col.pl.125
Untitled III, 1960
 Fig.Art, pl.86 (b/w)

KUDO, Tetsumi (Japanese, 1935-)
Bottled Humanism, Paris, 1963
 UK4, pl.42 (b/w)
Confluent Reaction in Plane Circulation Substance, 1960
 Pellegrini, p.257 (b/w)
Cultivation by Radioactivity in an Electronic Circuit, 1967-68, assemblage NHiB
 Fig.Art, pl.321 (b/w)
For Your Living-Room (For Nostalgic Purpose), 1965, polyester and fluorescent color
 Kahmen, pl.7 (b/w)
 UK1, pl.65 (b/w)
Harakiri of Humanism, Paris, 1963
 UK4, pl.41 (b/w)
Instant Sperm, Paris, 1963-66
 UK4, pl.112 (b/w)
Love (L'amour), 1964, polyester, NHiB
 Kahmen, pl.183 (b/w)
 UK1, pl.44 (b/w)
Philosophy of Impotence, Paris, 1962
 UK4, pls.39-40 (b/w)
Sneeze of Guinea Pigs, Paris, 1966
 UK4, pl.111 (b/w)
Your Portrait, 1962, assemblage of objects FPY
 New Art, pl.56 (b/w)
Your Portrait, 1964
 UK1, pl.II (col)
Your Portrait-P, 1965

UK1, pl.126 (b/w)

KUEHN, Gary (American, 1939-)
Untitled, 1966
 UK1, pl.228 (b/w)

KUNIYOSHI, Yasuo (Japanese-American, 1893-1953)
Deliverance, 1947, oil UNNW
 Whitney, p.54 (col)
Look It Flies!, 1946, o/c UDCHi
 Hh, pl.541 (b/w)

KUNST, Mauro
Bones, 1965
 UK1, pl.30 (b/w)

KUNTZ, Roger (American, 1926-)
101, 1961, o/c UCLL
 Lippard, pl.147 (b/w)

KUNZ, Wolfgang
Foto, 1967
 UK2, pl.157 (b/w)

KURLIOFF, Aaron
Fuse Box, 1963, mounted on wood, UNNFis
 Lippard, pl.158 (b/w)

KURT, Kay (American, 1944-)
For All Their Innocent Airs, They Know Exactly Where They're Going, 1968, o/c, UNNKor
 UK3, pl.77 (b/w)
 Russell, pl.108 (b/w)
Weingummi, 1969, o/c UNNNe
 Battcock, p.55 (b/w)

KUSAMA, Yayoi (Japanese, 1929-)
Air Mail Stickers, 1962, collage on canvas UNNW
 Lippard, pl.59 (b/w)
 Pellegrini, p.294 (b/w)
Armchair, 1962
 Kahmen, pl.196 (b/w)
 UK1, pl.120 (b/w)
Endless Love Room, 1965-66
 UK1, pl.XII (col)
 Henri, fig.41 (col)
Endless Love Show, New York, 1965
 UK1, pl.341 (b/w)
From the Driving Image, Show, 1964, environment
 Kaprow, nos.20-21,49 (b/w)

Seuphor, no.310 (col)

LAING, Gerald (British, 1936-)
AA-D, 1964, o/c -UNjP
 Amaya, p.127 (b/w)
C.T. Strokers, 1964, o/c UNNFei
 Finch, p.115 (b/w)
Deceleration II, 1964, o/c GCoZ
 Finch, p.116 (b/w)
Jean Harlow, 1964, o/c UCoAP
 Compton 2, fig.86 (b/w)
Lotus I, 1963, o/c UNNFei
 Lippard, pl.49 (b/w)
 UK2, pl.258 (b/w)
Number 62, 1964, o/c UNNJe
 Finch, p.114 (b/w)
Rain Check, 1965
 UK2, pl.80 (b/w)
Sky Diver VII, 1964, o/c
 Amaya, p.121 (col)
Skydiver VIII, 1964, o/c
 Finch, p.117 (b/w)

LALANNE, Francois Xavier (French,
 1927-)
Le rhinoceros, 1966
 UK1, pl.82 (b/w)
Sheep (Les moutons), 1966 FPIo
 Kahmen, pl.306 (b/w)
 UK1, pl.85 (b/w)

LALOY, Yves
Under the Twinkling Stars, 1953,
 FPSal
 Fig.Art, pl.140 (b/w)

LAM, Wilfredo (Cuban, 1902-)
Bruit dans la porte, 1962, o/c,
 UNNLoe
 Metro, p.197 (b/w)
Dog with Two Heads, 1964, oil,
 SwGK
 Haftmann, pl.945 (b/w)
Les Enfants sans ame, 1964, o/c,
 SwGK
 New Art, pl.44 (b/w)
Head, 1947, oil on paper and
 canvas
 Haftmann, pl.944 (b/w)
Liberation, 1957, o/c
 Fig.Art, pl.117 (b/w)
La nuit a nous, 1962, o/c,
 UNNLoe
 Metro, p.196 (b/w)
The Sacred, 1962, o/c SwGK
 Fig.Art, pl.118 (b/w)

The Siren of the Niger, 1950,
 oil and charcoal on canvas,
 UDCHi
 Hh, pl.551 (b/w)
Tropic of Capricorn, 1961, o/c,
 UCLHe
 Arnason, fig.961 (b/w)

LANCASTER, Mark (British, 1938-)
Cambridge Michaelmas, 1969,
 liquitex on canvas ELGor
 Walker, pl.37 (col)
Zapruder II, 1967
 UK2, pl.389 (b/w)

LANDFIELD, Ronnie (American,
 1947-)
Rain Dance III, 1969-70, a/c,
 UDCHi
 Hh, pl.950 (b/w)

LANDI, Edoardo (Italian, 1937-)
Visual Dynamics, 1964-65 (in
 collaboration with Alberto
 Biasi) IRN
 Pellegrini, p.174 (b/w)

LANDSMAN, Stanley (American,
 1930-)
Infinity Chamber, 1968, coated
 mirrors, lights and wood,
 Coll.Artist
 Hunter, pl.931 (b/w)

LANDUYT, Octave (Belgian, 1922-)
The Pearl, 1953, oil on panel,
 Priv.Coll.
 Fig.Art, pl.93 (b/w)
Presence immobile, 1960, o/c,
 Priv.Coll.
 New Art, pl.195 (b/w)

LANGLAIS, Bernard (American,
 1921-)
Southern Comfort, collage con-
 struction of wood
 Janis, p.206 (b/w)
Totem, 1960, natural wood con-
 struction -Fo
 Janis, p.206 (b/w)

LANSKOY, Andre (Russian, 1902-)
Atrocities of the Reds, 1959,
 o/c FPCa
 Seuphor, no.172 (col)
Composition, o/c SwBBe

Sculpture, 1935 (now destroyed),
plaster on pipe and wire arma-
ture
Andersen, p.32 (b/w)
Sculpture, 1936, plaster
Andersen, p.33 (b/w)
Sculpture in Steel, 1938, steel,
Coll.Artist
Andersen, p.34 (b/w)
Hunter, pl.508 (b/w)
Space Densities, 1967, steel,
brass and phosphor bronze,
UKWA
L-S, pl.183 (b/w)
Star Cradle, 1949, stainless
steel and plastic
Andersen, p.58 (b/w)
Torso, 1931, painted plaster
Andersen, p.31 (b/w)
Zodiac House, 1958, copper,
nickel-silver and bronze,
UNNSt
G-W, p.249 (b/w)

LASSUS, Bernard
Ambiance 10, 1966
Popper 2, p.188 (b/w)
Ceiling of Plastic Elements,
FStA
Popper, p.110 (col)

LATASTER, Gerard (Dutch, 1920-)
Alert, 1966, o/c FPFa
Abstract, pl.61 (b/w)
Come Liberty, 1963-65 FPFa
Pellegrini, p.61 (b/w)
La cote se defend, 1959 FPFa
Ponente, p.160 (col)

LATHAM, John (British, 1921-)
Art and Culture, Aug.1966, case,
papers, miscellany
6 Yrs, p.16 (b/w)
The Burial of Count Orgaz, 1958,
billiard board, bottle, pipes,
etc., Coll.Artist
Eng.Art, p.137 (b/w)
Figures, 1956, spray medium, oil
on cellulose on board ELSm
Eng.Art, p.137 (b/w)
Film Star, 1961, books, plaster,
metal on canvas ELT
Compton, pl.30 (b/w)
Great Uncle, 1960, canvas, paint,
etc. on board, Coll.Artist
Eng.Art, p.138 (b/w)

Observer 4, 1960, canvas, paint,
mixed media on board, Coll.
Artist
Eng.Art, p.139 (b/w)
Shem, 1958, Hessian-covered door
with books and other objects,
Coll.Artist
Seitz, p.123 (b/w)
Whatareyoulookingat?, 1975,
photographic enlargement on
board, Coll.Artist
Eng.Art, p.139 (b/w)

LAUBIES, Rene (French, 1922-)
Ink Drawing, 1951, Coll.Artist
Seuphor, no.193 (b/w)

LAURENS, Henri (French, 1885-1954)
L'Adieu, 1941, bronze FPAM
G-W, p.73 (b/w)
Amphion (Statue), 1952, bronze,
VCU
G-W, pp.74-75 (b/w)
UK1, pl.239 (b/w)
The Awakening (L'eveil), 1952,
bronze GCoMe
Kahmen, pl.94 (b/w)
Grand Amphion, 1952, bronze,
GDuK
Trier, fig.56 (b/w)
The Great Farewell (Le grand
adieu), 1941, bronze GCoZ
Kahmen, pl.173 (b/w)
La Petite Espagnole, 1954,
bronze FPLe
Fig.Art, pl.37 (b/w)
Siren, 1944, bronze FPAM
G-W, p.71 (b/w)
Striding Female Nude, 1948,
black chalk GStSt
Kahmen, pl.92 (b/w)
Striding Female Nude, 1948, pen-
cil, Priv.Coll.
Kahmen, pl.93 (b/w)

LAVIE, Raffi (Israeli, 1937-)
Peinture, 1965, oil and collage
New Art, pl.231 (b/w)

LAVONEN, Ahti (Finnish, 1928-)
Composition, 1964, mixed media
New Art, pl.182 (b/w)

LAW, Bob (British, 1934-)
Castle XV, 1975, a/c, Coll.
Artist

Castle XVII, 1975, a/c, Coll.
 Artist
 Eng.Art, p.143 (b/w)
Castle XVIII, 1975, a/c, Coll.
 Artist
 Eng.Art, p.145 (b/w)
Castle XXI, 1975, a/c, Coll.
 Artist
 Eng.Art, p.145 (b/w)
No.61 Violet and Blue Plum
 Black, 1967, a/c, Coll.Artist
 Eng.Art, p.142 (b/w)
No.62 Black Blue Violet Blue,
 1967, a/c, Coll.Artist
 Eng.Art, p.144 (b/w)

LAWRENCE, Jacob (American, 1917-)
 Tombstones, 1942, gouache UNNW
 Whitney, p.99 (b/w)

LEBEL, Jean-Jacques (French,
 1926-)
 Ceremonie Funebre, Venice, 1960
 UK4, pls.30 & 144 (b/w)
 Kaprow, pp.228-32 (b/w)
 Do It Yourself, 1969, diagram
 Henri, fig.150 (b/w)
 Effacement, 1960, painting and
 collage on wood, Priv.Coll.
 New Art, pl.49 (b/w)
 For Exorcising the Spirit of
 Catastrophe, Paris, Oct.1962
 and Boulogne, Feb.1963
 Kaprow, pp.234-40 (b/w)

LEBENSTEIN, Jan (Polish, 1930-)
 Aquatic, 1965, Priv.Coll.
 Pellegrini, p.202 (b/w)
 Arnason, fig.949 (b/w)
 Axial Figure 63, 1960, o/c,
 UNNCh
 Seuphor, no.342 (col)
 Axial Figure No.90, 1960, o/c,
 UDCHi
 Hh, pl.659 (b/w)
 Figure N.110, 1961 UNNMMA
 Metro, p.201 (b/w)
 Figure No.125, 1961, o/c, Priv.
 Coll.
 Abstract, pl.76 (b/w)
 Figure No.152, 1962, oil FPL
 Metro, p.200 (b/w)
 Vertical Blue, 1965, o/c
 New Art, pl.235 (b/w)

LEBLANC, Walter (Belgian, 1932-)
 Mobile-static Torsion, 1965,
 Coll.Artist
 Abstract, pl.267 (b/w)
 Painting, 1961, Coll.Artist
 Seuphor, no.424 (col)
 Torsions, 1963 -BM
 Barrett, p.102 (b/w)

LE BROCQUY, Louis (Irish, 1916-)
 The Last Tinker, 1948, o/c
 1945, pl.133 (b/w)
 Willendorf Venus, 1964, o/c,
 UDCHi
 Hh, pl.808 (b/w)
 Woman, 1960, o/c ELG
 Seuphor, no.398 (col)

LEBRUN, Rico (American, 1900-1964)
 Buchenwald Pit, 1955, charcoal
 on canvas UNNS
 Selz, p.96 (b/w)
 Dachau Chamber (Study), 1958,
 o/c UNNS
 Selz, p.101 (col)
 'Double Disparate', 1958, casein
 and oil on board, Coll.Artist
 Selz, p.98 (b/w)

LE CORBUSIER. See JEANNERET,
 Charles Edouard

LEEPA, Allen (American, 1919-)
 Composition 25, 1960, o/c
 Seuphor, no.359 (col)

LEEUW, Bert de (Belgian, 1926-)
 Les Baigneurs de Baden-Baden,
 1963, mixed media SwGK
 New Art, pl.191 (b/w)

LEFAKIS, C. (Greek, 1906-)
 Painting, 1963, o/c
 New Art, pl.225 (b/w)

LEGER, Fernand (French, 1881-1955)
 Big Julie (La grande Julie),
 1945, o/c UNNMMA
 Kahmen, pl.53 (b/w)
 Composition, 1940-42, oil FPLe
 Haftmann, pl.441 (b/w)
 The Constructors, 1950, o/c,
 FBioL
 L-S, pl.29 (b/w)
 Divers, 1945, oil GMaM
 Haftmann, pl.439 (b/w)

Divers Against Yellow Background
 (Les plongeurs), 1941, oil,
 UICA
 Haftmann, pl.438 (b/w)
Homage to Louis David, 1948-49,
 oil FPAM
 Haftmann, pl.442 (b/w)
Landscape, 1947, oil FPCa
 Haftmann, pl.437 (b/w)
Marie the Acrobat (Marie L'Acro-
 bat), 1948, lithograph FPLe
 Castleman, p.23 (col)
Romantic Landscape, 1946 FPCa
 Haftmann, pl.436 (b/w)
Study for Homage to David, 1951,
 oil FPLe
 Haftmann, pl.444 (b/w)
Sunflower, c.1954, glazed cera-
 mic and stone mosaic UDCHi
 Hh, pl.729 (col)
The Three Sisters, 1952, oil,
 CStSt
 Haftmann, pl.443 (b/w)
The Walking Flower, 1951, cera-
 mic UNBuA
 A-K, p.181 (col)

LE GRICE, Malcolm (British, 1940-)
 Little Dog for Roger, 1967, film
 Eng.Art, p.455 (b/w)
 Matrix, 1973, film
 Eng.Art, p.441 (b/w)

LEHMDEN, Anton (Austrian, 1929-)
 Family Scene II, 1951-52, water-
 color AVA
 Fig.Art, pl.150 (b/w)

LEISSLER, Arnold (German, 1939-)
 Fluidum eines Mobels, 1963, o/c,
 GHaB
 New Art, col.pl.124
 Oil, 1963 GHaB
 Pellegrini, p.291 (b/w)

LEKAKIS, Michael (American, 1907-)
 Rhythmos, 1950-64, cherry with
 elm base, Coll.Artist
 Ashton, pl.XIX (b/w)
 Sympan, 1960, oak UNNW
 Whitney, p.116 (b/w)

LEKBERG, Barbara (American, 1925-)
 Prophecy, 1955, welded steel
 Andersen, p.92 (b/w)

LE MOAL, Jean (French, 1909-)
 Autumn, 1958-60 FPRoq
 Ponente, p.38 (col)
 Roots and Water, 1959, o/c,
 FPFr
 Seuphor, no.235 (col)
 Tranquil Nature
 Seuphor, no.236 (col)

LENICA, Jan (Polish, 1928-)
 Labyrinth, 1962
 UK2, pl.397 (b/w)

LENK, Kaspar Thomas (German,
 1933-)
 Farb-Raum-Objekt 8, 1964-65
 UK1, pl.256 (b/w)
 Schichtung, 1966, colored wood,
 GStMu
 L-S, pl.213 (col)

LEONARDI, Leoncillo. See LEON-
 CILLO

LEONCILLO (Leoncillo Leonardi)
 (Italian, 1915-)
 San Sebastiano, 1962 IRO
 New Art, col.pl.61

LE PARC, Julio (Argentinian,
 1928-)
 Cerchi potenziali, 1965
 UK1, pl.251 (b/w)
 Continual Light, 1967
 Abstract, pl.293 (b/w)
 Continual Light Mobile, 1960,
 Priv.Coll.
 Barrett, p.107 (b/w)
 Continuel-lumiere, 1963, archi-
 tectural design
 New Art, pl.213 (b/w)
 Continuel Lumiere Formes en
 Contorsion, 1966, motorized
 aluminum and wood UNNWise
 Arnason fig.1092 (b/w)
 Continuel-mobile, Continuel-
 lumiere, 1963, assembled re-
 lief ELT
 L-S, pl.160 (b/w)
 Compton, pl.23 (b/w)
 Contorted Circle, 1966 FPRe
 Barrett, p.95 (b/w)
 Corbes virtuelles, 1965
 UK1, pl.268 (b/w)
 Double Movement by Displacement
 by the Spectator, 1965 FPRe

Plug Assist, 1966
 UK1, pl.162 (b/w)
Snapshot, 1974, 20 photographs,
 20 candles, 4 tapes
 Arnason 2, fig.1255 (b/w)
Standard Equipment, 1968, neon
 light tubing, Coll.Artist
 Hunter, pl.932 (b/w)

LEVINE, Marilyn (American, 1935-)
 Brown Bag "Sid's Suitcase",
 1972, stoneware UVRMu
 Battcock, p.106 (b/w)
 Brown Boots, Leather Laces,
 1973, stoneware and leather
 Battcock, p.283 (b/w)

LEVINSON, Mon (American, 1926-)
 The Edge I, 1965, mixed media,
 UDCHi
 Hh, pl.833 (b/w)
 Reflected Color III, 1964, paper
 relief UNNKor
 Ashton, pl.LXXVIII (b/w)
 The Source III, 1970, cast
 acrylic and light, Coll.Artist
 Hunter, pl.714 (b/w)

LEVITAN, Israel (American, 1912-)
 Helix, 1959, wood UFKD
 Andersen, p.115 (b/w)
 Macrocosm, 1953-54, wood -U
 Andersen, p.115 (b/w)

LEWITIN, Landes (Rumanian-Ameri-
 can, 1892-1966)
 Innocence in a Labyrinth, 1940,
 collage of colored photo-
 engravings UNNMMA
 Seitz, p.160 (b/w)
 Knockout, 1955-59, oil and
 ground glass on composition
 board UNNMMA
 Hunter, pl.381 (b/w)
 The Wizard, 1940-42, decoupage
 of colored lithography, Coll.
 Artist
 Janis, p.171 (b/w)

LEWITT, Sol (American, 1928-)
 A7, 1967, painted metal UNNDw
 L-S, pl.5 (b/w)
 B5 (from Serial Project #1),
 1966, painted metal
 Busch, fig.8 (b/w)
 B7 (from Serial Project #1),

1966, painted metal
 Busch, fig.7 (b/w)
B8 A8 (from Serial Project #1),
 1966-68, baked enamel and
 aluminum
 Busch, fig.6 (b/w)
Box in the Hole, The Visser House
 in Bergeyk, The Netherlands,
 July 1, 1968, photographic re-
 port on a cube that was buried
 Hunter, pl.873 (b/w)
C369, 1968, enamel and aluminum,
 GCoZ
 Kahmen, pl.295 (b/w)
C369 (workshop drawing), 1968,
 pencil and pen GCoZ
 Kahmen, pl.296 (b/w)
Composite, 1970
 Meyer, pp.176-77 (b/w)
Drawing, Oct.1969, ink on paper
 6 Yrs, p.76 (b/w)
Four Basic Colors, 1971, print,
 ELLis
 Walker, pl.39 (col)
4-Part Set ABCD 2, 1968, baked
 enamel on steel GKrefL
 Calas, p.273 (b/w)
46 3-Part Variations on 3 Dif-
 ferent Kinds of Cubes, 1967,
 baked enamel on aluminum
 6 Yrs, p.42 (b/w)
Hanging Modular Structure, 1966
 UK1, pl.234 (b/w)
Model for Untitled Sculpture,
 1966, painted wood UNNDw
 Goossen, p.43 (b/w)
Models for Sculpture, 1966,
 painted aluminum
 Popper, p.235 (b/w)
Modular Low Floor Sculpture,
 1966
 UK1, pl.235 (b/w)
Serial Project #1, Set A, 1966
 Busch, fig.5 (b/w)
Series A, 1967
 Walker, p.29 (b/w)
Series 3,2,3:47 3-Part Varia-
 tions on 3 Different Kinds of
 Cubes, 1968, baked enamel on
 aluminum
 Andersen, p.225 (b/w)
7 Part Variation of 2 Different
 Cubes, 1968, painted plastic
 and wood UNNWe
 Hunter, pl.832 (b/w)
Six Thousand Two Hundred and

Arnason, fig.1043 (b/w)
Woman in Armchair, 1963, magna
 on canvas FPBo
 Russell, pl.68 (b/w)
Woman in Bath, 1963, pencil and
 touche UNNWeb
 Wilson, p.11 (b/w)
Woman with Flowered Hat, 1963,
 o/c
 Lippard, pl.69 (col) UNNMnu
 Hunter, pl.682 (col) UNNTy
 Alloway, fig.70 (b/w), Priv.
 Coll.
Yellow and Green Brushstrokes,
 1966, oil and magna on canvas,
 ELFr
 Calas, p.106 (b/w)
Yellow and Red Brushstrokes,
 1966, o/c -Dur
 L-S, pl.126 (b/w)

LICINI, Osvaldo (Italian, 1894-)
 Amalassunta No.3, c.1940, oil,
 Priv.Coll., New York
 Angelo, 1951, oil on cardboard
 1945, pl.48 (col)
 Rebellious Angel with Red Heart
 (Angelo ribelle col cuore ros-
 so fondo blu), 1953, oil ITL
 Haftmann, pl.928 (b/w)

LIGARE, David (American, 1945-)
 Sand Drawing #18, 1973, pencil on
 paper
 Battcock, p.284 (b/w)

LIGHT, Alvin (American, 1931-)
 June, 1961, 1961, hardwoods,
 UCSFGo
 Andersen, p.159 (b/w)
 November, 1964, hardwoods, Coll.
 Artist
 Ashton, pl.LIV (b/w)

LIJN, Liliane (American, 1939-)
 Cosmic Flare, 1966
 UK2, pl.407 (b/w)
 Liquid Reflections, 1966, Coll.
 Artist
 Brett, p.51 (b/w)
 Liquid Reflections, 1966-67, per-
 spex disc, water, oil ELAx
 L-S, pl.157 (b/w)
 Liquid Reflections, 1966-67
 UK1, pl.279 (b/w)
 Liquid Reflections (Saturnian

I), 1966, plexiglass, water
 and steel, Priv.Coll.
 Abstract, pl.278 (b/w)
3 Liquid Reflections, 1966-67,
 perspex discs, water and
 lamps, Coll.Artist
 Brett, p.52 (b/w)
 Popper, p.46 (b/w)

LINCK, Walter (Swiss, 1903-)
 Sculpture Mobile, 1959, steel
 and iron
 Trier, fig.21 (b/w)

LIND, Pi
 Living Sculpture, Stockholm,
 1969
 UK4, pl.51 (b/w)

LINDELL, Lage (Swedish, 1920-)
 Figure Composition, 1964, o/c,
 SnSNM
 New Art, pl.177 (b/w)

LINDNER, Richard (German-American,
 1901-)
 Adults-only, 1967, watercolor,
 UNNCor
 Kahmen, pl.15 (b/w)
 Coney Island No.2, 1964, o/c,
 UNNCor
 Lippard, pl.118 (b/w)
 Fig.Art, pl.87 (b/w)
 Disneyland, 1965, o/c GCoZ
 Kahmen, pl.156 (b/w)
 Hello, 1966, o/c UNNAb
 Hunter, pl.68 (col)
 Arnason, col.pl.235
 Ice, 1966, oil UNNW
 Whitney, p.76 (b/w)
 Leopard Lily, 1966, o/c GCoW
 Hunter, pl.650 (b/w)
 New York City IV, 1964, o/c,
 UDCHi
 Hh, pl.976 (col)
 No!, 1966, o/c SoJH
 Compton 2, fig.187 (b/w)
 119th Division, 1965, o/c UMnMW
 Arnason, fig.1032 (b/w)
 One Way, 1964, o/c UNNCor
 New Art, pl.20 (b/w)
 The Street, 1963, o/c UNNP
 Hunter, pl.651 (b/w)
 Target No.1, 1962, o/c GCoL
 Kahmen, pl.14 (b/w)

Green by Gold, 1958, a/c,
 UNNSchwar
 Hunter, pl.724 (col)
Hot Half, 1962, acrylic resin on
 canvas UDCB
 Geldzahler, p.227 (b/w)
I-99, 1962, a/c UNNEm
 Carmean, p.24 (col)
Iris, 1954, a/c UNNSchwar
 Geldzahler, p.90 (col)
Kaf, 1959-60, a/c UNNPow
 Arnason, col.pl.252
Moving In, 1961, magna acrylic
 on canvas
 Arnason, col.pl.253 UNNEm
 Calas, p.186 (b/w)
 Geldzahler, p.226 (b/w), Priv.
 Coll., New York
Omicron, 1961, synthetic polymer
 paint on canvas ELW
 L-S, pl.80 (col)
Pillar of Fire, 1961, plastic
 and paint on canvas UNNAb
 Hunter, pl.718 (b/w)
Point of Tranquility, 1958, a/c,
 UDCHi
 Hh, pl.765 (col)
Saraband, 1959, a/c UNNG
 Geldzahler, p.222 (b/w)
 Rose, p.197 (col)
Sigma, 1961, acrylic resin on
 canvas UNNSchwar
 Hunter, pl.717 (b/w)
Sky Gamut, 1961, a/c, Priv.Coll.
 Abstract, pl.254 (col)
Tau, 1960-61 UNNEm
 Pellegrini, p.231 (col)
Terranean, 1959, acrylic resin
 paint on canvas UNNNol
 Geldzahler, p.223 (b/w)
Tet, 1958, acrylic resin on
 canvas UNNW
 Hunter, pl.716 (b/w)
Untitled, 1959, magna acrylic
 on canvas
 L-S, pl.78 (col)
Where, 1960, o/c UDCHi
 Hh, pl.695 (b/w)
While, 1959-60, acrylic resin on
 canvas UNNAb
 New Art, col.pl.9
 Geldzahler, p.224 (b/w)

LOUW, Roelof (British, 1935-)
 300 Wooden Slats Scattered in
 Holland Park at Irregular In-

tervals, London, Oct.1967
 6 Yrs, p.34 (b/w)

LOVING, Alvin (American, 1935-)
 Wyn, Time Trip, 1971, a/c UNNZi
 Hunter, pl.740 (col)

LOWE, Peter (British, 1938-)
 Construction No.1, 1974, painted
 wood, Coll.Artist
 Eng.Art, p.149 (b/w)
 Construction No.2, 1974, painted
 wood, Coll.Artist
 Eng.Art, p.149 (b/w)
 Construction No.3, 1974, painted
 wood, Coll.Artist
 Eng.Art, p.150 (b/w)
 Reliefs a,b,c,d,e,f, 1975,
 painted wood, Coll.Artist
 Eng.Art, p.151 (b/w)
 Suspended Squares, 1964-75, wood,
 paint and resin, Coll.Artist
 Eng.Art, p.150 (b/w)

LOZANO, Lee
 I Ching Charts, 1969
 6 Yrs, p.97 (b/w)

LUBARDA, Petar (Yugoslavian,
 1907-)
 Motif from Brazil, 1955, o/c,
 Coll.Artist
 New Art, pl.256 (b/w)

LUCEBERT (Dutch, 1924-)
 Child, Mother, Father, 1962,
 o/c, Priv.Coll., New York City
 Arnason, col.pl.225
 Queen of the Gypsies, 1965,
 gouache on paper BOsF
 Fig.Art, pl.79 (b/w)
 Suzanne, 1965, o/c, Coll.Artist
 New Art, col.pl.74

LUCENA, Victor
 Unexpected Weights
 Popper, p.186 (b/w)

LUDWIG, Wolfgang
 Cinematic Painting, 1964, Coll.
 Artist
 Barrett, p.13 (b/w)
 Kinematische Scheibe IX, 1965,
 UK2, pl.294 (b/w)
 Kinematische Scheibe X, 1965
 UK2, pl.296 (b/w)

Kinematische Scheibe XI, 1965
 UK2, pl.295 (b/w)

LUEG, Konrad
 Triptychon BDR63, 1963, Coll.
 Artist
 Lippard, pl.181 (b/w)

LUGAN (Luis Garcia Nunez) (Span-
 ish)
 Movement-Light-Sound Controlled
 by High Frequency, 1970,
 plexiglass, wood and electron-
 ic elements, Coll.Artist
 Dyckes, p.107 (col)
 Polysensorial Works, Biennale
 of Sao Paolo, 1973
 Popper, pp.172-73 (b/w)
 Tactile-Sonoric Cups, 1968,
 mixed media
 Dyckes, p.84 (b/w)
 Tactile-Sonoric Sphere, 1967,
 plastic, iron, bolts SpBilB
 Dyckes, p.84 (b/w)

LUGINBUHL, Bernhard (Swiss,
 1929-)
 Composition, 1959, iron SwBeKM
 Trier, fig.158 (b/w)
 Grosser Bulldog, 1964, iron,
 Coll.Artist
 New Art, pl.213 (b/w)

LUKIN, Sven (Latvian-American,
 1934-)
 Bride, 1964, liquitex on canvas
 construction
 Rose, p.214 (b/w)
 Carolina Pine, 1963
 UK2, pl.343 (b/w)
 Gypsy Cross, 1968, enamel and
 synthetic polymer on wood,
 UNNW
 Hunter, pl.712 (b/w)

LUORATELL
 Tenia Soliens Spaziale, Riete,
 Italy, 1969
 Popper, p.191 (b/w)

LUPAS, Ana (Rumanian, 1940-)
 Flying Carpet, a Peace Symbol,
 1972
 Popper, p.114 (b/w)

LURIE, Boris
 Les lions, 1960, pasted paper
 Janis, p.169 (b/w)

LUTHER, Adolf (1912-)
 Optogon, 1966
 Popper 2, p.194 (b/w)
 Ostracism, Utrecht, 1968, en-
 vironment
 Popper, p.97 (b/w)
 Smoke and Light Sculpture (from
 "Strategy: Get Arts", Edin-
 burgh, 1970), mixed media
 Henri, fig.126 (b/w)

LYE, Len (New Zealandic-American,
 1901-)
 Colour Box, 1935, film
 Eng.Art, p.439 (b/w)
 Flip and Two Twisters, 1965,
 stainless steel UNNWise
 New Art, pl.28 (b/w)
 Ashton, pl.LXXX (col)
 Hunter, pl.926 (b/w)
 Fountain, 1963, steel, motorized
 Janis, p.291 (b/w)
 Fountain II, 1959, steel, motor-
 ized UNNWise
 Hunter, pl.925 (b/w)
 Arnason, fig.1086 (b/w)
 Loop, 1965, polished steel
 Calas, p.285 (b/w)
 Roundhead, 1963, Priv.Coll.
 Barrett, p.145 (b/w)
 Steel Fountein, 1959
 Popper 2, p.142 (b/w)
 Storm (comprising Storm King and
 Thundersheet), 1969
 Calas, p.287 (b/w)

MABE, Manabu (Japanese, 1924-)
 Composition 50, 1959
 Metro, p.213 (b/w)
 Composition 270, 1961
 Metro, p.212 (b/w)

McCALL, Anthony (British, 1946-)
 Line Describing a Cone, 1973,
 film
 Eng.Art, p.457 (b/w)

MACCIO, Romulo (Argentinian,
 1931-)
 Emplacement, 1965 UNNBoni
 Pellegrini, p.224 (b/w)
 La Momia, 1963, o/c ArBT

New Art, col.pl.92

McCLANAHAN, Preston (American, 1933-)
Mirage, 1967, plexiglass and fluorescent tube
 Popper, p.49 (b/w)
Star Tree, 1966-67, plexi rods and fluorescent light UNNWise
 Arnason, fig.1095 (b/w)

McCRACKEN, John (American, 1934-)
Blue Board, 1966, plywood, fiberglass, lacquer UICMay
 Abstract, pl.257 (b/w)
There's No Reason Not To, 1967, wood and fiberglass UCLWi
 L-S, pl.214 (col)
 Goossen, p.50 (col)
 Walker, pl.23 (col)
Untitled, 1966, lacquer, fiberglass, plywood -Row
 Andersen, p.235 (b/w)
Untitled, 1970, wood, fiberglass and polyester resin UNNSo
 Busch, fig.33 (b/w)
 Hunter, pl.792 (col)
Violet Block in Two Parts, 1966 UK1, pl.224 (b/w)

McCRACKEN, Philip (American, 1928-)
Winter Bird, 1960, cedar UNNWi
 Ashton, fig.18 (b/w)

MACDONALD-WRIGHT, Stanton (American, 1890-1973)
Flight of the Butterfly, 1955, o/c, Coll.Artist
 Seuphor, no.327 (col)

MAC ENTYRE, Eduardo (Argentinian, 1929-)
Painting, 1964
 Pellegrini, p.190 (b/w)

McGARRELL, James (American, 1930-)
Bathers, 1956, o/c UCEnH
 Selz, p.104 (col)
Equinox, 1956, o/c UCSBL
 Selz, p.103 (b/w)
Rest in Air, 1958, oil on masonite UCBeP
 Selz, p.105 (b/w)
Veracity, 1969, o/c

Fig.Art, pl.89 (b/w) FPB
Hh, pl.874 (b/w) UDCHi

MACIVER, Loren (American, 1909-)
Hopscotch, 1940, o/c UNNMMA
 Arnason, fig.692 (b/w)
Skylight Moon, 1958, o/c UDCHi
 Hh, pl.745 (col)

MACK, Heinz (German, 1931-)
Door of Paradise, 1964, aluminum on wood UNNWise
 Arnason, fig.1104 (b/w)
Dynamic Structure in Black and White, 1962, painting BBDo
 Metro, p.215 (b/w)
Fata morgana, 1968, metal relief GDusSc
 Kahmen, pl.263 (b/w)
Five Angel's Wings, 1965, aluminum on wood under plexiglass, GCoW
 Abstract, pl.289 (b/w)
Light Dynamo, 1963, kinetic sculpture ELT
 L-S, pl.156 (b/w)
 Barrett, p.84 (b/w)
 Compton, pl.22 (b/w)
Light in Movement and Movement in Light, 1960-61
 Metro, p.214 (b/w)
Light Object (using Fresnel's lens), 1966
 Popper 2, p.184 (b/w)
Light Relief, 1964 GDusSc
 Pellegrini, p.264 (b/w)
Light, Wind, Water, 1959, polished aluminum
 Janis, p.288 (b/w)
Lumen et Luxuria, 1967, aluminum on wood UDCHi
 Hh, pl.919 (b/w)
Rotor IV: "Silbersonne", 1965, glass, aluminum, wood, motorized GDusSc
 New Art, pl.288 (b/w)
Structures in Black and White, 1961 GDusSc
 Pellegrini, p.265 (b/w)
The Three Graces, 1966, stainless steel
 Janis, p.289 (b/w)

McLAUGHLIN, John (American, 1898-)
Painting No.6, 1959 UCLR

Seuphor, no.417 (col)

McLEAN, Bruce (British, 1944-)
People Who Make Art in Glass
 Houses, 1970
 6 Yrs, p.194 (b/w)

McLEAN, Richard (American, 1934-)
Albuquerque, 1972, o/c -Krau
 Battcock, p.290 (b/w)
All American Standard Miss,
 1968, o/c
 UK3, pl.68 (b/w)
Blue and White Start, 1968, o/c
 UK3, pl.69 (b/w)
Installation Shot, 1971, o/c
 Battcock, p.288 (b/w)
Miss Paulo's 45, 1972, o/c -Lew
 Battcock, p.42 (b/w)
Mr. Fairsocks, 1973, o/c -Hof
 Battcock, p.31 (b/w)
Rustler Charger, 1971, o/c GAaL
 Battcock, p.289 (b/w)
Still Life with Black Jockey,
 1969, o/c UNNW
 UK3, pl.67 (b/w)
Synbad's Mt. Rainer, 1968, o/c,
 UICS1
 UK3, pl.70 (b/w)
Untitled, 1969, a/c -UM
 UK3, pl.66 (b/w)

MAD MINAS (Dollie Minas)
Demonstration, Amsterdam, 1970
 Henri, fig.147 (b/w)

MADDOX, Conroy
Uncertainty of the Day, 1940,
 collage, Coll.Artist
 Wolfram, pl.69 (b/w)

MAEDA, Josaku (Japanese)
Birth, 1963, o/c JTId
 New Art, pl.199 (b/w)

MAFAI, Mario (Italian, 1902-)
Circus Caravan, 1931, oil IGenR
 Haftmann, pl.632 (b/w)
Fantasy, 1942, oil IGenR
 Haftmann, pl.648 (b/w)
Flowers, 1932, oil IRB
 Haftmann, pl.645 (b/w)

MAGLIONE, Milvia (Italian, 1934-)
Nuages sur le champ, 1968
 UK2, pl.222 (b/w)

MAGNELLI, Alberto (Italian, 1888-
1971)
Almost Serious, 1947, o/c BLG
 Abstract, pl.205 (b/w)
Collage, 1949, cut paper and
 cloth
 Janis, p.198 (b/w)
Composition
 Pellegrini, p.34 (col)
Composition, 1940
 Pellegrini, p.22 (b/w)
Conception Claire N.2, 1958
 Metro, p.216 (b/w)
Confrontation, 1952, oil BLG
 Haftmann, pl.975 (b/w)
Contrasted Aspects, 1941
 Pellegrini, p.23 (b/w)
Conversation, 1956 IRN
 Ponente, p.16 (col)
Miscellaneous Forms, 1958, Coll.
 Artist
 Ponente, p.17 (col)
Tranquillite siderale, 1950,
 o/c FPFr
 1945, pl.23 (b/w)
Variations No.4, 1959
 Metro, p.217 (b/w)
Without Fear (Sans crainte),
 1945, oil BLG
 Haftmann, pl.665 (b/w)

MAGRITTE, Rene (Belgian, 1898-
1967)
L'aimable verite, 1966
 UK2, pl.185 (b/w)
The Castle of the Pyranees,
 1959, o/c UNNTo
 Arnason, fig.582 (b/w)
La Corde sensible, 1955, o/c,
 BBLac
 New Art, col.pl.82
Delusions of Grandeur, 1948,
 o/c UDCHi
 Hh, pl.857 (b/w)
Delusions of Grandeur, 1961,
 o/c FPIo
 Arnason, fig.584 (b/w)
Delusions of Grandeur, 1967,
 bronze UDCHi
 Hh, pl.858 (b/w)
L'empire des lumieres, 1955, o/c
 1945, pl.35 (b/w)
Exhibition of Painting, 1965,
 o/c -Io
 L-S, pl.13 (b/w)
La folle du logis, 1948, gou-

ache, Priv.Coll., Brussels
Kahmen, pl.I (col)
Girl's Head (Madchenkopf), 1948,
pencil on paper, Priv.Coll.
Kahmen, pl.96 (b/w)
Le jeu de mourre, 1966
UK2, pl.183 (b/w)
The Lady (La dame), 1943,
painted bottle BBMag
Kahmen, pl.36 (b/w)
The Listening Chamber, 1953,
o/c, Priv.Coll., New York City
Arnason, fig.583 (b/w)
Memory, 1948, o/c BBC
Fig.Art, pl.122 (b/w)
L'Ovation, 1962, oil UNNI
Metro, p.218 (b/w)
Perspective, David's Madame Re-
camier, 1950 or 1951, o/c,
BBV
Fig.Art, pl.121 (b/w)
Arnason, fig.585 (b/w)
Philosophy in the Boudoir, 1948,
o/c, Priv.Coll., New York City
Fig.Art, pl.120 (col)
Les promenades d'Euclyde (The
Promenades of Euclid), 1955,
oil UMnMI
Metro, p.219 (col)
Arnason, fig.580 (b/w)
Red Model (Le modele rouge I),
1947, gouache UNNI
Haftmann, pl.804 (b/w)
Sketch for La contenue pictor-
ale, 1947, colored pencil on
paper, Priv.Coll.
Kahmen, pl.44 (b/w)
The Therapeutist, 1967, bronze,
UDCHi
Hh, pl.856 (b/w)
Untitled, c.1940, pencil on pa-
per drawings, Priv.Coll.
Kahmen, pls.2-5 (b/w)
Untitled, c.1940, pencil, Priv.
Coll.
Kahmen, pl.49 (b/w)
Untitled, c.1945, pencil, Priv.
Coll.
Kahmen, pl.57 (b/w)
The Works of Alexander, 1950,
o/c UNNJac
Fig.Art, pl.123 (b/w)

MAHAFFEY, Noel (American, 1944-)
Minneapolis, Minnesota, 1970,
a/c
UK3, pl.148 (b/w)

Portland, Oregon, 1970, o/c
UK3, pl.146 (b/w)
St. Louis, Missouri, 1971, o/c
UK3, pl.145 (b/w)
St. Paul, Minnesota, 1970, o/c
UK3, pl.147 (b/w)
Tools-Hardware, 1973, a/c -Gu
Battcock, p.15 (b/w)
Untitled, 1969, o/c
UK3, pl.71 (b/w)
Untitled, 1969, a/c UPPPM
UK3, pl.72 (b/w)
Waco, Texas, 1970, o/c
UK3, pl.149 (b/w)

MAHLMANN, Max (German, 1912-)
Red Accent, 1959-60, o/c, Coll.
Artist
Seuphor, no.376 (col)

MAIER, Ulf (German, 1940-)
Untitled, 1963, reed pen, Priv.
Coll.
Kahmen, pl.56 (b/w)

MAIER-BUSS, Ingeborg (German,
1950-)
Black Venus (Schwarze Venus),
1963, colored polyester, Priv.
Coll.
Kahmen, pl.175 (b/w)
Landscape, 1969, charcoal draw-
ing, Priv.Coll.
Kahmen, pl.178 (b/w)
Untitled, 1966, oil-based
chalks, Priv.Coll.
Kahmen, pl.180 (b/w)
Xylei, 1969-70, colored poly-
ester, Priv.Coll.
Kahmen, pl.176 (b/w)

MAKOWSKI, Zbigniew (Polish,
1930-)
Separated Objects, 1963, o/c,
UNNMMA
New Art, pl.237 (b/w)

MALAVAL, Robert (French, 1937-)
Anne. Left Knee (25 times), 1966
Fig.Art, pl.272 (b/w)

MALDONADO, Tomas (Argentinian,
1922-)
U-T-54, 1954, o/c, Coll.Artist
Abstract, pl.187 (b/w)

The Execution, 1956, bronze re-
 lief UDCHi
 Hh, pl.641 (b/w)
Fruit and Vegetables on a Chair,
 1960, gilded bronze
 L-S, pl.175 (b/w)
Large Standing Cardinal, 1954
 bronze UDCHi
 Hh, pl.645 (b/w)
 Arnason, fig.931 (b/w)
Monumental Standing Cardinal,
 1958, bronze UDCHi
 Hh, pl.757 (col)
Praying Cardinal, 1955, gouache
 on paper mounted on masonite,
 UDCHI
 Hh, pl.646 (b/w)
Self-Portrait with Model, 1942,
 bronze relief UDCHi
 Hh, pl.455 (b/w)
Standing Cardinal, 1952, bronze,
 BAKO
 Fig.Art, pl.53 (b/w)
Standing Cardinal, 1957, bronze,
 UNBuA
 A-K, p.187 (b/w)
Study for the Opening of the
 Ecumenical Council (Pope John
 XXIII and Cardinal Rugambwa),
 1962, bronze relief UDCHi
 Hh, pl.790 (b/w)
Three Studies of St. Severin,
 1958, bronze relief UDCHi
 Hh, pl.643 (b/w)
Young Girl on a Chair, 1955,
 bronze UDCHi
 Hh, pls.649-50 (b/w)
 Arnason, fig.930 (b/w)

MAPSTON, Tim (British, 1954-)
 Sculpture I, 1974, wood, Coll.
 Artist
 Eng.Art, pp.265-67 (b/w)
 Sculpture II, 1974, wood, Coll.
 Artist
 Eng.Art, p.268 (b/w)
 Sculpture III, 1974, wood, Coll.
 Artist
 Eng.Art, p.269 (b/w)
 Untitled Sculpture IV, 1974
 Eng.Art, p.231 (b/w)
 Untitled Sculpture V, 1974
 Eng.Art, p.231 (b/w)

MARA, Pol (Belgian, 1920-)
 Le Cycliste, 1965, o/c, Priv.

Coll.
 New Art, col.pl.85
La fille en oeuf, 1967
 UK2, col.pl.II
Out of the Corner of One's Eye,
 1968, o/c and aluminum mon-
 tage, Priv.Coll., Los Angeles
 Fig.Art, pl.170 (b/w)

MARCA-RELLI, Conrad (American,
 1913-)
 Bar-T Corral, 1958, oil and
 canvas collage, Coll.Artist
 Hunter, pl.440 (b/w)
 The Battle, 1956, oilcloth, can-
 vas, enamel and oil on canvas,
 UNNMM
 Rose, p.158 (b/w)
 Battle Theme, 1957, oil and col-
 lage UNNKo
 Geldzahler, p.401 (b/w)
 The Blackboard, 1961, oil and
 canvas UWaSA
 Arnason, col.pl.210
 Cristobal, 1962
 Metro, p.220 (b/w)
 The Inhabitant, 1955, canvas
 collage on canvas UNNKo
 Janis, p.203 (b/w)
 Junction, 1958, collage of
 painted canvas UNNW
 Whitney, p.70 (b/w)
 L-6-74, 1974, oil and collage on
 canvas UNNMa
 Arnason 2, fig.914 (b/w)
 L-9-74, 1974, oil and collage on
 canvas UNNMa
 Arnason 2, fig.913 (b/w)
 L-2-66, 1966, oil and canvas,
 UNNMa
 Arnason, fig.869 (b/w)
 Odalisque, 1957, oil and collage,
 UNBuA
 A-K, p.58 (col)
 El Passo, 1959, canvas and paint
 on canvas UNNKo
 Janis, p.204 (b/w)
 The Picador, 1965, oil and can-
 vas collage UDCHi
 Hh, pl.782 (b/w)
 RXL-4, 1966, aluminum UNNMa
 Arnason, fig.868 (b/w)
 Seated Figure, Outdoors, 1953 or
 1954, paint and canvas collage,
 UCtGBa
 Hunter, pl.406 (b/w)

Arnason, fig.867 (b/w)
Site D, 1962, plastic on board
 Metro, p.221 (b/w)
The Snare, 1956, oil on cut-up
 canvas and cloth UICM
 Seitz, p.100 (b/w)
3 December, 1959, canvas and
 paint on canvas UNNKo
 Janis, p.205 (b/w)
The Trial, 1956, canvas and
 paint on canvas UMnMI
 Janis, p.205 (b/w)
U-4 (SCP-5-66), 1966, aluminum,
 UNNMa
 Hunter, pl.441 (b/w)
Untitled, 1964, aluminum UNNKo
 New Art, pl.4 (b/w)

MARCHEGIANI, Elio (Italian, 1929-
)
Progetto per una lapide luminosa
 a James Bond, 1965
 UK1, pl.157 (b/w)
Venus, 1965
 UK1, pl.36 (b/w)
Venus, 1965
 UK1, pl.37 (b/w)

MARCKS, Gerhard (German, 1889-)
Girl with Braids, 1950, bronze,
 UDCHi
 Hh, pl.624 (b/w)

MARDEN, Brice (American, 1938-)
For Pearl, 1970, oil and wax on
 canvas UFPL
 Hunter, pl.706 (b/w)
From Bob's House, no.1, 1970,
 oil and wax on canvas UMnMW
 Rose, p.234 (b/w)
Untitled, 1971-72, oil and bees-
 wax on canvas UMnMW
 Arnason 2, fig.1258 (b/w)

MARFAING, Andre (French, 1925-)
Painting, 1960 FPB
 Seuphor, no.480 (col)

MARI, Enzo (Italian, 1932-)
Structure No.862, 1968, anodized,
 natural and black aluminum,
 Coll.Artist
Struttura d.724, 1963, aluminum
 and plastic, Coll.Artist
 New Art, pl.122 (b/w)

MARIANI, Umberto (Italian, 1936-)
Quite in the Fashion, 1967-68,
 mixed media on canvas
 Fig.Art, pl.294 (b/w)

MARIN, John (American, 1870-1953)
Beach, Flint Island, Maine,
 1952, o/c UNNMa
 Hunter, pl.226 (b/w)
Movement: Boat and Sea in Greys,
 1952, o/c UDCHi
 Hh, pl.714 (col)

MARINI, Marino (Italian, 1901-)
Bull, 1953, bronze UDCHi
 Hh, pl.562 (b/w)
Cavallo con giocolieri, 1956,
 oil GER
 Haftmann, pl.985 (b/w)
Composition of Elements, 1964-
 65, bronze UNKinS
 Arnason 2, fig.970 (b/w)
Dancer, 1949-58, polychromed
 bronze GDuK
 Trier, fig.59 (col)
Dancer, 1954, bronze UNNHi
 Arnason, fig.925 (b/w)
Equestrian Monument, 1958-59,
 bronze NHB
 Trier, fig.181 (b/w)
Horse, 1957, bronze UNNWo
 G-W, p.286 (b/w)
Horse and Rider, 1947, bronze,
 ELT
 L-S, pl.172 (b/w)
Horse and Rider, 1949, bronze,
 UMnMW
 Arnason, fig.927 (b/w)
Horse and Rider, 1952-53,
 bronze UDCHi
 Hh, pl.558 (b/w)
 Arnason, fig.928 (b/w)
Horseman, 1947, bronze UNNRock
 Fig.Art, pl.51 (b/w)
Ideal Stone Composition, 1971,
 stone, Coll.Artist
 Arnason 2, fig.972 (b/w)
Juggler (Dancer, Acrobat), 1954,
 bronze UDCHi
 Hh, pls.559-60 (b/w)
Little Horse and Rider, 1949,
 polychromed bronze UDCHi
 Hh, pl.561 (b/w)
Miracolo, 1953-61, bronze
 Metro, p.223 (b/w)
Miracolo, 1954, bronze

Trier, fig.60 (b/w)
Pomona, 1941, bronze BBR
Fig.Art, pl.50 (b/w)
Portrait of Curt Valentin, 1953,
bronze UNNHi
Arnason, fig.926 (b/w)
Portrait of Henry Miller, 1961,
bronze UDCHi
Metro, p.222 (b/w)
Hh, pl.802 (b/w)
Portrait of Igor Stravinsky,
1951, bronze UMnMI
Fig.Art, pl.52 (b/w)
Red Horse, 1952, oil NVM
Haftmann, pl.984 (b/w)
Susanna, 1943, bronze UDCHi
Hh, pl.457 (b/w)

MARISOL (Marisol Escobar) (French-
American, 1930-)
Baby Boy, 1962-63, mixed media
and wood UNNL
Hunter, pl.617 (b/w)
Couple I, 1965-66, mixed media
Busch, pl.I (col)
The Dealers (11 Figures), 1965-
66, mixed media
Trier, fig.218 (b/w)
Calas, p.100 (b/w)
Dinner Date, 1962-63, wood,
Priv.Coll.
Fig.Art, pl.168 (b/w)
Double Date, 1963, painted wood,
GDusSc
Kahmen, pl.124 (b/w)
The Family, 1962, painted wood,
etc. UNNMMA
Andersen, p.189 (b/w)
Arnason, col.pl.240
Ford, 1964, collage on construc-
tion with automobile parts
Janis, p.302 (b/w)
From France, 1960, wood con-
struction with objects, Coll.
Artist
Seitz, p.135 (b/w)
The Generals, 1961-62, wood and
mixed media UNBuA
A-K, p.292 (col)
Henry, 1965, construction UMiDB
Russell, pl.74 (b/w)
Compton 2, fig.149 (b/w)
John Wayne, 1963, wood and
mixed media UIWMa
Lippard, pl.79 (b/w)
Kennedy Family, 1960, wood and

various materials UNNJa
New Art, pl.16 (b/w)
UK1, pl.12 (b/w)
Kiss, 1966
UK1, pl.45 (b/w)
Love, 1962, stucco and Coca Cola
bottle -Wes
Kahmen, pl.35 (b/w)
Russell, pl.100 (b/w)
Mi Mama y yo, 1968, painted
steel and bronze
Calas, p.101 (b/w)
The Party, 1965-66, mixed media,
UIWMa
UK1, pl.13 (b/w)
Calas, p.99 (b/w)
Hunter, pl.618 (b/w)
Janis, p.297 (b/w)
Compton 2, fig.155 (b/w)
Veil, 1975, plaster, rope, hair,
UNNJa
Arnason 2, fig.1145 (b/w)
The Visit, 1964, painted wood,
UNNJa
Ashton, fig.25 (b/w)
Women and Dog, 1964, mixed
media UNNW
Hunter, pl.680 (col)

MAROTTA, Gino (Italian, 1935-)
Albero, 1967
UK1, pl.135 (b/w)
Aleph, 1964
UK1, pl.V (col)
Fiore, 1967
UK1, pl.111 (b/w)
Naturale-artificiale, 1967
UK1, pl.339 (b/w)

MARSH, Reginald (American, 1898-
1954)
Bowery and Pell Street-Looking
North, 1944, Chinese ink on
paper
Rose, p.95 (b/w)
Hudson Burlesk Chorus, 1948, egg
tempera on masonite UDCHi
Hh, pls.719-20 (col)

MARTHAS, Takis (Greek, 1905-)
Harbor, 1960, o/c FPCre
Seuphor, no.311 (col)

MARTIN, Agnes (Canadian-American,
1912-)
Bones Number 2, 1961, o/c UNNPa

Goossen, p.40 (b/w)
Hunter, pl.774 (b/w)
Play, 1966, a/c
 Abstract, pl.238 (b/w) UMiDH
 Hh, pl.831 (b/w) UDCHi
Trumpet, 1967, a/c
 Calas, p.216 (b/w)
Untitled, 1963, ink
 Rose, p.232 (b/w)
Untitled #44, 1974, acrylic,
 pencil, gesso UNNMack
 Arnason 2, fig.1257 (b/w)

MARTIN, Kenneth (British, 1905-)
Blue Tangle, 1964, oil on board,
 ELStu
 Stuyvesant, p.37 (b/w)
Chance and Order (5) red, 1970,
 o/c ELAr
 Eng.Art, p.156 (b/w)
Chance and Order (10) monastral
 blue, 1972, o/c ELT
 Eng.Art, p.156 (b/w)
Chance and Order (16) black,
 1973, o/c ELW
 Eng.Art, p.157 (b/w)
Collage in Red and Grey, 1950,
 pasted paper
 Janis, p.238 (b/w)
Construction in Aluminum, 1967,
 ECamE
 Popper 2, p.192 (b/w)
Drawing for Screw Mobile, 1967,
 pencil on paper, Coll.Artist
 Eng.Art, p.155 (b/w)
Drawing for Screw Mobile, 1968,
 pencil on paper, Coll.Artist
 Eng.Art, p.155 (b/w)
Oscillation, 1962, phosphor
 bronze and brass ELT
 Compton, pl.17 (b/w)
Rotary Rings, 1967, brass ELAx
 L-S, pl.202 (b/w)
Rotary Rings (4th version),
 1968, brass ELT
 Eng.Art, p.154 (b/w)
Rotation, 1966, oil on board,
 ELStu
 Stuyvesant, p.38 (b/w)
Screw Mobile, 1953-73, nickel-
 plated brass, Coll.Artist
 Eng.Art, p.154 (b/w)
Screw Mobile, 1956
 Popper 2, p.148 (b/w)
Screw Mobile, 1959, phosphor-
 bronze

Trier, fig.167 (b/w)
 Janis, p.136 (b/w)
Screw Mobile, 1968, brass ELMar
 Eng.Art, p.154 (b/w)
Screw Mobile with Black Centre,
 c.1958-65, phosphor-bronze and
 wood ELT
 Compton, pl.16 (b/w)
Small Screw Mobile, 1953, brass
 and steel ELT
 Compton, pl.14 (b/w)
Three Oscillations, 1963-64,
 brass, Coll.Artist
 Arnason, fig.1001 (b/w)

MARTIN, Mary (British, 1907-1969)
Black Relief, 1957, painted
 hardwood
 Janis, p.239 (b/w)
Compound Rhythms, 1966, painted
 wood and stainless steel on
 wood and formica support,
 ELStu
 Stuyvesant, p.41 (b/w)
Diagonal Permutation, 1964,
 painted wood and stainless
 steel on wood and formica sup-
 port ELStu
 Stuyvesant, p.40 (b/w)
Spiral, 1963, formica, stainless
 steel, wood ELT
 Compton, pl.18 (col)

MARTIN, Philip (British, 1927-)
Affiche N.135, 1959
 Metro, p.224 (b/w)
Esprits d'un affichage, 1959
 Metro, p.225 (col)
Relief No.3, 1964, wood, metal
 and assorted materials
 New Art, pl.61 (b/w)

MARTINELLI, Ezio (American,
 1913-)
Harp, 1963, steel UNNWi
 Ashton, pl.XLIII (b/w)

MARTINS, Mary (Brazilian, 1910-)
Ritual of Rhythm, 1958, bronze,
 BrBP
 G-W, p.258 (b/w)

MARYAN (Pinchas Burstein) (Polish,
 1927-1977)
Figure, 1959 FPChar
 Fig.Art, pl.95 (b/w)

Personage, 1962 FPFr
 Pellegrini, p.199 (b/w)

MASON, John (American, 1927-)
 Gray Wall, 1960, clay
 Andersen, p.166 (b/w)
 Untitled Green Spear, 1961,
 fired clay UCBeW
 Ashton, pl.XLVᴵ (col)

MASON, Raymond (British, 1922-)
 Big Midi Landscape, 1961, bronze
 relief UDCHi
 Hh, pl.796 (b/w)

MASS MOVING GROUP
 Butterfly Incubator, St. Mark's
 Square, Venice, 1972
 Popper, p.196 (b/w)
 Metamorphosis, Graz, 1972
 Popper, p.195 (b/w)

MASSIN, Eugene (American, 1920-)
 Black and White, 1969, carved
 and laminated acrylic sheet
 Busch, fig.91 (b/w)
 Chinese Puzzle, 1969, cast poly-
 ester resin with acrylic in-
 clusions
 Busch, pls.XV-XX (col)
 Everybody's Different, acrylic,
 UFMiA
 Busch, fig.49 (b/w)
 Mural for City National Bank of
 Miami Beach, Florida, acrylic
 sheet and electric light UFMC
 Busch, pl.XXXIII (col)
 Mural for City National Bank of
 Miami Beach, Florida (study),
 1969-72, acrylic sheet and
 electric light
 Busch, pl.XXI (col)
 Mural for Cafritz Building,
 Washington, D.C., 1965, acry-
 lic painted on acrylic sheet
 Busch, pl.XXII (col)
 Reclining Woman, 1970, acrylic
 cut-out mounted on acrylic
 sheet
 Busch, fig.47 (b/w)
 Reclining Woman II, 1970, acry-
 lic line drawing mounted on
 acrylic sheet
 Busch, fig.48 (b/w)

MASSON, Andre (French, 1896-)
 Blossoming III, 1956, o/c FPLei
 Seuphor, no.341 (col)
 Combat and Migration, 1956,
 UNNSai
 Ponente, p.100 (col)
 Elk Attacked by Dogs, 1945, o/c,
 UDCHi
 Hh, pl.483 (b/w)
 Entre la plante et l'oiseau,
 1961, oil
 Metro, p.226 (b/w)
 La Fin de l'ete, 1955, oil and
 paper on canvas FPLei
 New Art, col.pl.20
 Les goules, 1961, oil
 Metro, p.227 (b/w)
 Landscape with Precipices, 1948,
 o/c FPLei
 L-S, pl.9 (b/w)
 Legende, 1945, tempera on can-
 vas UDCHi
 Hh, pl.525 (col)
 Malevolent Thaumaturges Threat-
 ening the People of the
 Heights, 1964, o/c FPLei
 Fig.Art, pl.102 (b/w)
 Meditation on an Oak Leaf, 1942,
 tempera, pastel and sand on
 canvas UNNMMA
 Sandler, p.36 (b/w)
 Pasiphae, 1943, oil and tempera
 on canvas, Priv.Coll., Glen-
 coe, Ill.
 Arnason, col.pl.158
 Street Singer, 1941, collage of
 paper, leaf, etc. UNNMMA
 Janis, p.96 (b/w)

MASTROIANNI, Umberto (Italian,
 1910-)
 Meteor, 1968, bronze and brass,
 Coll.Artist
 Liverpool, no.54 (b/w)
 Personaggio, 1961 IRPog
 New Art, pl.110 (b/w)
 The Rider, 1953, white marble,
 BAM
 Trier, fig.70 (b/w)

MATANOVIC, Milenko
 String Bending Wheat, 1970
 6 Yrs, p.153 (b/w)

MATARE, Ewald (German, 1887-)
 Cow, 1948, wood, Coll.Artist

G-W, p.287 (b/w)

MATHIEU, Georges (French, 1921-)
 Baroque vert, 1961, o/c
 Metro, p.228 (b/w)
 Battle of Bouvines, 1964, o/c,
 Coll.Artist
 L-S, pl.58 (b/w)
 The Capetians (The Capetians
 Everywhere), 1954, o/c FPAM
 Ponente, p.122 (col)
 Abstract, pl.23 (b/w)
 Composition, 1957
 Pellegrini, p.55 (b/w)
 Composition, c.1958, oil, Priv.
 Coll.
 Haftmann, pl.906 (b/w)
 Gouache, 1958 FPRi
 Seuphor, no.402 (col)
 Hommage a Louis XI, 1950
 UK2, pl.4 (b/w)
 Magnificence de Bon Duc de Bor-
 gogne a son banquet de voeux,
 1957, o/c
 1945, pl.32a (b/w)
 Olivier III Beheaded, 1958, o/c,
 FPRi
 Seuphor, no.401 (col)
 Painting, 1953, o/c UNNG
 Arnason, col.pl.229
 Ravissement, 1961, o/c
 Metro, p.229 (b/w)
 Werther, o/c, Priv.Coll.
 Abstract, pl.106 (b/w)

MATISSE, Henri (French, 1869-1954)
 Blue Nude with Flowing Hair,
 1953, paper cut-out
 Eng.Art, p.222 (b/w)
 The Burial of Pierrot (L'Enter-
 rement de Pierrot) (Plate VIII
 from Jazz), 1947, pochoir,
 UCLUG
 Castleman, p.19 (col)
 Chapel of the Rosary, Vence
 (interior view showing "Sta-
 tions of the Cross"), 1947-51
 Hamilton, pl.345 (b/w)
 Design for Red and Yellow Chau-
 sible, c.1950, gouache on cut
 and pasted paper UNNMMA
 Janis, p.218 (b/w)
 Head (Tete de Face), 1948, aqua-
 tint UNNMMA
 Castleman, p.21 (col)
 Maquette for Nuit de Noel, 1952,

 gouache on cut and pasted
 paper UNNMMA
 Janis, p.219 (b/w)
 The Snail (L'Escargot), 1953,
 gouache cut-out ELT
 L-S, pl.31 (col)
 Wolfram, pl.87 (b/w)
 Still Life with Black Fern
 (L'interior a la fougere
 noire), 1948, oil ELSo
 Haftmann, pl.489 (col)
 Still Life with Pineapple and
 Anemones, 1940, oil UNNLas
 Haftmann, pl.483 (b/w)
 Swimming Pool, 1952, gouache on
 cut and pasted paper, Priv.
 Coll.
 Brett, p.14 (b/w)
 Zulma, 1950, gouache cut-out,
 DCSt
 L-S, pl.30 (b/w)
 Haftmann, pl.488 (b/w)

MATTA ECHAURREN, Roberto Sebastian
 (Chilean, 1912-)
 The Bachelors 20 Years Later,
 1943, o/c, Priv.Coll., Willi-
 amstown, Mass.
 Hunter, pl.413 (b/w)
 The Basis of Things, 1964, o/c
 New Art, pl.212 (b/w)
 Being With, 1945-46, o/c UNNMat
 L-S, pl.10 (b/w)
 The Cinema (Le Cinema) (from
 Scenes familieres), 1962,
 etching FPVis
 Castleman, p.61 (col)
 The Clan, 1958, bronze and iron,
 UDCHi
 Hh, pl.566 (b/w)
 Disasters of Mysticism, 1942,
 o/c UCtNcS
 Arnason, col.pl.203
 The Djamila Affair (La question
 Djamila), Priv.Coll., Milan
 Haftmann, pl.941 (b/w)
 The Earth is a Man, 1942, o/c,
 UIOS
 Hunter, pl.368 (b/w)
 Elle Hegramme a l'etonnement
 general, 1969, o/c FPIo
 Fig.Art, pl.113 (b/w)
 Give Light Without Pain, 1955,
 BRU
 Ponente, p.101 (col)
 Les grands transparents, 1942,

MECKSEPER, Friedrich (German, 1936-)
Neuen indische Vulkane, 1964, o/c GHBr
New Art, col.pl.130

MEDALLA, David (Philippine-British, 1942-)
Cloud Canyons (Bubble Mobile No. 2), 1964, wood and foam ELKee
Brett, pp.8,40-41 (b/w)
Cloud Canyons No.2, 1964
UK1, pl.299 (b/w)
The First Sound Machine, 1964
UK1, pl.300 (b/w)
Lament, 1964, sand, metal, wire and motor, Coll.Artist
Brett, p.43 (b/w)
Mud Machine, 1967, wood, wire, sponges, mud, glass and electric light, Coll.Artist
Brett, pp.44-45 (b/w)

MEDEK, Mikulas (Czechoslovakian, 1926-)
162 cm^2 of Fragility, 1964, oil with enamel
New Art, pl.246 (b/w)

MEFFERD, Boyd
Photo-Electric Viewer Programmed Coordinate System, 1968 (in collaboration with Hans Haacke)
UK4, pl.99 (b/w)

MEGAN, Terry
Viet-Rock, Buenos Aires, 1969
UK4, pl.49 (b/w)

MEGERT, Christian (Swiss, 1936-)
Fountain, 1965 SwI
UK1, pl.285 (b/w)
Glass Sculptures, 1964 SwLaL
UK1, pl.255 (b/w)
Luminous Box; Play of Mirrors, 1968, mirrors
Abstract, pl.303 (b/w)
Mirror Environment, Documenta 4, Kassel
Popper, p.96 (b/w)
Zoom, 1966
Popper 2, p.197 (b/w)

MEHRING, Howard (American, 1931-)
Cadmium Crystal, 1966-67

UK2, pl.278 (b/w)

MEIER-DENNINGHOFF, Brigette (German, 1923-)
Afrika, 1962, brass and tin, ELMa
Metro, p.233 (b/w)
62/24, 1962, brass and tin ELMa
Metro, p.232 (b/w)
65/1, 1965, brass ELMa
New Art, pl.332 (b/w)
Wings, 1958 GLeM
Trier, fig.151 (b/w)

MEISTERMANN, Georg (German, 1911-)
Glasfenster, 1958, o/c GDaS
1945, pl.83 (col)
The Golden Tree, 1952, oil, Priv. Coll., Cologne
Haftmann, pl.862 (b/w)
Ground Plan, 1955, oil, Coll. Artist
Haftmann, pl.863 (b/w)
With the Black, 1960, o/c, Priv. Coll., Germany
Seuphor, no.296 (col)

MELCHERT, James (American, 1930-)
Still Life with Rapt Heart, 1965, painted clay UCDaH
Andersen, p.167 (b/w)

MELOTTI, Fausto (Italian, 1901-)
Infinity, 1968, stainless steel, IMAr
Liverpool, no.51 (b/w)

MENDELSON, Marc (British, 1915-)
Tellurian Immanence, 1961, o/c, BBJ
Abstract, pl.126 (b/w)

MENDENHALL, Jack (American, 1937-)
2 Figures in a Setting, 1972, a/c UMoKM
Battcock, p.291 (b/w)
Yellow Sofa and Swan Vase, 1972, o/c -Mayer
Battcock, p.292 (b/w)

MENNE, Walter (German, 1908-)
Ink Drawing 12, 1966, ink
New Art, p.308 (b/w)

L-S, pl.55 (b/w)
Painting in India Ink, 1966,
 FPPoi
 Abstract, pl.111 (b/w)
' Watercolour, 1961
 Kahmen, pl.333 (b/w)

MIDDLEDITCH, Edward (British,
 1923-)
 Dead Chicken in a Stream, 1955,
 oil on board ELT
 L-S, pl.43 (b/w)
 Pigeons in Trafalgar Square,
 1953-54, o/c ELBea
 1945, pl.137 (b/w)

MIDGETTE, Willard (American,
 1937-)
 Choreography: The Paul Taylor
 Company (Panel #4), 1972, o/c
 Battcock, p.293 (b/w)

MIKI, Tomio (Japanese, 1937-)
 Ear, 1963, aluminum JTMi
 New Art, pl.201 (b/w)
 Ears, 1968, plated aluminum,
 JTMi
 L-S, pl.108 (b/w)
 Untitled, 1965
 UK1, pl.66 (b/w)
 Untitled (Ear), 1964, cast
 aluminum UNO1P
 Lieberman, pl.109 (b/w)
 Untitled (Ears), 1964, cast
 aluminum UNNMMA
 Lieberman, p.108 (b/w)

MIKL, Josef (Austrian, 1929-)
 Resurrection, 1957, stained
 glass AS
 1945, pl.107a (b/w)

MIKULSKI, Kazimierz (Polish,
 1918-)
 Woman and Window, 1965, tempera,
 Coll.Artist
 New Art, pl.234 (b/w)

MILANI, Umberto (Italian, 1912-)
 Two-Front Sculpture No.2, 1958,
 bronze IMMi
 Trier, fig.143 (b/w)

MILKOWSKI, Antoni (American,
 1935-)
 Diamond-I of III, 1967, Cor-Ten

steel UNBuA
 A-K, p.97 (b/w)

MILLARES, Manolo (Spanish, 1926-
 1972)
 Antropofauna, 1969, etching
 Dyckes, p.145 (b/w)
 Black Gouache, 1960 FPCo
 Seuphor, no.194 (b/w)
 Character, 1966, mixed media
 Dyckes, p.25 (b/w)
 Cuadro, 1962, plastic
 Metro, p.238 (b/w)
 Cuadro, 1962 FPCo
 Metro, p.239 (col)
 Cuadro 120, 1960, torn paper,
 cloth, paint FPCor
 Janis, p.200 (b/w)
 Fallen Figure, 1970, mixed
 media, Coll.Artist
 Dyckes, p.100 (col)
 Homunculus, 1964, plastic paint
 on sackcloth UNNMatC
 New Art, col.pl.70
 No.165, 1961, plastic paint on
 canvas ELMa
 L-S, pl.54 (b/w)
 Nunez de Balboa Entering the
 Pacific, 1970, acrylic on
 burlap, Priv.Coll., Madrid
 Dyckes, p.25 (b/w)
 Painting, 1965, oil and collage
 on canvas UDCHi
 Hh, pl.929 (b/w)
 Painting 27, 1957, acrylic on
 burlap
 Dyckes, p.24 (b/w)
 Triptych, 1964, mixed media
 Dyckes, p.24 (b/w)
 Untitled
 Pellegrini, p.104 (b/w)
 Untitled, 1965, paint on paper
 Dyckes, p.25 (b/w)

MILLER, Mariann (American, 1932-)
 Untitled, 1974, o/c
 Battcock (col)
 Women on Beach, 1973, a/c
 Battcock, p.75 (b/w)

MILLER, Renee
 Bug, Mask, and Stars, 1960,
 extension painting
 Kaprow, no.9 (b/w)

Composition, 1953, oil ELT
 Haftmann, pl.547 (b/w)
Ecriture sur fond rouge, 1960
 Metro, p.242 (b/w)
Equinox, 1968, etching and
 aquatint SwZKo
 Castleman, p.55 (col)
Femme assise, 1960
 Metro, p.243 (b/w)
Figures and Dog Before the Sun,
 1949 SwBKM
 Ponente, p.98 (col)
Lunar Bird, 1966, bronze UDCHi
 Hh, pl.854 (b/w)
Painting, 1953, o/c UNNG
 Arnason, col.pl.155
The Poetess (from Constellation
 series), 1940, gouache on
 paper UNNColi
 Sandler, p.112 (b/w)
 Arnason, fig.562 (b/w)
The Red Disc, 1960, o/c UNNKia
 Fig.Art, pl.104 (b/w)
 Arnason, fig.563 (b/w)
Series I, No.4 (The Family),
 1952, etching, engraving,
 aquatint FPMa
 Castleman, p.53 (col)
Wall of the Sun (Day), 1955-58,
 ceramic mural FPUn
 Arnason, col.pl.156
Woman (Personnage), 1953, black
 marble UDCHi
 Hh, pl.597 (b/w)
Woman and Bird in the Night,
 1945, o/c UNBuA
 A-K, p.207 (b/w)
Woman and Birds in the Night,
 1945, o/c, Priv.Coll.
 Fig.Art, pl.103 (b/w)
Woman and Little Girl in Front
 of the Sun, 1946, o/c UDCHi
 Hh, pl.734 (col)
Women and Bird in Moonlight,
 1949, oil ELT
 Haftmann, pl.546 (b/w)

MITCHELL, Joan (American, 1926-)
 Abstract, 1950, o/c UNPV
 Geldzahler, p.40 (b/w)
 Allo, Amelie, 1973, o/c UNNFou
 Arnason 2, fig.1224 (b/w)
 Auguste Daguerre, 1957, oil,
 UNNMMA
 Haftmann, pl.912 (b/w)
 Blue Territory, 1972, o/c UNBuA

 A-K, p.74 (col)
 Cercando un ago (Looking for a
 Needle), 1960, o/c, Priv.Coll.
 Abstract, pl.43 (b/w)
 Composition, 1959, o/c FPDu
 Seuphor, no.382 (col)
 George Went Swimming at Barnes
 Hole, but It Got Too Cold,
 1957, o/c UNBuA
 A-K, p.73 (b/w)
 Harbour December, 1956, o/c,
 UNNSta
 Geldzahler, p.401 (b/w)
 Liens colores, 1958, o/c, Priv.
 Coll., Milan
 Metro, p.244 (b/w)
 Lucky Seven, 1962, o/c UDCHi
 Hh, pl.781 (b/w)
 Mephisto, 1958, o/c, Priv.Coll.,
 Milan
 Metro, p.245 (b/w)
 Mont St. Hilaire, 1957, o/c,
 UFPL
 Hunter, pl.442 (b/w)

MOGAMI, Hisayuki (Japanese, 1936-)
 Laugh, Laugh, Laugh, 1962, pine,
 Coll.Artist
 Lieberman, p.105 (b/w)

MOLFESIS, Jason (Greek, 1924-)
 Untitled, 1964, o/c
 New Art, col.pl.100

MOLINARI, Guido (Canadian, 1933-)
 Mutazione viola, 1964
 UK2, pl.277 (b/w)
 Violet Mutation, 1964, Priv.
 Coll.
 Abstract, pl.231 (b/w)

MOLINIER, Pierre (French, 1900-)
 Twin Courtesans in an Oblong
 Egg, 1962, oil on panel, Priv.
 Coll.
 Fig.Art, pl.129 (b/w)

MONDINO, Aldo (Italian, 1938-)
 Penguins, 1963-64, plastic paint
 on masonite with object IRSal
 Lippard, pl.174 (b/w)

MONK, Meredith
 Education of a Girl-child, New
 York, 1972, action
 Henri, fig.86 (b/w)

MONORY, Jacques (French, 1924-)
 Ariane, hommage a Gesualdo, 1967
 UK2, col.pl.XII
 Un autre, 1966
 UK2, pl.114 (b/w)
 Meurtre No.VI, 1968
 UK2, pl.115 (b/w)
 Murder No.X/1, 1968, o/c and
 mirror, Priv.Coll., Paris
 Fig.Art, pl.308 (col)
 Regards, o/c, Priv.Coll., Paris
 New Art, pl.60 (b/w)
 Stylistic exercise no.1 (Exer-
 cise de style no.1), 1968, o/c
 Kahmen, pl.22 (b/w)

MONRO, Nicholas (British, 1936-)
 African Dancer, 1962, fiberglass,
 GET
 Fig.Art, pl.188 (b/w)
 Douglas Fairbanks Senior, 1966,
 fiberglass GET
 Fig.Art, pl.189 (b/w)
 Ghost, 1965, fiberglass ELFr
 Compton 2, fig.190 (b/w)
 Seven Reindeer, 1966, fiberglass,
 ELFr
 Fig.Art, pl.187 (b/w)
 Russell, pl.124 (b/w)

MONTONAGA, Sadamasa
 Work, 1965, water and plastic
 Busch, fig.52 (b/w)

MOON, Jeremy (British, 1934-1973)
 Blue Rose, 1967, o/c ELT
 L-S, pl.91 (b/w)
 Chart, 1962, o/c ELStu
 Stuyvesant, p.132 (b/w)
 Concord, 1964, a/c PoLG
 Eng.Art, p.166 (b/w)
 Golden Section 21/68, 1968, a/c,
 ELRo
 Eng.Art, p.168 (b/w)
 Indian Journey, 1965, a/c IViL
 Eng.Art, p.168 (b/w)
 Japan 7/71, 1971, a/c ELRo
 Eng.Art, p.169 (b/w)
 Joy Ride, 1967, a/c ELRo
 Eng.Art, p.167 (col)
 Spring Voyage, 1964, acrylic and
 aluminum paint on canvas,
 ELStu
 Stuyvesant, p.133 (b/w)
 Untitled 25/69, 1969, a/c ELRo
 Eng.Art, p.169 (b/w)

Untitled 13/73, 1973, a/c ELBrC
 Eng.Art, p.169 (b/w)

MOORE, Henry Spencer (British,
 1898-)
 Atom Piece, 1964, bronze
 New Art, pl.103 (b/w)
 Atom Piece, 1967, bronze UICU
 Trier, fig.214 (b/w)
 Double Standing Figure, 1950,
 bronze UNNSal
 G-W, p.148 (b/w)
 Draped Reclining Figure, 1952-
 53, cast 1956, bronze UDCHi
 Hh, pl.636 (b/w)
 Trier, fig.180 (b/w)
 Draped Reclining Woman, 1957,
 GMB
 Trier, fig.58 (b/w)
 Elephant Skull, Plate 26, 1970,
 etching SwGC
 Castleman, p.57 (col)
 Falling Warrior, 1956-57, bronze,
 UDCHi
 Hh, pl.634 (b/w)
 Arnason, fig.897 (b/w)
 Family Group, 1945-49, bronze,
 UNNMMA
 G-W, p.150 (b/w)
 Family Group, 1946, bronze,
 UDCHi
 Hh, pl.542 (b/w)
 Glenkiln Cross, 1956, bronze,
 ELMa
 G-W, p.315 (b/w)
 Interior-Exterior Reclining Fig-
 ure, 1951, bronze UDCHi
 Hh, pl.635 (b/w)
 Arnason, fig.893 (b/w)
 Internal and External Forms,
 1953-54, elmwood UNBuA
 L-S, pl.165 (b/w)
 A-K, p.155 (b/w)
 Internal-External Forms, 1951,
 bronze SwBKM
 Trier, fig.5 (b/w)
 King and Queen, 1952-53, bronze,
 BAKO
 Fig.Art, pl.32 (b/w)
 King and Queen, 1952-53, bronze,
 UDCHi
 Hh, pl.752 (col)
 Arnason, fig.896 (b/w)
 King and Queen, 1952-53, bronze
 Trier, fig.52 (b/w)
 King and Queen, 1952-53, bronze,

ScGlK
1945, pl.121 (b/w)
(Lambert) Locking-Piece, 1963-
 64, bronze BBLa
L-S, pl.166 (b/w)
Lincoln Center Reclining Figure,
 1963-65, bronze UNNLinc
Arnason, fig.899 (b/w)
Miners, 1942, crayon and chalk
 on paper UDCHi
Hh, pl.470 (b/w)
Mother and Child on Rocking
 Chair, 1948, watercolor, gou-
 ache and crayon on paper,
 UDCHi
Hh, pl.545 (b/w)
Northampton Madonna (Mother and
 Child), 1943-44, Hornton
 stone ENorM
L-S, pl.164 (b/w)
Arnason, fig.895 (b/w)
Reclining Figure, 1945-46, wood,
 UMiBC
G-W, p.149 (b/w)
Reclining Figure, 1957-58, Roman
 travertine FPUn
Trier, fig.210 (b/w)
Reclining Figure, 1963-64
UK1, pl.1 (b/w)
Reclining Figure (External
 Forms), 1953-54, bronze
1945, pl.123 (b/w)
Reclining Figure No.4, 1954-55,
 bronze UDCHi
Hh, pl.544 (b/w)
Reclining Figure N.1, 1959,
 bronze GDuK
Metro, p.247 (b/w)
Trier, fig.41 (b/w)
Reclining Figures, 1947, chalk,
 pencil and watercolor -EMo
1945, pl.122 (b/w)
Reclining Figures, 1948, draw-
 ing UDCHi
Hh, pl.546 (b/w)
Reclining Mother and Child, 1960
 -61, bronze ELMa
New Art, pl.104 (b/w)
Reclining Mother and Child, 1960
 -61, bronze UCLCM
Metro, p.246 (b/w)
Reclining Mother and Child, 1960
 -61, bronze UMnMW
Arnason, fig.900 (b/w)
Rocking Chair No.2, 1950, bronze,
 UDCHi

Hh, pl.543 (b/w)
Sculpture in Three Parts No.3
 Vertebrae, 1968, bronze ELMa
Fig.Art, pl.31 (col)
Seated Woman, 1956-57, bronze,
 UDCHi
Hh, pl.638 (b/w)
Three Motives Against Walls No.
 2, 1959, bronze UDCHi
Hh, pl.639 (b/w)
Three-Piece Reclining Figure No.
 2: Bridge Prop, 1963, bronze,
 UDCHi
Hh, pl.788 (b/w)
Three Points, 1939-40, bronze,
 -Moo
Kahmen, pl.212 (b/w)
Three Upright Motives, 1965-66,
 bronze NO
Kahmen, pl.201 (b/w)
Time/Life Screen, 1952 ELTL
UK1, pl.249 (b/w)
Time/Life Screen (working model),
 1952
UK1, pl.248 (b/w)
Tube Shelter Perspective, 1941,
 chalk, pen and watercolor,
 -EMo
Arnason, fig.894 (b/w)
Two-Piece Reclining Figure No.1,
 1959, bronze UNBuA
A-K, p.156 (b/w)
Upright Motive No.1: Glenkiln
 Cross, 1955-56, bronze UDCHi
Hh, pl.637 (b/w)
Arnason, fig.898 (b/w)
Upright Motive No.2, 1955-56,
 bronze
Trier, fig.180 (b/w)
Upright Motive No.7, 1955-56,
 bronze
Trier, fig.180 (b/w)
Wall Relief at the Bouwcentram,
 Rotterdam, 1955, brick
Trier, fig.190 (b/w)
Working Model for Standing Fig-
 ure: Knife Edge, 1961, bronze,
 UDCHi
Hh, pl.789 (b/w)
Working Model for Three-Way Piece
 No.2: Archer, 1964, bronze,
 UDCHi
Hh, pl.791 (b/w)

MOORE, John J. (American, 1941-)
 Cylinders, 1969, o/c
 UK3, pl.82 (b/w)
 Summer, 1972, o/c
 Battcock, p.294 (b/w)
 Yellow Table, 1970, o/c
 UK3, pl.83 (b/w)

MOORMAN, Charlotte
 Participation TV, 1969 (in col-
 laboration with Nam June Paik)
 UK4, pl.94 (b/w)
 TV Bra for Living Sculpture,
 1969
 UK4, pl.67 (b/w)

MOOY, Jaap (Dutch, 1915-)
 Icarus, iron
 Trier, fig.99 (b/w)
 Sentinel, 1961, iron NAS
 New Art, pl.160 (b/w)

MORANDI, Giorgio (Italian, 1890-
 1964)
 Fiori, 1944, o/c
 1945, pl.39 (col)
 Landscape, 1943, oil IMD
 Haftmann, pl.597 (b/w)
 Painting, 1942, o/c IParM
 Fig.Art, pl.4 (b/w)
 Still Life, 1946, oil, Priv.
 Coll., Milan
 Haftmann, pl.598 (b/w)
 Still Life, c.1957, oil GHK
 Haftmann, pl.594 (b/w)
 Still Life with Nine Objects
 (Natura morta con nove ogget-
 ti), 1954, etching
 Kahmen, pl.32 (b/w)

MORANDINI, Marcello (Italian,
 1940-)
 Composizione 3, 1964
 UK2, pl.283 (b/w)

MORELLET, Francois (French,
 1926-)
 Aleatoric Distribution, 1961,
 seriograph
 Barrett, p.77 (b/w)
 Four Superimposed Webs, 1959,
 Coll.Artist
 Barrett, p.3 (b/w)
 Grilles Deformables
 Popper, p.34 (b/w)
 Mural, 1970-71 FPBea

 Popper, p.70 (col)
 Neon Installation, 1971 ELM
 Wolfram, pl.117 (b/w)
 Neon Lights with Two Superim-
 posed Rhythms, 1965 FPRe
 Brett, p.87 (b/w)
 Sphere-trames, 1962, aluminum,
 ELIn
 L-S, pl.159 (b/w)
 Popper 2, p.152 (b/w)
 Successive Illumination, 1963,
 FPRe
 Barrett, frontispiece & p.103
 (b/w)
 Tirets 0°-90°, 1960, Priv.Coll.
 Barrett, p.76 (b/w)
 Wire with Undulating Movement,
 1965 FPRe
 Abstract, pl.292 (b/w)

MORENI, Mattia (Italian, 1920-)
 Ancora un immagine come avverti-
 mento, 1962, oil IMB1
 Metro, p.249 (col)
 Cry of the Sun (L'urlo del sole),
 1954, oil IRaP
 Haftmann, pl.886 (b/w)
 Image Nearly Destroyed, 1960,
 o/c, Coll.Artist
 Seuphor, no.336 (col)
 Incendio, 1957, o/c GCoAA
 1945, pl.61 (b/w)
 Paesaggio con apparizione, 1962,
 o/c IRaP
 Metro, p.248 (b/w)
 Sun Over the Heath IRN
 Pellegrini, p.89 (b/w)

MORETTI, Alberto (Italian, 1922-)
 Vege, 1964, o/c and collage
 Amaya, p.69 (b/w)

MORITA, Shiryu (Japanese, 1912-)
 Upon the Black, 1954, Coll.
 Artist
 Seuphor, no.300 (b/w)

MORLEY, Malcolm (British, 1931-)
 "Amsterdam" in Front of Rotter-
 dam, 1966, liquitex on canvas
 UK2, pl.269 (b/w)
 UK3, pl.119 (b/w)
 Beach Scene, 1968, a/c UDCHi
 Hh, pl.992 (col)
 Chateau, 1969, a/c -Po
 Battcock, p.175 (b/w)

Coronation and Beach Scene, 1968
or 1969, acrylic and magnacol-
or on canvas UNNKor
UK3, pl.125 (b/w)
Calas, p.158 (b/w)
Cristoforo Colombo, 1965, o/c,
-Hof
Battcock (col)
Cutting Horse, 1967
UK2, pl.175 (b/w)
First Class Cabin, 1965, liqui-
tex on canvas UNNKor
UK3, pl.118 (b/w)
Knitting Machine, 1971, o/c -Pi
Battcock, p.184 (b/w)
Los Angeles Yellow Pages, 1971,
acrylic in wax
Battcock, p.178 (b/w)
New York City, 1971, acrylic in
wax
Battcock, p.181 (b/w)
New York Foldout, 1972, o/c and
resin
Battcock, p.45 (b/w)
On Deck, 1966, magna color
Battcock, p.295 (b/w)
Racetrack, 1969-70, a/c with en-
caustic GAaN
UK3, pl.124 (b/w)
Walker, pl.47 (col)
Calas, p.159 (b/w)
Rotterdam, 1965 or 1966, liqui-
tex on canvas UVAM
Battcock, p.xxvii (b/w)
Russell, pl.122 (b/w)
Rotterdam, 1974, a/c
Battcock, p.296 (b/w)
S.S. France, 1974, o/c
Battcock (col)
Ship's Dinner Party, 1966, magna
on canvas UCoAP
Compton 2, fig.183 (b/w)
St. John's Yellow Pages, 1971,
o/c GCoW
L-S, pl.219 (b/w)
U.S. Marine at Valley Forge,
1968, liquitex on canvas
Battcock, p.173 (b/w)
"United States" with (NY) Sky-
line, 1965, liquitex on can-
vas UNLaK
UK2, pl.268 (b/w)
Hunter, pl.690 (b/w)
Vermeer-Portrait of the Artist
in His Studio, 1968, a/c -Mil
UK3, pl.73 (b/w)

MORLOTTI, Ennio (Italian, 1910-)
La colazione sull'erba, 1956,
o/c
1945, pl.44 (col)
Landscape, 1960 IRO
Pellegrini, p.97 (b/w)

MORRIS, Kyle (American, 1918-)
Summer Series '70 No.1, 1970,
a/c, Coll.Artist
Arnason 2, fig.1227 (b/w)
Untitled, 1959 UNNKo
Geldzahler, p.392 (b/w)

MORRIS, Robert (American, 1931-)
The Card File, 1962
Meyer, p.185 (b/w)
6 Yrs, p.29 (b/w)
Dance Performance, Dusseldorf,
1964
UK4, pl.57 (b/w)
Hearing, 1972, copper chair,
lead bed, galvanized aluminum
table
Walker, pl.22 (col)
I-Box, 1962 or 1963, mixed media
Andersen, p.211 (b/w) -Ya
Hunter, pl.892 (b/w), Priv.
Coll., New York City
Labyrinth, 1972, painted plywood
Rose, p.278 (b/w)
Lead Relief, 1954 GDusSc
Kahmen, pl.280 (b/w)
Los Angeles Project II, 1969
UK4, pl.158 (b/w)
Metered Bulb, 1963, mixed media,
UNNJohn
Andersen, p.211 (b/w)
Observatory, 1971, earth, timber,
granite, etc.
Andersen, p.250 (b/w)
Walker, pl.41 (col)
Pace and Process, Edmonton, Can-
ada, 1969, photograph of artist
riding
Hunter, pl.830 (b/w)
'Participation' Objects in
Space, Tate Gallery, London,
1971
Popper, p.234 (b/w)
The Peripatetic Artists' Guild
Prospectus for Robert Morris,
1970
Henri, fig.133 (b/w)
Plan for Tate Gallery exhibition,
1971
Henri, fig.134 (b/w)

Site, New York, 1964, action
 Henri, fig.132 (b/w)
Slab, 1962
 UK1, pl.221 (b/w)
Statement of Aesthetic With-
 drawal, Nov.15, 1963
 Celant, p.192 (b/w)
Steam Cloud, 1966 (as executed
 at Corcoran Gallery of Art,
 Washington, D.C., 1969)
 6 Yrs, p.18 (b/w)
Steam Cloud, 1969, environmental
 structure
 Hunter, pl.936 (b/w)
37 Minutes 3879 Strokes, 1961,
 pencil on paper UMiDWa
 Russell, pl.59 (b/w)
Untitled
 Celant, p.197 (b/w)
Untitled, 1963, wood and rope,
 UMiDWa
 Hunter, pl.615 (b/w)
 Russell, pl.29 (b/w)
Untitled, 1963-64
 UK1, pl.90 (b/w)
Untitled, 1964, pencil UNNGree
 New Art, pl.15 (b/w)
Untitled, 1964, painted plywood,
 IMPan
 Geldzahler, p.228 (b/w)
Untitled, 1964, lead UNNBel
 Hunter, pl.827 (b/w)
Untitled, 1965, fiberglass,
 UNNDw
 Busch, fig.9 (b/w)
 Hunter, pl.784 (b/w)
Untitled, 1965, fiberglass,
 UNNJoh
 Busch, fig.10 (b/w)
Untitled, 1965, plexiglass mir-
 rors on wood ITSp
 Andersen, p.212 (b/w)
Untitled, 1965, aluminum UNNScu
 Geldzahler, p.92 (col)
Untitled, 1965, painted plywood,
 UNNC
 Hunter, pl.817 (b/w)
Untitled, 1965
 UK1, pl.201 (b/w)
Untitled (Circular Light Piece),
 1965 or 1966, fiberglass or
 plexiglass
 L-S, pl.211 (b/w) UNNDw
 Rose, p.267 (b/w)
 Trier, fig.232 (b/w)
 Calas, p.260 (b/w) UCoAP

Untitled, 1966
 UK1, pl.202 (b/w)
Untitled, 1966, reinforced fi-
 berglass and polyester resin,
 UNNW
 Whitney, p.127 (b/w)
 Abstract, pl.240 (b/w)
Untitled, 1966 or 1967, steel
 mesh UCBeK
 Geldzahler, p.229 (b/w)
 Calas, p.261 (b/w)
Untitled, 1967, 9 steel units,
 UNNG
 Arnason, fig.1081 (b/w)
Untitled, 1967
 Eng.Art, p.318 (b/w)
Untitled, 1967-68, red felt,
 UMiD
 Celant, p.194 (b/w)
 Andersen, p.240 (b/w)
 Geldzahler, p.229 (b/w)
Untitled, 1967 or 1968, black
 felt UNNJoh
 Celant, p.195 (b/w)
 Hunter, pl.884 (b/w)
Untitled, 1967-68, aluminum I-
 beams UNNC
 Goossen, p.47 (b/w)
Untitled (Earthwork), 1968,
 earth, peat, steel, etc.
 Kahmen, pl.84 (b/w) UNNDw
 Celant, p.196 (b/w)
 Calas, p.263 (b/w)
 Hunter, pl.827 (b/w) UNNBel
Untitled, 1968, felt
 Celant, p.193 (b/w)
Untitled, 1968, 9 units of
 translucent fiberglass UCtNcJ
 Geldzahler, p.230 (b/w)
Untitled, 1968, mixed media,
 UNNJoh
 Hunter, pl.837 (col)
Untitled, 1968, tan felt
 Calas, p.262 (b/w)
Untitled, 1968-69, aluminum,
 UNNC
 Hunter, pl.844 (b/w)
Untitled, 1969, trees, soil,
 wood, etc.(installation view
 at Museum of Modern Art, New
 York, 1970)
 Hunter, pl.935 (b/w)

MORTENSEN, Richard (Danish,
 1910-)
 After a Serigraph, 1960, o/c,

FPRe
Seuphor, no.387 (col)
After a Serigraph, 1960, o/c,
 FPRe
Seuphor, no.388 (col)
Dedie a l'Espagne, 1962, o/c,
 -DA
New Art, pl.167 (b/w)
Espace pour I. Meyerson, 1962
 Metro, p.250 (b/w)
Grisaille Collage, 1952 FPMS
Seuphor, no.294 (b/w)
Lora, 1962 FPRe
Metro, p.251 (col)
Haftmann, pl.974 (b/w)
L'Ouveze, 1955, o/c FPRe
Seuphor, no.389 (col)
Peinture, 1957, o/c FPRe
1945, pl.8 (col)
Propiano, 1960 FPRe
Ponente, p.23 (col)
Sequel to Ominanda IV, 1964,
 kinetic relief
Popper 2, p.128 (b/w)
South East, 1956, o/c FPRe
Abstract, pl.175 (b/w)
Suite a Ominanda I, 1963 -Ren
Pellegrini, p.25 (b/w)
Theme from the Odyssey (plate
 from the album Le Va Chant)
Popper 2, p.87 (col)

MORTIER, Antoine (Belgian, 1908-)
Le Bandit, 1960, o/c, Priv.
 Coll., Brussels
New Art, pl.197 (b/w)
Daily Bread, 1954, o/c, Priv.
 Coll.
Abstract, pl.114 (b/w)

MOSER, Wilfried (Swiss, 1914-)
Painting, 1960, o/c FPBu
Seuphor, no.527 (col)

MOSES, Ed (American, 1926-)
Dax, 1974, laminated tissue with
 rhoplex and pigment UNNEm
Arnason 2, col.pl.285

MOSKOWITZ, Robert (American,
 1935-)
Untitled, 1961, o/c with window-
 shade UNNC
Seitz, p.161 (b/w)

MOTHERWELL, Robert (American,
 1915-)
Africa, 1965, a/c UMdBM
Geldzahler, p.233 (b/w)
Afternoon in Barcelona, 1958,
 o/c UNNJa
Seuphor, pl.385 (col)
Ancestral Presence, 1976, a/c,
 UVNC
Arnason 2, col.pl.220
At Five in the Afternoon, 1949,
 casein on cardboard
Sandler, p.207 (b/w), Coll.
 Artist
Rose, p.152 (b/w)
Arnason, fig.871 (b/w)
Tuchman, p.135 (b/w) UCMM
Beige Figuration No.3, 1967,
 paper collage, Coll.Artist
Geldzahler, p.234 (b/w)
Beside the Sea No.5, 1962, oil
 on rag paper, Coll.Artist
Sandler, p.209 (b/w)
Beside the Sea N.33, 1962, o/c
 Metro, p.252 (b/w)
The Best Toys Are Made of Paper,
 1948, collage and mixed media
 on cardboard UCBeK
Tuchman, p.134 (b/w)
Black and White Plus Passion,
 1958, o/c UDCHi
Hh, pl.696 (b/w)
Black on White, 1961, o/c UTxHA
Sandler, p.210 (b/w)
Blue Air, 1946, oil on card-
 board UDCHi
Hh, pl.700 (col)
Blue with China Ink-Homage to
 John Cage, 1946, gouache and
 oil with collage on cardboard,
 UNNBake
Tuchman, p.132 (b/w)
Cambridge Collage, 1963, oil and
 paper on board -UBl
Hunter, pl.478 (b/w)
Collage with Ochre and Black,
 1958, collage with oil -Roe
Janis, p.162 (b/w)
Diary of a Painter, 1958 UNNJ
Pellegrini, p.117 (b/w)
Drawing, 1944, colored inks on
 paper
Sandler, p.37 (b/w)
Elegy for the Spanish Republic,
 1958, oil on paper UNNJa
Haftmann, pl.881 (b/w)

Project for an Electric Chair,
1966
Pellegrini, p.109 (b/w)
Situal, 1965, carved and painted
wood
Dyckes, p.32 (b/w)

MURAKAMI, Saburo
"Murakami breaks the big paper-
screen..." (from First Gutai
Theater Art), Tokyo and Osaka,
May 1957
Kaprow, p.215 (b/w)
Running Through, Tokyo, 1955 or
1957
UK4, pl.23 (b/w)
Kaprow, p.216 (b/w)
Torn Paper Screen, 1956 JTOh
Janis, p.270 (b/w)

MURCH, Walter (Canadian-American,
1907-1967)
Sewing Machine, 1953, o/c,
UNNLav
Hunter, pl.315 (b/w)

MURRAY, Robert (Canadian, 1936-)
Duet, 1965, steel
Ashton, pl.LXIV (col)
Marker, 1964-65, painted steel,
UDCHi
Hh, pl.836 (b/w)
Mesa, 1968, painted aluminum,
CTMi
Andersen, p.229 (b/w)

MURTIC, Edo (Yugoslavian, 1921-)
Painting, 1959, o/c FPCre
Seuphor, no.309 (col)
Persistenza, 1958, o/c
1945, pl.72 (b/w)
Vertical Conception, 1965, o/c
New Art, col.pl.110
White Departure, 1964, Priv.
Coll.
Abstract, pl.83 (b/w)

MUSIC, Antonio Zoran (Italian,
1909-)
Adam, 1951-52, o/c UNNHell
Metro, p.261 (b/w)
Eclat d'Automne, 1962, oil on
paper FPFr
Metro, p.260 (b/w)
Empty Landscape I, 1959, o/c,
FPFr

Seuphor, no.338 (col)
Landscape, 1955, oil FPFr
Haftmann, pl.960 (b/w)
Paysage, 1954, o/c
1945, pl.65 (b/w)
Wind-Sun, 1958, o/c FPFr
Abstract, pl.54 (b/w)

MYERS, Forrest (American, 1941-)
For Leo, 1968, welded aluminum,
UCtSB
Hunter, pl.839 (b/w)
Laser's Daze, 1966, aluminum,
acrylic and lacquer
Busch, fig.41 (b/w)
Light Schulpture, 1967, 4 search-
lights
Andersen, p.232 (b/w)

N.E. THING CO. See BAXTER, Iain
and Ingrid

NAGARE, Masayuki (Japanese,
1923-)
Enclosure, 1959, granite UNNRoJ
Lieberman, p.63 (b/w)
Plowing, 1958, granite UNNBen
Lieberman, p.62 (b/w)
Wind Form, 1965, Italian traver-
tine marble UDCHi
Hh, pl.901 (b/w)
Windwoven, 1962, granite UNNSt
Lieberman, p.62 (b/w)

NAKAGAWA
White Angel, 1973, a/c
Battcock, p.297 (b/w)

NAKANISHI, Natsuyuki (Japanese,
1935-)
Compact Objects (6), 1962, as-
semblage in polyester, Coll.
Artist, UNNRoJ, UCStbT, UNNMMA
Lieberman, p.18 (col) & p.99
(b/w)

NAKIAN, Reuben (American, 1897-)
Birth of Venus (first version),
1963-66, plaster UNNE
Ashton, pl.I (col)
Descent from the Cross, 1972,
plaster to be cast in bronze
Arnason 2, fig.1045 (b/w)
Ecstasy, 1946-57, bronze UNNH
Hunter, pl.519 (b/w)
The Emperor's Bedroom, 1953-54,

ored neon light tubing UNNFis
UK2, pl.386 (b/w)
Hunter, pl.923 (b/w)
Window Screen, 1967
UK2, pl.387 (b/w)

NAVES, Francis
The Nature of Things, 1967,
paint on isorel FPSt
Fig.Art, pl.295 (b/w)

NAVIN, Richard (American, 1934-)
Untitled, 1964, epoxy, Coll.
Artist
Ashton, pl. LXXVII (col)

NAY, Ernst Wilhelm (German, 1902–
1968)
Diamant Rot, 1958, o/c
1945, pl.78 (col)
Dynamik-Bild, 1965, o/c, Priv.
Coll.
New Art, col.pl.115
Echo in Blue, 1957, oil, Priv.
Coll., U.S.A.
Haftmann, pl.867 (b/w)
Orbit, 1963, oil UNNK
Haftmann, pl.868 (b/w)
Arnason, fig.973 (b/w)
Ovestone, 1955, o/c UNBuA
A-K, p.251 (col)
Receding Ocher, 1959, o/c GCoSc
Seuphor, no.273 (col)
Salome, 1946, oil GMF
Haftmann, pl.865 (b/w)
Shepherd I, 1948, oil GGmH
Haftmann, pl.866 (b/w)
Untitled, 1954, o/c UDCHi
Hh, pl.660 (b/w)
Watercolor, 1957, Coll.Artist
Seuphor, no.312 (col)
Yellow and Purple, 1959 GEK
Ponente, p.157 (col)
Haftmann, pl.864 (col)
Yellow Chromatic, 1960, o/c GEF
Abstract, pl.93 (col)

NEAGU, Paul (Rumanian-British,
1938-)
Blind Man's Bite, series begun
in 1971
Popper, p.197 (b/w)

NEAL, Reginald (British-American,
1909-)
Square of Three, Yellow and

Black, 1964 UNjTrN
Barrett, p.141 (b/w)

NEGRET, Edgar (Colombian, 1920-)
Mask, 1966
UK1, pl.189 (b/w)
Mask A, 1966
UK1, pl.190 (b/w)
Navigator, 1964, black paint on
aluminum
Trier, fig.243 (b/w)

NEIMAN, Yehuda
Hard Edge, 1966
UK2, pl.48 (b/w)
Lips, 1968
UK2, pl.49 (b/w)

NEJAD, Mehemed D. (Turkish,
1923-)
The Six Arrows, 1954, o/c FPMP
Seuphor, no.276 (col)

NELE, E. R. (German, 1932-)
Architektur Kopf, 1964, bronze,
GML
New Art, pl.330 (b/w)

NEMES, Endre (Hungarian, 1909-)
Insects and Vegetal Forms, 1956,
o/c
1945, pl.143 (b/w)
Old Cities, 1967, o/c
Fig.Art, pl.1 (col)

NEMOURS, Aurelie (French, 1910-)
Angular Stone, 1960, o/c, Priv.
Coll., Paris
Seuphor, no.285 (col)
Margarita or The Pearl, 1959,
pastel FPMS
Seuphor, no.507 (b/w)

NEPRAS, Karel
Hlava, 1964
UK1, pl.49 (b/w)

NERI, Manuel (American, 1930-)
Untitled, 1963, painted plaster,
Priv.Coll.
Andersen, p.158 (b/w)
Wader, 1964, plaster, Coll.
Artist
Ashton, pl.LXXIII (b/w)

ing
Metro, p.262 (b/w)
Feb.1959 (Half Moon) SwZL
Ponente, p.26 (col)
Feb.1960 (Off-ice-blue) SwZL
Ponente, p.27 (col)
Kerrowe, 1953 FPMS
Seuphor, no.291 (col)
March 64 (Circle and Venetian
Red), 1964, oil on fiberboard,
-Vog
New Art, col.pl.43
March 64 (Sirius), oil on hard-
board ELStu
Stuyvesant, p.30 (b/w)
Night Facade, 1955, oil on
pressed wood UNNG
Arnason, fig.887 (b/w)
Painting, 1938, o/c, Priv.Coll.
Abstract, pl.171 (b/w)
Painting (Version I), 1938 SwZL
Seuphor, no.289 (col)
Pale Grey Bottle, 1965, oil-
wash-drawing, Priv.Coll.
Kahmen, pl.34 (b/w)
Relief, 1958 SwZBec
Metro, p.263 (col)
Saronikos, 1966, carved pavatex
relief UNNMa
Arnason, col.pl.217
Still Life June 4, 1949 (Diago-
nal), 1949, oil on board,
UDCHi
Hh, pl.747 (col)
Still Life (Nightshade), 1955,
o/c SwZBe
Seuphor, no.290 (b/w)
Still Life (Rhino) March 13-47,
oil EBramM
Haftmann, pl.968 (b/w)
Tableform, 1952, oil and pencil
on canvas UNBuA
A-K, p.137 (b/w)
Tuscan Relief, 1967, relief and
oil ELMa
Trier, fig.27 (b/w)

NICKFORD, Juan (Cuban-American,
1925-)
Running Dog, 1954, steel
Andersen, p.92 (b/w)

NICKLE, Robert (American, 1919-)
Collage, 1958-59, Coll.Artist
Seitz, p.98 (b/w)

NICOLSON, Annabel (British,
1946-)
At the Piano Factory, 1975, film
Eng.Art, p.459 (b/w)
Reel Time, 1972-73, film
Eng.Art, p.459 (b/w)
Slides, 1971, film
Eng.Art, p.440 (b/w)

NIEUWENHUYS, Constant Anton. See
CONSTANT

NIGRO, Mario (Italian, 1917-)
From 'Total Space', 1954, Priv.
Coll.
Abstract, pl.226 (b/w)

NIIZUMA, Minoru (Japanese, 1930-)
Castle of the Eye, 1964, marble,
UNNMMA
Lieberman, p.78 (b/w)
The Waves' Voice, 1963, granite,
UNNRoJ
Lieberman, p.79 (b/w)

NIKOLAIS, Alwin
Fusions, 1967
UK4, pl.53 (b/w)
A Gothic Tale, 1966
UK4, pl.54 (b/w)

NIKOS (Nikos Kessanlis) (Greek,
1930-)
The 4 Chavigniers, emulsified
canvas UMnMWa
Fig.Art, pl.277 (b/w)

NILSSON, Gladys (American, 1940-)
Many Swingers Out-of-Doors,
1966, watercolor UNNW
Whitney, p.101 (b/w)

NITSCH, Hermann (Austrian, 1938-)
Crucifixion, 1967
UK4, pl.128 (b/w)
"Lamb" Happening, 1962
UK4, pl.126 (b/w)
O.M. Theater (Orgy-Mystery Thea-
ter), 1968
UK4, pl.127 (b/w)
Orgien-Mysterien-Theater, Munich,
Jan.1974, action
Walker, p.51 (b/w)

NUSBERG, Lev (Russian, 1937-)
 Flower (phase 5), 1965, kinetic
 object
 Popper 2, p.187 (b/w)
 Plan for Kinetic Environment for
 the Seaside Area of Odessa,
 1970
 Henri, fig.103 (col)

NUTTALL, Jeff (British, 1933-)
 The Marriage, London, 1966,
 action
 Henri, fig.91 (b/w)
 The Stigma, London, 1965, action
 Henri, fig.90 (b/w)

OBREGON, Alejandro (Colombian,
 1920-)
 Torocondor, 1963, o/c
 New Art, col.pl.94

ODATE, Toshio (Japanese-American,
 1930-)
 Argonaut, 1964, oak, Coll.Artist
 Ashton, pl.XX (col)
 Midnight Goddess, 1963-64, Lon-
 don plane, Coll.Artist
 Ashton, pl.XX (col)

O'DOWD, Robert
 $5.00, 1962, o/c, Coll.Artist
 Lippard, pl.144 (b/w)

OEHM, Herbert
 Nr.6/31-67, 1967
 UK2, col.pl.XVII

OELZE, Richard (German, 1900-)
 An einer Kirche (In a Church),
 1949-54, o/c, Priv.Coll.
 1945, pl.94 (b/w)
 Arnason, fig.948 (b/w)
 Epikur, 1960, o/c, Priv.Coll.
 New Art, col.pl.131
 Expectation (Erwartung), 1935-
 36, o/c UNNMMA
 Kahmen, pl.37 (b/w)
 Fig.Art, pl.134 (b/w)
 In Place of Flowers and Blood,
 1963, oil GHPo
 Haftmann, pl.953 (b/w)
 Untitled, c.1935, pencil GDusKl
 Kahmen, pl.318 (b/w)

OHASHI, Yutaka (Japanese-American,
 1923-)
 Mashiko No.5, 1959, paper and
 gold leaf with oil on canvas
 Janis, p.155 (b/w)
 Rain Box, 1965
 UK1, pl.282 (b/w)
 Smoke Box, 1964
 UK1, pls.286-88 (b/w)

OHLSON, Doug (American, 1936-)
 Cythera, 1967
 UK2, pl.315 (b/w)
 Untitled, 1968, a/c UNNFis
 Goossen, p.54 (b/w)

OHNO, Masuho
 Untitled, 1966
 UK2, pl.298 (b/w)

OITICICA, Helio (Brazilian,
 1937-)
 Box Poem, 1966, wood, plastic,
 and pigment, Priv.Coll.
 Cape No.1 (Parangole), 1964,
 various materials, Coll.Artist
 Brett, p.67 (b/w)
 Cape No.2, 1965, Coll.Artist
 Brett, p.66 (b/w)
 Dialogue of Hands, 1966, elastic
 moebius band (in collaboration
 with Lygia Clark)
 Brett, p.63 (b/w)
 Glass Bolide No.6, 1965, glass,
 earth, gauze, Coll.Artist
 Brett, p.58 (b/w)

OKADA, Kenzo (Japanese-American,
 1902-)
 Height, 1959 UNNPa
 Ponente, p.93 (col)
 Memories, 1957, oil UNNW
 Whitney, p.63 (col)
 White and Gold, 1961, o/c UNBuA
 A-K, p.59 (col)

OKAMOTO, Shinjiro (Japanese,
 1933-)
 The Big Laugh, 1963, a/c UTxFW
 Lieberman, p.91 (b/w)
 Laughing Landscape, 1963, water-
 color on canvas -UTxW
 New Art, pl.202 (b/w)
 Ninth Little Indian, 1964, a/c,
 UTxFW
 Lieberman, p.90 (b/w)

acrylic, lacquer, Coll.Artist
Geldzahler, p.265 (b/w)
Warehouse Light, 1969, a/c,
UNNRubi
Geldzahler, p.265 (b/w)
Yaksi Juice, 1963, a/c UNNPoi
New Art, pl.11 (b/w)

OLIVEIRA, Nathan (American, 1928-)
Man Walking, 1958, o/c UDCHi
Selz, p.115 (b/w)
Hh, pl.662 (b/w)
Seated Man with Object, 1957,
o/c UNNBake
Selz, p.114 (b/w)
Standing Man with Stick, 1959,
o/c UNNMMA
Selz, p.112 (col)
Standing Woman with Hat, 1958,
o/c UNNNe
Selz, p.116 (b/w)

OLSON, Eric
Optochromi H8-1, 1965, glass,
aluminum, plastic ELT
Compton, pl.9 (b/w)

ONO, Yoko (Japanese, 1933-)
Painting for the Wind, 1961,
UNNAlm
Wolfram, pl.133 (b/w)

ONOSATO, Toshinobu (Japanese,
1912-)
Untitled, 1961, o/c JTO
Lieberman, p.39 (b/w)
Untitled, 1962, o/c UNNRoJ
Lieberman, p.16 (col)
Untitled, 1964, o/c UNNRoJ
Lieberman, p.38 (b/w)
Untitled 100A, 1964, o/c JTMi
New Art, col.pl.91

OPPENHEIM, Dennis (American,
1938-)
Annual Rings, St. John River at
Ft. Kent, Me., 1968, frozen
river
Celant, pp.130-31 (b/w)
UK4, pl.162 (b/w)
Arm & Wire, 1969, 16mm film
6 Yrs, p.185 (b/w)
Branded Mountain, San Pueblo,
Calif., 1969
Henri, fig.53 (col)
Canceled Crop, 1969, Finster-

wolde,Holland, grain field
Hunter, pl.862 (b/w)
Arnason 2, fig.1192 (b/w)
Directed Seeding-Wheat, Finster-
wolde,Holland, 1969
UK4, pl.165 (b/w)
Energy Displacement-Approaching
Theatricality, 1970
Meyer, p.197 (b/w)
Ground Mutations, 1969
Andersen, p.249 (b/w)
Maze, Whitewater, Wis., 1970,
hay, straw, corn, cattle
Calas, p.333 (b/w)
Nebraska Project, 1968
UK4, pl.163 (b/w)
New Haven, Conn. Piece, 1968,
contour lines and metal filing
Celant, p.129 (b/w)
1 Hour Run, Ft. Kent, Me., Dec.
1968
Celant, p.132 (b/w)
Parallel Stress (Part I), 1970
Meyer, p.198 (b/w)
Parallel Stress (Part II/Bottom),
1970
Meyer, p.199 (b/w)
Reading Position, 1970
L-S, pl.231 (col)
Walker, p.46 (col)
Snow-Fencing, Grass, near Hau-
burg, Pa., 1968
Celant, p.127 (b/w)
Time-Line, American-Canadian
border, 1968
UK4, pl.161 (b/w)
6 Yrs, p.66 (b/w)
Vegor Spear, near Hauburg, Pa.,
June 1968, oat field
Celant, p.128 (b/w)
Weather Data Plotted on Bean
Field, Finsterwolde, Holland,
1969
UK4, pl.164 (b/w)

OPPENHEIM, Meret (Swiss, 1913-)
Fur-Covered Cup, Saucer and
Spoon, 1936 UNNMMA
Kahmen, pl.259 (b/w)
Seitz, p.60 (b/w)
Spring Feast (Banquet), Galerie
Cordier, Paris, 1959, action
Henri, fig.48 (b/w)
Fig.Art, pl.133 (b/w)
Squirrel, 1960, glass beer mug,
plastic foam, fur IMSc

Seitz, p.60 (b/w)

ORELLANA, Gaston (Chilean, 1933-)
Train in Flames, 1970, o/c,
UDCHi
Hh, pl.938 (b/w)

ORGEIX, Christian d' (French,
1927-)
Assemblage, c.1955 GDusKl
Kahmen, pl.62 (b/w)
Cathedrale de Cologne, 1954,
o/c GBSp
1945, pl.30 (b/w)
La Confidante, 1965, object,
FPDr
New Art, pl.70 (b/w)

ORLOP, Detleff
Taurus-Pass II, 1966
UK2, pl.227 (b/w)

ORTIZ, Ralph (American, 1934-)
Archaeological Find No.4, 1964,
upholstered furniture and
plastic glue, Coll.Artist
Wolfram, pl.128 (b/w)
Archaeological Find No.7, 1964,
upholstered furniture and
plastic glues UNNW
Wolfram, pl.130 (b/w)
Archaeological Find No.9, 1964,
furniture and plastic glues
Wolfram, pl.129 (b/w)
Destruction of an Armchair by
the Artist and the Sea, Prov-
incetown, Mass., 1966 UVNC
Henri, fig.104 (col)

ORTMAN, George (American, 1926-)
Blue Diamond, 1961, mixed media
Calas, p.134 (b/w)
The Good Life, or Living by the
Rules, 1960, o/c UNNWise
New Art, pl.12 (b/w)
Peace I, 1959, painted canvas on
wood, collage construction,
SpIV
Hunter, pl.768 (b/w)
A Sweet Woman, 1957, plaster
object panel
Janis, p.254 (b/w)

OSBORNE, Tim (British, 1909-)
Impulse, 1959, o/c FPV
Seuphor, no.329 (col)

OSSORIO, Alfonso (American,
1916-)
Between, 1963, assemblage on
composition board UNNW
Whitney, p.92 (col)
Embrace, 1968, mixed media
Calas, p.48 (b/w)
Excelsior, 1960, various objects
on wooden board UNNPa
Seitz, p.105 (b/w)
Target Gone, 1969, mixed media
Calas, p.49 (b/w)
To You the Glory, 1950, water-
color and wax UNEaD
Hunter, pl.379 (b/w)

OSTLIHN, Barbro (Swedish, 1930-)
Gas Station, N.Y.C., 1963, o/c,
FPCor
Russell, pl.125 (b/w)

OTT, Jerry (American, 1947-)
Study from Manson/Tate Murder,
1973, a/c -Mo
Battcock (col)

OZAWA, Chikutai (Japanese, 1902-)
A Lonely Road, 1954
Seuphor, no.314 (b/w)

PAALEN, Wolfgang (Austrian, 1907-
1959)
The Earth Arises, 1953, o/c,
FPDup
Seuphor, no.201 (col)
Fossil Light, 1953, o/c FPVG
Fig.Art, pl.108 (b/w)
Painting, 1940
Pellegrini, p.113 (b/w)

PACE, Achille (Italian, 1923-)
Itinerario, 1964, o/c
New Art, pl.126 (b/w)

PACHECO, Julian (Spanish, 1937-)
Fragment No.43, n.d., o/c
New Art, pl.148 (b/w)

PACHECO, Maria Luisa (Bolivian,
1919-)
Tiahuanaco III, 1964, oil and
collage on canvas, Coll.Artist
New Art, pl.222 (b/w)

PAIK, Nam June (Korean, 1932-)
Charlotte Moorman "Bra for Liv-

ing Sculpture", 1969 UNNWis
 Hunter, pl.896 (b/w)
Marshall McGhost, 1968, elec-
 tronically distorted televi-
 sion image
 Calas, p.314 (b/w)
Participation TV, 1969 (in col-
 laboration with Charlotte
 Moorman)
 UK4, pl.94 (b/w)
Robot, c.1964, assemblage, Coll.
 Artist
 L-S, pl.151 (b/w)
Untitled, 1965
 UK1, pl.320 (b/w)

PALAZUELO, Pablo (Spanish, 1916-)
 Dilimir, 1969, o/c
 Dyckes, p.40 (b/w)
 Gardens 2, 1957, o/c FPMa
 Seuphor, no.517 (col)
 Image, 1955, o/c
 Dyckes, p.40 (b/w)
 Indigo, 1952, o/c
 Dyckes, p.40 (b/w)
 Omphalo I, 1962, o/c
 Dyckes, p.41 (b/w)
 Orto III, 1969, o/c
 Dyckes, p.103 (col)

PALERMO, Blinky (Peter Heister-
 Kamp) (German, 1943-1977)
 Untitled, 1968, wood GCoZ
 Kahmen, pl.261 (b/w)

PAN, Marta (Hungarian-French,
 1923-)
 Floating Sculpture, Central
 Park, New York, 1973
 Popper, p.58 (b/w)
 Sculpture 53: Equilibrium, 1958,
 ebony UOClWi
 Trier, fig.139 (b/w)

PANAMARENKO, Jurgen Harten (Bel-
 gian, 1940-)
 Airship, mixed media GCD,1972
 L-S, pl.229 (b/w)

PANE, Gina (Italian, 1939-)
 Nourriture: slow and difficult
 absorption of 600 grammes of
 minced meat which disturb the
 usual digestive operations,
 Paris, Nov.24, 1971
 Popper, p.245 (b/w)

PAOLINI, Giulio (Italian, 1940-)
 Astrolabe (a F.P.), 1967,
 painted metal and plexiglass
 Celant, p.147 (b/w)
 Averroe, 1967
 Celant, p.149 (b/w)
 I Spy (The Quest of My Visual
 Field), 1969-71, crayon on
 canvas, Coll.Artist
 Liverpool, no.64 (b/w)
 Primo appunto sul tempo, 1968
 Celant, p.148 (b/w)
 Qui, 1967, transparent plastic
 Celant, p.146 (b/w)
 Raphael Urbinas MDIII, 1968,
 photographic reproduction
 Celant, p.150 (b/w)

PAOLOZZI, Eduardo (British,
 1924-)
 Automobile Head, 1954, print
 Compton 2, fig.37 (b/w)
 Basla, 1967, stainless steel,
 UDCHi
 Hh, pl.913 (b/w)
 The Cage, 1950-51, bronze ELBrC
 G-W, p.260 (b/w)
 Diana as an engine I, 1963-66
 Eng.Art, p.217 (b/w)
 Drawing for Patio and Pavilion
 (for 'This is Tomorrow,' Lon-
 don, 1957)
 Henri, fig.15 (b/w)
 Durunmal, 1966
 UK1, pl.193 (b/w)
 Etsso, 1967, aluminum ELH
 L-S, pl.201 (b/w)
 Gexhi, 1967, polished aluminum,
 GCoZ
 Kahmen, pl.233 (b/w)
 Head, 1960, torn paper with
 drawing
 Janis, p.158 (b/w)
 Helmet in a Japanese Manner,
 1966
 Eng.Art, p.217 (b/w)
 History of Nothing, 1963, film
 Eng.Art, p.437 (b/w)
 I Was a Rich Man's Plaything,
 1947, collage ELT
 Finch, p.33 (b/w)
 Icarus, 1949
 Eng.Art, p.217 (b/w)
 Icarus II, 1957, bronze UNNPa
 Selz, p.120 (b/w)
 Japanese God of War, 1958,

PATELLA, Luca (Italian, 1934-)
 Coppice with perfumed and speak-
 ing trees and musical bushes
 under the sky, 1971, Coll.
 Artist
 Liverpool, no.65 (b/w)

PATELLI, Paolo (Italian, 1934-)
 Insentatez, 1968
 UK2, pl.342 (b/w)

PAVIA, Phillip (American, 1913-)
 Horsetail, 1961, bronze UDCHi
 Hh, pl.797 (b/w)

PAVLOS
 Hats, 1968
 UK2, pl.197 (b/w)

PEARLSTEIN, Philip (American,
 1924-)
 Drawing, 1961
 UK2, pl.28 (b/w)
 Female Model in Robe Seated on
 Platform Rocker, 1973, o/c
 Rose, p.238 (b/w)
 Female Model on Bolster and In-
 dian Rug, 1973, o/c
 Battcock, p.19 (b/w)
 Male and Female Nudes with Red
 and Purple Drapes, 1968, o/c,
 UDCHi
 Hh, pl.907 (b/w)
 Model in the Studio, 1965, o/c,
 UNNFru
 UK3, pl.19 (b/w)
 Models in the Studio, 1967, o/c,
 UNNFru
 UK3, pl.20 (b/w)
 Models in the Studio, 1965, o/c,
 UNNFru
 Hunter, pl.675 (b/w)
 Nude on Kilim Rug, 1969, o/c,
 UNNLau
 Kahmen, pl.104 (b/w)
 Seated Nude on Creen Drape,
 1969, oil UNNW
 Whitney, p.79 (b/w)
 Standing Male, Sitting Female
 Nude, 1969, o/c UNcGrC
 Kahmen, pl.119 (b/w)
 Calas, p.151 (b/w)
 Two Female Models, 1967 UNNBo
 UK3, pl.21 (b/w)
 Two Female Models with Cast Iron
 Bench and Indian Rug, 1971,

 o/c
 Battcock, p.299 (b/w)
 Two Female Models with Regency
 Sofa, 1974, o/c UNNFru
 Arnason 2, fig.1245 (b/w)
 Two Models-One Seated, 1966
 UK2, pl.29 (b/w)
 Two Seated Female Nudes, 1968,
 o/c -Car
 L-S, pl.134 (b/w)
 Calas, p.151 (b/w)
 Woman Reclining on Couch, 1966,
 o/c UNNFru
 UK3, pl.18 (b/w)

PEARSON, David (British)
 Bedroom at Arles, environment
 Henri, fig.42 (col)

PEARSON, Henry (American, 1914-)
 Black and White, 1964 UNNRa
 Barrett, p.140 (b/w)
 Ethical Movement, 1965, ink,
 UNNW
 Whitney, p.101 (b/w)

PEDERSEN, Carl Henning (Danish,
 1913-)
 Flying Bird, 1951, o/c UNBuA
 A-K, p.235 (col)
 Gray Equestrian Picture with
 Pegasus, o/c, Priv.Coll., Den-
 mark
 New Art, pl.171 (b/w)
 Roman Landscape, 1950, o/c DHuL
 Fig.Art, pl.69 (b/w)

PEETERS, Henk (Dutch, 1925-)
 Aquarel, 1964-65, wood and water
 -filled plastic bags NAS
 New Art, pl.157 (b/w)

PEIRE, Luc (Belgian, 1916-)
 Expo 58, 1958, o/c BBNa
 Seuphor, no.435 (col)
 Graphy XIII, 1958, Coll.Artist
 Seuphor, no.431 (b/w)
 Graphie XXXXV, 1965, o/c, Coll.
 Artist
 Abstract, pl.180 (b/w)
 Tessa, 1957, Priv.Coll., Paris
 Seuphor, no.430 (b/w)

PENALBA, Alicia Perez (Argentini-
 an, 1918-)
 Absente, 1961, bronze

coal IRCat
Seuphor, no.523 (b/w)
Sun in the Mountain, 1954, o/c,
Coll.Artist
Seuphor, no.299 (col)

PEVERELLI, Cesare (Italian,
1922-)
Birds of Paradise (Les paradisi-
ers), 1962-63, o/c
Kahmen, pl.126 (b/w)
Untitled, 1962, pencil -Kr
Kahmen, pl.130 (b/w)

PEVSNER, Antoine (Russian, 1884-
1962)
Bird Soaring, 1956, bronze,
UMiDG
Trier, fig.211 (b/w)
The Black Lily (Spiral Construc-
tion), 1943, bronze UDCHi
Hh, pl.465 (b/w)
Column of Peace, 1954, bronze,
UDCHi
Hh, pl.758 (col)
Column Symbolizing Peace (La
colonne symbolisant la paix),
1954, bronze NOK
G-W, pp.192-93 (b/w)
Developable Column, 1942, brass
and oxidized bronze UNNMMA
Arnason, fig.659 (b/w)
Developable Column of Victory,
1945-46, brass and oxidized
tin, Coll.Artist
G-W, p.190 (b/w)
Dynamic Projection in the 30th
Degree, 1950-51, brass and
oxydized bronze VCU
G-W, p.191 (b/w)
Arnason, fig.661 (b/w)
UK1, pl.241 (b/w)
Oval Fresco, 1945, bronze and
oxydized tin, Location unknown
Arnason, fig.660 (b/w)
Twinned Column, 1947, bronze,
UNNG
G-W, p.229 (b/w)
World Construction, 1947, brass
and oxydized tin, Coll.Artist
G-W, p.189 (b/w)

PEZZO, Lucio del (Italian, 1933-)
The Game of Solitude, 1965 SwGK
Pellegrini, p.274 (b/w)
Large White Interior, 1963,

paint and plaster on canvas,
IMSc
Lippard, pl.176 (b/w)
Mensola con decorazione rom-
boidale, 1964 IMMarc
New Art, col.pl.65
Small Corbel, 1964, montage on
panel SwGK
Fig.Art, pl.174 (b/w)

PFAHLER, Georg Karl (German,
1926-)
Accmet, 1964, o/c GStMu
Abstract, pl.232 (b/w)
Farbraumobjekt Nr.6, 1965-66
UK1, pl.198 (b/w)
Metro/K-53, 1966-67
UK2, col.pl.XX
SP.O.R./M., 1964, polymer, Priv.
Coll.
New Art, col.pl.118
Untitled
Pellegrini, p.250 (col)

PHILLIPS, Helen (American, 1913-)
Genetrix, 1943, grey marble,
UNNRey
G-W, p.285 (b/w)

PHILLIPS, Peter (British, 1939-)
Autokustomotive, 1964, oil and
candy glaze on canvas ELStu
Stuyvesant, p.159 (b/w)
Compton 2, fig.72 (b/w)
Custom Painting, 1962, o/c with
silver background, Coll.Artist
Amaya, p.13 (col)
Custom Painting No.3, 1964-65,
o/c UIaDP
Lippard, pl.38 (col)
Arnason, col.pl.234
Custom Painting No.5, 1965, o/c
Janis, p.302 (b/w)
Distributor, 1962 or 1963, o/c
and collage
Lippard, pl.45 (b/w) ELGra
Finch, p.118 (b/w), Priv.Coll.
Drawing, 1967
Finch, p.119 (b/w)
The Entertainment Machine, 1961,
o/c ELStu
Stuyvesant, p.158 (b/w)
For Men Only, MM and BB Star-
ring, oil and collage on can-
vas, 1961 ELBrC
Lippard, pl.46 (b/w)
Compton 2, fig.47 (col)

Metro, p.286 (b/w)
La femme et les fillettes, 1961
 Metro, p.287 (b/w)
Flesh Painting, 1961
 UK2, pl.400 (b/w)
Goat, 1950 FPLe
 Arnason, fig.617 (b/w)
 UK1, pl.69 (b/w)
Head of a Woman, 1951, bronze
 L-S, pl.178 (b/w) UNNG
 Hh, pl.554 (b/w) UDCHi
Little Owl, 1953, painted
 bronze UDCHi
 Hh, pl.728 (col)
Man with Sheep (The Shepherd),
 1944, bronze
 Fig.Art, pl.30 (b/w) FPLe
 Arnason, fig.616 (b/w)
Massacre in Korea, 1951, oil,
 Coll.Artist
 L-S, pl.28 (b/w)
Las Meninas II, 1957, o/c FPLe
 Fig.Art, pl.12 (b/w)
Odysseus and the Sirens, 1946,
 oil and ripolin on fiber
 cement FAntP
 Haftmann, pl.571 (col)
The Painter and His Model, 1963,
 o/c FPLe
 Fig.Art, pl.13 (b/w)
Pastoral (Joie de vivre), 1946,
 oil on fiber cement
 Haftmann, pl.576 (b/w) FAntP
 Arnason, col.pl.173 FAntG
Pregnant Woman, 1950, bronze,
 UDCHi
 Hh, pl.555 (b/w)
Sculpture for Chicago Civic
 Center, installed 1967
 Hunter, pl.950 (b/w)
7 September 1968, etching FPLe
 Kahmen, pl.139 (b/w)
The She-Ape and Her Young, 1952,
 bronze FPLe
 Fig.Art, pl.29 (b/w)
Statuette, 1945-47, bronze,
 UPPiT
 G-W, p.18 (b/w)
Still Life Under Lamp (Nature
 Morte sous la Lampe), 1962,
 linoleum cut FPLe
 Castleman, p.29 (col)
Sylvette David, 1954, oil,
 GBremKH
 Haftmann, pl.574 (b/w)
347 Series (Trois cent quarante-

sept Gravures), Plate 1,
 1968, etching FPLe
 Castleman, p.31 (b/w)
3 September 1968, etching FPLe
 Kahmen, pl.138 (b/w)
31 August 1968, etching FPLe
 Kahmen, pl.137 (b/w)
Woman at the Window (La Femme
 a la Fenetre), 1952, etching
 and aquatint UNNMMA
 Castleman, p.27 (b/w)
Woman Dressing Her Hair, 1940,
 o/c UNNSmi
 Arnason, fig.604 (b/w)
Woman with Baby Carriage, 1950,
 bronze UDCHi
 Hh, pl.553 (b/w)
Woman with Hairnet (La Femme a
 la Resille), 1949, lithograph,
 FPLe
 Castleman, p.25 (col)
Woman with Dog, 1962, oil,
 UNNSei
 Haftmann, pl.575 (b/w)
The Women of Algiers, 1955, o/c
 L-S, pl.6 (b/w) UNNGan
 Arnason, col.pl.174
 Hamilton, pl.352 (b/w)
 Haftmann, pl.573 (b/w), Coll.
 Artist

PICELJ, Ivan (Yugoslavian, 1924-)
 Composition XWY-2, 1960, o/c,
 YLMo
 New Art, pl.262 (b/w)
 Itta, 1966
 Abstract, pl.266 (b/w)
 Surface XLVII, 1964 -Ren
 Pellegrini, p.186 (b/w)

PIEMONTI, Lorenzo
 Alluminio, 1966
 UK1, pl.192 (b/w)

PIENE, Otto (German, 1928-)
 Any Fire Flower, oil and smoke
 on canvas UNBuA
 A-K, p.243 (col)
 Archaic Light Ballet, 1959,
 light projections
 Busch, fig.118 (b/w)
 Corona Borealis, 1965, aluminum,
 light bulbs, chromed stand,
 UNNWise
 Busch, fig.115 (b/w)
 Electric Flower, 1967, light

PISANI, Vettor (Italian, 1938-)
 Study of Marcel Duchamp (Studi
 su Marcel Duchamp), 1965-70,
 IR
 Kahmen, pl.241 (b/w)

PISIS, Filippo de (Italian, 1896-
 1956)
 Beato Labre, 1942, oil YLMo
 Haftmann, pl.640 (b/w)

PISTOLETTO, Michelangelo (Italian,
 1933-)
 Bagneuse sur 4 plans, 1963
 UK2, pl.79 (b/w)
 Bagno barca, 1967, rags, sheet
 steel, colored water, light
 Celant, p.23 (b/w)
 Balcony with Three Men, 1964,
 FPSon
 Pellegrini, p.247 (b/w)
 Candele, 1967, aluminum paper
 and candles
 Celant, p.21 (b/w)
 Chair, 1970, stainless steel with
 paint and collage, Coll.Artist
 Liverpool, no.66 (b/w)
 Coreto, 1965, collage drawing on
 reflecting steel plate ITSp
 New Art, pl.132 (b/w)
 Donna seduta vista de tre quarti,
 1963, pasted paper on polished
 steel
 Janis, p.284 (b/w)
 In zuppa, Oct.1968, photograph
 Celant, p.24 (b/w)
 The Lovers, 1967, heightened
 drawing mounted on steel,
 BBLac
 Fig.Art, pl.173 (b/w)
 Man Reading, 1968 UNNKor
 Wilson, pl.59 (col)
 Megafoni da concerto, 1968
 Celant, p.19 (b/w)
 Il mondo d'oro, la palla che
 prima andava in giro per
 strada e entrata nella gabbia,
 1967-68, paper pulp and rags
 Celant, p.20 (b/w)
 Nude Girl Drinking Tea, 1971,
 stainless steel with paint and
 collage, Coll.Artist
 Liverpool, no.68 (b/w)
 Orchestra di stracci, 1968, rags,
 vapor pot under a plastic
 transparent sheet

 Celant, p.22 (b/w)
 Pistoletto's New Work, 1965
 UK1, pl.110 (b/w)
 Reclining Woman, 1967
 UK2, pl.38 (b/w)
 Sacra Conversazione, 1963,
 painted tissue paper on stain-
 less steel UNBuA
 A-K, p.287 (b/w)
 UK2, pl.71 (b/w)
 Seated Figure, 1962, collage on
 polished steel GKrefW
 L-S, pl.106 (b/w)
 Self-Portrait with Soutzka, 1967
 UK2, pl.146 (b/w)
 Sur la plage-Titre intelligent,
 1962
 UK2, pl.82 (b/w)
 Tete Homme avec cigarette, 1962
 UK2, pl.58 (b/w)
 Two People, 1964, painted paper
 on polished steel FPSon
 Lippard, pl.179 (b/w)
 Woman with a Child, 1964, col-
 lage on stainless steel, Priv.
 Coll.
 Compton 2, fig.184 (b/w)
 Wood Cage, 1970, stainless steel
 with paint and collage, Coll.
 Artist
 Liverpool, no.67 (b/w)

PIZA, Arthur Louis (Brazilian,
 1928-)
 Engraving, 1960 FPHu
 Seuphor, no.524 (b/w)
 Relief-Painting, No.26, 1960,
 FPHu
 Seuphor, no.347 (col)

PLACKMAN, Carl (British, 1943-)
 Installation, "Magic and Strong
 Medicine" exhibition, Walker
 Art Gallery, 1973
 Eng.Art, p.229 (b/w)
 Sisyphus Descends Again, 1974,
 mixed media installation, Coll.
 Artist
 Eng.Art, pp.286-89 (b/w)
 Your Voice Must be Heard/Herd
 (The Archaeology of Love),
 1975
 Eng.Art, p.230 (b/w)

PLATSCHEK, Hans (German, 1923-)
 Job bonvivant, 1961

Geldzahler, p.269 (b/w)
Sandler, p.111 (b/w)
Circular Shape, 1948, o/c UNNJa
Seuphor, no.266 (col)
Composition No.6, 1952, o/c
Seuphor, no.267 (b/w)
Convergence, 1952, o/c UNBuA
A-K, p.25 (col)
Sandler, p.112 (b/w)
Cutout, 1949 UNNJ
Pellegrini, p.114 (b/w)
The Deep, 1953
Pellegrini, p.115 (b/w) UNNJa
UK2, pl.5 (b/w)
Geldzahler, p.272 (b/w) UMiDWa
Drawing in oil and tempera,
c.1946 UNNJa
Seuphor, no.263 (col)
Easter and the Totem, 1953, o/c
Sandler, p.120 (b/w)
Echo, 1951, o/c
Sandler, p.119 (b/w) UNNMMA
Hunter, pl.377 (b/w)
Arnason, fig.857 (b/w) UNNHell
Eyes in the Heat, 1946, o/c IVG
Rose, p.148 (b/w)
Eyes in the Heat II, 1947, o/c,
FPBer
Seuphor, no.265 (col)
Flame, c.1937, o/c UNNPol
Hunter, pl.374 (b/w)
The Flame, 1937, oil on card-
board UNNMMA
Abstract, pl.1 (b/w)
Four Opposites, 1953, o/c
1945, pl.159 (b/w) UPHaL
Tuchman, p.157 (col) UCThoJ
Frieze, 1952-55, o/c UCtMeT
Seuphor, no.262 (col)
Frieze Drawing, 1950 UNNJa
Seuphor, no.264 (b/w)
Gothic, 1944, o/c UNNPol
Sandler, p.109 (b/w)
Guardians of the Secret, 1943,
o/c UCSFM
Sandler, p.107 (b/w)
Lavender Mist, 1949-50, oil,
enamel and aluminum paint on
canvas UNEaD
Hunter, pl.391 (col)
Arnason, col.pl.205
Lucifer, 1947, oil, enamel and
aluminum paint on canvas,
UNNHa
Geldzahler, p.270 (b/w)
Male and Female, 1942, o/c,

UPHavL
Geldzahler, p.266 (b/w)
Sandler, p.65 (b/w)
Moon Woman Cuts the Circle,
1943, o/c UNNMa
Geldzahler, p.267 (b/w)
Sandler, p.108 (b/w)
Abstract, pl.2 (b/w)
Mural, 1943, o/c UIaIU
Sandler, p.155 (b/w)
Rose, p.147 (b/w)
Mural, 1950, oil, enamel and
aluminum paint on canvas on
wood UNNRub
Geldzahler, p.99 (col)
Mural on Indian Red Ground,
1950, o/c UNNRub
Rose, p.149 (col)
Night Ceremony, 1944, oil and
enamel on canvas
Geldzahler, p.268 (b/w) UNNPo
Arnason, fig.856 (b/w) UNNRe
Night Dancer (Green), 1944, o/c,
UNNMa
Tuchman, p.152 (b/w)
Number 1, 1948, o/c UNNMMA
Goossen, p.17 (b/w)
Geldzahler, p.357 (b/w)
No.1, 1949, duco and aluminum
paint on canvas UCBeSc
Tuchman, p.155 (col)
Number 2, 1949, oil, duco and
aluminum paint on canvas,
UNUtM
L-S, pl.14 (col)
Number 2, 1951, pasted paper
with oil UNNH
Janis, p.161 (b/w)
Number 3, 1949, 1949, oil and
aluminum paint on canvas
mounted on masonite UDCHi
Hh, pl.698 (col)
No.3, 1951, o/c UNNOs
Selz, p.124 (b/w)
No.6, 1952, o/c UNNC
Selz, p.127 (b/w)
Number 14, 1951, duco on canvas,
UNNPol
Sandler, p.118 (b/w)
No.23 (Frogman), 1951, o/c UNNJ
Selz, p.126 (b/w)
Sandler, p.117 (b/w)
Number 25, 1950, 1950, encaustic
on canvas UDCHi
Hh, pl.557 (b/w)
Number 27, 1950, oil UNNW

3 Travellers Columns, 1961–64,
 bronze UNNMa
 Arnason, fig.1022 (b/w)
The Traveler's Column, 1962,
 bronze UDCHi
 Hh, pl.841 (b/w)

POMODORO, Gio (Italian, 1930–)
 Una bandiera per Vladimiro,
 1962, bronze study IRMarl
 Metro, p.298 (b/w)
 Borromini Square II, 1966,
 bronze UNNMa
 Arnason, fig.1023 (b/w)
 Co–existence, 1958, bronze
 Trier, fig.130 (b/w)
 Espanzione, 1960 IRMarl
 Metro, p.299 (b/w)
 Euclid's Doubts, 1968–70, fiber–
 glass, Coll.Artist
 Liverpool, no.49 (b/w)
 Grandi Contatti, 1962, bronze,
 Priv.Coll.
 New Art, pl.115 (b/w)
 Matrix I, 1962, bronze UDCHi
 Hh, pl.840 (b/w)
 Opposition, 1968, fiberglass and
 metallic paint UDCHi
 Hh, pl.941 (b/w)

PONCET, Antoine (French, 1928–)
 Cororeol, 1966, aluminum UDCHi
 Hh, pl.900 (b/w)
 Tripatte, 1958, bronze
 G–W, p.268 (b/w)

POONS, Larry (American, 1937–)
 Brown Sound, 1968, a/c UDCWo
 Geldzahler, p.100 (col)
 Cutting Water, 1970, a/c UICS
 Hunter, pl.776 (b/w)
 Arnason 2, fig.1233 (b/w)
 Doge's Palace, 1969, a/c,
 UNNRubi
 Geldzahler, p.277 (b/w)
 Double Speed, 1962–63, acrylic
 and fabric dye on canvas,
 UNNStel
 Geldzahler, p.273 (b/w)
 East India Jack, 1964 UNNC
 Pellegrini, p.150 (b/w)
 The Enforcer, 1963, o/c UNNScu
 New Art, pl.27 (b/w)
 Geldzahler, p.273 (b/w)
 Han–San Cadence, 1963, acrylic
 and fabric dye on canvas,

UIaDA
 Rose, p.201 (col)
 Carmean, p.29 (col)
In Here, 1975, a/c
 Arnason 2, col.pl.283
Knoxville, 1966, a/c –T
 Abstract, pl.243 (col)
 Walker, pl.15 (col)
Mary Queen of Scots, 1965, a/c,
 UNNScu
 Geldzahler, p.274 (b/w)
Night Journey, 1968, a/c,
 UNNBurd
 L–S, pl.84 (col)
 Geldzahler, p.276 (b/w)
Nixe's Mate, 1964, a/c UNNScu
 Hunter, pl.741 (col)
 Arnason, col.pl.248
 Calas, p.209 (b/w)
No.5, 1972, a/c
 Walker, pl.16 (col)
Northeast Grave, 1964 UNNH
 Barrett, p.147 (b/w)
Ode, 1969, a/c UNNNewh
 Calas, p.211 (b/w)
Orange Crash, 1963
 UK2, pl.275 (b/w)
Orange Crush, 1963, a/c UNBuA
 A–K, p.311 (col)
Railroad Horse, 1971, a/c
 Rose, p.222 (b/w)
Richmond Ruckus, 1963–64
 UK2, pl.276 (b/w)
Rosewood, 1966, a/c UNNRub
 Geldzahler, p.275 (b/w)
Sicilian Chance, 1964, a/c,
 UDCHi
 Hh, pl.998 (col)
Slice and Reel, 1963, acrylic
 and fabric dye on canvas
 Andersen, p.207 (b/w)
Stewball, 1966, a/c CTMi
 Calas, p.210 (b/w)
Untitled, 1967, a/c NEA
 Hunter, pl.748 (b/w)
Untitled, 1967, a/c UWiMA
 Carmean, p.63 (b/w)
Untitled, 1969, a/c UOClA
 Carmean, p.64 (b/w)
Untitled–2, 1970, a/c
 Walker, pl.14 (col)
Via Regia, 1964, a/c UDCHi
 Hh, pl.997 (col)

PORTER, David (American, 1912–)
 Collage, 1960, pasted paper

PREM, Heimrad (German, 1934–)
 Er und Sie (second version),
 1965, o/c GML
 New Art, pl.321 (b/w)

PRESTOPINO, Gregorio (American,
 1907–)
 Supper in Bethlehem, 1945, o/c,
 UDCHi
 Hh, pl.449 (b/w)

PRICE, Kenneth (American, 1935–)
 B.G. Red, 1963, fired and paint-
 ed clay UCLF
 Ashton, pl.XLVIII (col)
 D. Black, 1961, glazed ceramic,
 UDCHi
 Hh, pl.870 (b/w)
 Orange, 1961, glazed ceramic,
 UDCHi
 Hh, pl.869 (b/w)
 S.D. Green, 1966, painted clay
 Andersen, col.pl.4

PRINA, Carla (Swiss, 1917–)
 Composition, 1942, ink
 Seuphor, no.449 (b/w)

PRINI, Emilio (Italian, 1943–)
 La costruzione (projetto) bei
 cartelli..., 1967–68
 Celant, pp.214–15 (b/w)
 Ho preparato una serie di ipo-
 tesi di azione..., 1967–68
 Celant, p.213 (b/w)
 Io, tu, Dionisio anche, 1968
 Celant, pp.216–17 (b/w)
 Il mondo e una stanza-Stati di
 simpatia con la tua stanza,
 1968
 Celant, p.218 (b/w)
 I punti di luce sull'Europa,
 1967
 Celant, p.212 (b/w)

PROESCH, Gilbert. See GILBERT &
 GEORGE

PROTIC, Miodrag (Yugoslavian,
 1922–)
 Bouquet I, 1965, o/c YLMo
 New Art, pl.260 (b/w)

PULLINEN, Laila (Finnish, 1933–)
 Primavera II, 1964, bronze, Coll.
 Artist

 New Art, pl.183 (b/w)

PULSA GROUP
 Yale Golf Course Work, New
 Haven, Conn., 1969, environ-
 ment
 Hunter, pl.937 (b/w)
 6 Yrs, p.83 (b/w)

PURRMANN, Hans (German, 1880–)
 Still Life with Fruit, 1955,
 oil, Coll.Artist
 Haftmann, pl.733 (b/w)

QUENNELL, Nicholas
 Adam and Eve, 1965 (in collabor-
 ation with Dakota Daley)
 UK2, pl.20 (b/w)
 Eve 2, 1965 (in collaboration
 with Dakota Daley)
 UK2, pl.57 (b/w)

QUINTE, Lothar (German, 1923–)
 Ohne Titel, 1968
 UK2, col.pl.XXI
 Untitled, 1963
 Pellegrini, p.267 (col)

RABAN, William (British, 1948–)
 Boardwalk, 1972, film
 Eng.Art, p.461 (b/w)

RADICE, Mario (Italian, 1900–)
 Composition A.N.F., 1950,
 gouache SwLutS
 Seuphor, no.425 (col)
 Composition R.S.A., 1950, oil,
 IVaT
 Haftmann, pl.667 (b/w)
 T.R.I.P.R.O.G., 1975, o/c,
 IRMarl
 Arnason 2, fig.1035 (b/w)

RAFFAEL, Joseph (American, 1933–)
 African Lady, 1971, o/c
 Battcock, p.58 (b/w)
 Autumn Leaves (Homage to Keturah
 Blakeley), 1970, o/c UCSFP
 UK3, pl.98 (b/w)
 Barn Owl, 1971, o/c
 Battcock, p.215 (b/w)
 Bataleur, 1970, o/c –A
 Battcock, p.214 (b/w)
 Cheyenne, 1969, o/c –Fr
 UK3, pl.2 (b/w)
 Eyes, Mouth, Fish, Watch, Can-

yon, Operation, 1966, o/c,
UNNSta
 Compton 2, fig.186 (b/w)
Heads, Birds, 1966
 UK2, pl.136 (b/w)
Lizard's Head, 1971, o/c
 Battcock, p.218 (b/w)
Mountain Lion, 1972, o/c
 Battcock, p.301 (b/w)
New Guinea Man, 1972, o/c
 Battcock, p.220 (b/w)
Picasso, 1969, o/c UCSFP
 UK3, pl.1 (b/w)
Pomo, 1970, o/c UCBC
 UK3, pl.3 (b/w)
Seal, 1971-72, o/c
 Battcock, p.217 (b/w)
Water Painting IV, 1973, o/c,
 -Go
 Battcock, p.221 (b/w)

RAFOLS CASAMADA, Albert (Spanish,
1923-)
 August, 1964, o/c, Coll.Artist
 New Art, pl.133 (b/w)
 September, 1965, mixed media
 Dyckes, p.121 (b/w)

RAINER, Arnulf (Austrian, 1929-)
 Irma la Douce, 1963, o/c GBSp
 New Art, pl.301 (b/w)
 Panorama beruhmter Menschen,
 1967
 UK2, col.pl.XXXIII
 Parting, 1964, o/c, Coll.Artist
 Abstract, pl.84 (b/w)

RAINER, Yvonne
 Check, Stockholm, 1964
 UK4, pl.60 (b/w)

RAMIREZ, Eduardo (Colombian,
1923-)
 Untitled, 1966
 UK1, pl.188 (b/w)

RAMOS, Mel (American, 1935-)
 Batmobile, 1962, o/c GAaN
 Alloway, fig.10 (b/w)
 Catsup Queen, 1965, o/c
 Kahmen, pl.150 (b/w)
 Chic, 1965, silkscreen print,
 GCoZ
 Kahmen, pl.149 (b/w)
 David's Duo, 1974, o/c
 Battcock, p.225 (b/w)

Gorilla, 1967, o/c -UKM
 Compton 2, fig.167 (b/w)
The Great Red Kangeroo, 1968,
 o/c, Priv.Coll., Lugano
 Kahmen, pl.152 (b/w)
The Joker, 1962, o/c UNNA11
 Compton 2, fig.142 (col)
 Alloway, fig.11 (b/w)
Kar Kween, 1964, o/c UDCHi
 Hh, pl.885 (b/w)
Leta and the Pelican, 1969, o/c,
 UCLStu
 Compton 2, fig.163 (b/w)
Lucky Strike, 1965, o/c UNNBia
 Kahmen, pl.151 (b/w)
 UK2, pl.87 (b/w)
Miss Velveeta (Val-Veta), 1965,
 o/c UNNBia
 Pellegrini, p.242 (b/w)
 Fig.Art, pl.245 (b/w)
 Russell, pl.107 (b/w)
Monterey Jackie, 1965, o/c,
 UCSacS
 Hunter, pl.654 (b/w)
 Arnason, fig.1064 (b/w)
Ode to Ang, 1972, o/c GDusWi
 Wilson, pl.29 (col)
The Pause That Refreshes, 1967,
 o/c GFW
 Russell, pl.99 (b/w)
Philip Morris, 1965, silkscreen,
 UCoAP
 Wilson, cover (col)
Photo Ring, 1962, o/c UCLO
 Lippard, pl.133 (b/w)
Regard Gerard, 1974, o/c
 Battcock, p.226 (b/w)
Touche Boucher, 1973, o/c
 Arnason 2, fig.1153 (b/w)
Virnaburger, 1965
 UK2, pl.43 (b/w)

RAMSDEN, Mel (American)
 Abstract Relations, title page,
 1968
 Meyer, p.205 (b/w)
 Secret Painting, 1967-68
 Meyer, p.204 (b/w)

RANCILLAC, Bernard (French,
1931-)
 Allan Ginsberg, 1968, serigraph
 on altuglas, Coll.Artist
 Fig.Art, pl.287 (b/w)
 Of What to Be Angry, 1964
 Pellegrini, p.284 (b/w)

Exile, 1962, silkscreen print
and o/c, Priv.Coll., Switzer-
land
Kahmen, pl.9 (b/w)
Express, 1963, o/c UNNBe
Finch, pp.92-93 (b/w)
Factum I, 1957, combine paint-
ing IMPan
Geldzahler, p.280 (b/w)
Alloway, fig.46 (b/w)
Fig.Art, pl.205 (b/w)
Factum II, 1957, oil and collage
on canvas UICNeu
Geldzahler, p.281 (b/w)
Alloway, fig.47 (b/w)
Fig.Art, pl.206 (b/w)
First Landing Jump, 1961, com-
bine painting UNNMMA
Finch, p.45 (b/w)
Forge, 1959, combine painting,
IBrC
Finch, p.40 (b/w)
Fossil for Bob Morris, N.Y.,
1965, combine painting on can-
vas UDCHi
Hh, pl.987 (col)
Gift for Apollo, 1959, combine
painting IMPan
Janis, p.266 (b/w)
Hawk, 1960, combine painting
Janis, p.266 (b/w)
Hymnal, 1955, combine painting,
UNNSon
Calas, p.66 (b/w)
Image Wheels, 1967
UK2, pl.297 (b/w)
Inlet, 1959, combine painting,
IMPan
Janis, p.266 (b/w)
Interview, 1955, combine
Kaprow, p.5 (b/w)
Lake Placid Glori-Fried Yarns
From New England, 1971, card-
board, wood, rope UNNC
Arnason 2, fig.1110 (b/w)
Leadville Description, Stock-
holm, 1964
UK4, pl.36 (b/w)
Marsh, 1969, lithograph
Calas, p.71 (b/w)
Mona Lisa, 1958, mixed media on
paper
Alloway, fig.5 (b/w)
Monogram, 1959, combine with ram
Alloway, fig.56 (b/w) SnSNM
Hunter, pl.601 (b/w)
UK1, pl.80 (b/w)

Fig.Art, pl.211 (b/w) -No
Arnason, fig.1036 (b/w) UNNC
Janis, p.267 (b/w), Coll.
Artist
Nettle, 1960, combine painting
Busch, fig.62 (b/w)
Nude Blue Print, c.1949-50, blue
print paper, Coll.Artist
Alloway, fig.54 (b/w)
Odalisk, 1955-58, construction
Geldzahler, p.279 (b/w) UNNGan
Fig.Art, pl.210 (col)
UK1, pl.83 (b/w)
Alloway, figs.52-53 (b/w) GCoW
½ GALS/AAPCO, 1971, cardboard
and plywood with rope UNNC
Hunter, pl.604 (b/w)
Oracle, 1965 (now destroyed),
construction
Hunter, pl.897 (b/w)
Overdrive, 1963, oil and silk-
screen on canvas SwLaM
Lippard, pl.149 (b/w)
Pail for Ganymeade, 1959, con-
struction, Coll.Artist
Russell, pl.30 (b/w)
Painting with Red Letter S,
1957, oil and collage on can-
vas UNBuA
A-K, p.362 (b/w)
Persimon, 1964, o/c UNNC
Fig.Art, pl.209 (b/w)
Alloway, fig.43 (b/w)
Pilgrim, 1960, combine painting
Calas, p.67 (b/w)
Quote, 1964, o/c
Pellegrini, p.287 (col) UNNC
Calas, p.71 (b/w) GDusKN
Radiant White 952, 1971, card-
board and plywood UMnMW
Arnason 2, fig.1111 (b/w)
Rebus, 1955, combine painting,
UNNGan
Geldzahler, p.278 (b/w)
Alloway, fig.50 (b/w)
Retroactive I, 1964
UK2, pl.116 (b/w)
Retroactive II, 1964, Priv.Coll.
Arnason, fig.1037 (b/w)
UK2, pl.117 (b/w)
Rigger, 1962, combine painting
Metro, p.301 (col)
Satellite, 1955, mixed media
combine painting UNNZeis
Andersen, p.183 (b/w)
Rose, p.185 (col)

Soundings (Chairs), 1968, silk-
screen on plexiglass, electric
equipment GCoW
Hunter, pl.903 (b/w)
Popper, p.25 (b/w)
Spring Training, New York, 1965
Henri, fig.131 (b/w)
Summer Rental, Number 2, 1960,
oil UNNW
Whitney, p.88 (col)
Tadpole, 1963, mixed media
Fig.Art, pl.212 (b/w) -No
Alloway, fig.57 (b/w) SwZBisc
Talisman, 1958, oil paint, pa-
per, wood, etc. UICM
Seitz, p.116 (b/w)
Thaw, 1958, o/c UNNScu
Seuphor, no.519 (col)
Third Time Painting, 1961, o/c
with clock UNNAb
Geldzahler, p.282 (b/w)
Calas, p.69 (b/w)
Tracer, 1964, o/c with silk-
screen UPAT
Geldzahler, p.283 (b/w)
Alloway, pl.5 (col)
Haftmann, pl.994 (b/w)
UK2, col.pl.1
Wolfram, pl.105 (b/w)
Trapeze, 1964, o/c with silk-
screen ITSp
Alloway, fig.44 (b/w)
Trophy V, 1962, combine painting
on canvas UCBeW
Metro, p.300 (b/w)
Untitled, 1950-51, oil and pen-
cil on canvas UNNGan
Abstract, pl.138 (b/w)
Untitled, 1954
UK2, pl.7 (b/w)
Untitled, 1955, construction,
IMPan
Hunter, pl.599 (b/w)
Kaprow, no.88 (b/w)
White Painting, 1951, house
paint on canvas, Coll.Artist
Hunter, pl.702 (b/w)
White Painting, 1952
UK2, pl.312 (b/w)
Windward, 1963, o/c UCtMeT
New Art, col.pl.11
Winter Pool, 1959, combine
painting UNNGan
Russell, pl.34 (b/w)

RAVEEL, Roger (Belgian, 1921-)
La Fenetre, 1963, wood and
glass, Priv.Coll.
New Art, pl.189 (b/w)
The Yellow Man, 1962, o/c,
Coll.Artist
Fig.Art, pl.171 (b/w)

RAVOTTI, Berto (Italian, 1924-)
Ombra, 1966
UK2, pls.150-152 (b/w)

RAY, Man (American, 1890-1976)
Blue Bred (Pain peint), 1960,
plastic UDCHi
Hh, pl.982 (col)
Chess Set, 1962, bronze, enam-
eled brass on wood UDCHi
Hh, pls.848 & 984 (b/w & col)
Indestructible Object (Replica
of the earlier "Object to be
Destroyed"), 1958, metronome
and cutout photograph of eye,
UICNeu
Seitz, p.49 (b/w)
Mr. Knife and Miss Fork, 1944,
knife, fork, etc. on cloth,
FPRi
Seitz, p.86 (b/w)
New York 17, 1966, bronze repli-
ca of 1917 object UDCHi
Hh, pl.849 (b/w)
Puericulture II: Dream, January
1920, 1964, bronze UDCHi
Hh, pl.850 (b/w)
Red Hot Iron, 1965, painted
steel UDCHi
Hh, pl.851 (b/w)
Shakespearean Equation: "Twelfth
Night", 1948, o/c UDCHi
Hh, pl.552 (b/w)

RAYNAUD, Jean-Pierre (French,
1939-)
Psycho-objet, 1964, assemblage
of objects FPLar
New Art, pl.58 (b/w)
Psycho-Objet, 1966, Priv.Coll.
Fig.Art, pl.320 (b/w)
Psycho-objet oiseau, 1965
UK1, pl.159 (b/w)

RAYSSE, Martial (French, 1936-)
America, America, 1964
UK1, pl.60 (b/w)
Cine, peinture et neon, 1964,

RENQUIST, Torsten (Swedish,
 1924-)
 Flodaltare, 1963, oil and tem-
 pera SnSNM
 New Art, pl.178 (b/w)

REQUICHOT, Bernard (French, 1929-
 1961)
 Sans, 1961, collage on wood,
 Priv.Coll., London
 New Art, col.pl.24

RESNICK, Milton (Russian-American,
 1917-)
 Capricorn, 1960, oil on paper,
 mounted on canvas UNNWise
 Seuphor, no.360 (col)
 Rubble, 1957, o/c UNNPoi
 1945, pl.168 (b/w)

RETH, Alfred (Hungarian, 1884-)
 Rhythm-Harmonies of Matter and
 Color, 1957, Coll.Artist
 Seuphor, no.203 (col)

REUTERSWARD, Carl Fredrik (Swed-
 ish, 1934-)
 The Cigar of Eternity, 1960,
 lacquer and tempera on canvas,
 Priv.Coll., Paris
 New Art, col.pl.81
 Looping the Loop the Masters,
 1959 -Hen
 Pellegrini, p.277 (b/w)

REVILLA, Carlos
 Attraverso il Gioco, 1968
 UK2, pl.363 (b/w)
 Il gioco segreto, 1968
 UK2, pl.362 (b/w)

REYNAL, Jeanne (American, 1903-)
 Cardinal, mosaic and photograph,
 UNNCop
 Janis, p.213 (b/w)

REZVANI, Serge (Iranian, 1928-)
 Viande a saigner sous le mar-
 teau, 1964, o/c, Priv.Coll.,
 Paris
 New Art, pl.74 (b/w)

RHEE, Seund Ja (Korean, 1928-)
 Drawing, 1961
 Seuphor, no.301 (b/w)
 Drawing, 1961, Coll.Artist

Seuphor, no.302 (b/w)

RHO, Manlio (Italian, 1901-)
 Composition No.45, gouache
 study for a fresco SwLutS
 Seuphor, no.393 (col)

RHODES, Liz
 Dresden Dynamo, 1972, film
 Eng.Art, p.463 (b/w)

RICHARDS, Ceri (British, 1903-)
 La Cathedrale engloutie, 1961,
 o/c ELNL
 New Art, col.pl.47
 La Cathedrale engloutie augmentez
 progressivement triptych,
 1960-61, oil on three can-
 vases ELStu
 Stuyvesant, pp.32-33 (b/w)
 Cycle of Nature, 1955-56, o/c,
 -Will
 1945, pl.117 (col)

RICHIER, Germaine (French, 1904-
 1959)
 The Bat, 1952
 G-W, p.259 (b/w)
 Don Quixote of the Forest, 1950-
 51, bronze UMnMW
 Selz, p.133 (b/w)
 Arnason, fig.917 (b/w)
 Don Quixote with the Sail of a
 Windmill, 1949, gilt bronze,
 Priv.Coll.
 Trier, fig.67 (b/w)
 Don Quixote with the Windmill,
 1954, bronze UMnMU
 Arnason, fig.916 (b/w)
 The Grain, 1955, bronze FPCr
 Selz, p.132 (b/w)
 Grain, 1955, bronze UDCHi
 Hn, pl.676 (b/w)
 The Grasshopper, 1946-55,
 bronze UNGK
 Selz, p.129 (b/w)
 Le Griffu, 1952
 UK1, pl.3 (b/w)
 The Horse with Six Heads, 1953,
 bronze FPCr
 Arnason, fig.918 (b/w)
 The Hurricane, 1948-49, bronze
 Arnason, fig.915 (b/w) SwZBec
 Fig.Art, pl.35 (b/w) FPCr
 Hydra, 1954, bronze UIOS
 Selz, p.130 (b/w)

Ogre, 1951, bronze UICF
 Selz, p.131 (b/w)
Praying Mantis, 1949, bronze,
 BAKO
 Fig.Art, pl.33 (b/w)
The Storm, 1948, bronze
 Fig.Art, pl.35 (b/w) FPCr
 L-S, pl.163 (b/w) FPAM
The Top, 1953, lead with color-
 ing by Hans Hartung GDuK
 Trier, fig.120 (col)

RICHTER, Gerhard (German, 1932-)
 Emma-Nude on a Staircase (Emma-
 Akt auf einer Treppe), 1966,
 o/c GCoL
 Kahmen, pl.17 (b/w)
 UK2, pl.37 (b/w)
 Entwurf zu 5 Turen, 1967
 UK2, pl.251 (b/w)
 Female Student (Studentin), 1967,
 o/c
 Kahmen, pl.105 (b/w)
 5 Turen, 1967
 UK2, pl.252 (b/w)
 Landscape, 1970, o/c
 Wilson, pl.58 (col)
 Liebespaar, 1965
 UK2, pl.145 (b/w)
 Madrid, 1968
 UK2, pl.237 (b/w)
 Motorboat, 1965
 UK2, pl.267 (b/w)
 Pedestrians, 1963, o/c, Coll.
 Artist
 Lippard, pl.182 (b/w)
 Die Sphinx von Gise, 1964, o/c,
 GMFr
 New Art, pl.277 (b/w)
 Vorhang, 1965
 UK2, pl.253 (b/w)
 Waiting (Group of Passengers),
 IRTar
 Pellegrini, p.251 (b/w)

RICHTER, Hans (German, 1888-1976)
 Scroll Paintings, installation
 at Galerie Denise Rene, Paris,
 1960
 Abstract, pl.204 (b/w)
 Untitled, 1960, o/c IMGr
 Seuphor, no.224 (col)

RICHTER, Vjenceslav (Yugoslavian,
 1917-)
 Rasver III, 1968, aluminum,

UDCHi
 Hh, pl.904 (b/w)

RICKEY, George (American, 1907-)
 Four Lines Up, 1967, stainless
 steel UMdLL
 Arnason, fig.1088 (b/w)
 Four Planes Hanging, 1966
 UK1, pl.196 (b/w)
 Homage to Bernini, 1958, steel
 kinetic sculpture UNNMMA
 Abstract, pl.281 (b/w)
 Joe's Silver Vine, 1964, steel
 and sterling silver UDCHi
 Hh, pl.846 (b/w)
 Peristyle: Five Lines, 1963-64,
 stainless steel UNBuA
 A-K, p.339 (b/w)
 Peristyle-Four Lines, 1963-64,
 stainless steel, Coll.Artist
 Calas, p.232 (b/w)
 Peristyle-Six Lines II, 1966,
 stainless steel UMoSLMa
 Hamilton, pl.372 (b/w)
 Six Squares, One Rectangle,
 1967, stainless steel
 Calas, p.283 (b/w)
 L-S, pl.148 (b/w)
 Trier, fig.234 (b/w)
 Space Churn with Octagon, 1971,
 stainless steel, Coll.Artist
 Arnason 2, fig.1200 (b/w)
 Summer III, 1962 63, stainless
 steel UDCHi
 Hh, pl.844 (b/w)
 Three Red Lines, 1966, lacquered
 stainless steel UDCHi
 Hh, pl.845 (b/w)
 Two Lines, 1965, steel, Coll.
 Artist
 Ashton, fig.28 (b/w)
 Two Lines Oblique, Twenty-Five
 Feet, 1967-68, stainless
 steel, Coll.Artist
 Hunter, pl.924 (b/w)
 Two Lines Up, 1964
 Popper 2, p.149 (b/w)

RILEY, Bridget (British, 1931-)
 Arrest 1, 1965, emulsion paint
 on canvas ELStu
 Stuyvesant, p.118 (b/w)
 Arrest 4, 1965, emulsion on
 board ELivMo
 Eng.Art, p.179 (b/w)
 Blaze 1, 1962 ELDo

RIS, Gunter Ferdinand (German,
 1928-)
 Bonner Relief, 1966, chromium-
 plated bronze GBoRL
 Trier, fig.244 (b/w)
 Relief in Concrete, Hildegardis
 Gymnasium, Cologne, 1959
 Trier, fig.191 (b/w)

RITSCHL, Otto (German, 1885-)
 Composition 61/54, 1961, o/c,
 Coll.Artist
 Seuphor, no.392 (col)

RIVERA, Manuel (Spanish, 1927-)
 Cabalastic Mirror, 1970, painted
 metal screen over wood
 Dyckes, p.53 (b/w)
 Composition 8, 1956-57, mixed
 media UNNMatC
 Dyckes, p.30 (b/w)
 Melancholy Mirror, 1968, painted
 wire mesh over wood
 Dyckes, p.31 (b/w)
 Metamorfosis Heraldica, 1960,
 wire and wire mesh on wood
 Janis, p.209 (b/w)
 Metamorphosis (Homage to Kafka),
 1963, painted wire mesh over
 aluminum UPPiC
 Dyckes, p.31 (b/w)
 Metamorphosis-Small Sun, 1960,
 painted wire mesh in aluminum
 frame UNNMatC
 Dyckes, p.30 (b/w)
 Mirror of the Sun, 1968, painted
 wire mesh over wood SpCuM
 Dyckes, p.102 (col)
 Spare Metamorphosis, 1961, paint-
 ed wire mesh in aluminum frame,
 UNNMatC
 Dyckes, p.30 (b/w)

RIVERS, Larry (American, 1923-)
 Billboard for the First New York
 Film Festival, 1963, o/c,
 UDCHi
 Hh, pls.814-15 & 977 (b/w &
 col)
 Buick Painting with P, 1960, o/c
 Alloway, fig.15 (b/w)
 Double Portrait of Berdie, 1955,
 o/c UNNW
 Whitney, p.68 (b/w)
 Hunter, pl.592 (b/w)
 Arnason, fig.1033 (b/w)

Double Portrait of John Myers,
 1954, bronze
 Andersen, p.181 (b/w)
Dutch Masters, 1963, oil and
 cardboard on canvas UNNAb
 New Art, col.pl.12
Dutch Masters and Cigars, 1963,
 o/c UNNMa
 Lippard, pl.153 (b/w)
Dutch Masters and Cigars III,
 1963, oil and collage on can-
 vas, Priv.Coll., New York City
 Arnason, fig.1034 (b/w)
Dying and Dead Veteran, 1961,
 o/c UMCheW
 Hunter, pl.627 (col)
The Final Veteran, 1960, o/c,
 UNBuA
 A-K, p.403 (b/w)
French Money I, 1961, o/c, Coll.
 Artist
 Hunter, pl.443 (b/w)
The Friendship of America and
 France, 1961, canvas
 Metro, p.304 (b/w)
The Greatest Homosexual, 1964,
 oil and collage on canvas,
 UDCHi
 Hh, pl.876 (b/w)
 Calas, p.63 (b/w)
Horses, 1959-60
 UK2, pl.174 (b/w)
How to Eat Fish, gouache on
 cloth-mounted paper, Priv.
 Coll., Brussels
 Fig.Art, pl.163 (col)
Molly and Breakfast, 1956, oil
 on masonite UDCHi
 Hh, pl.621 (b/w)
Mr. Art (Portrait of David Syl-
 vester), 1962, o/c UNNMa
 Russell, pl.71 (b/w)
Noses, 1962, watercolor and
 collage
 Calas, p.60 (b/w)
OK Robert OK Negro, 1966, spray
 paint, pencil, collage, Priv.
 Coll.
 Russell, pl.73 (b/w)
Parts of the Body, 1962, collage
 on paper UNNDw
 Kahmen, pl.145 (b/w)
 UK2, pl.134 (b/w)
Parts of the Face, 1961, o/c,
 ELT
 L-S, pl.130 (col)

Three Camels, 1962, o/c
 Metro, p.305 (b/w)
Utamaro's Courtesans, 1974, a/c,
 UNNMa
 Arnason 2, fig.1107 (b/w)
Washington Crossing the Delaware,
 1953, o/c
 Hunter, pl.591 (b/w) UNNMMA
 Compton 2, fig.17 (b/w), Now
 destroyed
Webster and Cigars, 1964-66,
 construction UNNMa
 Russell, pl.111 (b/w)

ROBUS, Hugo (American, 1885-1964)
 Despair, 1927, bronze UNNW
 Whitney, p.105 (b/w)
 Girl Washing Her Hair, 1940,
 marble UNNMMA
 Hunter, pl.492 (b/w)

ROCKBURNE, Dorothea (Canadian)
 A, C & D, 1970, paper, chip-
 board and graphite on chip-
 board
 Rose, p.273 (b/w)
 Gradient and Fields, 1971, pa-
 per, cardboard, nails, char-
 coal UNNByk
 Hunter, pl.888 (b/w)
 Scalar, 1971, paper, chipboard,
 crude oil
 6 Yrs, p.249 (b/w)

ROCKLIN, Raymond (American,
 1922-)
 Clouds, 1956, brass UICBe
 Andersen, p.117 (b/w)

ROEDER, Emy (German, 1890-)
 Self-Portrait, 1958, bronze
 Trier, fig.90 (b/w)

ROHM, Robert (American, 1934-)
 Untitled, 1971, wood, rope,
 sandbags, droplights, Coll.
 Artist
 Hunter, pl.890 (b/w)

ROLLIER, Charles (Swiss, 1912-)
 Actualization of the Body, 1960,
 o/c, Coll.Artist
 Seuphor, no.379 (col)

ROMAGNONI, Giuseppe (Italian,
 1930-1964)
 Racconto, 1963, collage and
 tempera on canvas IMMarC
 Haftmann, pl.1001 (b/w)

ROMATHIER, Georges (French,
 1927-)
 Painting, 1961 FPP
 Seuphor, no.457 (col)

ROMITI, Sergio (Italian, 1928-)
 Untitled, 1961, o/c IBoT
 New Art, pl.108 (b/w)

RONALD, William (Canadian, 1929-)
 Chieftain, 1957, o/c UCtCoR
 1945, pl.172 (b/w)

ROSATI, James (American, 1912-)
 Big Red, 1970-71, painted alumi-
 num UNBuA
 A-K, p.107 (col)
 The Bull, 1951 or 1954, bronze,
 Coll.Artist
 G-W, p.262 (b/w)
 Andersen, p.109 (b/w)
 Delphi II, 1960, bronze UNNMa
 Ashton, pl.XXVII (col)
 Hamadryad, 1957-58, marble,
 UDCHi
 Hh, pl.616 (b/w)
 Andersen, p.110 (b/w)
 Heroic Galley, 1959, bronze
 Andersen, p.111 (b/w)
 Ideogram, 1967-73, stainless
 steel UNNWor
 Arnason 2, fig.1186 (b/w)
 Lippincott I, 1965-67, painted
 Cor-Ten steel, Anon.Coll.
 Hunter, pl.788 (col)
 Phoenix and the Turtle, 1958,
 marble UNNFi
 G-W, pp.274-75 (b/w)
 Shorepoints II, 1967-70, painted
 steel UNNMa
 Hunter, pl.815 (b/w)
 Undine, 1957, Georgia marble,
 UNNRap
 Ashton, fig.21 (b/w)

ROSE, Herbert (American, 1909-)
 Skyline, New York, 1949, o/c,
 UDCHi
 Hh, pl.620 (b/w)

Arnason, fig.991 (b/w)
Sea Sentinel, 1956, steel and
 bronze UNNW
 Hunter, pl.513 (col)
 Rose, p.257 (b/w)
Skylark, 1950-51, steel UNNMat
 Selz, p.135 (b/w)
The Spectre of Kitty Hawk, 1946,
 welded and brazed steel,
 UNNMMA
 Andersen, p.66 (b/w)
 Ashton, fig.16 (b/w)
Surveyor, 1959, steel and silver
 -nickel UNNMat
 Selz, p.140 (b/w)
Thorn Blossom, 1947, steel,
 brazed with nickel silver,
 UNNW
 Andersen, p.67 (b/w)
 Whitney, p.109 (b/w)
 Trier, fig.116 (b/w)
Turret and Belfry, Chapel of the
 Massachusetts Institute of
 Technology, Boston, 1955, alu-
 minum
 Trier, fig.202 (b/w)
Vigil (Architecture Wall in High
 Relief), 1975, bronze, copper,
 nickel UNNMat
 Arnason 2, fig.1047 (b/w)
Whaler of Nantucket, 1952, steel,
 UICA
 Hunter, pl.512 (b/w)
 Hamilton, pl.351 (b/w)
Young Fury, 1950
 UK1, pl.74 (b/w)

ROT, Dieter (German, 1930-)
Extended Embryo (Gedehntes Em-
 bryo), 1964 GCoB
 Kahmen, pl.345 (b/w)

ROTELLA, Mimmo (Italian, 1918-)
Auto-portrait, 1960, torn pos-
 ters
 Janis, p.179 (b/w)
Before or After, 1961, torn
 posters on canvas, Coll.Artist
 Seitz, p.108 (b/w)
Buitos (Artypo), 1970, Coll.
 Artist
 Liverpool, no.34 (b/w)
Come la Gioconda, 1962, torn
 posters
 Metro, p.310 (b/w)
Decollage IRSal

Pellegrini, p.258 (b/w)
Flask of Wine, 1963, torn
 poster IRTar
 Lippard, pl.178 (b/w)
Frigo, 1960, collage ELBo
 Wolfram, pl.90 (b/w)
In Red with Woman, 1961, torn
 posters IRTar
 Wilson, pl.60 (col)
Listening, 1962, decollage,
 Priv.Coll., Milan
 Fig.Art, pl.263 (b/w)
Marilyn Decollage, 1963
 Amaya, p.68 (b/w)
 Wolfram, pl.89 (b/w)
Marilyn Monroe, 1962, decollage,
 NHiB
 Compton 2, fig.171 (b/w)
Metro-Goldwyn-Mayer, 1963, seri-
 agraph on canvas IRSal
 New Art, col.pl.63
Michelin (Artypo), 1970, Coll.
 Artist
 Liverpool, no.33 (b/w)
P.P.A. (Artypo), 1970, Coll.
 Artist
 Liverpool, no.32 (b/w)
Sua Maesta la Regina, 1962, torn
 posters IMAp
 Metro, p.311 (col)
Untitled, 1959, torn posters on
 zinc
 Janis, p.180 (b/w)

ROTHKO, Mark (Russian-American,
1903-1970)
Baptismal Scene, 1945, water-
 color UNNW
 Sandler, p.64 (b/w)
 Arnason, fig.876 (b/w)
Black and Tan on Red, 1957, o/c,
 UNNGros
 Sandler, pl.XIV (col)
Black over Reds, 1957, o/c,
 UMdBMe
 1945, pl.153 (col)
Black, Pink, and Yellow Over
 Orange, 1951-52, o/c UNNRub
 Geldzahler, p.298 (b/w)
 Rose, p.168 (col)
Blue, Orange, Red, 1961, o/c,
 UDCHi
 Hh, pl.959 (col)
Brown and Black on Plum, 1958,
 SwZMey
 Ponente, p.143 (col)

Brown, Black, and Blue, 1958,
o/c UMoSLM
Geldzahler, p.301 (b/w)
Browns, 1957, o/c UNNNewh
Hunter, pl.459 (b/w)
Entombment I, 1946 UNNW
Pellegrini, p.126 (b/w)
Fantasy, 1947, watercolor,
UNNBli
Geldzahler, p.297 (b/w)
Four Darks in Red, 1958, oil,
UNNW
Whitney, p.84 (col)
Sandler, p.182 (b/w)
Geologic Reverie, c.1946, water-
color and gouache UCLCM
Sandler, p.177 (b/w)
Green on Blue, 1956, o/c UAzTUA
Tuchman, p.186 (b/w)
Light Cloud, Dark Cloud, 1957,
o/c UCThoJ
Tuchman, p.187 (col)
Light, Earth and Blue, 1954, o/c,
ELGo
Geldzahler, p.355 (b/w)
Maroon on Blue, 1957-60, o/c,
UCtMeT
Seuphor, no.251 (col)
Mauve Intersection (Number 12),
1948, o/c over composition
board UDCP
Sandler, p.180 (b/w)
Tuchman, p.183 (b/w)
No.7, 1960, o/c UNNMa
Hunter, pl.470 (col)
No.8, 1958, o/c UCtMeT
Seuphor, no.255 (col)
Abstract, pl.28 (col)
Geldzahler, p.300 (b/w)
Number 10, 1950, o/c UNNMMA
Goossen, p.14 (b/w)
Sandler, p.181 (b/w)
No.10, 1952, o/c UWaSWr
Geldzahler, p.299 (b/w)
Number 18, 1949, o/c
Arnason, fig.877 (b/w) UNPV
Hunter, pl.457 (b/w)
Sandler, p.179 (b/w) UNNMMA
Number 24, 1949, o/c UDCHi
Hh, pl.697 (col)
Rose, p.167 (b/w)
Sandler, p.180 (b/w)
Tuchman, p.184 (b/w)
No.26, 1947, o/c UNNPa
Geldzahler, p.297 (b/w)
Hunter, pl.445 (b/w)

Sandler, p.178 (b/w)
Tuchman, p.181 (b/w)
Number 207 (Red Over Dark Blue
on Dark Gray), 1961, o/c UCBC
Geldzahler, p.302 (b/w)
Orange and Yellow, 1956, o/c,
UNBuA
A-K, p.45 (col)
Arnason, col.pl.213
Hamilton, col.pl.57
Sandler, pl.XIII (col)
Orange-Brown, 1963, o/c UMiD
Carmean, p.65 (b/w)
Orange Yellow Orange, 1969, oil
on paper mounted on linen
Arnason 2, col.pl.216 -Ph
L-S, pl.20 (col) UNNMa
Prehistoric Memories, 1946,
watercolor on paper
Rose, p.141 (b/w)
Red and Black, 1959 UNNSto/
Pellegrini, p.195 (col) UNNGol
Red, White and Brown, 1957,
SwBKM
Ponente, p.141 (col)
Haftmann, pl.963 (col)
Reds, No.16, 1960, o/c UNNScu
Geldzahler, p.105 (col)
Slate Blue and Brun on Plum No.
37, 1958, o/c
Metro, p.312 (b/w)
Slow Swirl By the Edge of the
Sea, 1944, o/c, Estate of the
Artist
Hunter, pl.466 (b/w)
Untitled, 1946, watercolor,
UNNBli
Geldzahler, p.295 (b/w)
Sandler, p.177 (b/w)
Untitled, 1948, o/c UCMM
Tuchman, p.182 (b/w)
Untitled, 1951, o/c
Sandler, p.181 (b/w) UCSmoP
Tuchman, p.185 (b/w) UDCPh
Untitled, 1960, o/c UNNMa
Carmean, p.33 (col)
Untitled, 1961, o/c
Metro, p.313 (b/w)
Untitled, 1968
UK2, pl.320 (b/w)
Untitled (Black and Gray), 1969,
a/c UCAtA
Arnason 2, fig.919 (b/w)
Vessels of Magic, 1946-47,
watercolor UNBB
Geldzahler, p.296 (b/w)

Lieberman, p.27 (b/w)
Untitled (red), 1962, oil on
 wood UNNRoJ
 Lieberman, p.15 (col) & p.26
 (b/w)

SALT, John (British, 1937-)
 Arrested Vehicle Broken Window,
 1970, o/c, Priv.Coll.
 UK3, pl.110 (b/w)
 Arrested Vehicle (Writing on
 Roof), 1970, o/c UNNHarr
 UK3, pl.106 (b/w)
 Blue Interior, 1970, o/c,
 UNNHarr
 UK3, pl.105 (b/w)
 Chevy in Green Fields, 1973, o/c,
 GHG
 Battcock, p.47 (b/w)
 Demolished Vehicle (Fat Seats),
 1970, o/c BBrP
 Hunter, pl.694 (b/w)
 Desert Wreck, 1971
 Popper, p.235 (b/w)
 Pioneer Pontiac, 1972-73, o/c
 Battcock (col)
 Pontiac with Tree Trunk, 1973,
 o/c -J
 Battcock, p.33 (b/w)
 Purple Impala, 1973, o/c UNNKar
 Battcock, p.304 (b/w)
 Untitled, 1968-69, o/c UNNHarr
 UK3, pl.104 (b/w)
 White Roofed Wreck Pile, 1971,
 o/c -Re
 Battcock, p.133 (b/w)

SAMARAS, Lucas (Greek, 1936-)
 Autopolaroid, 1970-71, Coll.
 Artist
 Hunter, pl.909 (col)
 Autopolaroids, 1971 UNNPac
 Hunter, pl.879 (b/w)
 Box No.3, 1962-63, mixed media,
 UNNLip
 Arnason, fig.1059 (b/w)
 Box No.41, 1965, wool and wood,
 UNNLip
 Hunter, pl.548 (b/w)
 Box No.43, 1966, mixed media,
 UCLHa
 Hunter, pl.547 (b/w)
 Box No.48, 1966, mixed media,
 UNNJu
 Hunter, pl.634 (col)
 Box #61, 1967, mixed media

Finch, p.69 (b/w)
Mirrored Room (Room No.2), 1966,
 mirrors on wooden frame UNBuA
 A-K, p.323 (col)
 Arnason, fig.1060 (b/w)
 Finch, p.68 (b/w)
 Henri, fig.59 (b/w)
 Hunter, pl.932 (b/w)
 UK1, pls.343-44 (b/w)
Photo-Transformation, 1973, SX-
 70 Polaroid, Priv.Coll.
 Arnason 2, fig.1149 (b/w)
Photo-Transformation, 1973-74,
 SX-70 Polaroid UNNMack
 Arnason 2, fig.1150 (b/w)
Rag Sculpture, 1959-60, burlap
 and plaster, Coll.Artist
 Hunter, pl.639 (b/w)
Untitled, 1962, wood, cloth,
 plastic, etc. UDCHi
 Hh, pl.821 (b/w)
Untitled, 1964, wood box, nails,
 glass, etc. UMNeW
 New Art, pl.13 (b/w)
Untitled, Box Number 3, 1962 or
 1963, pins, rope, stuffed
 bird, wood UNNW
 Whitney, p.119 (b/w)
 Hunter, pl.616 (b/w)

SANCTIS, Fabio de
 Anthropomorph, 1963, oak (in
 collaboration with Ugo Ster-
 pini)
 Fig.Art, pl.132 (b/w)

SANDER, Ludwig (American, 1906-
 1975)
 Arapahoe XVI, 1974, o/c, Priv.
 Coll.
 Arnason 2, col.pl.291
 Cherokee III, 1968, o/c,
 UNNSchwar
 Hunter, pl.739 (col)
 Untitled, 1963, o/c UNBuA
 A-K, p.393 (col)

SANDLE, Michael
 Orange and Lemons, 1966
 UK1, pl.100 (b/w)

SANDLER, Barbara (American,
 1943-)
 Tumbling Tumbleweeds, 1972, o/c
 Battcock, p.305 (b/w)

SANEJOUAND, Jean-Michel (French,
 1934-)
 81 cubitenairs, 1965
 UK1, pl.163 (b/w)
 Map for organizing the summit of
 Vesuvius, 1972
 Popper, p.71 (col)
 Zoe, Charge Object, 1963, assem-
 blage
 Amaya, p.60 (b/w)

SANFILIPPO, Antonio (Italian,
 1923-)
 Fragment, 1965 -Ar
 Pellegrini, p.92 (b/w)
 Frammenti d'ali, 1962, o/c
 New Art, pl.106 (b/w)

SANTOMASO, Giuseppe (Italian,
 1907-)
 Andalusian Song, 1960, Priv.
 Coll., Amsterdam
 Ponente, p.91 (col)
 Double Step, 1960, o/c UICMar
 Seuphor, no.335 (col)
 Fence Pickets (I Basti), 1955,
 oil, Coll.Artist
 Haftmann, pl.854 (b/w)
 Fire of Santa Maria de Mar,
 1959 IMPo
 Pellegrini, p.92 (b/w)
 Nocturnal Song (Canto notturno
 III), 1960, oil, Coll.Artist
 Haftmann, pl.855 (b/w)
 Rossi e gialli della mietura,
 1957, o/c
 1945, pl.46 (col)
 Suite Friulana, 1963, o/c
 New Art, col.pl.55
 Terra di Castiglia, 1961 UNBuA
 Metro, p.315 (col)
 Verso Gravina, 1962, oil, Priv.
 Coll., Zurich
 Metro, p.314 (b/w)
 The White Wall, 1965, tempera,
 UNNKahnM
 Abstract, pl.87 (b/w)

SANTORO, Pasquale (Italian,
 1933-)
 Lafcadio, 1965, wood laths
 New Art, pl.123 (b/w)

SARET, Alan (American, 1944-)
 Untitled, 1970, wood and glass,
 Coll.Artist

 Hunter, pl.864 (col)
 Untitled, 1971, wire, straw,
 rubber, cloth, Coll.Artist
 Hunter, pl.785 (b/w)

SARKIS (Sarkis Sarkisian) (Turkish
 -American, 1909-)
 Exhibition No.5, 1967 FPB1
 Fig.Art, pl.291 (b/w)

SARKISIAN, Paul (American, 1928-)
 Untitled (Mendocino), 1970, a/c,
 UCSFW
 UK3, pl.92 (b/w)

SARKISIAN, Sarkis. See SARKIS

SATO, Key (Japanese, 1906-)
 Birth of Stones, 1958, o/c,
 FPMas
 Seuphor, no.315 (col)
 History of Space (black), 1965,
 o/c UNNRoJ
 Lieberman, p.31 (b/w)
 Of the Essence, 1960-63, oil on
 burlap, Coll.Artist
 Lieberman, p.30 (b/w)

SAUL, Peter (American, 1934-)
 Officer's Club, 1963 IRTar
 Pellegrini, p.217 (b/w)
 Orange Business, 1962, o/c,
 Priv.Coll.
 Compton 2, fig.97 (b/w)
 Society, 1964, o/c UNNFru
 Lippard, pl.74 (b/w)

SAURA, Antonio (Spanish, 1930-)
 Ada, 1962 FPSt
 Pellegrini, p.104 (b/w)
 Aurelia, 1968, etching
 Dyckes, p.143 (b/w)
 Brigitte Bardot, 1959, oil,
 Priv.Coll., Rome
 Haftmann, pl.885 (b/w)
 Collage, 1959, cut paper with
 drawing and painting
 Janis, p.158 (b/w)
 Crucifixion, 1960, oil
 Dyckes, p.23 (b/w)
 Crucifixion VII, 1959, oil,
 FPSta
 Haftmann, pl.882 (b/w)
 Crucifixion (Triptych), 1959-60,
 o/c UDCHi
 Hh, pl.640 (b/w)

Elisabeth Harmister, 1967, o/c,
 FPSt
 Dyckes, p.56 (b/w)
Fele, 1957, Priv.Coll.
 Abstract, pl.78 (b/w)
Gina, 1959, o/c -UW
 Fig.Art, pl.82 (b/w)
Goodbye, 1959, oil UNNG
 Dyckes, p.22 (b/w)
Grande Crucifixion rouge et
 noir, 1963, o/c FPSt
 New Art, pl.139 (b/w)
 Arnason, fig.950 (b/w)
 Pellegrini,p.107 (b/w)
Imaginario retrato de Goya, 1962
 Metro, p.317 (col)
Imaginary Portrait of Goya,
 1963, oil UPPiC
 Dyckes, p.23 (b/w)
Louise, 1960, o/c UICMar
 Seuphor, no.337 (col)
Marta, 1958, o/c
 1945, pl.68 (b/w)
Retrato, 1960, oil, Priv.Coll.,
 Stockholm
 Metro, p.316 (b/w)
The Scream, 1959, oil SpMaM
 Dyckes, p.21 (b/w)
Untitled, 1962, mixed media
 Dyckes, p.22 (b/w)
Untitled, 1966, oil sketch
 Dyckes, p.101 (col)

SCANAVINO, Emilio (Italian,
 1922-)
E morte forse non avra piu do-
 minio, 1961
 Metro, p.318 (b/w)
The Gray Little Square, 1965,
 IMNav
 Pellegrini, p.89 (b/w)
Presenza incombente, 1962
 Metro, p.319 (b/w)
The Warning, 1959, o/c FPChar
 Seuphor, no.337 (col)
The Window, 1964 IMNav
 Pellegrini, p.89 (b/w)

SCARPITTA, Salvatore (American,
 1919-)
Composition, 1960, oil, Priv.
 Coll., France
 Metro, p.323 (col)
Directory, 1960
 UK2, pl.11 (b/w)
Gunner's Mate, 1960, cloth,

naval insignia, etc.
 Janis. p.263 (b/w)
Langhorne, 1961, canvas relief,
 NAS
 Metro, p.322 (b/w)
Out of Step, 1960, cloth and
 wire collage UNNC
 Janis, p.263 (b/w)
Rajo Jack Special, 1964
 Janis, p.302 (b/w)
 UK1, pl.131 (b/w)

SCHAPIRO, Miriam (American,
 1923-)
Keyhole, 1971, a/c
 Rose, p.214 (b/w)
St. Peters, 1965
 UK2, pl.281 (b/w)

SCHEGGI, Paolo (Italian, 1940-
 1971)
Geremia and Galone s.p.a.,
 Bologna, 1969
 UK4, pl.65 (b/w)
Intercamera plastica, 1967
 UK1, pl.336 (b/w)
Interventi plastico-visuale,
 Milan, 1968
 UK4, pl.66 (b/w)
Progression of the Circle, 1965,
 wood -Arc
 Abstract, pl.148 (b/w)

SCHENDEL, Mira (Italian-Brazilian,
 1919-)
Another Droghinas, 1966, rice-
 paper, Priv.Coll.
 Brett, p.47 (b/w)
Droghinas, 1966, knotted rice-
 paper, Priv.Coll.
 Brett, p.46 (b/w)

SCHENK, William
Untitled, 1974, a/c
 Battcock, p.306 (b/w)

SCHEPS, Marc (Israeli, 1933-)
Espace de Reve II, 1963, wood
 New Art, pl.229 (b/w)

SCHIFANO, Mario (Italian, 1934-)
Composition
 Fig.Art, pl.292 (b/w)
Smalto su carta, 1963, o/c IRO
 New Art, col.pl.64
Space, 1965

colored light projections
Metro, p.324 (b/w)
Prime Multiple with Lux 11,
1960, copper-coated steel,
UNNWadd
Arnason, fig.1082 (b/w)
Prisme avec lux II
Busch, fig.127 (b/w)
Projections Luminodynamisme,
1958
UK1, pl.319 (b/w)
Spatiodynamique 17, 1968,
chromed metal and motor UDCHi
Hh, pl.980 (col)
Spatiodynamique 22, 1954, steel
and aluminum UNBuA
A-K, p.341 (b/w)
Tour lumiere cybernetique de
Paris (model), projected for
1975
Busch, fig.125 (b/w)
Tour spatiodynamique et cyber-
netique, mirrors and motors,
BL
Metro, p.325 (b/w)

SCHOLZ, Werner (German, 1898-)
Zirkusreiterin, 1950, o/c
1945, pl.91 (b/w)

SCHONZEIT, Ben (American, 1942-)
Cabbage, 1973, a/c
Battcock, p.308 (b/w)
Dairy Bull (without horns),
1972, a/c
Battcock, p.61 (b/w)
Ice Water Glass, 1973, a/c
Battcock, p.309 (b/w)

SCHOOFS, Rudolf (German, 1932-)
Landscape, 1963, drypoint
New Art, p.306 (b/w)

SCHOONHOVEN, Johannes Jacobus
(Dutch, 1914-)
Relief with Squares, 1964, mixed
media NEA
New Art, pl.159 (b/w)

SCHREIB, Werner (German, 1925-)
Petrification semantique, 1963,
seal ring on wood board IRBie
New Art, pl.315 (b/w)

SCHRODER-SONNENSTERN, Friedrich
(Russian, 1892-)
The Brand Mark of the Moon Cul-
ture (Das Mondkulturschand-
mal), 1960, colored chalk on
cardboard GCoBa
Kahmen, pl.II (col)
Der Friedenshabicht fuhrt den
Friedensengel zum Elysium,
1960, colored pencil on card-
board, Priv.Coll.
New Art, col.pl.132
The Marriage of Adam and Eve,
That Pair of Seekers After
Truth, Solemnized by the
Devil... FPT
Fig.Art, pl.15 (b/w)
Der moralische Monddualism, 1960
UK2, pl.135 (b/w)

SCHUBERT, Peter (German, 1929-)
Savono, 1965, o/c, Coll.Artist
New Art, col.pl.129

SCHULTZE, Bernard (German, 1915-)
Baal-Migof, 1965, polyester on
canvas, wire, textiles, oil,
UNNWise
New Art, col.pl.121
Cham-migof, 1962 IMLu
Metro, p.327 (col)
Drawing, 1960
Seuphor, no.186 (b/w)
Green Migof (Gruner Migof),
1963, color relief, polyester,
oil
Kahmen, pl.195 (b/w)
Orch, 1959, color relief, poly-
ester, o/c FPCor
Kahmen, pl.194 (b/w)
The Painter and His Model, 1967,
mixed media, Coll.Artist
Fig.Art, pl.156 (b/w)
Plastikbild Pymalith, 1960,
FPCor
Metro, p.326 (b/w)
Table du Migof, 1963
Pellegrini, p.79 (b/w)
Torsyt, 1958, o/c
1945, pl.82 (col)
Zlorrib, 1959, wire and natural
material with o/c GDaS
Janis, p.250 (b/w)

SCHULZE, Alfred Otto Wolfgang.
See WOLS

original
Dyckes, p.87 (b/w)
Number 48, 1962, bronze IRAt
Dyckes, p.87 (b/w)
Portrait of Joseph H. Hirshhorn,
1967, plaster UDCHi
Hh, pl.801 (b/w)
Taurobolo, 1960
UK1, pl.79 (b/w)

SERVRANCKX, Victor (Belgian, 1897-
1965)
Opus 5, o/c BBBi
1945, p.60 (b/w)

SERYCH, Jaroslav (Czechoslovakian,
1928-)
Impression, mixed media
New Art, fig.4 (b/w)

SEUPHOR, Michel (Ferdinand Louis
Berckelaers) (Belgian, 1901-)
Coryphee rouge, 1959, collage,
UNNLej
Janis, p.167 (b/w)
In Branches, 1958, drawing,
Priv.Coll., Germany
Seuphor, no.229 (b/w)
Rondo IV, 1957, drawing UCtMeT
Seuphor, no.228 (b/w)

SEVERINI, Gino (Italian, 1883-
1966)
Pastel Drawing, 1949 FPMS
Seuphor, no.209 (col)
Still Life, 1942, oil
Haftmann, pl.622 (b/w)

SHAHN, Ben (Lithuanian-American,
1898-1969)
Brothers, 1946, tempera on
masonite UDCHi
Hh, pl.702 (col)
Liberation, 1945, tempera,
UCtNcS
Haftmann, pl.816 (b/w)
Hunter, pl.324 (b/w)
Mine Building, 1956, silkscreen
and color UNNDo
Metro, p.334 (b/w)
Pretty Girl Milking a Cow, 1940,
tempera on masonite UNNKau
Hunter, pl.325 (b/w)
The Red Stairway, 1944, tempera
on masonite UMoSL
Hunter, pl.298 (col)

Fig.Art, pl.16 (b/w)
Song, 1950, tempera on canvas
mounted on board UDCHi
Hh, pl.539 (b/w)
Study for Goyescas, 1956, water-
color -Ste
Metro, p.335 (b/w)

SHARP, Martin (Australian)
Vincent van Gogh Poster
Walker, pl.54 (col)

SHAW, Kendall (American, 1924-)
Bicycle II, 1965
UK2, pl.254 (b/w)
Gidrud, 1964
UK2, pl.155 (b/w)

SHEMI, Yehiel (Israeli, 1922-)
Sculpture, 1964, iron
New Art, pl.228 (b/w)

SHERWIN, Guy (British, 1948-)
At the Academy, 1974, film
Eng.Art, p.465 (b/w)

SHIELDS, Alan (American, 1944-)
Devil, Devil, Love, 1970, mixed
media UNNCo
Walker, pl.55 (col)
Wow, It's a Real Cannonball,
1972-73, mixed media IMMo
Rose, p.224 (b/w)

SHIMAMOTO, Shozo
Destruction of Object, 1957
UK1, pl.293 (b/w)
Untitled (from First Gutai Thea-
ter Art), Tokyo and Osaka,
May 1957
Kaprow, p.217 (b/w)

SHINODA, Morio (Japanese, 1931-)
Tension and Compression, 1960,
bronze and wire
Lieberman, p.80 (b/w)
Tension and Compression, 1962,
bronze and wire UNNRoJ
Lieberman, p.81 (b/w)

SHINODA, Toko (Japanese, 1913-)
Sadness, 1954, Coll.Artist
Seuphor, no.303 (b/w)

SHIRAGA, Kazno (Japanese, 1924-)
Attacking the red-painted logs

with an ax, Nishinomiya Beach,
 April 1956
 Kaprow, p.219 (b/w)
Making a Work with His Own Body:
 Material is Mind, Tokyo, 1955,
 action
 Henri, fig.108 (b/w)
 Kaprow, p.218 (b/w)
Painting, 1961 FPSt
 Pellegrini, p.100 (b/w)
Some assistants shot arrows onto
 the screen...(from First Gutai
 Theater Art), Tokyo and Osaka,
 May 1957
 Kaprow, p.220 (b/w)
Untitled, 1964, o/c
 Lieberman, p.64 (b/w)
Untitled, 1964, o/c JNagaM
 Lieberman, p.65 (b/w)

SIBURNEY, Alan
 Welcome to Maryland, 1974,
 acrylic on paper -Ro
 Battcock, p.311 (b/w)

SIEGELAUB, Seth
 March 1-31, 1969, exhibition
 catalogue
 6 Yrs, p.79 (b/w)

SIGNORI, Carlo Sergio (Italian,
 1906-)
 Black Portrait, 1958, marble
 G-W, p.280 (b/w)

SILLS, Paul
 Monster Model Fun House, 1965,
 diagram
 Henri, fig.69 (b/w)

SIMON, Sidney (American, 1917-)
 Kiosk, 1961, wood, Coll.Artist
 Seitz, p.120 (b/w)

SIMONETTI, Gianni-Emilio (Italian,
 1940-)
 Archaic Zelotypia, 1966, mixed
 media on canvas BBR
 Abstract, pl.137 (b/w)

SIMPSON, David (American, 1928-)
 Blue, Green Stripe, 1959, o/c
 Seuphor, no.433 (col)

SINGIER, Gustave (Belgian,
 1909-)
 Drawing, 1957 FPFr
 Seuphor, no.491 (b/w)
 Haute Provence II, 1960, o/c,
 FPMP
 Seuphor, no.225 (col)
 Meridian and Sands, 1965
 Pellegrini, p.21 (b/w)
 Navigable Space (Espace naviga-
 ble), 1954, oil SwBBe
 Haftmann, pl.832 (b/w)
 Sea Window, 1957 IRG
 Ponente, p.45 (col)
 Solitude, oliviers et la mer,
 1956, o/c GCoAA
 1945, pl.17 (b/w)
 Watercolour, 1956 FPRe
 Abstract, pl.49 (b/w)

SIQUIEROS, David Alfaro (Mexican,
 1896-1974)
 Flowers, 1962, acrylic on cedar,
 MeMM
 Arnason, fig.959 (b/w)
 Our Contemporary Countenance,
 1947
 Haftmann, pl.808 (b/w)
 Self-Portrait, 1945 MeMN
 Fig.Art, pl.59 (b/w)

SITTER, Inger (Norwegian, 1929-)
 White, 1964, oil and collage,
 Coll.Artist
 New Art, pl.174 (b/w)

SITUATIONIST GROUP
 The Return of the Durutti Column,
 1967
 Henri, fig.148 (b/w)

SKULASON, Thorvaldur (Icelandic,
 1906-)
 Composition, 1962, o/c IcRN
 Arnason 2, col.pl.235

SLEIGH, Sylvia (British)
 Wish You Were Here, 1969, o/c,
 UNNSai
 Calas, p.160 (b/w)

SLIVKA, David (American, 1914-)
 Laocoon, bronze
 Busch, fig.84 (b/w)
 Young Flower, 1958, bronze,
 UNNRosen

Hunter, pl.913 (b/w)
UK1, pl.232 (b/w)
Untitled, 1967, stainless
 steel UNNW
Calas, p.246 (b/w)

SNOW, Michael (American, 1929-)
Five Girl-Panels, 1964, enamel
 on canvas UNNPoi
Lippard, pl.186 (b/w)
Of a Ladder, 1971, photographs
6 Yrs, p.219 (b/w)

SOBIESKI, Joan
Child in the Bank, 1973, a/c
Battcock, p.312 (b/w)

SOBRINI, Francisco (Spanish,
 1932-)
Color Block I, 1970, plexiglass
Dyckes, p.106 (col)
Free in the Wind, 1970, poly-
 ester and steel
Dyckes, p.81 (b/w)
Indefinite Space, 1963, trans-
 parent plexiglass
Dyckes, p.81 (b/w)
Indefinite Spaces S, 1963,
 plexiglass ELT
Compton, pl.19 (b/w)
Kaleidoscope, 1963 (in collabor-
 ation with Joel Stein)
Popper 2, p.214 (b/w)
Structure en Plexiglas, 1963-64
New Art, pl.146 (b/w)
Transformation instable (inter-
 ference structure), 1963 FPRe
Popper 2, p.118 (b/w)
Unstable Displacement, 1968,
 plexiglass UDCHi
Hh, pl.829 (b/w)
Unstable Transformation H2,
 1962-65
Pellegrini, p.184 (b/w)
Unstable Transformation 1PB,
 1971, stainless steel
Dyckes, p.81 (b/w)

SOLDATI, Atanasio (Italian, 1896-
 1953)
Composizione, 1952, o/c
1945, pl.41 (col)
Last Stars IRN
Pellegrini, p.37 (b/w)
Spiritual Architecture (Archi-
 tettura spirituale), 1950,

oil ILegC
Haftmann, pl.668 (b/w)

SOLMAN, Joseph (Russian-American,
 1909-)
Studio Interior with Statue,
 1950, o/c UDCHi
Hh, pl.575 (b/w)

SOMAINI, Francesco (Italian,
 1926-)
Ferito VI, 1961, bronze
Metro, p.338 (b/w)
Iron 5925, 1959, iron IRMe
Trier, fig.115 (b/w)
Large Bleeding Martyrdom, 1960,
 lead UDCHi
Hh, pl.668 (b/w)
Piccolo racconto sul mare,
 1961, bronze
Metro, p.339 (b/w)

SONDERBORG, Kurt R. H. (Danish,
 1923-)
Composition, 1961, tempera on
 paper FPF1
Metro, p.340 (b/w)
Drawing 14.IV.59, India ink on
 paper, Priv.Coll.
Abstract, pl.115 (b/w)
Flying Thought, 1958, o/c
1945, pl.100 (b/w)
Flying Thought, 12.11.1958,
 tempera on paper, Priv.Coll.,
 Paris
Haftmann, pl.887 (b/w)
Gouache, 1958
Pellegrini, p.76 (b/w)
Nautical, 1952 FPF1
Seuphor, no.197 (b/w)
Pellegrini, p.77 (b/w)
Nautical, 1952, tempera GCoW
Haftmann, pl.888 (b/w)
October 25, 1960 from 11:48 P.M.
 to 12:36 A.M., egg tempera,
 FPF1
Seuphor, no.486 (col)
10.VIII.58, 19.27 to 21.30,
 1958, tempera UNNPre
Abstract, pl.22 (b/w)
27.April 65 11.31-12.43, 1965,
 oil tempera UNNLef
New Art, pl.269 (b/w)

SONNIER, Keith (American, 1941-)
Abaca Code-Rectangle, 1976, cast

Ponente, p.53 (col)
Les Martigues, 1952, o/c GCoAA
1945, pl.2 (col)
Oil, 1952 GCoAA
Pellegrini, p.70 (col)
The Roofs, o/c FPAM
Abstract, pl.71 (col)
La Seine, 1954, o/c UDCHi
Hh, pl.666 (b/w)

STAHLY, Francois (German-French,
1911-)
The Castle of Tears (Chateau des
Larmes), 1952, wood FPSp
G-W, p.289 (b/w)
Fontaine des quatre Saisons,
1962
Metro, p.345 (b/w)
La foret de Tacoma, 1962
Metro, p.344 (b/w)
Medusa, 1959, olive wood
Trier, fig.129 (b/w)
Mountain Mothers (An-Di-Andi ou
Les Meres Montagnes), 1956-57,
cherry wood, Coll.Artist
G-W, p.290 (b/w)

STAIGER, Paul (American, 1941-)
The Home of Kirk Douglas, 707
North Canon Drive, 1970, a/c,
UNNT
UK3, pl.127 (b/w)
The Home of Randolph Scott, 156
Copley Place, 1970, a/c,
UCSFWa
UK3, pl.126 (b/w)

STAMOS, Theodoros (American,
1922-)
Ancestral Worship, 1947, pastel,
gouache, ink UNNW
Sandler, p.66 (b/w)
Black Spring, 1960, o/c UNNEm
Seuphor, no.383 (col)
Byzantium II, 1958, o/c UDCHi
Hh, pl.607 (b/w)
High Snow-Low Sun II, 1957, oil,
UNNW
Whitney, p.81 (col)
Levant for E.W.R., 1958, o/c,
UNBuA
A-K, p.29 (col)
Sounds in the Rock, 1946, oil on
composition board UNNMMA
Hunter, pl.419 (b/w)
Stirling VII, 1959, collage

Janis, p.165 (b/w)
Sunrise I, 1957, o/c GEBo
Abstract, pl.25 (b/w)

STAMPFLI, Peter (Swiss, 1937-)
Grand Sport, 1966
UK2, pl.256 (b/w)
The Neck of the Bottle, 1967
Fig.Art, pl.297 (b/w)
Super Sport, 1966
UK2, col.pl.XI

STANCZAK, Julian (Polish-American,
1928-)
Summer Light, 1966
UK2, pl.282 (b/w)

STANKIEWICZ, Richard (American,
1922-)
The Candidate, 1960, steel,
-Mand
Calas, p.51 (b/w)
Europa on a Cycle, 1953, welded
iron and steel FPCor
Janis, p.235 (b/w)
Female, 1954, welded steel -Gar
Janis, p.236 (b/w)
Figure, 1955, iron UDCHi
Hh, pl.589 (b/w)
Gross Bather, 1955, iron
Andersen, p.102 (b/w)
Kabuki Dancer, 1956, steel and
cast iron UNNW
L-S, pl.193 (b/w)
Andersen, p.103 (b/w)
Hunter, pl.596 (b/w)
Rose, p.264 (b/w)
My Bird, 1957, iron and steel,
Coll.Artist
G-W, p.264 (b/w)
No Title, 1974, steel UMWoP
Arnason 2, fig.1078 (b/w)
Our Lady of All Protections,
1958, iron and steel UNBuA
A-K, p.279 (b/w)
Personage, 1960, welded steel,
Coll.Artist
Janis, p.236 (b/w)
Sculpture, 1962, steel
Metro, p.346 (b/w)
Sculpture, 1962, steel
Metro, p.347 (b/w)
Soldier, 1955, welded steel and
iron UNNHell
Janis, p.236 (b/w)
The Travels of the Pussycat

Norwegische Impression, 1963-65
UK2, pl.215 (b/w)
Prof. Karl von Frisch, 1962
UK2, pl.62 (b/w)

STEINWENDNER, Kurt. See STEN-
VERT, Curt

STELLA, Frank (American, 1936-)
Abajo, 1964, a/c UNNC
New Art, pl.42 (b/w)
Agbatana I, 1968, synthetic
polymer UNNW
Whitney, p.96 (col)
Arundel Castle, 1959, o/c UDCHi
Hh, pl.694 (b/w)
Chocorua I, 1965-66, a/c UCLCM
Carmean, p.67 (b/w)
Chocorua III, 1967, fluorescent
alkyd and epoxy paint on can-
vas UNNC
Geldzahler, p.416 (b/w)
Conway III, 1966, fluorescent
alkyd and epoxy paint on can-
vas UNNC
Geldzahler, p.416 (b/w)
Ctesiphon III, 1968, fluorescent
acrylic on canvas GCoW
Geldzahler, p.320 (b/w)
Darabjerd III, 1967, fluorescent
acrylic on canvas UDCHi
Hh, pl.1010 (col)
Effingham I, 1967, fluorescent
alkyd and epoxy paint on can-
vas NEA
Hunter, pl.760 (b/w)
Effingham III, 1966, fluorescent
alkyd and epoxy paint on can-
vas UCLF
Geldzahler, p.419 (b/w)
Empress of India, 1965, metallic
powder, polymer emulsion on
canvas UCLB1
Carmean, p.36 (col)
Fez, 1964, fluorescent alkyd on
canvas UNBuA
A-K, p.369 (col)
Hagmatana II, 1967, a/c,
UNNSchwar
Geldzahler, p.320 (b/w)
Ifafa II, 1964, metallic powder
in acrylic emulsion on canvas,
UNNScu
Rose, p.200 (col)
Ileana Sonnabend, 1963, o/c,
Coll.Artist

Hunter, pl.759 (b/w)
Andersen, p.206 (b/w)
UK2, pl.287 (b/w)
Les Indes Galantes, 1961, o/c
Busch, fig.17 (b/w) -Rub
Hunter, pl.703 (b/w) UIWMa
Jasper's Dilemma, 1962-63, alkyd
on canvas ELPow
Arnason, col.pl.258
Calas, p.194 (b/w)
Jill, 1959, enamel on canvas,
UNBuA
A-K, p.368 (b/w)
Calas, p.193 (b/w)
UK2, pl.286 (b/w)
Lac La Ronge II, 1968, fluores-
cent acrylic on canvas UTxHLe
Carmean, p.37 (col)
Lac Laronge III, 1969, polymer
paint on canvas UNBuA
A-K, p.370 (col)
Lanckorona III, 1971, mixed
media relief UNNRubi
Hunter, pl.727 (col)
Walker, pl.9 (col)
The Marriage of Reason and Squa-
lor, 1959, o/c UNNMMA
Andersen, p.206 (b/w)
Eng.Art, p.312 (b/w)
Hunter, pl.701 (b/w)
Mogielnica II, 1972, mixed media
Rose, p.226 (b/w)
Montenegro I, 1975, lacquer and
oil on aluminum UNNKn
Arnason 2, col.pl.288
Moultonboro III, 1966, fluores-
cent alkyd and epoxy paint on
canvas UNNBurd
Geldzahler, p.416 (b/w)
Moultonboro IV, 1966, a/c
Rose, p.213 (col)
New Madrid, 1961, liquitex on
canvas ELK
L-S, pl.82 (b/w)
Newstead Abbey, 1960, metallic
paint on canvas, Priv.Coll.,
New York
Goossen, p.28 (b/w)
Nunca Pasa Nada, 1964, metallic
powder in acrylic emulsion,
-Lann
Geldzahler, p.316 (b/w)
Oil, 1963 FPSon
Pellegrini, p.149 (b/w)
Ossippee I, 1966, fluorescent
alkyd and epoxy paint on can-

Eng.Art, p.191 (b/w)
Sfumato, 1963, o/c ELStu
 Stuyvesant, pp.134-35 (b/w)
 New Art, pl.82 (b/w)

STERN, Bert
 The Last Sitting, 1962
 UK2, pl.84 (b/w)
 Marcel Duchamp, 1967
 UK2, pl.59 (b/w)
 Marilyn Monroe, 1962
 UK2, pl.103 (b/w)

STERPINI, Ugo
 Anthropomorph, 1963, oak (in
 collaboration with Fabio de
 Sanctis)
 Fig.Art, pl.132 (b/w)

STEVENS, Graham
 Canalysis, 1970
 Popper, p.109 (b/w)
 Inflatable, St.Catherine Dock,
 London
 Popper, p.111 (col)
 Overland, Over water, Airbourne,
 Submarine Transport System,
 Cornwall, 1971
 Popper, p.109 (b/w)

STEVENSON, Harold (American,
 1929-)
 An American in the Museum of
 Naples, 1971, o/c
 Battcock, p.313 (b/w)
 Black Fates I, 1973, o/c -Ja
 Battcock, p.314 (b/w)
 Love is an offering-length of a
 chain IV, 1965
 UK2, pl.209 (b/w)
 Oil, 1962 FPCle
 Pellegrini, p.219 (b/w)

STEZAKER, John (British, 1949-)
 Liberty Misleading the People,
 1975, photoprint, Coll.Artist
 Eng.Art, p.405 (col)
 Mundus, 1973, perspex and wood,
 ELGr
 Walker, pl.61 (col)
 Eng.Art, p.327 (b/w)
 Subject-Object, 1975
 Eng.Art, p.328 (b/w)
 Who? What? Why?, 1974, photo-
 graphic panels, Coll.Artist
 Eng.Art, pp.401-04 (b/w)

STILL, Clyfford (American, 1904-)
 April 1962, 1962, o/c UNBuA
 A-K, p.41 (col)
 Fear, 1945, oil on paper UNNPa
 Sandler, p.158 (b/w)
 Jamais, 1944, o/c IVG
 Hunter, pl.467 (b/w)
 Rose, p.163 (b/w)
 1943-A, oil on blue cloth, Coll.
 Artist
 Rose, p.163 (b/w)
 1944-N No.1, 1944, o/c, Coll.
 Artist
 Tuchman, p.191 (b/w)
 1945, 1945, o/c UNNMa
 Sandler, p.68 (b/w)
 1946-E, 1946, o/c UNNMa
 Sandler, p.162 (b/w)
 1946-H, 1946, o/c UCBeW
 Tuchman, p.192 (b/w)
 1947-R No.2, 1947, o/c UCBeW
 Tuchman, p.193 (col)
 1948, 1948, o/c UNNMa
 Sandler, p.162 (b/w)
 1949-G, 1949, o/c UNNMa
 Sandler, p.163 (b/w)
 1950-1, 1950, o/c, Coll.Artist
 Tuchman, p.195 (b/w)
 1950-A No.2, 1950, o/c UDCHi
 Hh, pl.710 (col)
 Tuchman, p.194 (b/w)
 1951-N, 1951, o/c UNNMa
 Sandler, pl.XII (col)
 1954 (formerly Red and Black),
 1954, o/c UNBuA
 Sandler, p.166 (b/w)
 Abstract, pl.27 (b/w)
 1955-6, 1955, o/c, Coll.Artist
 Tuchman, p.197 (b/w)
 1955-K, 1955, o/c, Coll.Artist
 Tuchman, p.196 (b/w)
 1957-D no.1, 1957, o/c UNBuA
 L-S, pl.27 (col)
 Geldzahler, p.110 (col) &
 p.352 (b/w)
 1960-F, 1960, o/c UNNMa
 Carmean, p.40 (col)
 1960-R, 1960, o/c
 Hh, pl.770 (col) UDCHi
 Sandler, p.170 (b/w) UNNMa
 1962-D, 1962, o/c UNNMa
 Sandler, p.171 (b/w)
 1964, 1964, o/c UNNMa
 Sandler, p.171 (b/w)
 No.1, 1941, o/c ELPo
 Seuphor, no.260 (col)

L-S, pl.154 (b/w)
Electromagnetic (Electromagne-
tique), 1964 FPIo
Kahmen, pl.228 (b/w)
Electromagnetic telepainting
No.4, 1964, permanent magnet,
electromagnet, steel, wire
Brett, p.33 (b/w)
First Telemagnetic Sculpture,
1959, Coll.Artist
Brett, pp.28-29 (b/w)
Indicator Time-to-go, 1969,
plexiglass and magnets
Calas, p.289 (b/w)
Light Signal, 1966
Busch, fig.111 (b/w)
Lignes paralleles
Busch, fig.107 (b/w)
Magnetic Ballet, 1961, electro-
magnet and 2 permanent magnets,
Priv.Coll.
Brett, pp.30-31 (b/w)
Magnetron II, 1966, metal, mag-
net, nylon, needle
Calas, p.288 (b/w)
Musical, 1964
Busch, fig.110 (b/w)
Pendule magnetique, 1962
Busch, fig.108 (b/w)
Signal, 1956
Popper 2, p.141 (b/w)
Signal, 1966, steel
Abstract, pl.285 (b/w), Coll.
Artist
L-S, pl.153 (b/w) UTxIIMen
Signal 'Insect-Animal of Space',
1956, iron, steel, bronze ELT
Compton, pl.29 (b/w)
Tableau Tele-magnetique, 1959,
magnet and steel IMSc
Metro, p.361 (b/w)
Telelight: Cosmic flower in a
blue cage, 1964, mercury-vapor
lamp and electromagnet, Coll.
Artist
Brett, p.32 (b/w)
Tele-lumiere, 1962, glass, mer-
cury, etc.
Metro, p.360 (b/w)
Telelumiere, 1963-67 FPC
Busch, fig.99 (b/w)
Telemagnetic Musical, 1966,
electromagnetic construction,
UNNWise
Arnason, fig.1087 (b/w)
Telemagnetic Sculpture, 1959,

magnet and iron FPCle
Trier, fig.23 (b/w)
Tele-magnetique vibratif, 1962
Busch, fig.106 (b/w)
'Tele'-Peinture Electromagne-
tique III, 1964, o/c FPIo
New Art, pl.53 (b/w)
2 Oscillating Parallel Lines,
1970
Busch, fig.112 (b/w)

TAL COAT, Pierre (French, 1905-)
Composition, 1962, o/c
Metro, p.362 (b/w)
Composition, 1962
Metro, p.363 (b/w)
Painting, 1958 FPB
Seuphor, no.243 (col)
Painting, 1960 FPMa
Seuphor, no.242 (col)
Passage, 1957, o/c FPMa
Abstract, pl.72 (b/w)
Pathway at the Bottom of the
Valley, 1956 FPAM
Ponente, p.92 (col)
Peint sur le rocher, 1955, o/c,
FPMa
1945, pl.19 (b/w)
Red Patches on Rock (Points
rouges sur le rocher), 1953,
oil FPMa
Haftmann, pl.844 (b/w)

TAMAYO, Rufino (Mexican, 1899-)
Animals, 1941, oil UNNMMA
Haftmann, pl.807 (b/w)
Imagen en el Espejo, 1961, oil
Metro, p.366 (b/w)
Man in Face of the Infinite,
1950, o/c BBR
Fig.Art, pl.138 (b/w)
Negro sobre ocre, 1962
Metro, p.367 (col)
Portrait of Dubuffet, 1972, o/c,
UNNPer
Arnason 2, fig.1010 (b/w)
Woman in Gray, 1959, o/c UNNG
Arnason, fig.958 (b/w)

TAMBELLINI, Aldo
Black Zero, 1965, simultaneous
sequence
UK4, pl.101 (b/w)

TANAKA, Atsuko (Japanese, 1932-)
Fantastic Garments for the

Stage, Osaka, 1957
 Kaprow, p.221 (b/w)
 UK1, pl.115 (b/w)
 UK4, pl.25 (b/w)
Figure Costumes with Electric
 Bulbs, 1957
 Janis, p.271 (b/w)
Light Costume, 1956
 Henri, fig.107 (b/w)
Painting, 1962, vinyl color on
 canvas FPFran
 New Art, col.pl.87
Untitled, 1964, vinyl on canvas,
 UNNMMA
 Lieberman, p.18 (col)
Untitled, 1964, vinyl on canvas,
 JTMi
 Lieberman, p.87 (b/w)

TANDBERG, Odd (Norwegian, 1924-)
 Free-Standing Garden Wall, 1962,
 terrazzo NoON
 New Art, pl.172 (b/w)

TANGE, Kenzo (Japanese, 1913-)
 Monument JHiP
 UK1, pl.250 (b/w)

TANGUY, Yves (French-American,
 1900-1955)
 Fear, 1949, oil UNNW
 Whitney, p.53 (col)
 Indefinite Divisibility, 1942,
 o/c UNBuA
 A-K, p.211 (b/w)
 Arnason, fig.571 (b/w)
 Imaginary Numbers, 1954, o/c,
 UNNMat
 Fig.Art, pl.119 (b/w)
 Naked Water, 1942, o/c UDCHi
 Hh, pl.484 (b/w)
 The Rapidity of Sleep, 1945, o/c,
 UICA
 L-S, pl.12 (b/w)
 Slowly Toward the North, 1942,
 o/c UNNMMA
 Arnason, fig.570 (b/w)
 La tour marine, 1944, oil,
 UMoSLWa
 Haftmann, pl.552 (b/w)

TANNING, Dorothea (American,
 1910-)
 Even the Young Girls, 1966, o/c,
 Priv.Coll., Paris
 Fig.Art, pl.107 (b/w)

TAPIES, Antonio (Spanish, 1923-)
 Arc, 1967
 UK2, pl.13 (b/w)
 Bag's Blue, 1970, mixed media
 Dyckes, p.13 (b/w)
 Black with Red Stripe, 1963,
 o/c UNNJ
 New Art, col.pl.67
 Black with Two Lozenges, 1963,
 o/c, Priv.Coll., Buenos Aires
 L-S, pl.53 (col)
 Brown and Ocher, o/c UICMar
 Seuphor, no.333 (col)
 C.89 Grey Ochre Square, Priv.
 Coll., Johannesburg
 Abstract, pl.20 (col)
 Collage, 1961 GWurS
 Kahmen, pl.335 (b/w)
 Cover for Dau al Set magazine,
 1949
 Dyckes, p.9 (b/w)
 Double Beige Door, 1960 NEA
 Ponente, p.173 (col)
 Dream Garden, 1949, oil GCoW
 Dyckes, p.11 (b/w)
 The Envelope (L'Enveloppe), 1967,
 lithograph FPMa
 Castleman, p.73 (col)
 Gouache on Paper, 1967 FPMa
 Abstract, pl.117 (b/w)
 Great Painting, 1958, oil and
 sand on canvas UNNG
 Hamilton, pl.355 (b/w)
 Hieroglyphics, 1958, mixed media,
 GML
 Haftmann, pl.937 (b/w)
 Illustration for Dau al Set maga-
 zine, 1949
 Dyckes, p.10 (b/w)
 Landscape (Red), 1953, encaustic
 Dyckes, p.11 (b/w)
 Large Picture in Blue (Gran pin-
 tura azul), 1957, sand and
 cement FPD
 Haftmann, pl.938 (b/w)
 Materia Organica Sobre Blanco,
 1974, sand and mixed media on
 canvas UNNJ
 Arnason 2, fig.1030 (b/w)
 Newspaper, 1969, etching and
 lithograph
 Dyckes, p.143 (b/w)
 Number 16, 1959, collage with
 oil
 Janis, p.158 (b/w)
 Ocre-Grey, 1963

TURTURRO, Domenick (American, 1936-)
Water, 1967, o/c UDCHi
Hh, pl.879 (b/w)

TUTTLE, Richard (American, 1941-)
Drift 3, 1965, painted wood, Coll.Artist
Hunter, pl.764 (b/w)
First Green Octagon, 1967, dyed canvas UNNPa
Hunter, pl.887 (b/w)
Red Octagon, 1967, dyed canvas, UNNPa
Hunter, pl.887 (b/w)
Violet Octagon, 1967, dyed canvas UNNPa
Hunter, pl.887 (b/w)

TWOMBLY, Cy (American, 1928-)
August Notes from Rome, 1961, oil and pencil on canvas, UDCHi
Hh, pl.868 (b/w)
A Crime of Passion, 1960, oil, chalk and crayon on canvas, GCoW
Abstract, pl.120 (b/w)
Mars and Venus, 1962, pencil and colored pencil on paper GCoZ
Kahmen, pl.341 (b/w)
Triumph of Galatea, 1961 IRTar
Metro, p.377 (col)
Untitled, 1957, oil on cardboard and linen GCoMu
Kahmen, pl.338 (b/w)
Untitled, 1959, pencil on paper, Priv.Coll.
Kahmen, pl.339 (b/w)
Untitled, 1962 IRTar
Pellegrini, p.269 (b/w)
Untitled, 1969, oil and crayon on paper UNNC
Hunter, pl.777 (b/w)
Untitled, 1969, oil and crayon on canvas UNNW
Calas, p.135 (b/w)
Venere Anadiomene, 1962 IRTar
Metro, p.376 (b/w)

TWORKOV, Jack (Polish-American, 1900-)
Boon, 1960, o/c, Priv.Coll.
Arnason, fig.861 (b/w)
Brake II, 1960, o/c UNNEas
Seuphor, no.380 (col)

Crest, 1957-58, o/c UOC1A
Abstract, pl.37 (b/w)
Duo I, 1956, oil UNNW
Whitney, p.67 (b/w)
Haftmann, pl.907 (b/w)
East Barrier, 1960, o/c UNBuA
A-K, p.53 (b/w)
House of the Sun, 1953, o/c, Coll.Artist
Hunter, pl.410 (b/w)
LP No.1, 1961, liquitex on paper
Metro, p.379 (col)
Nightfall, 1961, o/c
Metro, p.378 (b/w)
North American, 1966, o/c, Coll. Artist
L-S, pl.76 (b/w)
Pink Mississippi, 1954, o/c, UNNSta
1945, pl.156 (col)
Q1-75-#4, 1975, o/c -Hoff
Arnason 2, fig.901 (b/w)
Script, 1962 UNNC
Pellegrini, p.122 (b/w)
Watergame, 1955, o/c UNNEas
Rose, p.177 (b/w)

UBAC, Raoul (Belgian, 1910-)
Corps, 1962, slate
Metro, p.380 (b/w)
Mur, 1956-58, o/c FPMa
1945, pl.34 (b/w)
Objects, 1959, o/c FPMa
Seuphor, no.223 (col)
Slate Relief, 1954
Trier, fig.169 (b/w)
Still-Life with Tangled Skein, 1952, oil FPMa
Abstract, pl.67 (b/w)
Torse, 1961, slate
Metro, p.381 (b/w)
The Tree: Stele, 1961, slate, UDCHi
Hh, pl.897 (b/w)

UECKER, Gunter (German, 1930-)
Field in Motion, 1964 GDusSc
Pellegrini, p.270 (b/w)
Flotter flottant, 1959
Popper 2, p.248 (b/w)
Lichtregen, 1966
UK1, pl.324 (b/w)
Light-disc, 1960, hardboard, sacking, nails, motor GKrefW
L-S, pl.147 (b/w)
Moving Field III, 1964, nails on

tych of engraved plates, Priv.
Coll.
 Arnason, fig.1098 (b/w)
 Abstract, pl.197 (b/w)
Spatial Development in Units,
 1964, metal multiple
 Abstract, pl.202 (b/w)
Supernovae, 1959-61, canvas ELT
 Barrett, p.29 (b/w)
 Compton, pl.1 (b/w)
 UK2, pl.272 (b/w)
Tau-Ceti, 1964 FPRe
 Popper 2, p.9 C (b/w)
 Janis, p.314 (b/w)
Tolna, 1953-58, o/c
 Abstract, pl.195 (b/w)
Transparency, 1953 FPRe
 Barrett, p.55 (b/w)
TriDim-A, 1968 FPRe
 Barrett, p.61 (b/w)
Untitled, 1964
 Pellegrini, p.268 (col)
Untitled, 1968, collage con-
 struction UNNLejw
 Calas, p.171 (b/w)
Untitled, 1968, tempera on paper
 on board UNNLejw
 Calas, p.171 (b/w)
Vega, 1956 or 1957, o/c FPRe
 Barrett, p.8 (b/w)
 Arnason, fig.1099 (b/w)
Vega-Nor, 1969, o/c UNBuA
 A-K, p.317 (b/w)
Vonal-KSZ, 1968, o/c, Coll.
 Artist
 Arnason, col.pl.246
Zebegen, 1964, gouache, Coll.
 Artist
 Arnason, col.pl.245
Zebras, 1932-42 FPRe
 Barrett, p.53 (b/w)
Zombor, 1949-53, oil FPAM
 Haftmann, pl.972 (b/w)

VASSILAKIS, Panayiotis. See TAKIS

VAUGHAN, Keith (British, 1912-)
 Assembly of Figures VIII, 1964,
 o/c ELStu
 Stuyvesant, p.53 (b/w)
 Blackmore Church, 1961, o/c
 New Art, pl.95 (b/w)
 Figures by a Torn Tree Branch,
 1946, o/c, Priv.Coll., London
 1945, pl.132 (b/w)

VAUTIER, Ben. See BEN

VEDOVA, Emilio (Italian, 1919-)
 For Spain N.6, 1962 -Marl
 Pellegrini, p.86 (b/w)
 Homage to Garcia Lorca, 1959,
 o/c
 Seuphor, no.326 (col)
 Image of Time, 1957, tempera,
 IBrC
 Abstract, pl.85 (b/w)
 Invasion, 1952, tempera IBrC
 Haftmann, pl.883 (b/w)
 Lettera aperta, 1957, tempera on
 cardboard
 1945, pl.47 (col)
 Per la Spagna, 1962
 Metro, p.388 (b/w)
 Plurimi di Berlino, 1964, mixed
 media ELMa
 New Art, col.pl.50
 Plurimo N.8 Feet on Top, 1962-
 63 -Marl
 Pellegrini, p.85 (b/w)
 Presenza, 1959
 Metro, p.389 (col)
 (Tumult) Image of Time, No.6V,
 1958 IMPan
 Ponente, p.80 (col)
 Warsaw No.IV, 1959-60 UNNHe
 Ponente, p.81 (col)
 White, Black, Grey, 1959,
 tempera IRMarl
 Haftmann, pl.884 (b/w)

VEGA, Jorge de la (Argentinian,
 1930-)
 The Diary of Saint Louverture,
 n.d., mixed techniques UCOA
 New Art, pl.219 (b/w)
 The Four Legged Table, 1965,
 UNNBoni
 Pellegrini, p.226 (b/w)
 Arnason, fig.954 (b/w)

VELA, Vicente (Spanish, 1931-)
 Painting, 1958, o/c
 1945, pl.71b (b/w)

VELDE, Bram van (Dutch, 1895-)
 Composition, 1961, o/c NAS
 Metro, p.384 (b/w)
 Composition, 1970, o/c, Priv.
 Coll.
 Arnason 2, fig.1016 (b/w)
 Gouache, 1939-40 FPPu

1971, oil UNNW
Whitney, p.97 (b/w)

WELLS, John (British, 1907-)
 Involute No.6, 1962, oil on
 hardboard ELStu
 Stuyvesant, p.42 (b/w)

WELSBY, Chris (British)
 Seven Days, 1974, film
 Eng.Art, p.467 (b/w)

WERNER, Theodor (German, 1886-)
 In Bewegung, 1957, oil with
 tempera on cardboard
 1945, pl.46 (col)
 No.122, 1959, oil on paper,
 Coll.Artist
 Seuphor, no.355 (col)
 Nr.I/64, 1964, oil on fiber-
 board GMRu
 New Art, col.pl.114
 Source, 1951, oil, Coll.Artist
 Haftmann, pl.860 (b/w)

WERNER, Woty (German, 1903-)
 Harlekinade, 1956, tapestry
 1945, pl.84 (col)
 Ouverture, 1964-65, wool
 tapestry GBoE
 New Art, pl.280 (b/w)

WERTHMANN, Friedrich (German,
 1927-)
 Gordischer Knoten, 1963, tung-
 sten steel ELouC
 New Art, pl.334 (b/w)

WESLEY, John (American, 1928-)
 Captives, 1962, o/c
 Kahmen, pl.140 (b/w)
 UK2, pl.44 (b/w)
 Holstein, 1964, o/c UNNEl
 Lippard, pl.148 (b/w)
 Polly, 1963 UNNEl
 Pellegrini, p.240 (b/w)
 Service Plaque for a Small Le-
 gion Post, 1962, o/c UCLK
 Lippard, pl.11 (b/w)
 Sheila and the Apes, 1965, o/c,
 UNNEl
 Compton 2, pl.137 (col)
 Six Maidens, 1962, o/c UNNEl
 Kahmen, pl.141 (b/w)
 UK2, pl.42 (b/w)
 Squirrels, 1965, oil and liqui-

tex on canvas UNNEl
 Lippard, pl.130 (col)
 Tea Tray with Five Maidens,
 1962, o/c, Priv.Coll., New
 York City
 Arnason, fig.1056 (b/w)

WESSEL, Wilhelm (German, 1904-)
 Relief, 1956, shells, stones,
 wood, etc.
 Janis, p.250 (b/w)

WESSELMAN, Tom (American, 1931-)
 Bathtub Collage No.1, 1963, con-
 struction and mixed media
 Compton 2, fig.130 (b/w) UNNKr
 Russell, pl.8 (b/w) GMS
 Bathtub Collage No.3 (Nude),
 1963, mixed media
 Alloway, pl.1 (col) & fig.16
 (b/w) GCoW
 Lippard, pl.92 (col) UNNJa
 Bedroom Painting No.1, 1967,
 o/c UNNJa
 Compton 2, fig.5 (col)
 Bedroom Tit Box, 1968-70, oil,
 acrylic collage, human breast,
 UNNJa
 Hunter, pl.659 (b/w)
 Blonde Listening to the Radio,
 1959, collage on paper, Coll.
 Artist
 Compton 2, fig.126 (b/w)
 Gan N.74, 1965 UNNJa
 Pellegrini, p.239 (b/w)
 Gan N.75, 1965, color study
 UK2, col.pl.III
 Gan 48, 1963
 UK2, pl.242 (b/w)
 Great American Nude, 1967
 UK2, pl.36 (b/w)
 Great American Nude No.1, 1961,
 o/c -UG
 Compton 2, fig.129 (b/w)
 Great American Nude No.10, 1961,
 o/c with collage UCPaR
 Lippard, pl.64 (b/w)
 Great American Nude 26, 1962,
 oil and collage on canvas,
 UIWMa
 Alloway, fig.45 (b/w)
 Great American Nude No.38, 1963,
 o/c UIWMa
 Compton 2, fig.128 (b/w)
 Great American Nude no.44, 1963,
 assemblage painting UNNScu

GDaS
Kahmen, pl.153 (b/w)
Untitled, 1968, pencil GCoZ
Kahmen, pl.147 (b/w)
Untitled, 1968, pencil GCoZ
Kahmen, pl.148 (b/w)

WESTERIK, Co (Jacobus) (Dutch,
1924-)
Schoolmaster with Child, 1961,
o/c NLoB
New Art, pl.151 (b/w)
To Cut Oneself with Grass, 1966,
oil on panel NAS
Fig.Art, pl.94 (b/w)

WESTERMAN, Horace Clifford (Amer-
ican, 1922-)
About a Black Magic Maker, 1959-
60, slot machine and various
objects UNNFru
Seitz, p.85 (b/w)
Janis, p.135 (b/w)
Angry Young Machine, 1959, metal
and wood UICF
Andersen, p.143 (b/w)
The Evil New War God, 1958,
brass, partly chrome-plated,
UNNLip
Selz, p.145 (b/w)
The Great Mother Womb, 1957,
wood and metal -Marm
Andersen, p.143 (b/w)
Memorial to the Idea of Man If
He Was an Idea, 1958, wood and
metal UICMa
Selz, pp.142-43 (b/w)
The Mysterious Yellow Mausoleum,
1958, wood UICN
Selz, p.144 (b/w)
Rotting Jet Wing, 1967, glass,
wood and green material GCoB
Kahmen, pl.181 (b/w)
Westermann's Table, 1966, ply-
wood and books
Busch, fig.42 (b/w), Priv.
Coll., Paris
UK1, pl.92 (b/w)
Hunter, pl.633 (col) FPB
White for Purity, 1959-60, plas-
ter, glass, wood, metal
Hunter, pl.806 (b/w) UICB
Lippard, pl.19 (b/w) UNNFru

WESTPFAHL, Conrad (German, 1891-)
Colored Pencil VI, 1960 FPCaz

Seuphor, no.472 (col)
Colored Pencil VIII, 1960 FPCaz
Seuphor, no.471 (col)

WEWERKE, Stefan (1928-)
Chair-Piece (from 'Strategy: Get
Arts', Edinburgh, 1970), mixed
media
Henri, fig.125 (b/w)

WHITE, Charles (American, 1918-)
The Mother, 1952, sepia ink on
paper UDCHi
Hh, pl.583 (b/w)
Wanted Poster Number Four, 1969,
oil on composition board UNNW
Whitney, p.79 (b/w)

WHITELEY, Brett (Australian,
1939-)
Kiss, 1967
UK2, pl.170 (b/w)
.....No, 1968
UK2, pl.262 (b/w)
Untitled, 1960 ELCont
Seuphor, no.270 (col)
Women in the Bath IV, 1964, oil
and tempera on canvas ELMa
Fig.Art, pl.92 (b/w)

WHITMAN, Robert (American, 1935-)
The American Moon, New York,
1960, action
Henri, figs.81-83 (b/w)
Janis, p.277 (b/w)
Kaprow, nos.42-46,56 (b/w)
UK4, pls.27-28 (b/w)
Cinema Piece, 1968
UK4, pl.68 (b/w)
Cinema Piece (Shower), 1967
Henri, fig.84 (b/w)
UK2, pl.52 (b/w)
E.G., 1960, happening
Kaprow, no.14 (b/w)
Mouth, 1961, happening
Kaprow, nos.7 & 47 (b/w)
Pond, 1968, environment, Coll.
Artist
Hunter, pl.934 (b/w)
Rose, p.276 (b/w)
Untitled, 1958, assemblage
Kaprow, no.30 (b/w)
Vibrating Mirror Room, 1968
UK4, pl.62 (b/w)

Lieberman, p.44 (b/w)

YAMAGUCHI, Katsuhiro (Japanese,
 1928-)
 Jet, 1964, cloth over metal
 wire, Coll.Artist
 Lieberman, p.73 (b/w)

YAMAGUCHI, Takeo (Korean-Japanese,
 1902-)
 Enshin, 1961, oil on wood JTMi
 Lieberman, p.23 (b/w)
 TAKU, 1961, oil on wood UNNMMA
 New Art, pl.204 (b/w)

YAMAMOTO, Sei (Japanese, 1915-)
 Sarusawa Pond, 1964, o/c UNNRoJ
 Lieberman, p.42 (b/w)
 Yoshino Path, 1964, o/c UNNRoJ
 Lieberman, p.43 (b/w)

YAMASAKI, Tsuruku
 Untitled Performance (from Gutai
 Theater Art), Sankei Hall,
 Osaka, Nov.1962
 Kaprow, p.222 (b/w)
 Work No.5-Turning Silver Wall,
 1962
 UK2, pl.406 (b/w)

YEATS, Jack Butler (British, 1871-
 1957)
 Tales of California Long Ago,
 1953, o/c UDCHi
 Hh, pl.622 (b/w)

BEN-YEHUDA, Yehuda
 Untitled, 1970, plastics
 UK3, pl.64 (b/w)
 Untitled, 1970, plastics
 UK3, pl.65 (b/w)

YOSHIHARA, Jiro (Japanese, 1905-)
 Untitled, 1959 -Tap
 Pellegrini, p.99 (b/w)
 Untitled, 1962, o/c FPTap
 Lieberman, p.29 (b/w)

YOSHIHARA, Michio
 Untitled Theater Ensemble (from
 Gutai Theater Art), Osaka,
 Nov.1962
 Kaprow, p.222 (b/w)

YOSHIMURA, Fumio (Japanese,
 1926-)
 Motorcycle, 1973, wood
 Battcock, p.109 (b/w)

YOSHIMURA, Masanobu (Japanese,
 1932-)
 Coffer, 1963, plaster on wood
 and canvas, Coll.Artist
 Lieberman, p.84 (b/w)
 Two Columns, 1964, plaster on
 wood UNNMMA
 Lieberman, p.85 (b/w)

YOSHIOKO, Yasuhiro
 Foto, 1968
 UK2, pl.46 (b/w)
 Foto, 1968
 UK2, pl.47 (b/w)

YOUNGERMAN, Jack (American,
 1926-)
 Anajo, 1962, o/c
 Rose, p.195 (b/w)
 Black Yellow Red, 1964, o/c,
 UNNPa
 Hunter, pl.708 (b/w)
 Delfina, 1961, o/c UNBuA
 A-K, p.395 (col)
 Palma, 1964-65 UNNPa
 Pellegrini, p.149 (b/w)
 Roundabout, 1970, a/c UNBuA
 Hunter, pl.733 (col)
 September White, 1967, a/c,
 UDCHi
 Hh, pl.905 (b/w)
 Totem Black, 1967, o/c UNNPa
 L-S, pl.73 (b/w)

YUNKERS, Adja (Latvian-American,
 1900-)
 Tarassa X, 1958, pastel on
 paper UDCHi
 Hh, pl.661 (b/w)

YVARAL (Jean-Pierre Vasarely)
 (French, 1934-)
 Acceleration No.18, Series B,
 1962, wood and plastic UDCHi
 Hh, pl.827 (b/w)
 Instabilite, 1963 FPRe
 Popper 2, p.231 (b/w)
 Interference A, 1966 FPRe
 Barrett, p.99 (b/w)
 Kinetic Relief-Optical Accelera-
 tion, 1963, painted card, vinyl

thread, etc. ELT
 Compton, pl.5 (b/w)
Optical Acceleration, 1964-65,
 -Ren
 Pellegrini, p.184 (b/w)
Polychromatic Diffraction, 1970,
 a/c UNBuA
 A-K, p.318 (col)

ZACK, Leon (Russian, 1892-)
 Grisaille Painting, 1960 FPMas
 Seuphor, no.484 (b/w)

ZADKINE Ossip (Russian, 1890-1967)
 The Destroyed City (Monument of
 Rotterdam), 1951-53, bronze,
 NRC
 Trier, fig.179 (b/w)
 The Forest Dreamer, 1952, pink
 limestone BAKO
 Fig.Art, pl.38 (b/w)
 Monument, 1953-54 NR
 UK1, pl.238 (b/w)
 Small Orpheus, 1948, bronze,
 GDuK
 Trier, fig.57 (b/w)

ZAJAC, Jack (American, 1929-)
 Big Skull II, 1964, bronze,
 UDCHi
 Hh, pl.822 (b/w)
 Big Skull and Horn in Two Parts
 II, 1963, bronze UCLL
 Ashton, pl.XXXIX (b/w)
 Easter Goat, 1957, bronze,
 UNNMMA
 Andersen, p.149 (b/w)
 Falling Water II, 1965-67,
 bronze UDCHi
 Hh, pl.826 (b/w)

ZAO WOU KI (Chinese-French,
 1921-)
 Composition, 1954, watercolor,
 Priv.Coll.
 Metro, p.396 (b/w)
 Drawing, 1960 FPPr
 Seuphor, no.414 (b/w)
 4a-1-62, 1962, painting, Priv.
 Coll.
 Metro, p.397 (b/w)
 In Memory of Chu Yan, 1956,
 o/c CML
 Abstract, pl.80 (b/w)
 January 6, 1960, o/c
 Seuphor, no.245 (col)

Stele pour un ami, 1956, o/c,
 GMSta
 1945, pl.27 (b/w)
3-12-74, 1974, o/c FPFr
 Arnason 2, col.pl.240
Untitled, 1965, o/c, Priv.Coll.,
 New York City
 Arnason, fig.970 (b/w)

ZARITSKY, Joseph (Russian-Israeli,
 1891-)
 Painting, 1954, o/c
 New Art, col.pl.103

ZEN, Giancarlo (Italian, 1929-)
 AEF/TSL/01, 1971-72, white can-
 vas and red neon
 Popper, p.49 (b/w)

ZIEGLER, Laura (American, 1927-)
 Eve, 1958, bronze UDCHi
 Hh, pl.585 (b/w)

ZIGAINA, Giuseppe (Italian,
 1924-)
 Grass for the Rabbits (Erba ai
 conigli), 1949, oil IVA
 Haftmann, pl.990 (b/w)

ZOGBAUM, Wilfrid (American, 1915-
 1965)
 Bird in 25 Parts, 1962, painted
 steel UDCHi
 Hh, pl.894 (b/w)
 Twin Corporal, 1960, iron and
 bronze UNNB
 New Art, pl.32 (b/w)
 Untitled, 1962, painted metal
 and stone UCSFM
 Busch, pl.IV (col)

ZOLLNER, Waki
 Mobiles Objekt, 1966
 UK1, pl.317 (b/w)

THE ZOO
 (The Epoch of Aquarius is Pre-
 paring Itself), Turin
 Celant, pp.231-40 (b/w)

ZORACH, William (Lithuanian-
 American, 1887-1966)
 Eve, 1951, pink granite UDCHi
 Hh, pl.658 (b/w)
 Head of Christ, 1940, black
 porphyry UNNMMa

PART II

Subject and Title Index

About the Compiler

PAMELA JEFFCOTT PARRY is editor of the *ARLIS/NA Newsletter*. She was a contributor to the book-length work *From Realism to Symbolism: Whistler and His World* and is currently working on a photography index.